W9-BKZ-073

200 -

KURT SCHWITTERS

MERZ – a Total Vision of the World

KURT SCHWITTERS
MERZ – a Total Vision of the World

WITHDRAWN
FROM
UNIVERSITY OF PENNSYLVANIA
LIBRARIES

Benteli Publishers Bern

FINE ARTS
N
6888
S42
A413
2004

'I saw these photos [of the *Merz Building*]
when I was only seventeen. They influenced
me very profoundly and have remained alive
in my memory ever since. Hardly a week
goes by without my thinking about
Schwitters in one way or another.'

Jean Tinguely, 1977

'I was totally beschwittered.
Schwitters was my hero.'

Jean Tinguely, 1987

Cat. 205
Redemann, photographer
Grosse Gruppe (Teilansicht des Merzbaus
von Kurt Schwitters, 1933)
Grand Group (Detail of Kurt Schwitters's Merzbau, *1933)*
1933
Silver gelatine print
23.2 x 17.2 cm
Archiv Georges Vantongerloo,
Angela Thomas Schmid

UNIVERSITY
OF
PENNSYLVANIA
LIBRARIES

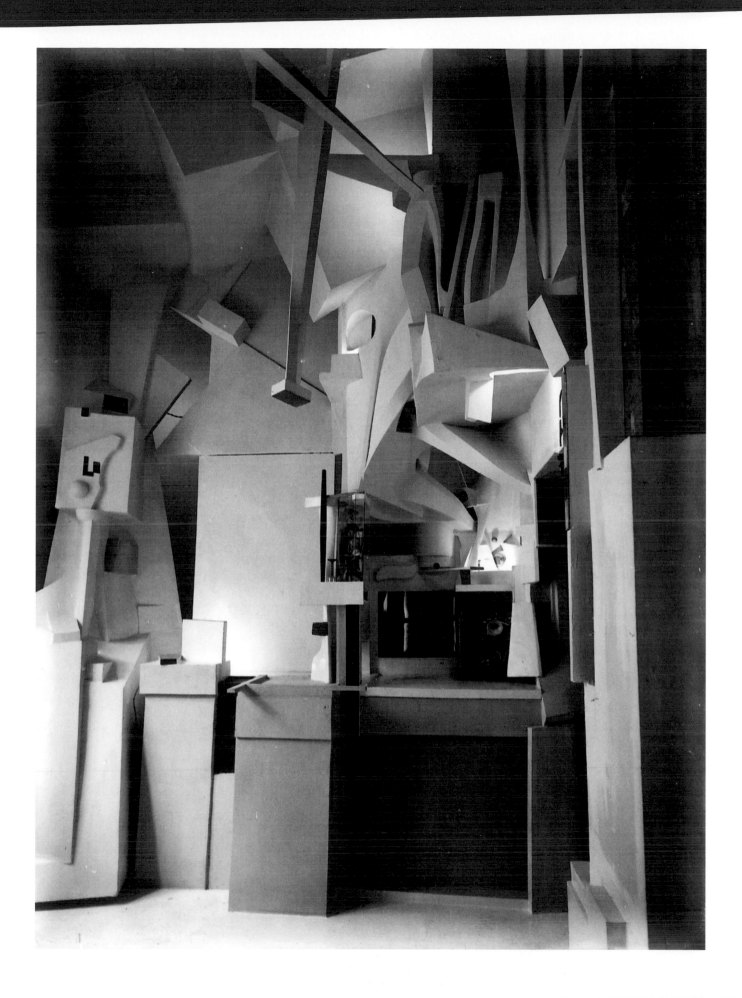
289770

We dedicate this volume

to the memory of Hans Bolliger,

the eminent Dada-expert

and biographer.

Contents

	Guido Magnaguagno	Foreword	9
		Thanks	21
	Iris Bruderer-Oswald	The New Optics Kurt Schwitters, Carola Giedion-Welcker and Sigfried Giedion	22
Merzbau	Karin Orchard	Kurt Schwitters's Spatial Growths	32
	Peter Bissegger	Notes on the Reconstruction of the *Merzbau*	66
	Eric Hattan	Merzbauaftermerz	68
	Eric Hattan	Anarchistic Proliferation – Safe and Secure	70
'One can use waste material to shout out loud'	Beat Wyss	*Merzpicture Horse Grease* Art in the Age of Mechanical Reproduction	72
	Jakob Kolding	Contesting Architecture and Social Space	86
	Daniel Spoerri	Nine written questions about Kurt Schwitters	88
Merz in the Machine Age	Christoph Bignens	Cogs and Wheels	108
	Kurt Schwitters	The Raddadist Machine	120
	Konrad Klapheck	The Machine and I	122
Merz is not Dada	Ralf Burmeister	'Related Opposites' Differences in Mentality between Dada and Merz	140
	Klaus Staeck	For me There is No Such Thing as Unpolitical Art	150
	Thomas Hirschhorn	'dada is important to me'	152
Games with Chance	Christian Janecke	Schwitters and Chance	168
	Jean Tinguely	The Brazilian Baked Apple Tube	200
	Juri Steiner	The Tale of Paradise Dada, Merz and the 'Other' Oeuvre	208
	Karl Gerstner	Kurt Schwitters: A Virtual Reminiscence	216
	Appendix	Kurt Schwitters Biography	220
		List of the Exhibited Works	232
		Authors	253
		Further Reading (selection)	260
		Photos	262
		Imprint	264

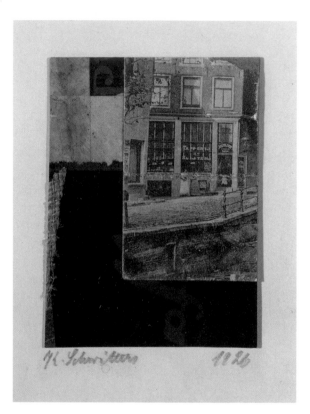

Cat. 85
Ohne Titel (fa)
Untitled (fa)
1926
Collage on paper
7.6 x 5.7 cm
Daria Brandt & David Ilya
Brandt, New York

Foreword

'My ultimate goal is the unification
of art and non-art in a "Merz total vision
of the world".'

Kurt Schwitters, 1920

Early one evening in the autumn of 1988 in Paris, near the Place des Vosges, about a dozen collages by Kurt Schwitters shone through a shop window onto the dark side-street. It had rained briefly. On the streets – as was still allowed in this city – pieces of paper rubbish gleamed over the black asphalt. The 'Galerie Gilbert Brownestone' was showing for a limited period a small number of little pieces which the Dusseldorf art consultant Helge Achenbach had proudly collected together from widely scattered provenances – delicate splashes of colour as fresh as the morning that had not been shown to the public for decades. That was at any rate how they appeared seen from outside, and it seemed that the pasted, framed scraps of paper were joining in solidarity with the refuse, the material of the street, and vice versa. The perfect Schwitters *mise-en-scène*. A jewel.

That was my dream. If Schwitters, then like this. Years later, during the preparations for his current appearance in the Museum Tinguely, the very first Schwitters exhibition to be put on by a Swiss museum, with more respect for light sensitivity, larger glass fronts, less street and far more space and height, I leafed through a slim catalogue published by the New York gallery owner Adam J. Boxer for his exhibition of a good sixty collages by Kurt Schwitters in 2003. Here, I also rediscovered a few 'lost' Paris sheets, and my eye fell particularly on a miniature made in 1926, 7.6 x 5.7 cm (see illus. p. 8).
I could not forget it. Early self-reflective photo-art? Between 'agfa' commercial and

Sigmar Polke – the 'f' mounted like a pair of scissors between found illustration and photo-paper, and everything so beautifully frayed and weathered, or 'beschwittered', just as the artist desired, as the perfection of his aesthetic ideal. The window immediately reminded me of the gallery in Paris, even if the place suggested in the work was more like Amsterdam. Of course I picked up the strongest magnifying glass I could find to examine the shop-sign and the display. It's a matter of guesswork; the most one finds is the word 'Jewellery'.

I later saw the original, cat. rais. no. 1440, in the home of the collector Arthur Brandt in New York. An immigrant from Eastern Europe and admirer of Schwitters, whose many Schwitters collages stood on dusty shelves in a grandiose layering of collection and furniture that the artist would no doubt have found appealing – this too was a life-collage, tolerable only in combination with large quantities of vodka and reminiscences of the divine Garbo.

Schwitters's *oeuvre* is loved by many. Sometimes, the smaller the work, the more it is loved. They are treasures, delicacies beyond any market price. One becomes attached to them. Not for nothing did so many artists admire the 'Kuwitter' – the 'Künstler Schwitters' – and collect his work, or collectors guard it like the apple of their eye. Only the politically high-profile Berlin Dadaists disliked him, with the exception of Hannah Höch, whom he wooed in vain, and Raoul Hausmann – and that paved the way to 'Merz' like nothing else. To his own label, his trade-mark, behind which lay hidden a whole concept for life and art. Is it this fragility, this mix of poverty and grace, of the pain and humour (*Schmerz* and

Scherz) of a lost bourgeois world reconstructed by the son of a ladies'-wear shop proprietor with such dreamlike assuredness, that caused his work to enter the canon of modernity as a highly ingenious patchwork? Do we admire this talent of transforming rubbish into something precious? He was a brilliant cutter-out, who most likely picked up the dexterity of the tailor's assistants intuitively as a child. Who took the broken fragments of things, the ruins of the First World War, of the fluttering Weimar Republic and the misery of a double exile, and turned them into a survival world made of art. He called this 'Merz', since this was a summary of all his immense abilities: Merz drawing, Merz sculpture, Merz poetry (which is to 'have its say' on 20 June, his 117th birthday) or Merz theatre, Merz typography, and Merz advertising (which he used to introduce himself in the Basel Gewerbemuseum [Trade Museum] in 1927 and 1930). The central piece in all this was the *Merzbau*, the *Merz Building*, which was totally destroyed in Hanover in 1943 and later, first in Norway and then in England, three times begun anew; this was the *MerzgesamtKunstwerk*, the Merz total work of art, and finally the 'Merz total vision of the world', which combined art and basic survival. The Berlin Dadaists branded him a lone warrior, and that was what he remained. He settled into the total world view of a one-man enterprise.

Not merely his work, his whole life became a collage in his hands. In Norway he dreamed of a world exhibition on his lonely island – with animals as visitors. Among the sixty million Germans there was in his judgement nobody who understood him. To find someone, he had to travel to Zurich to visit the Giedions ('Persil is always Persil, but Giedion also always remains Giedion.') Only Herwarth Walden, his earlier gallery-contact in Berlin, his life-long friend Hans Arp and the architecture theorist Sigfried Giedion had understood his *Merz Building*. He had maybe forgotten his wife Helma, who always vigorously supported him and shielded his *Merz Building* in Hanover from the Nazis, while their son Ernst had to join his father in Norwegian exile when only sixteen. When Kurt Schwitters, just sixty, exhausted after years of illness, died of heart failure near Ambleside in 1948, his revival began – above all in the United States, as the artist had himself prophesied. (From Katherine Dreier's 'Société Anonyme' to John Elderfield.)

Even Alfred H. Barr, the legendary director of the Museum of Modern Art, had visited the *Merz Building* and promised to help finance its reconstruction in England. In an abandoned powder-mill belonging to a landscape architect, who 'lets the weeds grow as they like but uses small touches to turn it into a composition', Schwitters created, very much in the same way, 'art out of rubbish', as he wrote to Carola Giedion-Welcker in Zurich. Schwitters was delighted with Carola's tribute to him in the 'Weltwoche' on the occasion of his sixtieth birthday on 20 June 1947, describing it as 'the best thing anyone has yet written about me. [...] The article is simply marvellous.' – Because of her early friendship with James Joyce and her intense study of his work, Carola Giedion-Welcker was almost predestined to comprehend Schwitters's working methods as they deserved. – Understandably late, German art literature recovered from its 'cleansing', and in exhibitions and books made about the two great 'Werners' (Haftmann and Schmalenbach) Schwitters was reinstated alongside Kirch-

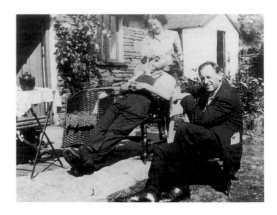

At Cylinders Farm on Schwitters's 60th birthday, 20 June 1947, with Harry Pierce and Edith Thomas. In Schwitters's pocket is the letter confirming the grant from the Museum of Modern Art.

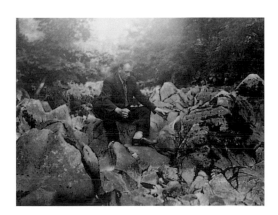

Kurt Schwitters sitting on a rock, 1940s

ner, Klee, Beckmann and Max Ernst in the community of the most important German artists of the first half of the twentieth century. He desperately wanted the essay translated into English – but he did not live long enough to see the exhibition 'Collage' in the Museum of Modern Art.

His immense legacy, photographed and cared for by his son Ernst (like his father a keen photogram-experimenter), travelled first to 'Klipstein and Kornfeld' in Bern in 1956 and from there, some time after 1962, to the 'Marlborough Gallery' in London. In New York the avant-garde 'Sidney Janis Gallery' presented three fabulous exhibitions between the years 1952 and 1959, which caused a phenomenal demand for Schwitters's works from American museums and collectors. The epoch-making anthology *The Dada Painters and Poets* by the artist Robert Motherwell, published in New York in 1951, rang in a Dada revival which had a decisive influence on almost all the Pop artists. Robert Rauschenberg, who has a Schwitters hanging in his bedroom, had 'the feeling he had done all this just for me'.

When travelling in Europe Schwitters stayed mostly with friends, as necessity dictated. The extensive, often desperate correspondence betrays financial difficulties, hidden as often as not behind satire and black humour. Schwitters's writings, edited between 1973 and 1981, comprise five volumes, and there are still some folios of letters yet unpublished. The most important journeys and contacts took him to Switzerland, first to Zurich, then to Basel. In the city on the Limmat, where in 1916 Dada was born in the Cabaret Voltaire and where Tristan Tzara published two Merzpictures in the magazine *Zeltweg* as

early as 1919, lived the two art critics Sigfried and Carola Giedion-Welcker, whom he had come to know in 1926 in a Dutch coastal town. (Schwitters's close connections with Holland, and more importantly with Theo van Doesburg, were the result of his Merz pamphlets and his lecturing journeys.) Soon afterwards, Sigfried Giedion tried to condense his experiences of a 'new optics' into an international exhibition, and put the matter to the Zurich Kunsthaus. His idea of joining with different representatives of the avant-garde, such as El Lissitzky and Hans Arp, and realizing these artists' legendary publication *Art-Isms* (1925) in an exhibition was vehemently opposed. In the end, the exhibition was shown in 1929 for four (!) weeks under the heading 'Abstract and Surrealist Painting and Sculpture' and included one hundred and fifty works by forty artists; Schwitters, with nine works, was more broadly represented than any other artist except Picasso.

This first demonstration of New Art in Switzerland was a milestone. It rounded off the progressive 1920s, but unfortunately produced no breakthrough for the international avant-garde, which by 1933 at the latest had to make itself scarce. Schwitters had enough time to react enthusiastically to the exhibition and to the reception of his soirée presented with Hans Arp, and the first collectors began to give him hope for better times (the Giedions, the Friedrichs, Alfred Roth, Hans Girsberger, Werner Moser).

In 1935, on the recommendation of Jan and Edith Tschichold, who had already emigrated, Schwitters was brought into contact with the collector couple Annie and Oskar Müller-Widmann in Basel, and later got to know Maja Sacher, Christoph Bernoulli and

BASEL

Es geht ein Bischen rauf,
Es geht ein Bischen runter,
Dazwischen fliesst der Rhein.
Grün soll sein Wasser sein.
Wenns regnet, stürmt und schneit,
Dann ist es braun,
Braun anzuschaun.
Verhältnismässig drückend föhnt der Föhn,
Es brodelt tief im Grunde;
Darüber eine Stadt,
Die Basels Namen trägt
Und hat.
Dort linst es Böck,
Dort beint es Hol,
Es waldet Grün
Und Witst.
Der Ritter sticht den Wurm
Am Turm.
Der Bruder holst,
Viel Speere und ein Zahn.

Cat. 179
Manuscript of the poem 'Basel',
December 1935
Manuscript: pencil
on paper, 1 sheet =
4 sides (each 22 x 17.5 cm)
Sprengel Museum
Hannover

Die Kirche aus Cement
Ist Mosers hohe Zeit.
Es brennt,
Wenns brennt,
Im Kleid.
Mann,
Sei gescheit!
Der Frauen holder Chor
Lächelt dem Tor.
Mann,
Sieh Dich vor!

K. Sch.

Bitte bei Abdruck nur K. Sch schreiben,
nichts weiter.
Honorar bitte an Tschichold, Steinenvorstadt.

This manuscript probably dates from December 1935, when Schwitters was staying in Basel and organized a Merz Evening on the Bruderholz hill together with the art collectors Dr Oskar and Annie Müller-Widmann. Schwitters gave the poem to Annie Müller-Widmann before he left the city. The poem's publication, which Schwitters clearly intended, did not occur until 1947, when it was printed in Carola Giedion-Welcker's anthology *Poètes à l'Ecart. Anthologie der Abseitigen*.

Felix Witzinger. In 1937 there was the exhibition 'Constructivists', conceived by Georg Schmidt, which showed four of his collages. Perhaps there was a more profitable period in the offing.

Then came the dark years, over a decade, of exile. In the English internment camp his preferred sleeping-quarters were in a dog-kennel. In 1947 he sent Carola Giedion (Sigfried had long since begun teaching in Harvard) the small pasted and overpainted collage he had made in England, *Für Carola Giedion Welker. Ein fertig gemachter Poët. (For Carola Giedion Welker. A finished poet.)* (see illus. p. 23). Although it shows a portrait of the poet Percy Bysshe Shelley, who had been driven out of England and who drowned near Viareggio, his obliteration of the poet's eyes and the ambivalent, but actually unequivocal, title refers to himself. Schwitters's melancholy and his humour shine through his work, as C. G. W. attested with the expression 'romantic irony', which Schwitters found perfect. As early as 1920, he had named melancholy as one of his basic characteristics; with Merz he defended his innermost self against the ravages of time. He countered the leap into the abyss with gentleness. That is why we love him. He is the grand-master of enchanting collages made of all sorts of materials which he was the first to distribute across the whole picture surface, and who thus created a new pictorial world ruled by the harmony of the outsider.

He is loved, too, by those who have loaned works to this exhibition, many of whom only very reluctantly part from their Schwitters. Our perhaps over-ambitious aim of collecting together as many precious jewels as possible, our hunt for such splendid trophies as

Merzbild K 6 Das Huthbild (Merzpicture K 6 The Huth Picture), 1919, made the project both exciting and difficult. The fact that the Museum Tinguely is now able to show an astonishingly high number of works in private ownership that have not been seen for decades fills us with joy and gratitude. Many pieces appear in this catalogue in colour for the very first time. They come from very special provenances, quite in keeping with our sought-after proximity to his 'total vision of the world', which encompasses not only his own immediate concerns for survival but also his hope that he would live on in the art world. Our thanks go above all to Andres Giedion and Verena Clay-Giedion for what I could call their 'inner scale of values' and their glorious loaned works; Eberhard Kornfeld, who as early as 1960 travelled to Japan with a suitcase full of Schwitters, and Carroll Janis for valuable conversations (and loans); and the 'Marlborough Gallery' as well as the 'Gmurzynska Gallery', promoters of Schwitters over many years, for their assistance. From the estates of Jan Tschichold, Willy Baumeister or Max Bill, from the collection of Jasper Johns we have received some extraordinary works. The famous *Heilige Sattlermappe (The Holy Saddlers' Portfolio)*, 1922, and the striking *Bäumerbild (The Bäumer Picture)*, 1920, – both fragile, and therefore particularly sought-after, material pictures – are as much part of our ideal selection as are homages to Friedrich Vordemberge-Gildewart and Rudolf Jahns, to Richard Huelsenbeck (his later enemy), Bloomfield, Auguste Herbin or the art historian Herbert Read. I have already mentioned the New York spoor-hunt in Adam J. Boxer's 'Ubu gallery' or in the house of Arthur Brandt: a list of works and acknowledgements to all lenders may be found elsewhere in this cata-

Carola Giedion-Welcker and James Joyce, Lucerne, 1935

logue. It is a list of at least one hundred and fifty pieces, including ten sculptures.

It is thanks to the Sprengel Museum in Hanover that the project could begin at all. On the occasion of its great exhibition of Niki de Saint-Phalle in the autumn of 1999, when it was able to present a large donation from the artist herself, I, then the freshly elected, not yet installed director of a future partner museum, approached him on the subject of Schwitters. After the initial agreement in principle there were many other hurdles to be taken to ensure that this artist, so central for the understanding of modernism, yet so little known in Switzerland (this is the first exhibition of his works here since 1971 [!], when one came here on tour from Dusseldorf), could be shown here again. (Even during my long Dada period at the Kunsthaus in Zurich, Schwitters was a long-cherished exhibition wish.) The Hanover Sprengel Museum and its dependency the Schwitters Estate Foundation participated in our project to the tune of a good forty works and many documents. This provided the essential basis for the really interesting work, which was generously supported by Karin Orchard and Isabel Schulz, both proven Schwitters specialists working on his estate and authors of the catalogue raisonné, of which the third volume is due out shortly. We give them our heartfelt thanks for their concentrated help and fruitful collaboration.

A particularly happy stroke of luck was the loan of the early assemblage *Ausgerenkte Kräfte. (Disjointed Forces.)*, 1920, one of the artist's principal works, from the Kunstmuseum in Bern. It was acquired by Professor Max Huggler, the then Director of the Kunstmuseum, in 1961 at 'Klipstein and Kornfeld', and given to the museum in 1966; since 1983

it has not been allowed to leave the house. We owe this extraordinarily accommodating attitude to Eberhard Kornfeld's persuasion and the insight of the present director, Matthias Frehner, and his art restorers. This loan and that of the *Huth Picture*, 1919, means that for the first time since 1956, all three large-scale masterpieces by Schwitters presently in Switzerland can be studied together in the art-city of Basel.

The third piece in the trio, *Das Frühlingsbild, Merzbild 20 B (The Springtime Picture, Merzpicture 20 B)* in the Basel Kunstmuseum, also made in the decisive years 1919/20, remains as ever 'yonder', on the other side of the Rhine, which we hope – to quote Schwitters's Basel poem (see illus. pp. 12, 13) – will never again flow between the two houses stained with brown. (The work belonged to Hans Arp. Marguerite Arp-Hagenbach donated it to the Öffentliche Kunstsammlung Basel in 1968.) We welcomed the simultaneous exhibition project entitled 'Schwitters Arp' in the Kunstmuseum Basel, which for the first time brings the two artists into direct dialogue in all the complexity of their relations, affinities and conflicts as a stimulating, presence-enhancing parallel event since, after all, the friendship between them had its centre here in Basel. This part of the story, and other important aspects in the art of Schwitters and Arp, may be found on the pages of the Kunstmuseum catalogue. A precursor of this was, in Schwitters's case, the book *Kurt Schwitters und die 'andere' Schweiz* by Gerhard Schaub, in which his correspondence with the collectors Annie and Oskar Müller-Widmann takes centre stage. For our part, we have turned our attention (again reflecting the loaned pieces) to the Zurich connections, with an essay by Iris Bruderer-Oswald, who is working on a

Schweizerischer Nationalfonds [Swiss National Fund] project on the immensely important communicative role of the Giedions. In a continual exchange of ideas with the director of the Öffentliche Kunstsammlung Basel, Bernhard Mendes Bürgi, and the exhibition curator, Hartwig Fischer, we sounded out our different concepts, agreed loans, discussed catalogue authors; it became a most fruitful collaboration, resulting in a joint opening, equal exhibition length, and, we hope, an equally positive echo from the press and the public.

Our own concept and its realization is the result of the enthusiasm, the expertise, and the rigorously precise work of our exhibition conservator, Annja Müller-Alsbach. From the beginning, we had the walk-through sculpture, the *Merz Building*, in the centre of our thoughts, so it is now also the centrepiece of the exhibition. Reconstructed by Peter Bissegger between 1981 and 1983 for Harald Szeemann's exhibition 'Der Hang zum Gesamtkunstwerk' [Tendencies to the total work of art], this work also forms the starting point for later cultural stations marked by Tinguely and Luginbühl. Around the *Merz Building* are grouped four thematically organized main chapels, which simultaneously outline the chronological and formally diverse contexts. Each square section is transformed into a six-cornered structure by the insertion of a main wall, a concept which forms the basic plan of the exhibition, and each is introduced thematically by a leading picture: the section 'Merz in the Machine Age' is represented by the assemblage *Disjointed Forces*. 1920, 'Material' by *Merzbild 14 B Die Dose (Merzpicture 14 B The Box)*, 1919, 'Merz is not Dada' by the *Huth Picture*, 1919, supported by the *Siegbild (Victory Picture)* a

valuable loan from the Wilhelm-Hack-Museum in Ludwigshafen and a series of politically explosive commentaries by Schwitters on the 'restoration of Germany'. The theme 'Games with Chance' is fought out between the stamp drawings and the i-Drawings. Around the *Merz Building* are grouped corresponding show-piece reliefs (splendid specimens from the Kunstmuseum Winterthur, the Sprengel Museum Hannover, the 'Gmurzynksa Gallery' and the IVAM Instituto Valenciano de Arte Moderno) and documents. At the 'edges' of the exhibition are a 'Constructive Cabinet', the *MERZ MAPPE* with the *Merz* pamphlets, the famous *Ursonate (Primal Sonata)*, 1925, and a corner for letters and postcards. An 'homage corner' shows the artist's self-stylizations and a wooden case, collaged inside the lid, which Schwitters probably used to transport his pictures from Germany to Norway (see illus. p. 47). The exhibition is rounded off with the figurative, more saleable 'parallel oeuvre' showing Norwegian landscapes, the *Merz Barn* he constructed in England and the collage *dead cissors* [sic!] of 1947.

Annja Müller-Alsbach has (with my help) not only done her utmost to keep the high standards set by the Duchamp show of 2002, designed by Harald Szeemann, but has dedicated herself with equal verve, and with Heinz Stahlhut's support, to the academic challenge of our enterprise: to the production of the catalogue published by the Benteli Verlag, which included overseeing the translations of the essays for the English language catalogue, and the guidance of its authors. Each main theme is covered by a different author. Christoph Bignens considers machines, wheels and advertising; Beat Wyss begins with the *Merzpicture Horse Grease* thus

with Schwitters's central concept of *'Material'*. Christian Janecke discusses the inexhaustible topic of 'chance' while Ralf Burmeister asks the equally unanswerable fool's question of whether Merz and Dada might not in fact amount to the same thing. Karin Orchard meanwhile shows us the development and the iconography of the *Merz Building* as a grotto and time capsule, from the early *Cathedral of Erotic Misery* to the bombed ruins and the consequent attempts at reconstruction. Our heartfelt thanks go to all the authors and translators for their profound yet highly readable essays. As a final touch, Juri Steiner, the *spiritus rector* in spe of the Dada House in the Spiegelgasse in Zurich, could not resist throwing a little sand in our eyes with his special praise for the figurative 'parallel *oeuvre*'.

A generous number of artist's statements, the newly-written such as those by Daniel Spoerri, Karl Gerstner, Klaus Staeck, Eric Hattan and Jakob Kolding, and the reread ones by Konrad Klapheck or Thomas Hirschhorn demonstrate, along with the large catalogue to the exhibition 'Aller Anfang ist Merz. Von Kurt Schwitters bis heute' (Hanover, Dusseldorf, Munich, 2000/2001), the unbelievable echo that Schwitters's work has found in the period since Neo-Dada, Nouveau Réalisme and Pop Art right up to today.

One of his greatest admirers was our own Jean Tinguely. He elatedly reports in 1987 that he is 'totally beschwittered'. In the *Art-Isms*, however, he could only have seen the two photographs of the *Merz Column* and a relief that is now lost; his teacher Julia Eble-Ris could perhaps have given him access to more 'material' from the artist's studio; he probably saw the 'Constructivists' exhibition

in the Basel Kunsthalle in 1937, and maybe also Nell Walden's exhibition on 'Der Sturm' in 1945 in the Bern Kunstmuseum, which showed nineteen works by Schwitters, or Suzanne Feigel's memorial exhibition in February 1948 in her 'Galerie d'Art Moderne' in Basel. In 1956, when 'Kurt Schwitters / Hans Arp' was shown in the Kunsthalle in Bern, he was already in Paris – although here he could have seen and admired Heinz Berggruen's first important postwar presentation of sixteen collages. What acquired particular importance for him were above all Schwitters's artistic principles of collage and assemblage. Working with fragments (scrap metal), with rubbish, with 'poor' materials. Accumulation and fragility. The laying-up of material deposits. His sculptures made especially in the years 1960 to 1962 frequently have the appearance of sculptural, three-dimensional collages. We have highlighted this aspect of Schwitters's influence with four works by Tinguely from the museum collection; we were happily able to acquire one of these, the relief *Ecrevisse* (1962), shortly before its present appearance. The four other pieces have been loaned from private collections and with the exception of *Crown-Jacket*, from the Hotz Collection, have never been shown here before. *Mes Roues No. 1* comes from Sylvio Perlstein's collection in Antwerp, *Radio Tokyo No. 2* from a private collection in Geneva, and *Tricycle* has been sent from the USA.
But the two characters are also linked by a common light-footed lyricism and lightning wit, acerbic humour, the sense of the grotesque and the tragicomic. And the *Merz Building* and the *Merz Stage* both introduce the concept of walk-through sculpture, the physical experience of art. This was transported by Tinguely with the help of his friends Spoerri and Luginbühl, with Niki and many

other secondary helpers, into his own 'stations of culture': from the unrealized *Dylaby* of 1964 to *Hon*, from *Tiluzi* to the *Gigantoleum* (lent by the Luginbühl family), from the *Crocrodrome* to what was really his central piece, the gigantic *Cyclop* in a forest outside Paris. The Museum Tinguely is presenting these continued developments of the *Gesamtkunstwerk* idea following on from Schwitters, which take the visitor via the traversable machine sculpture *Utopia* to the gallery, where we are showing the film version of *Cyclop* (commissioned by the Kunstmuseum Wolfsburg). Two further rooms follow with works by the Italian Art Brut artist G. B. Podestà, which Tinguely collected with a passion and integrated in part inside the one-eyed giant, very close to a true adaptation of the *Merz Building* made of iron. This part of the exhibition, showing works by G. B. Podestà, was made possible by the Musée d'Art et d'Histoire Fribourg and its director Yvonne Lehnherr, the curator of Tinguely's Podestà Collection, and the Musée de l'Art Brut in Lausanne and its conservator Lucienne Peiry, a Podestà specialist. Two people who have also loaned works are Seppi Imhof and his brother.

To close this outer circle around Schwitters and his *Merz Building*, we are showing from 16 May onwards, in the front room of the hall, the reconstruction of an early supermarket in the French provinces that was closed over twenty years ago and left untouched ever since, a discovery and project of Klaus Littmann. Both Schwitters and Tinguely drew sustenance from the culture of the everyday and would no doubt have been delighted at this true museum of commerce.

As we know, Schwitters took his label Merz from the Hanover Commerz- und Privatbank, which he simply cut out of an advert. He used these four letters in his lost (and first) *Merzpicture* of 1919. Since for him only Merz came into question as a visual element, 'Com' was left aside. This Schwitters exhibition also inaugurates our newly reworked image, designed for us by the Basel advertising agency 'desktalk', which incorporates a 360° colour panorama photograph by the unforgettable pioneer photographer Emil Schultheiss showing the reconstruction of the *Merz Building*.

In this gloriously florescent spring of art we have to bid farewell to the president of the Tinguely Foundation, the longstanding CEO and president of the Advisory Board of F. Hoffmann-La Roche AG, Dr Fritz Gerber. Three pieces from his collection are on loan for our Schwitters exhibition. The Tinguely Museum owes him and Paul Sacher its existence. In the office of his successor Dr Franz Humer there now hangs a collage entitled *Bâle*, dated 1947 and bearing the collaged label of a world-renowned firm: the work is by Kurt Schwitters (see illus. p. 19).

An early, unassuming oil painting by the 'finished poet' is called *Sleeping Crystal*. *(Schlafender Kristall)*.
From now on, we are counting on merz.com.

Guido Magnaguagno

Cat. 148
BÂLE
1947
Collage and gouache and oil on paper
25 x 20 cm
Kunstsammlung Roche, Basel

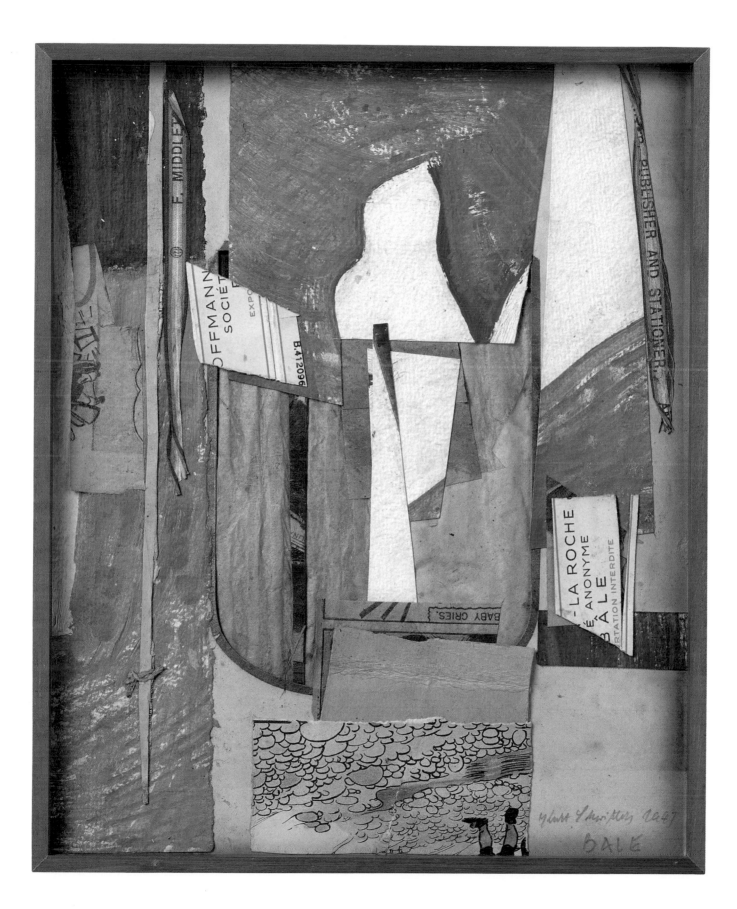

Cat. 19
Ohne Titel (Zeitu)
Untitled (Zeitu)
Circa 1919
Gouache on paper
4.1 x 4.9 cm
Kurt und Ernst Schwitters
Stiftung, Hanover

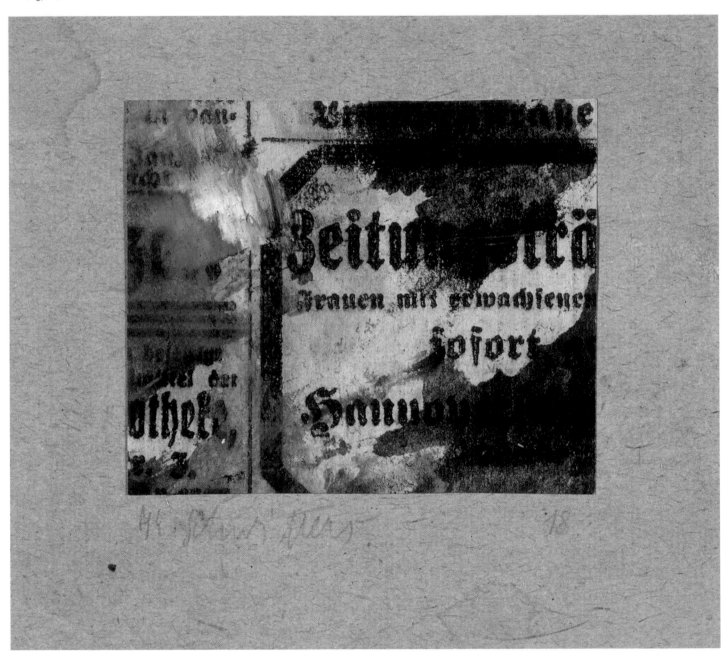

We extend our thanks to the following institutions and collectors for kindly lending us their works

Ahlers Collection: Stella A. Ahlers;
 Sabine Fröhling, Ahlers Pro Arte
Archiv Baumeister, Stuttgart: Felicitas
 Baumeister; Dr Jochen Guthbrod
Archiv Georges Vantongerloo, Zumikon:
 Dr Angela Thomas Schmid
Cabinet des estampes, Musée d'art et
 d'histoire, Geneva: Dr Cäsar Menz;
 Director; Dr Rainer Michael Mason,
 curator Cabinet des estampes
F. Hoffmann-La Roche Ltd., Basel, Kunst-
 sammlung: Dr Franz Humer, CEO
 F. Hoffmann-La Roche Ltd.; Doris Aebi,
 Roche Art Gallery
Fondation Le Corbusier, Paris:
 Michel Richard, Director
Galerie Gmurszynska, Cologne: Krystyna
 Gmurzynska; Mathias Rastdorfer
Galerie Kornfeld, Bern: Dr Eberhard W. Korn-
 feld
Indiana University Art Museum, Bloomington:
 Adelheid M. Gealt, Director
IVAM, Instituto Valenciano de Arte Moderno,
 Generalitat Valenciana, Valencia:
 Kosme de Baranano, Director
Johannes-Molzahn Centrum für Documenta-
 tion und Publication, Kassel:
 Hans Peter Reisse
J & P Fine Art, Zurich: Beda Jedlicka;
 Stefan Puttaert
Karl Ernst-Osthaus Museum der Stadt Hagen:
 Dr Michael Fehr, Director
Kunsthaus Zug, Stiftung Sammlung Kamm:
 Dr Matthias Haldemann, Director;
 Christa Kamm
Kunstmuseum Bern:
 Dr Mathias Frehner, Director
Kunstmuseum Winterthur:
 Dr Dieter Schwarz, Director
Kurt und Ernst Schwitters Stiftung, Hanover;
 Prof Dr Ulrich Krempel, Executive Director;
 Dr Karin Orchard, Director;
 Dr Isabel Schulz, Manager
Margo Pollins Schab Inc., New York:
 Margo Pollins Schab
Marlborough International Fine Art, London
 and Vaduz: Gilbert Lloyd;
 Franz K. Plutschow, Director
Musée d'Art Moderne et Contemporain, Stras-
 bourg: Emanuel Guigon, Chief Curator
Muzeum Sztuki w Lodz:
 Miroslaw Borusiewicz, Director
Norton Simon Museum, Pasadena:
 Walter W. Timoshuk, Executive Vice Presi-
 dent; Sara Campbell, Chief Curator

Rudolf Jahns Stiftung, Detmold:
 Barbara Roselieb-Jahns
Sammlung Deutsche Bank, Frankfurt am Main:
 Dr Ariane Grigoteit; Friedhelm Hütte
Sammlung E. W. K., Bern
Sammlung Sonanini, Switzerland
Schwitters-Archiv der Stadtbibliothek
 Hannover: Maria Haldenwanger,
 Deputy Director
Sprengel Museum Hannover, Sammlung
 NORD/LB in der Niedersächsischen
 Sparkassenstiftung
Sprengel Museum Hannover:
 Prof Dr Ulrich Krempel, Director;
 Dr Karin Orchard, Curator
Staatliche Museen zu Berlin, Kupferstich-
 kabinett: Prof Dr Peter-Klaus Schuster,
 General Director of the Staatliche Museen
 zu Berlin; Prof Dr Hein-Th. Schulze
 Altcappenberg, Director;
 Dr Anita Beloubek-Hammer, Curator
Staatliche Museen zu Berlin, Nationalgalerie:
 Prof Dr Peter-Klaus Schuster,
 General Director of the Staatliche Museen
 zu Berlin and Director of the Nationalgalerie;
 Prof Dr Angela Schneider, Vice-Director
Teutloff Kultur- und Medienprojekte, Bielefeld:
 Lutz and Hannelore Teutloff
The Menil Collection, Houston:
 Dr Josef Helfenstein, Director;
 Matthew Drutt, Chief Curator
The Museum of Modern Art, New York:
 Glenn Lowry, Director; Gary Garrells,
 Chief Curator, Department of Drawings;
 Jodi Hauptman, Assistant Curator,
 Department of Drawings
Ubu Gallery, New York: Allan J. Boxer;
 Giles Downes jun, Director
Von der Heydt-Museum, Wuppertal:
 Dr Sabine Fehlemann, Director
Wilhelm-Hack-Museum, Ludwigshafen am
 Rhein: Dr Richard W. Gassen, Director

Claude Berri, Paris
Arthur Brandt, New York
Daria & David Ilya Brandt, New York
Carla Emil and Rich Silverstein
Theo and Elsa Hotz, Zurich
Carroll Janis, New York
Jasper Johns
Renée l'Huillier
Per Kirkeby
Bernhard and Ursi Luginbühl, Mötschwil
Elaine Lustig Cohen
Sylvio Perlstein, Antwerpen
Dr Angela Thomas Schmid
and to all other lenders who prefer
not to be mentioned.

For valuable tips and help in finding lenders:

Berlinische Galerie, Museum für Moderne
 Kunst, Photographie und Architektur,
 Künstlerarchive, Berlin: Dr Gunda Luyken,
 Head of the Artists' Archives
Galerie Berinson, Berlin: Hendrick Berinson
Galerie Beyeler, Basel: Bernd Dütting
Galerie Brusberg Berlin: Dieter Brusberg
Galerie Kornfeld, Bern: Dr Eberhard
 W. Kornfeld
Galerie Michael Werner, Cologne:
 Michael Werner
Helly Nahmad Gallery, London: Helly Nahmad
J & P Fine Art, Zurich: Beda Jedlicka
 and Stefan Puttaert
Kunsthandlung Wolfgang Werner, Bremen:
 Wolfgang Werner
Kurt und Ernst Schwitters Stiftung, Hanover:
 Dr Karin Orchard; Dr Isabel Schulz
Rahel Adler Fine Art Inc., New York:
 Rahel Adler
Robert Rauschenberg Foundation, New York:
 David White, Curator
Rudolf Jahns Stiftung, Detmold:
 Barbara Roselieb-Jahns
Ubu Gallery, New York: Allan J. Boxer

Christoph Aeppli, Basel
Peter Bissegger, Intragna
Dr Silvan Faessler, Galerie Gmurzynska, Zug
Prof Dr Manfred Fath, Mannheim
Esther Grether, Basel
Dr Margrit Hahnloser, Fribourg
Bernhard and Ursi Luginbühl, Mötschwil
Olivier Masson, Zurich
Raimund Meyer, Zurich
Francis Naumann, New York
Daniel Spoerri
Dr Harald Szeemann, Maggia
Prof Dr Stanislaus von Moos, Zurich

The New Optics
Kurt Schwitters, Carola Giedion-Welcker and
Sigfried Giedion Iris Bruderer-Oswald[1]

Kurt Schwitters's *Merzbild K 6 Das Huthbild (Merzpicture K 6 The Huth Picture)*, 1919, (illus. p. 156) and his late collage *Für Carola Giedion Welker. Ein fertig gemachter Poët (For Carola Giedion Welker. A finished poet)*, 1947, (illus. p. 23) are landmarks of a friendship. They each mirror an important encounter between the artist and the two art critics Sigfried and Carola Giedion, who numbered among the most important Swiss 'advocates, patrons and collectors' of Kurt Schwitters.[2] *Merzpicture K 6 The Huth Picture*, 1919, was a principal work in the avantgarde exhibition 'Abstrakte und Surealistische Malerei und Skulptur' [Abstract and Surrealist Painting and Sculpture], which they acquired immediately afterwards.[3] The 'poet photomontage', as Carola Giedion-Welcker calls the 1947 collage, is a final gift from the exiled artist to his friends, which she reciprocates with a revealing essay.

The Avant-Garde Exhibition
in the Kunsthaus Zürich, 1929

On 30 October 1929 a remarkable event takes place in the Kunsthaus in Zurich. As a high point of the exhibition of 'Abstract and Surrealist Painting and Sculpture', Kurt Schwitters and Hans Arp recite their own poems. 'Kurt Schwitters [...] declaimed lines that recalled birdsong; articulated, melodic, atmospheric and totally void of meaning and thought.'[4] In the programme notes for this soirée, Carola Giedion introduces the artist with the words: 'Kurt Schwitters bases his poetry among other things on acoustic and rhythmic effects. In his *Systemschrift* [System Script] he calls language the "visual deposit of sound. Optophonetic" [...] Just as he uses the most banal scraps and discarded rags in his Merzpictures to [...] produce as if by magic an image alive and quivering with colour and form, his poetry chatters in golden, fatherly sentences, hackneyed phrases, distorted words, deep follies.'[5] Alongside this recitation there is a showing of the surrealist film *Un Chien Andalou* by the two Spanish artists Buñuel and Salvador Dalí and a performance of the *Ballet méchanique* by the composer George Antheil. In his review Sigfried Giedion notes: 'Hans Arp and Kurt Schwitters appeared in front of the paintings of Picasso and Braque. Kurt Schwitters was bold enough to start with some extracts from his spoken sound-sonatas; [...] these may be among the very few "literary" documents that will outlive our era.'[6]

With one hundred and fifty works by forty artists, this exhibition 'Abstract and Surrealist Painting and Sculpture' in Autumn 1929 does not merely provide the most important overview of contemporary artistic trends, it is a milestone in the art critics' efforts to promote modernism. In a concerted campaign throughout the duration of the exhibition, they woo the public with newspaper articles and lectures in the cause of the avant-garde. Kurt Schwitters is represented by *Merzpicture K 6 The Huth Picture*, 1919, *Merzrelief mit schrägem Gelb (Merz Relief with Diagonal Yellow)*, 1924, *Bild 1926, 13 mit gelbem Klotz / Merzbild mit gelbem Klotz*, 1926, *(Picture 1926, 13 with Yellow Block / Merzpicture with Yellow Block)*, 1926, and six small Merzpictures from the years 1920 to 1922.[7] In the course of the preparations Sigfried Giedion invites the artist to participate, to which he immediately responds: 'I will be happy to participate in the exhibition if it involves no costs for me. Please let me know how you would like to extend the scope of the exhibition into the literary sphere.'[8]

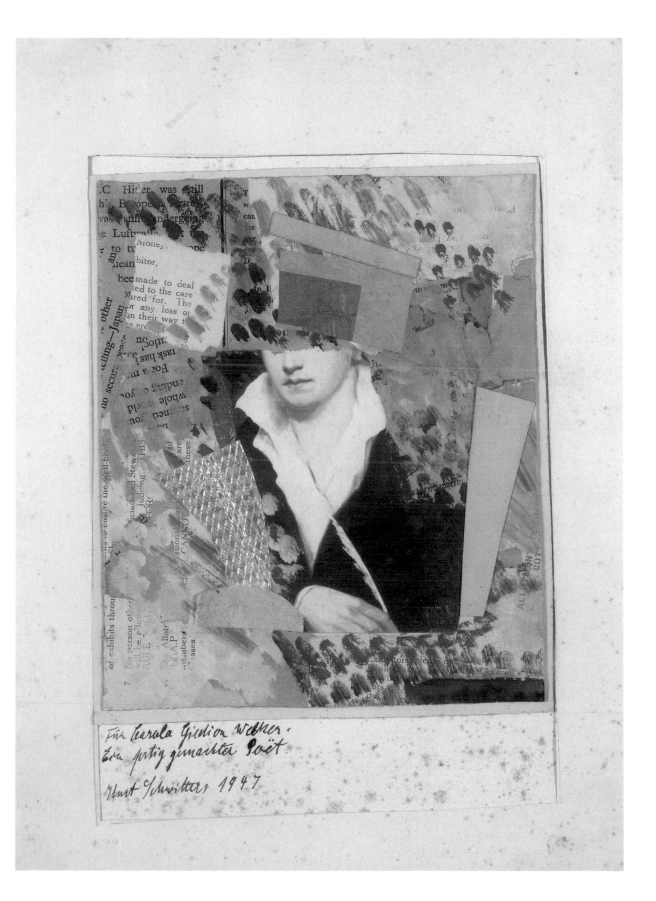

Cat. 144
Für Carola Giedion Welker.
Ein fertig gemachter Poët
For Carola Giedion Welker.
A Finished Poet
1947
Collage on paper
20 x 17 cm
Private collection

The exhibition concept is worked out with the help of various trusted friends who share the same attitude to the avant-garde. Hans Arp chooses the artists in France and is involved in the exhibition in many other ways. El Lissitzky, working in the Soviet department in St. Johann, is commissioned with the choice of Russian artists' works; a planned meeting between him and Sigfried Giedion fails because of visa difficulties.[9] Alexander Dorner of the Hanover Provinzialmuseum [Provincial Museum] shares the responsibility with Kurt Schwitters for the choice of works from Germany.

Sigfried and Carola Giedion-Welcker probably made the acquaintance of Kurt Schwitters in the summer of 1926 in Kijkduin, Holland.[10] While sending 'Honoured Madam' two copies of the short novel *Auguste Bolte* in August 1927,[11] he agrees to take part in the reading a week beforehand: 'I will be glad to [...] participate, announce, recite, whatever you like, and am most grateful to you [...] I am ready to perform at once on the spur of the moment or to wait, however you want to arrange me. Splendid.'[12]

Despite critical reviews, Schwitters experienced the exhibition as a success and on the way home wrote an elated letter to the 'Giedionses': 'After a heart-stopping voyage across the abysmal Bodensee [Lake Constance], I am now sitting in an overheated express train compartment, typing to you. My typing overruns with lyricism when it thinks of Zurich; it was fabulous staying with you, C. W., Giedion, [...] and experiencing all the great and small attractions. Thank the fates that Hanover is so far away, or I'd be forever inviting myself. But it's far away and only my tears can type to you how lovely it was. Life is washing me onto other shores, like driftwood in the breakers, and stones wear me down until I become quite small and round. Then evening comes. If only it were always morning!'[13]

Merzpicture K 6 The Huth Picture, 1919

As a souvenir of this exhibition, and as a gesture of support and recognition of the artist, the Giedions acquire *Merzpicture K 6 The Huth Picture*, 1919, at the end of the year. Schwitters is a welcome guest at their house in the Doldertal in Zurich whenever he visits Switzerland. Sitting at the head of the table, he creates variations of the sound sonata for the younger members of the family or repairs the fragile *Huth Picture* without further ado. Twenty-five years later, in her introduction to the double exhibition *Kurt Schwitters / Hans Arp* in the Kunsthalle Bern in 1956, Carola Giedion-Welcker recalls the personal, humorous contact the artist maintained to his pictures.[14] Her fears regarding the disintegrating *Huth Picture* are commented by Schwitters in January 1930 as follows: 'I am very sorry you are anxious for the picture [...] these cracks appeared when it was still in a sense a young girl, as sometimes happens. Of course I've been watching my daughter, so to speak, more closely since I noticed this lapse, and can confirm that for as long as it was under my supervision, no second lapse occurred. All the same she's a bit of a strumpet, this Miss Huth, it's a defect that sticks. [...] I'd be happy to exchange it, if you'd rather have another picture of mine, since Miss Huth's character may be on the light side, but she's my raciest daughter. As you see, the lady's actually quite moral. Just think: if, as a very young girl, so to speak, she goes and forgets herself, and later she remains true to this, it's even a sign of a really great character.'[15]

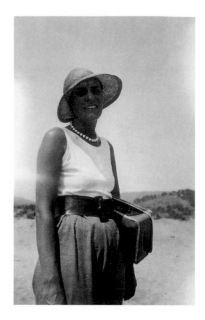

Carola Giedion-Welcker
at the CIAM Congress, Greece, 1933

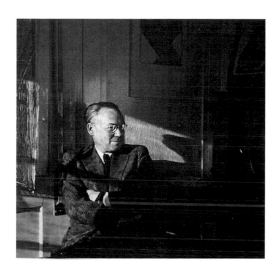

Sigfried Giedion in his house
in Zurich, later 1930s
In the background a painting
by Theo van Doesburg;
beside Giedion the 'Indi lamp'
whose design he had inspired

In the same letter Schwitters provides a memorable tribute to Sigfried Giedion's understanding of his art. 'It's a pity we are living so far apart. There is only one Giedion in the world, and he lives fourteen hours' train journey away. In the whole of Germany there is no person who approaches Merz with such understanding, such love and such initiative as Giedion. Isn't that amazing in a nation of sixty million people? [...] The exhibition in Zurich was the first large exhibition, and the most perfect, to show all the important artistic developments in the world today. It showed practically everything and left nothing out. I don't know, are people so blind that they can't see this?'[16]

With this exhibition the Giedions's house in Zurich develops into a meeting-point for the international avant-garde and a laboratory for new ideas. In an essay of 1930 entitled 'The art of the 20th century. Experiment cell. Time seismograph', Carola Giedion-Welcker describes Schwitters's *Merzpicture K 6 The Huth Picture* as a model of contemporary art, since the artist takes old scraps of paper and everyday waste and combines them with a delicate feeling for form and colour to produce, as if by magic, a whole whose inner structure shines through the randomness of the details.[17] What Carola Giedion-Welcker defines as a core cell, Sigfried Giedion places in a larger context, to which he ascribes clear intentions and which he gives the descriptive term *Neue Optik (New Optics)*, which is chosen as the title of the impending exhibition held in 1929. In a statement announcing the exhibition, he declares that the works to be shown not only spring from intentions of aesthetic form, but above all have their roots in a new perspective on the world. 'twentieth century painting demands a new culture of seeing!'[10]

A New Optics

At the time of the 1929 exhibition, Sigfried Giedion uses the term 'New Optics' to describe a broad programme. 'We consider it one of the most important tasks of today's art institutions to make the movements that emerge in different countries accessible to the public and to give it the opportunity of getting to grips with them. Images should not first be shown only when they have become history and have lost their power to shock. We want to be informed about what is happening now,' he demands in a letter to the director of the Kunsthaus Zürich.[19] 'Instead of a renaissance [...] of the laws of perspective, we want to define new ways of seeing.'[20] This demand covers two areas: firstly, the vessel of the New Optics embraces all the trends in modern art, Constructivist, geometrically and rationally conceived paintings as well as Surrealism. Secondly, Giedion's idea of a new vision is shown in his integration of the Stuttgart exhibition 'Film und Foto', 'to show the public the whole context of how our vision works', as he explains in a longish article for the Zürcher Illustrierte magazine. Here, he places Picasso's *Ma Jolie* alongside a sculpture by Brancusi and a photograph of the iron construction of the Eiffel Tower. 'Only today, now that our eyes have been trained by abstract artists of all schools, can we recognize the whole charm of the abstract forms found in iron bridges, the Eiffel Tower, and electric pylons, that have hitherto gone unnoticed,' is his caption below the images.[21]

The bold and programmatic original title for the exhibition in the Kunsthaus Zürich, 'Neue Optik' [New Optics], had in the end to be abandoned in favour of the matter-of-fact 'Abstract and Surrealist Painting and Sculp-

ture'. However, in his introductory speech Giedion picked up the theme of his original title and pleaded for 'a broadening field of vision': the barriers that had until then so carefully separated different disciplines and fields of knowledge from one another, painting from sculpture, art from technique, should be torn down; one must look for the 'common fundamentals' that lay hidden behind them. 'These elements fit together like the multiple facets of a whole [...]; more precisely, of the human being of today. Art and its direct expression is the most trustworthy document of our inner condition.'[22] A comprehensive programme accompanying the exhibition presents the avant-garde claims of the 'new optics', which aim to promote specific vision and the possibilities this gives of many-faceted understanding.[23] The highly pitched challenge of this exhibition reflects a many-layered world view. It reveals a fundamental effort to give modern art a status that directly corresponds with an integral humanity.

The friendship between Kurt Schwitters and Sigfried and Carola Giedion deepens over the years, although their contact, influenced as it is by the political situation, remains mostly on the epistolary level. Starting in the nineteen-thirties, Carola Giedion makes plans for a 'small pamphlet' about the artist and his work, which is to appear in the periodical 'XXe siècle'. For Schwitters, this announcement is a sign of hope: 'In MERZ, dearest CW! [...] I came from Molde to Oslo and found your letter and was happy: [...] Your confirmation that you want to write about my work, even the mention of a publisher. My thanks for all this comes very late in the day. But I must express my gratitude to you if you really want to take it on.'[24] The text is to take

shape with the help of the artist's thoughts and suggestions. 'Now I shall buy a ticket to travel to England, France and Switzerland in November and December,' he writes in July 1938. 'But this time you really must exploit me during my visit and ask me everything you want to know about my life. I shall be in Zurich from 25 November until 29 November. Can I stay with you then? And can you arrange a lecture for me?' Carola Giedion-Welcker also considers the possibility of visiting Norway to meet the artist there and see his new Merz Building. 'I'm delighted you're thinking of visiting me here. But when? [...] My *Merz Building* [...] in Hanover is no longer visible; it's been bricked up. I'm constructing a new Merz Building in Oslo. You can only really get an impression if you put your imagination to work. It is however important for any book about my work that your impression of my *Merz Building* should be a strong one. I have good photos of it. But I don't know whether you want to write about them. I'm active in so many areas that maybe it would be better just to allude to most of them and concentrate on paintings and sculpture and then maybe write about the other areas another time. On no account should the location be made public, since that would put the *Merz Building* in danger, you know?'[25]

Although Schwitters sends her some photographs of his work, the project comes to nothing. It coincides with Carola Giedion-Welcker's long-planned journey, delayed by visa difficulties, to join Sigfried Giedion in Harvard, where he is teaching. Contact between the artist in exile and the Giedions is maintained by letter.

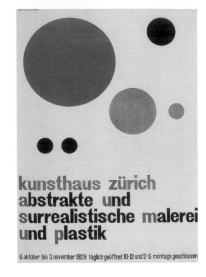

Poster advertising
the exhibition 'Abstrakte und
Surrealistische Malerei und
Plastik', Kunsthaus Zürich,
6 October – 3 November 1929

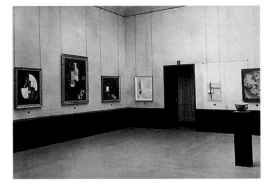

Documentary photograph of the exhibition
'Abstrakte und Surrealistische Malerei
und Plastik', Kunsthaus Zürich, 6 October –
3 November 1929; to the right of the
passage is Schwitters's *Relief with yellow
square–2* (1928) and *Merzbild K 6
The Huth Picture* (1919)

Poets on the Edge

In its exhibition of 1945 showing the artists of 'Der Sturm', the Kunstmuseum in Bern dedicates a special section to nineteen works by Schwitters. Carola Giedion-Welcker writes to him in the autumn of 1946 about the exhibition: 'Dear Schwitters [...] Two years ago I loaned the *Huth Picture* to the art museum in Bern for an exhibition that was very fine. Later it went to the Nell Walden exhibition at 'Der Sturm', [...] I have made an anthology entitled *Anthologie der Abseitigen* [Poets on the Edge] in which you play a major part. I'm sending you the proofsheets of your section, which is in the final stages of editing and is due for publication at Christmas. There is a photograph of each artist. There are fifteen German and fifteen French poets [...] The students love your paste pictures and buy them from all sorts of people in Zurich and hang them on their walls! Arp is here – has been here two weeks. We are very fond of him – really, the old guard is the true one!'[26] The Franco-German reader that is being prepared for the press at this time pays particular attention to poets 'whose works are difficult, who have found no publisher and who have only been printed in small, rapidly sold-out editions.'[27] Carola Giedion-Welcker selects thirteen poems by Schwitters which, above all, form 'interesting linguistic parallels to the revolutionary visual works of those years', as she explains in the biographical introduction. She chooses the *Ursonate (Primal Sonata)*, 1925, well-known from its inclusion in the *reine dichterische Laboratoriumsarbeit* [pure poetic experiment] compiled by Hugo Ball and Theo van Doesburg, and crowns the selection with *An Anna Blume (To Anna Blume)*, 1919, which also appears in a French translation. As an homage to Switzerland she in-

cludes the poem *Basel*, which rounds off the group: 'It goes a bit uphill / it goes a bit downhill / the Rhine flows in between.'[28] (see illus. pp. 12, 13)

For the poet working in Norway this book becomes more important than he can guess at the time, since it makes his poems available to the public. 'A book is about to be published in Zurich with six German and six French poets. Mrs. Giedion', he writes to Raoul Hausmann, 'she's sent me the correction proofs.'[29] And later: 'I can't send *To Anna Blume*, 1919, but you have her in the Giedion book. It's already been translated into French.'[30] Moreover, the bilingual anthology provides a point of contact for artists living in exile and a platform for scarcely accessible publications. 'I heard about his successful exhibition and his poems in Mrs. Giedion's book. I was very pleased to read Arp's poems again. I am of the opinion that his pieces in the book are the best and the strongest,' writes Schwitters to Arp.[31] Fifty years later, Giedion-Welcker's anthology is still seen as an influential source on which young artists could draw for inspiration after the Second World War; it stirred great enthusiasm for Schwitters's poetry.[32]

A Finished Poet

One year later, in 1947, Sigfried and Carola Giedion receive an unusual gift – it is one of the collages typical of the artist's years in England, with the dedication 'For Carola Giedion Welcker. A finished poet. Kurt Schwitters 1947'. The centre of the picture is dominated by a detail from a reproduced portrait; the attribute of the quill pen and the open white shirt under the black jacket indicate a Romantic poet. It is, in fact, a portrait of the English poet Percy Bysshe Shelley, painted in 1819, three years before he

drowned off the coast of the Italian resort Viareggio. The painting, reproduced by Schwitters, is partially covered so that the top of the poet's head is obliterated, down to below the eyes. The sheet is strewn with scraps of paper from English newspapers on which words such as 'Hitler', 'Japan', 'CANNOT' or 'Luftwaffe' can be made out. The texts on these fragments have been painted over with impasto strokes beneath which the fragmentary portrait of the poet seems to disappear. The double meaning of the title acquires additional dimensions when one considers that English society so attacked Shelley that in 1814 he saw no other option than to leave the country – just as Schwitters was forced to do more than a century later. *A finished poet* – that is the sum total of Schwitters's experience in English exile, in which he vainly attempted to achieve recognition as an artist. [33]

In June 1947 Carola sends the artist a birthday letter in which she thanks him for the 'poet photomontage'. She promises him that she will try to sell his works: 'Many thanks for your gift of the poet photomontage. I will show the others to possible buyers, who are becoming ever fewer, when I have the chance. You can tell me the prices. Most of them are young people (that speaks for you!), who are interested in your collages. I hope to come to London in the autumn to see you,' she adds encouragingly. In the same letter she mentions a forthcoming newspaper article that she is writing for the Swiss Weltwoche: 'I am going to write a few lines for the Weltwoche, which will appear in shortened form and rather late due to the type and paper shortage, and will send you what I've written at the beginning of July.' [34]

The text appears in August 1947 in Zurich under the title 'Kurt Schwitters: The Constructive Metamorphosis of Chaos'. [35] It is a summary of Giedion-Welcker's years of intense reflection on Merz. Schwitters's art, she writes, is characterized by 'games within games' and 'romantic irony' which use serenity of mind and the weapon of wit to triumph over the dullness and heaviness of life. Items from everyday life such as used tram tickets, stamps, fragments of advertisements – materials from Schwitters's lucky dip box – are taken out of their normal context in order to show them as absolutes and combine them in unaccustomed ways. Schwitters's work is characterized both in its clear construction and in the bold instinct of his inventions; they are the creations of a magician and a dreamer. This attitude to life is rooted in a German past and 'the wide plain of Low Germany where centuries earlier the comic tale of the legendary Till Eulenspiegel had thrived'. In this provincial setting the artist creates his Merz art, a *Gesamtkunstwerk* which shares Kandinsky's aim of 'artistic synthesis', and which is realized in his studio. Schwitters continually projects into his forever incomplete *Merzsäule (Merz Column)*, begun in 1923, new jokes, ideas, fantastical forms and objects, 'a strange mixture of cosmically-minded elementarism, biting political satire and the play-freedom of a German dreamer, realist and fool.' In a last great effort, Schwitters is at the time of his sixtieth birthday engaged in a reconstruction of the *Merz Building* in an old powder mill, 'which will later be situated in a nature reserve and become closely knit with nature,' as Giedion-Welcker quotes the artist. Behind his work one could discover a precise study of humanity and nature, yet out of this emerged the

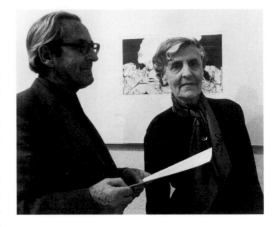

Carola Giedion-Welcker and Hans Bolliger, Zurich, 1950s

idiosyncratic, abstract *Vogel Rock (Bird Coat)*. His poems – like the concept he used in 1929, 'optophonetic' – follow the same laws. Giedion-Welcker refers the reader to the context of contemporary literature, in which *To Anna Blume*, 1919, the 'mad lover of my twenty-seven senses', is just as bizarrely dressed and described as Apollinaire's *Tristouse Ballerinette* or Joyce's river goddess *Anna Livia Plurabelle*. All of these are expressions of an age, 'an uncounted female, wearing her hat on her feet and walking on her hands', just like André Breton's wayward *Nadja* and all the other poems and prose grotesques that appear from 1919 on under the collective heading of *Anna Blume* and *Veilchenheft*.

Carola Giedion's essay comes as a ray of hope to the isolated artist and he immediately responds:

'How moved I am by your words in the Weltwoche [...] Am I really all of that? I must be, to go by the facts. I wrote to Miss Mille [...] that it was the best thing anyone has yet written about me. I recommended her to translate the article and publish it in an American paper in time for my coming exhibition. [...] The article is simply marvellous. Nobody could have written it nearly as well as you. [...] I at any rate am thrilled [...]
May I take the liberty of replying in detail to what you have written? The definitions "romantic irony" and "serenity ... life" are wonderful. It's what I called *Tran* [train oil / dream] in my article in *Der Sturm. Auguste Bolte was a Lebertran* [liver-dream; also cod-liver oil]. The term "Merz" was not an accident. I was at the time of my big exhibition in "Der Sturm" already aware that I was neither Cu-

bist, nor Futurist, nor Expressionist (*Erpressionist*, blackmailist, Ernst called it). That was why I named my art after the largest of my images, the Merzpicture. [...] And Merz was added to the picture for optical reasons, again not by accident. [...] You are right, I believe in art, not in the times we live in. [...] What you write about idylls behind which we sense that the times are out of joint is really excellent. I feel it myself. [...] In Hanover many people are now calling me "Till Eulenspiegel".'[36]

The wish expressed in Schwitters's letter acquires unexpected significance and weight when the artist dies the following January. The author expands her essay, which is published under the title 'Schwitters or the Allusions of the Imagination' in an English translation to coincide with the long-planned exhibition in New York.[37]

The Artist's Vision

Where do Carola and Sigfried Giedion see the importance of Schwitters's art? They recognize his qualities both as an artist and as a poet from the very beginning. The visual artist takes fragments of everyday advertising, worthless yellowed scraps of print, and turns this insignificant refuse into a timeless work of art. In the same sense Schwitters the poet turns the most banal scraps of words, grammatical solecisms, linguistic decay and hackneyed phrases into a grotesque poetry whose contours are drawn by the use of contrast and refrain. This urge to work in multiple layers is the basis for his combination of different creative activities in a *Gesamtkunstwerk*. The *Merz Column* embodies the polyphonic synthesis of a 'uniform stylistic idea'. It is begun in 1923 as a vertical column ex-

tending through two storeys and its construction is continually augmented with the addition of new sculptural elements. In contrast to Brancusi's *Pillar to Heaven*, writes Carola Giedion, the *Merz Column* is a 'branching, fantastical building with inner spaces and a rectangular bulk in the spirit of the architecture of De Stijl. This crazy, ornamental, spatial and material game contrasts brazenly with its clarity of form; it is, in the artist's words, 'a synthesis of pure cube and infinite form'. Schwitters's working method shows the dialectical principle that emerges from the tension between the useless and the formation of something new. This kind of abstraction (a word Schwitters uses in forever new senses) is a process of *'Aus-Merzen'* [eradication], a pun 'which seems to echo with the sounds of *"Schmerz"* [pain] and *"Scherz"* [joke], full of melancholy and tomfoolery'. In this sense the leading idea of Schwitters's art is not, as appears on the surface, improvisation, but rather a strict reworking into a new form and a paradoxical unity. Art is for Schwitters 'neither an aggressive political weapon nor a medium to raise social consciousness,' concedes Carola Giedion-Welcker, but rather 'a humanity deeply rooted in his personality'. [38]

The artist stands at the intersection of the visible and the invisible; he shapes the present, but has access to the unconscious and subconscious. 'The picture is a self-contained work of art,' writes Schwitters in 1923. 'It has no outside reference.' [39] The dominant characteristic of the vertical axis, the upward-reaching, earth-rooted *Merz Column*, is in this sense the symbol of a timeless constant. Strictly aesthetic laws on the one hand are balanced and interwoven with the mysteri-

ous irrationality of existence on the other. While the column represents a link between earth and heaven, the creative power of abstraction is the artist's own. 'I owe as large a debt to the artists of today as to [the] guides of my youth,' writes Sigfried Giedion in his book *Space, Time and Architecture*. 'It is they who have taught me to observe seriously objects which seemed unworthy of interest, […] Modern artists have shown that mere fragments lifted from the life of a period can reveal its habits and feelings; that one must have the courage to take small things and raise them to large dimensions. These artists have shown in their pictures that the furniture of daily life, the unnoticed articles that result from mass production – spoons, bottles, glasses, all the things we look at hourly without seeing – have become part of our natures.' [40]

1 The author is working under the aegis of the Schweizerischer Nationalfonds in association with the University of Basel on a research project entitled *Das Neue Sehen. Carola Giedion-Welcker und die Kunstkritik der Moderne* [The New Vision: Carola Giedion-Welcker and modern art critism]. Thanks to Prof. G. Boehm for his support.

2 Gerhard Schaub, *Kurt Schwitters und die 'andere' Schweiz*, Berlin 1998, p. 128.

3 'Abstrakte und Surrealistische Malerei und Plastik', Kunsthaus Zürich, 6 October – 3 November 1929.

4 'Surrealistische Soirée in Zürich', in *Der Bund*, 4 November 1929, Bern, evening issue.

5 Lesekreis [Readers' Circle] Hottingen, Zurich, Soirée in the Kunsthaus Zürich, Wednesday, 30 October 1929, on the occasion of the exhibition 'Abstract and Surrealist Painting and Sculpture', Kunsthaus Zürich, programme brochure by Carola Giedion-Welcker.

6 Sigfried Giedion in *Der Cicerone 21*, no. 24 (1929), pp. 711–713.

7 Provisional catalogue of the exhibition in the Kunsthaus Zürich, p. 10.

8 Letter from Kurt Schwitters to Sigfried Giedion, 13 August 1929, gta (= Institut für Geschichte und Theorie der Architektur)/ETH Zürich, in Schaub 1998 (see note 2), p. 128.

9 Letter from El Lissitzky to Sigfried Giedion, 10 July 1928, Giedion Estate.

10 Cf. Schaub 1998 (see note 2), p. 128, or Werner Schmalenbach, *Kurt Schwitters*, Cologne 1967, p. 52.

11 Letter from Kurt Schwitters to Carola Giedion-Welcker, 22 August 1927, Giedion Estate.

12 Letter from Kurt Schwitters to Sigfried Giedion, 21 October 1929, Giedion Estate.

13 Letter from Kurt Schwitters to the 'Giedionses', 5 November 1929, gta/ETH Zurich.

14 Double exhibition with works by Kurt Schwitters and Hans Arp, Kunsthalle Bern, 7 April – 6 May 1956.

15 Letter from Kurt Schwitters to Carola Giedion-Welcker, 15 January 1930, gta/ETH Zürich, in Reinhold Hohl (ed.), *Carola Giedion-Welcker: Schriften 1926–1971. Stationen zu einem Zeitbild*, Cologne 1973, pp. 503–504.

16 Ibid.

17 Carola Giedion-Welcker, 'Die Kunst des 20. Jahrhunderts. Experimentierzelle. Zeitseismograph,' in *Das Kunstblatt XIV*, March, Berlin 1930, pp. 65–70; cit. from Hohl 1973 (see note 15), p. 101ff.

18 Ibid.

19 Letter from Sigfried Giedion to Wilhelm Wartmann, 3 December 1929, cit. from Dorothee Huber, *Sigfried Giedion: Wege in die Öffentlichkeit, Aufsätze und unveröffentlichte Schriften aus den Jahren 1926–1956*, Zurich 1987, p. 45.

20 Sigfried Giedion, 'Ausstellung Neuer Optik', in *Frankfurter Zeitung*, 26 July 1929, no. 551, p. 2.

21 Sigfried Giedion in *Zürcher Illustrierte*, 25 October 1929, no. 43, p. 42f.

22 Sigfried Giedion, *Die Funktion der heutigen Malerei*. The manuscript of this text is in the Sigfried Giedion Archive, gta/ETH Zürich. See also Huber 1987 (see note 19), p. 9.

23 The accompanying programme included public events such as films and photographic exhibitions, essays by the artists Piet Mondrian, Robert Desnos, Joaquin Torres-Garcia etc.; see Huber 1987 (see note 19), p. 51.

24 Letter from Kurt Schwitters to Carola Giedion-Welcker, 18 July 1938, gta/ETH Zürich, in Hohl 1973 (see note 15), pp. 504–505.

25 Ibid.

26 Letter from Carola Giedion-Welcker to Kurt Schwitters, 24 October 1946, Schwitters-Archiv der Stadtbibliothek Hannover.

27 Carola Giedion-Welcker in her introduction to *Anthologie der Abseitigen/Poètes à l'Ecart*, Bern 1946.

28 Ibid., pp. 179–190.

29 Letter from Kurt Schwitters to Raoul Hausmann, 12 June 1947, in Ernst Nündel (ed.), *Kurt Schwitters. Wir spielen, bis uns der Tod abholt. Briefe aus fünf Jahrzehnten*, Frankfurt am Main and Berlin 1986, p. 243.

30 Letter from Kurt Schwitters to Raoul Hausmann, 30 October 1947, in Nündel 1986 (see note 29), p. 245.

31 Letter from Kurt Schwitters to Marguerite Hagenbach and Hans Arp, 11 June 1946, in Nündel 1986 (see note 29), p. 277.

32 Gerhard Schaub, '"An Schwitters kommt man nicht vorbei". [Schwitters cannot be ignored] Zur Rezeption des Merzdichters in der Literatur nach 1945', in *Aller Anfang ist Merz*, exh. cat., Hanover/Dusseldorf/Munich, 2000/2001, p. 312.

33 Ernst Nündel, *Kurt Schwitters*, Reinbek 1981, p. 112.

34 Letter from Carola Giedion-Welcker to Kurt Schwitters, 12 June 1947, Schwitters-Archiv der Stadtbibliothek Hannover.

35 Carola Giedion-Welcker, 'Kurt Schwitters: Konstruktive Metamorphose des Chaos', in *Die Weltwoche*, Zurich, 15 August 1957, cit. in Hohl 1973 (see note 15), pp. 285–288.

36 Letter from Kurt Schwitters to Carola Giedion-Welcker, 19 August 1947, cit. from Hohl 1973 (see note 15), pp. 506–507.

37 Carola Giedion-Welcker, 'Schwitters or the Allusion of the Imagination', in *Magazine of Art*, October 1948, vol. 41, no. 6, Washington/ New York 1948, pp. 218–221.

38 Carola Giedion-Welcker, 'Einheit in Vielfalt', in *Kurt Schwitters*, exh. cat., Dusseldorf/Berlin/Stuttgart/Basel 1971, p. 11.

39 Kurt Schwitters, *Merz 1. Holland Dada*, Hanover 1923, p. 8.

40 Sigfried Giedion, *Space, Time and Architecture: The Growth of A New Tradition*, Cambridge MA 1982, p. 4.

Kurt Schwitters's Spatial Growths Karin Orchard

'But how does one write of a disappearance? What of these events which leave no trace and those beings who leave no footprints? There are terrains which admit nothing and record nothing.'[1]

'But how does one write of a disappearance?' One of the works of high modernism which made an enormous impression on subsequent generations of artists is – like Marcel Duchamp's *Large Glass*, which Duchamp himself repaired after it broke – a work which no longer exists in its original state and can only be appreciated today in a partial reconstruction: Kurt Schwitters's *Merz Building* in Hanover. This latter construction was not the only one of its kind. The trail of bombed, burned, collapsed or unfinished spatial structures which Schwitters continued everywhere he set up his home can be traced through several European countries. I would like to argue that his various Merz Buildings and related structures are just continuations of one and the same work, shifted in space and time, taken up again and again and stylistically refined. 'Merz Building is Merz Building,' Schwitters asserted.[2] Especially in exile he felt himself to be, like a distributed network, present simultaneously in several places and connected with his friends and family. In 1946, he signed one letter 'Kurt Merz Schwitters from Lysaker, Hjertøya, Ambleside and Hanover'[3] and in another cheered up his old friends, the Spengemanns: 'I am a refugee. But just as I pluckily rebuild between New York, Hanover and Molde, you will too.'[4] According to Käte Steinitz, he commemorated the death of his wife, Helma, as follows: 'Kurt wrote all his friends – Arp, Moholy, the Tschicholds, me, Ernst and Eve Schwitters –

and asked them to think silently of Helma on a certain day at a certain time, united, despite being spatially separated in Oslo, in London, Basel and Los Angeles.'[5]

'Eternity Lasts Forever': Temporary Structures

There are two known large-format assemblages, which Schwitters called Merzbilder (Merzpictures), produced in 1920, the early period of his Merz art, but then reworked by him shortly before he fled from Norway to England. These two assemblages were sent, together with other works which Schwitters considered important, by his wife, Helma, from Hanover to Lysaker, near Oslo, presumably in the spring of 1938.[6] The two works are *Merzbild 29 A. Bild mit Drehrad. (Merzpicture 29 A. Picture with Turning Wheel.)*, 1920 and 1940, and *Bild mit Raumgewächsen / Bild mit 2 kleinen Hunden. (Picture with Spatial Growths / Picture with 2 Little Dogs.)*, 1920 and 1939 (see illus. 1). In contrast to the first work, the Merzpicture revised in 1939 has a second title, written on the slip of paper on the front, between the two small porcelain dogs, which suggests that the dogs were first introduced at this point in time. It is difficult to determine in detail what was present or what was added when. In the early assemblages of the 1920s, however, the palette is dominated by blue and green, so that the areas in those colours, and the corresponding underpainting, probably date from the first state. The cardboard box inserted in the ground, which has been transformed into a kennel, is clearly from the first version, especially since it was labelled on the back with the first title, *Picture with Spatial Growths*, 1920. It is no longer possible to determine the origin of that title or whether it referred to the

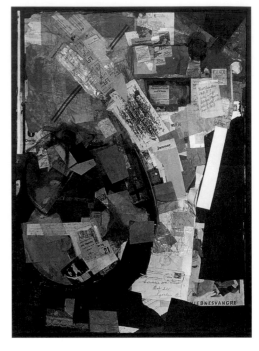

Illus. 1
Kurt Schwitters
*Bild mit Raumgewächsen /
Bild mit 2 kleinen Hunden.
Picture with Spatial Growths /
Picture with 2 Little Dogs.*
1920 and 1939
Assemblage
112.9 x 83.5 cm
Tate Modern, London

Illus. 2
Page 11 from the publication
Kunst-Ismen, 1925, eds. by
El Lissitzky and Hans Arp, with
the illustration (no. 68 above right)
of the *Merz Column*, now destroyed,
in Kurt Schwitters's studio
circa 1920
Museum Tinguely, Basel
Gift by Christoph Aeppli

MERZ

68

**SCHWITTERS
1920**

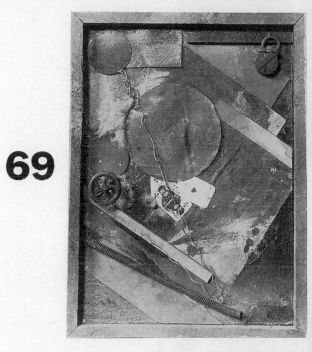

69

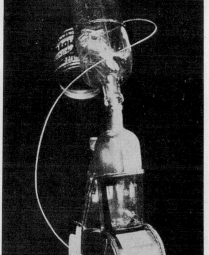

**MURAJAMA
1923**

54

picture's specific content, since the first version was so heavily altered – many of the pieces of paper which have been glued on clearly date from the later reworking in Norway. In the case of Schwitters's collages and assemblages it is possible to read through various chronological layers like an archaeologist and assign the materials to specific events or dates, based on their original use as train or theatre tickets. Although it was in keeping with Schwitters's approach to use recent found materials from his immediate surroundings, it is quite striking how many ephemeral slips of paper in *Picture with Spatial Growths / Picture with 2 Little Dogs.*, 1920 and 1939, allude to a time or place: various train tickets with place-names (Åndalsness, Vestness, Ålesund, Oslo), postmarked envelopes, tickets for entry to various events, and even the blotting paper in the middle of the picture has a date and a place-name (12.6. / Molde) prominently visible in the inverted, organic chaos of ink spots, along with three pages torn from a calendar, of which the most obvious is the one from January, in the middle of the curved line which runs through the composition. Time, dates and the topos of travelling – of crossing places and countries – all play an emphatic role in this assemblage. This spatio-temporal element is, however, important not just on the iconographic level; the very history of the picture's origin takes place on a space-time bridge, since it was created at two different times in two different places. Both periods and states of the picture are equally valid for Schwitters, since in this case he did not – as he usually did in such cases – cross out the old title as if to say that the original state was no longer valid.[7] When Schwitters was forced to flee to England in early 1940, he had to leave his

works behind in Oslo. The history of this picture's journey ended there, for the time being. Just as this assemblage, whose earliest phase predates the Hanover *Merz Building*, became overgrown with later materials, growth and proliferation were even more a constitutive element of the Merz Buildings themselves: 'now it has grown more', Helma Schwitters wrote to Hannah Höch and Til Brugman in 1934, and of course she was referring to a recent addition to the *Merz Building* in their Hanover flat at Waldhausenstrasse 5.[8] When Kurt Schwitters left Hanover for ever in January 1937, the *Merz Building* occupied a total of eight rooms, located throughout the multiple-flat building in the middle-class district of Waldhausen which belonged to the Schwitters family. He had begun in his studio around 1920 by designing the so-called Merz Columns (see illus. 2, p. 33 top right), collage-covered pedestals on which busts rested, glued and hung with all sorts of objects and papers. The walls of his studio were also richly decorated with collage elements and paintings. Inspired by meeting the Constructivists and De Stijl artists, he had begun to take up their challenges to free painting from the plane and to extend it into space – by turning his own studio into a Merz Building.[9] Around 1923, therefore, his studio had clearly changed its function from a demonstration area for Merz works into an autonomous work of art.[10] Columns and two-dimensional mural works were combined, to be seen as a single architectonic form. Schwitters identified this phase as the start of the *Merz Building*: 'The *Merz Columns* became the *Merz Building*, a whole room, designed all around.'[11] At first, it was limited to one room, but over the years other rooms in their flat, as well as other

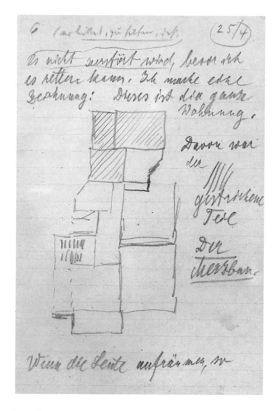

Illus. 3
Kurt Schwitters, sketch of the
Merz Building in a letter from
Kurt Schwitters to Christof and
Luise Spengemann, 25 April 1946
Schwitters-Archiv der Stadtbibliothek
Hannover

places in and on the building, were taken over by the *Merz Building*; more and more it grew into the bourgeois private space. In 1927, the main room, the '*Merz Building* proper' (see illus. 3), was moved to a backroom of the flat. It is no longer possible to reconstruct in detail what the rooms and features of the balcony, attic, rafters, well and cellar looked like, since the entire building was so heavily damaged by an air raid in October 1943 that only fragments of the *Merz Building* have survived. (see illus. p. 37 bottom) The devastation was finished off over the course of the following years by natural decay and weather. Only detail photographs of the '*Merz Building* proper' in various phases and views of the whole from around 1932 (see illus. pp. 5, 36, 37), together with descriptions and reports by Schwitters himself and friends and visitors, permit some insight into his approach. It was an additive process, very probably composed and designed in all its details but without planning or a concept for the whole and not aimed at completion – that is, a work in progress. Over the years, increasingly constructional elements of wood and plaster were applied to the walls and columns; at first the space grew from the outside in, and later vice versa, and it grew ever more dense. Earlier states, including the columns, were integrated or supplemented, were built over or disappeared completely under new construction. It was an aimless proliferation and permanent alteration; no plans or sketches exist. The *Merz Building* is chaotic and incomplete, 'namely, as a matter of principle'.[12] Hans Richter described it as 'a vegetation which never stops'.[13] In a letter to Hannah Höch and Til Brugman, Schwitters's wife expressed the fear: '[...] and if you ever come back to Hanover, grandma Schwitters's room will

also be grottoed and Merzed over. Perhaps Merz will find another annex as far as Berlin.'[14]

The *Merz Building* did not make it as far as Berlin, but only as far as the sky over Hanover; it was continued very soon thereafter, however, once Schwitters realized that he would not soon be able to return to Hanover from Norway. In January 1937, Schwitters followed his son Ernst into emigration. Before long a flat in Lysaker, near Oslo, had been rented, and in the garden by a slope he built his *Haus am Bakken (House by the Slope) – bakken* is Norwegian for 'the slope'. After his first experiences with emigration and the painful feeling of missing the *Merz Building*, this time he clearly approached it with more of a plan, and from the beginning he conceived his building as a 'studio which can be disassembled and transported',[15] ready to be hoisted onto a lorry and shipped off, if necessary. Probably for structural reasons and 'for reasons of abstract design', however, the individual parts had to be connected to one another, so that now it was only possible to have the upper storey of the *Haus am Bakken* transported as a whole.[16] The lower storey consisted of a cellar built into the cliff. Nothing detailed is known about the appearance of this Merz Building, since there are only descriptions, no photographs. Schwitters worked for three years, with interruptions, on this studio, and when he had to flee again, he had to leave it behind unfinished, and, in 1951, it was destroyed by fire. He considered the structure the direct continuation of his *magnum opus* in Hanover: 'I built the main window with the view of the moor in mind. The house was oriented around this window, and it turned out that I had more or less a southern orientation. The

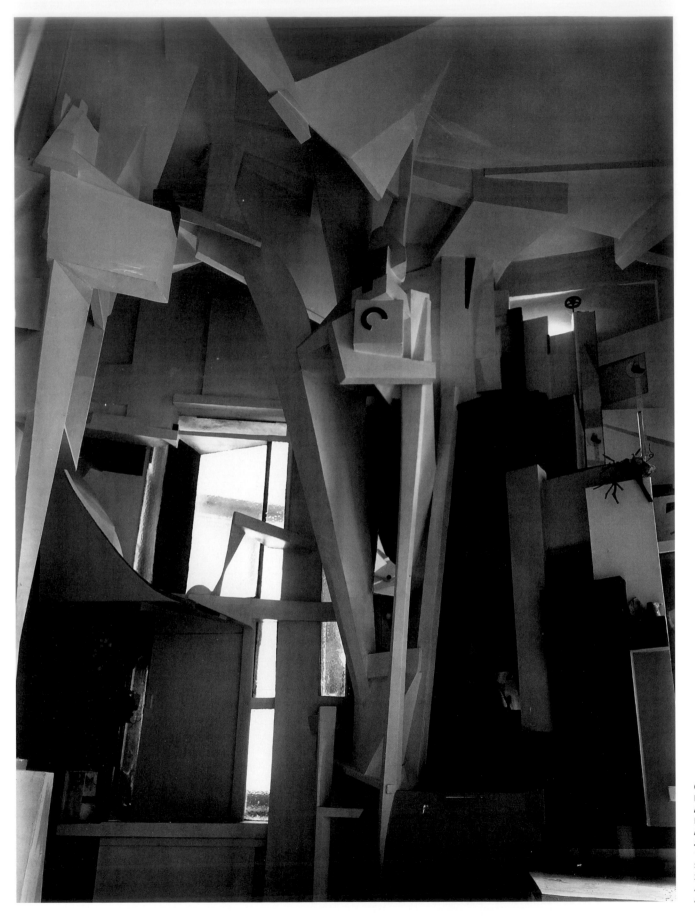

Cat. 206
Redemann, photographer
*Blaues Fenster (Teilansicht des
Merzbaus von Kurt Schwitters, 193[*
*Blue Window (Detail of Kurt
Schwitters's* Merzbau, *1933)*
1933
Silver gelatine print
22.9 x 17 cm
Archiv Georges Vantongerloo,
Angela Thomas Schmid

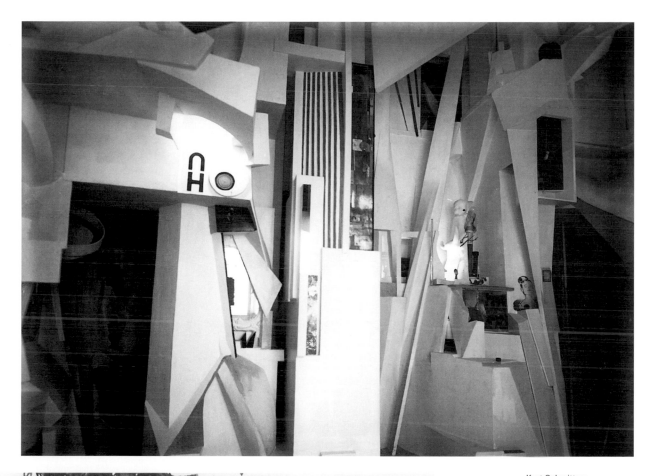

Kurt Schwitters
Merz Building (partial view)
side of staircase entrance,
1933, destroyed in 1943

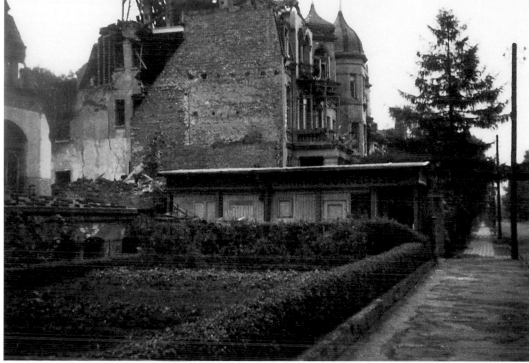

Schwitters's house in
Waldhausenstrasse 5 in
Hanover after its destruction
in an air raid, 1943

studio was pointing more or less to Hanover, to my old studio. The connection becomes even stronger as a result of the last form which I had designed in Hanover. [...] Suddenly I realized that the resulting form had been a horseshoe. Horseshoes are good luck, and my horseshoe was pointing to the north, approximately to the place where *Haus am Bakken* now stands.'[17] In stylistic terms, as well, the *Haus am Bakken* is oriented around the last state of the Hanover building, though it was more of a piece. Meanwhile, worried that his *Merz Building* in Hanover might be destroyed by the National Socialists, he tried through friends in the United States to find a patron and a place where he could create and plastically design a room, with or without the mobile elements from the Norwegian *Merz Building*.[18]

The Cubist-Expressionist constructions of the Hanover *Merz Building* were also reiterated in *Hütte auf Hjertøya* [Hut on Hjertøya], named after a narrow island off the coast near the town of Molde in western Norway, on which, in 1932 at the latest, Schwitters had leased a tiny hut for ninety-nine years to use as a summer home. He joined furniture and fixtures together 'with plaster'.[19] Photographs from the 1950s (see illus. 4) create the impression of an interior similar to that of the studios in Hanover and Lysaker, on which he was working in parallel, as presumably this space would be permanently redesigned and altered until the summer of 1939. After Schwitters left, the hut was exposed to the harsh climate, unattended and unprotected, and was only rescued in the 1970s.

The turn away from Cubist-Expressionist forms for his Merz Buildings and towards organically rounded, surreal forms happened in England. Even under the adverse conditions of his internment in Hutchinson Camp on the Isle of Man in the Irish Sea in 1940 to 1941, he was driven to use the few available means to design a grotto-like shell. With materials pilfered and misappropriated from the residences, such as wooden tabletops and chair legs, he constructed a 'grotto' around the window of his garret room.[20] The olfactory climax of his experiments with organic materials was surely the gruel sculptures, which, naturally, owing to their ephemerality, are known only from reports: 'A few statues made of porridge stood about, a material more impermanent than any known to mankind, and it emitted a faint but sickly smell and was the colour of cheese.'[21] 'He had festooned this mess with stones, shells, matchboxes, postage stamps and *objets trouvés*, and foul-smelling liquids kept dripping on the beds of the room below.'[22]

The last offshoot of his *Merz Building* did not even yet reach this scale of rotting-growing structure. After being released from internment and then spending four years in London, during which time, unusually, he did not make any spatial constructions, he settled in Ambleside, in the Lake District, in 1945. From late 1946 onwards, he was negotiating with the Museum of Modern Art in New York for financial support to document and repair the Hanover *Merz Building*. Alternatively, he considered making 'a new Merz Building. From the remains and dust of the old one',[23] and thus to resurrect it in a metamorphosed form. Over the course of the winter, however, he was forced to realize that the *Merz Building* and its remains could no longer be saved, and his health was too precarious for long journeys. Thus he decided to construct yet another Merz Building at the centre of his current life. A friend, a landscape architect,

Illus. 4
Kurt Schwitters
Hut on Hjertøya, 1932–1939
The photo shows its condition in 1953

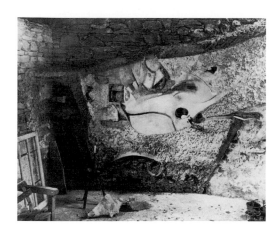

Illus. 5
Kurt Schwitters
Merz Barn
Cylinders Farm
Elterwater, 1946/47

offered him a stone barn in Elterwater, in the middle of the grandiose mountainous scenery of Langdale Fells, and in the last months of his life Schwitters succeeded in modelling one wall of the *Merz Barn* (see illus. 5) using wood, plaster and stone in flowing, organic forms. 'But I am an old, weak man. I am building the largest sculpture of my life 5 x 5 x 3 m. An interior sculpture.'[24] When this Merz Building too was threatened with decay after Schwitters's death, it was decided to transfer it to another location. In 1965 the relief mural was transported in a spectacular action and installed in the recently constructed university museum in Newcastle upon Tyne. The newly rekindled interest in Schwitters in the Lake District has led to initiatives to bring the wall back to its original location.

Given his involuntarily nomadic lifestyle as an emigrant and refugee, of course, Schwitters never did find the peace or time to let his Merz Buildings mature and grow, to change and expand them again and again, as had been possible over the thirteen-year development of the Hanover *Merz Building*. Moreover, in the later constructions, building on his Hanover experiences, he seems to have had more precise stylistic and constructional conceptions.[25] The individual offshoots of the *Merz Building* were more deliberately conceived, for during the process Schwitters transformed from an amateur constructor and handyman into an engineer. If, however, one views the individual Merz Buildings as temporarily sequential stages of a single architectonic and sculptural concept, then one can in turn see the continuous process of growth in them. And decay as well, for not one of the Merz Buildings exists in its original form, in its original place; they have all become will-o'-the-wisp phantoms.

House Within a House:
Spatial Structures

Whereas the rhizomatic process of growth of the Merz Buildings has left a temporal trace over two and a half decades throughout Europe, the characteristic feature of the internal spatial structure of his works is that shells and grottoes are inserted into existing architecture, and the spatial form consolidates from the outside in, to form offshoots in other places when the occasion arises. Reliefs which project far out into the room and relief-like assemblages were part of Schwitters's artistic repertoire from the early 1920s onwards. The house-within-a-house principle is already evident in the first state of the assemblage *Picture with Spatial Growths / Picture with 2 Little Dogs.*, 1920 and 1939. It is extremely unusual and unique among the material pictures that here the picture plane is punched through towards the back by the cardboard box. Originally uninhabited and just painted on, now that the picture plane has been covered with paper it offers a resting place for the dogs. This penetration into the space behind the wall, breaking through the sacrosanct picture plane, already recalls Lucio Fontana's slashed canvases. Normally, Schwitters accepted the rectangular picture plane as optimal and a given,[26] just as he preferred found spaces, particular limited ones, into which his Merz Buildings fit, such as the rooms of the house on Waldhausenstrasse or the *Hut on Hjertøya*. Starting out from these walls, in the Hanover *Merz Building* he worked inward, layering materials on top and in front of one another, integrating the *Merz Columns*, which were originally free standing (see illus. 6 and cat. 207, p. 42). In this way he formed niches, pedestals and interstices, and then with another change allowed them to

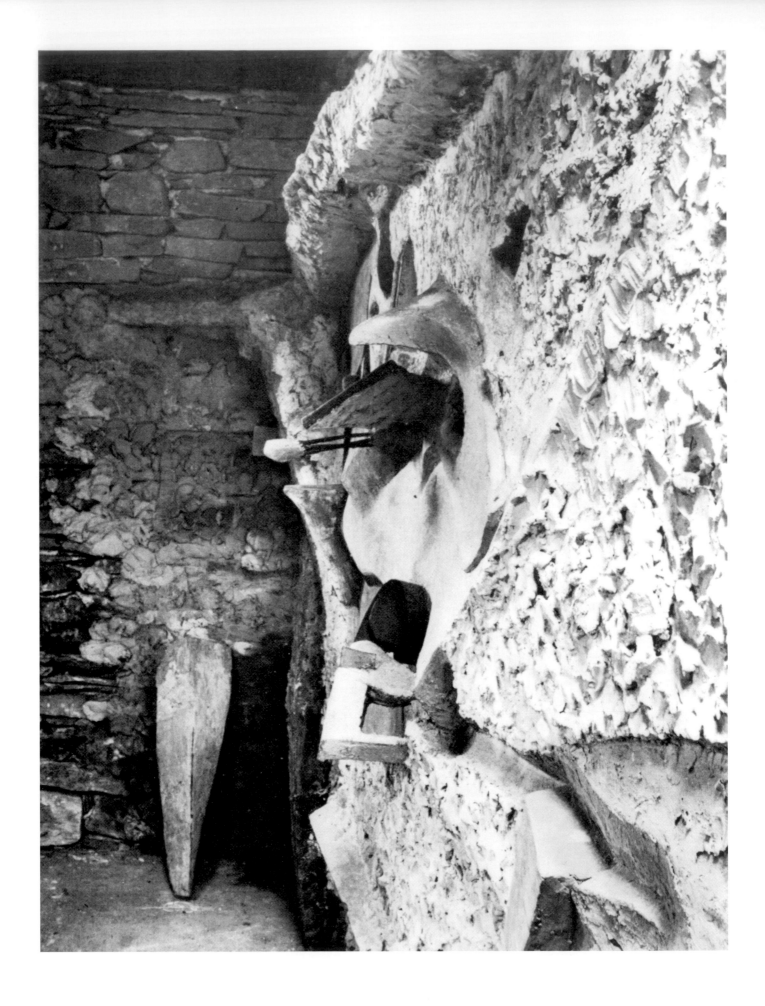

Kurt Schwitters,
Merz Barn, Cylinders Farm,
Elterwater, 1946/47, interior:
on the right next to the wall
is the relief, behind it one
of the sculptures in plaster
and bamboo that still exist

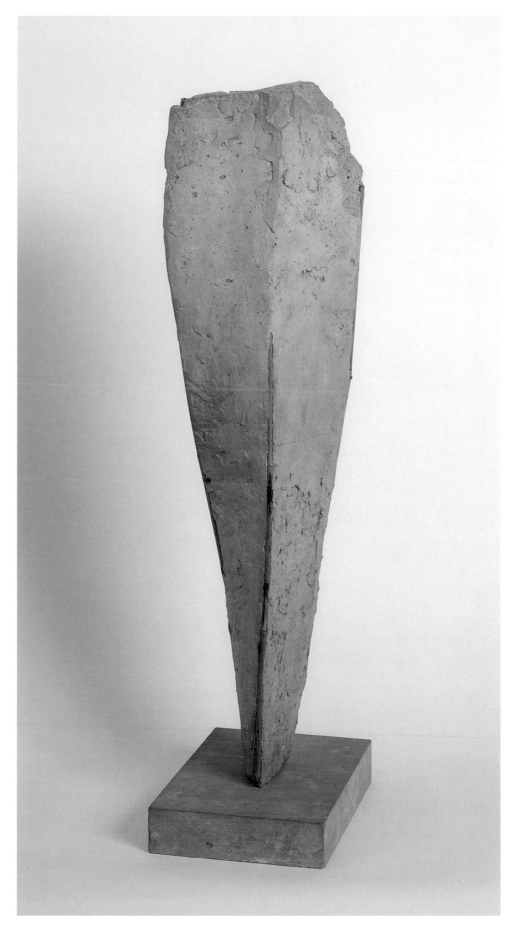

Cat. 142
Ohne Titel (Aus der Elterwater
Merz Barn)
Untitled (from the Elterwater
Merz Barn)
1947
Plaster, bamboo
80 x 27 x 19 cm
Private collection

disappear completely behind a wall or perhaps just behind a sheet of glass. 'During the thorough spring cleaning of my rooms, new things always result. I just finished two grottoes today.'[27] The result was rooms within rooms, sometimes invisible, hidden and only available to memory, but sometimes small, real, usable rooms as well, accessible via angular staircases, like the library[28] or the bedroom within the '*Merz Building* proper'. Only when the need for space grew urgent did he punch through the shell, pouring the *Merz Building* into the adjoining room, onto the balcony and from there into the hollow space under the balcony and into the well below. The balcony and the hollow space beneath it were, however, immediately enclosed again as self-contained interiors by means of glass – 'That makes it a room'[29] – and conversion, respectively. In addition, the *Merz Building* was – thanks to an ingenious lighting system, which simulated three times of day, and to mirrors which could reflect the outside space back inside – an utterly transformable space whose borders could be permanently varied. The *Haus am Bakken*, as the immediate continuation of the Hanover *Merz Building*, functioned according to this same principle. Because the rented flat in Lysaker did not present an opportunity to construct such a studio, Schwitters first had to create an outer shell by constructing a new, separate building. Fearing he would be discovered – initially he built it surreptitiously, without a building permit, for which he applied only later – he gave the *Haus am Bakken* a dappled coat of paint and further camouflaged it with a coat of dirt and fir needles.[30] It too had grottoes, but they were not as numerous as in Hanover, and, because of the different circumstances of their evolution, they were not covered up

by subsequent states. If, compared to the Hanover *Merz Building*, the *Haus am Bakken* could be said to have a closer connection to the surrounding nature, thanks to its site in the garden, the *Hut on Hjertøya* was even more porous and entirely exposed to the forces of nature. Schwitters described the veranda of the hut in a letter: 'A wooden wall protects against the east wind, the stone wall of the house against the north wind and the wire mesh against chickens, roosters, oxen and other poultry. Outside, in addition to cow pies, there are a meadow and cliffs, forest, sea, snow-covered mountains and, right now, cherry blossoms'[31] (see illus. 7). Because the hut was first and foremost a place to live, it was designed and decorated in a more functional way: 'Our little house consists, put simply, of two bed-frames with an attached pantry-kitchen made of oleo crates, a place to sit and eat, cupboards and shelves – all held together with plaster.'[32] Schwitters never designed an exterior space or an entire building.

Fellow internee Fred Uhlman recalled that in the English internment camp, after the famous-infamous *Barking Concert* with another fellow intern, Schwitters went to bed in his 'kennel': 'The business-man went to bed, as is normal for business-men, but Schwitters being – I venture to suggest – rather uncertain where the human kingdom ended and the animal world began, retired to a kennel which he had constructed himself and for the dachshund in him. He had covered his table with some blankets, put his mattress underneath, and crawling on all fours would go inside to sleep [...]. I often saw him in his kennel [...] .'[33] As in all Schwitters's spatial conceptions here too, with the 'hide-a-bed' under the table and the grotto arrangement

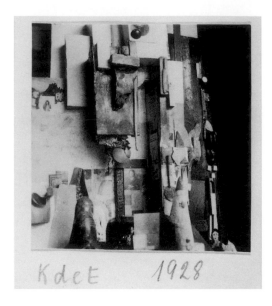

Illus. 6
Kurt Schwitters
KdeE (Cathedral of Erotic Misery), 1928
destroyed in 1943

Cat. 207
Anonymus photographer
*Goldgrotte und Grotte mit Puppenkopf
(Teil des* Merzbaus *von Kurt Schwitters, 1933)*
Golden Grotto and Grotto with Doll's Head
(Part of Kurt Schwitters's *Merzbau, 1933*)
1933
Silver gelatine print
22,5 x 15,9 cm
Archiv Georges Vantongerloo,
Angela Thomas Schmid

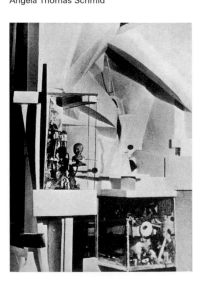

at the window, he was trying to distinguish the interior primarily by means of boxes, crates, shelves, niches, hollows and grottoes in various sizes and scales. Hans Richter characterized the Merz Building as a 'composite of hollows'. [34] Schwitters's interest in and desire for the infinite was concentrated on interiors and their design, a plastic space which opens inward. Only with the *Merz Barn* does he seem to have incorporated the exterior of the building and surroundings into his ideas. It too is an 'interior sculpture' but 'It is in a single house in a natural park in wonderful surroundings, a mountain landscape.' [35] And 'it will have a grass roof'. [36]

'The Spoor of White Mice': Living Structures

The Merz Buildings were not inanimate matter but living and enlivened architecture, an active space. The permanent and temporary occupants, real and fictive creatures, and the users of these spaces are an integral element of the concept of the *Merz Building*. Already in 1923 Schwitters was reflecting on the connection between Merz art and life practices: 'One has to create an intense relationship between people and space. And that is done by introducing the spoor into architecture. [...] Now I can reveal that very secret experiments are being conducted with white mice which are living in Merzpictures constructed for this purpose. For now, the spoor of white mice is being studied.' [37] There is no record of what these Merzpictures inhabited by mice might have looked like. It is conceivable, of course, that they were Merzpictures like *Picture with Spatial Growths / Picture with 2 Little Dogs.*, 1920 and 1939 – whose inserted cardboard box was reconceived, in its later variant, as a kennel for the two porcelain dogs – or con-

structions like those Rudolf Jahns described when he visited the *Merz Building* in 1927: 'I recall a box whose long side in front was half covered, about fifty centimetres, with a board and half with wire netting. Inside, lying on straw, were two strange creatures with coarse, dirty white bodies and heads. Each had only one thick black leg bent in an S-shape. A mysterious chiaroscuro held sway in the box, so that these creatures were sensed more than seen. They were two large porcelain insulators, like those seen on telegraph poles along railway tracks. A strange alienation of these technical objects. They had utterly transformed their essence.' [38] Many animals lived in the Schwitters household: in addition to white mice, they also raised guinea pigs. Evidently, they all lived quite matter-of-factly in the *Merz Building*, as a photograph by Käte Steinitz shows (see illus. 8, p. 44), and their gnawing caused failures of the lighting system. Even when fleeing to Norway in 1940, Schwitters took several white mice with him. [39] In addition to animals, of course, people also went in and out of the *Merz Building*, even if Schwitters was very sparing with invitations to the holiest of holies, in marked contrast to his usual hospitable and extrovert behaviour. Apparently, his own creation seemed too individualistic and supposedly unintelligible for strangers, and he believed only a few friends capable of truly understanding his 'life's work'. [40] The uses of the *Merz Building* were manifold. It was, of course, primarily a studio, as well as a performance space for his *Ursonate (Primal Sonata)*; [41] the alcove served as a guestroom for friends like Lucia Moholy; the so-called 'library' was a room for reading and writing; it was a space for meditation – visitors, such as Rudolf Jahns, for example,

Illus. 7
Kurt Schwitters
Hut on Hjertøya, before the extension:
Helma Schwitters, 1932–1939

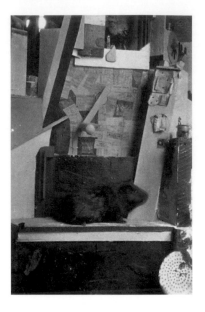

Illus. 8
Kurt Schwitters
Untitled (*KdeE*, with guinea-pig),
circa 1929; destroyed in 1943

were invited to put their thoughts and feelings about the *Merz Building* in a guest book on the table in the middle of the room. Absent friends were represented in the grottoes *pars pro toto* by personal objects like clipped ties (Theo van Doesburg), locks of hair (Hans Richter) or pencils (Mies van der Rohe). Some, like Hannah Höch, were permitted to design their own grottoes. [42]

The most important part of the *Merz Building* was, of course, Kurt Schwitters himself. He was Merz (see illus. p. 2). He frequently signed letters with 'Kurt Merz Schwitters' or just 'Merz'. His concept of the artwork not only included all the arts, which were to be combined in a *'Merzgesamtkunstwerk'*, [43] but also his own person: 'Now I call myself Merz.' [44] From that perspective, the Merz Building was the culmination of all genres of art: 'his life's work [...] with which he identified himself, more than with any other work, which had grown with him physically, in the truest sense of the word, and spiritually through all the periods of his life.' [45] This snail shell Merz which grew and wandered along with Schwitters is also manifested in other idiosyncrasies of his manner of living and working. Even in the settled periods before his emigration – and without this external pressure he would surely have died in his native city, Hanover – Schwitters was always an artist who enjoyed travelling. His journeys, with overnight stays with friends and acquaintances, have been related in numerous anecdotes, [46] and they often grew into small processions and happenings: tents, mattresses, sleeping bags or bedding and a portable gramophone were the basic equipment, and a special 'bicycle trailer' was built so he could also take 'painting equipment and supports'. [47] It was extremely important

to him to be ready, anywhere and any time, to find material for collages. So he would set up deposits for materials at friends' homes, [48] and trunks filled with papers, objects for Merz and glue were his constant travel baggage. [49] His fellow internee Richard Friedenthal credited him – a literary embellishment, of course – with having a travelling sculpture: 'And then there is time – time! In our time, dear friends, which is somewhat restless, of course, I invented years ago the travelling sculpture, which you pull out of your trunk and then pack it up again, snap, and take along and set up wherever there is room and need for it.' [50] The Merz Buildings, like the trunks, deposits for materials and grottoes, are externalized manifestations of Schwitters's Merz persona (see illus. pp. 46, 47). For him, art and the everyday coincided; he was one with his Merz concept and an incorporated element in his Merz Buildings. His actions and appropriates of the rubbish of civilization, of set pieces from nature and of souvenir scraps are bound into the materiality of his proto-installation, the Merz Building; they function there performatively in a symbiosis of happening and work.

'Time Capsule':
Four-Dimensional Collage

The Hanover *Merz Building* in particular functioned for Schwitters as a place in which memories, objects and events could be documented, collected and transformed into abstract art. His 'KdeE (Kathedrale des erotischen Elends [Cathedral of Erotic Misery]) is a shaping of all the things, with a few exceptions, in the past seven years of my life which were either important or unimportant to pure form; into which, however, a certain literary form crept.' [51] This hotchpotch, which charac-

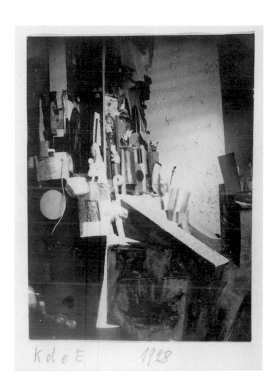

Illus. 9
Kurt Schwitters
KdeE (Cathedral of Erotic Misery, with
outside stairs to the 'Love Grotto'), 1928;
destroyed in 1943

terizes the individual grottoes, is composed of objects of varying degrees of abstraction: personal details like, for example, a key from Käte Steinitz or a clipping of Hans Richter's hair[52] are found in the friendship grottoes and, with their fetish character, stand as representatives for personal memories. Grottoes such as, for example, the 'Goethe grotto', the 'hoard of the Nibelungen' or the 'Luther corner' have a pedantic-bourgeois historical connection. Another group that should be mentioned are the grottoes with erotic connotations, like the 'Sex murder grotto', the 'Bordello' or the 'Grotto of love' (see illus. 9). Schwitters's ambition to transform the 'literary content' in the *Merz Building* into 'pure form' is one he does not really manage. The mementoes dominate too much for that. His friends recalled: 'But here it was not just sculpture, it was a living document of Schwitters and his friends, one which changed from day to day.'[53] Käte Steinitz associated the *Merz Building* with a 'time capsule' in which one could find 'Schwitters's emotional life hidden deep in the interior of the columns, his attempt to address all the problems of life and art, of language and literature, of human and non-human relations.'[54] In the *Haus am Bakken* in Lysaker, too, Schwitters set up friendship grottoes and asked Sophie Taeuber-Arp, for example, 'And I would very much like to have works. Even photos I can Merz in grottoes or for the studio book. Even small texts to paste into the studio book, which will remain here in the studio until the Last Judgement.'[55]

The microcosm Merz Building functioned as time storage in which history, memories and Schwitters's entire life could be recorded. The Merz Building was flexible, not fixed in time or space, so that Schwitters's private

moods and historical experiences could be adapted to the temporal dimensions of past and present and to changes in space. This humane, highly individualized architecture is a cabinet for private memories, a psycho-architecture. As if on a palimpsest, the various times interpenetrate and overlap in a mnemonic and pictorial space, distributed in various places like a network. If one thinks of the Merz Buildings as a 'distributed network', analyses them according to their functions and use – and in particular the role of Kurt Schwitters as a living element of his structures (apart from others involved in making or living in these structure) – then it becomes clear that these early avant-garde spatial projects can be viewed as precursors of artistic activities of recent years such as mapping, LKW (*Lebenskunstwerk* [life artwork]), performative installation or social practice.

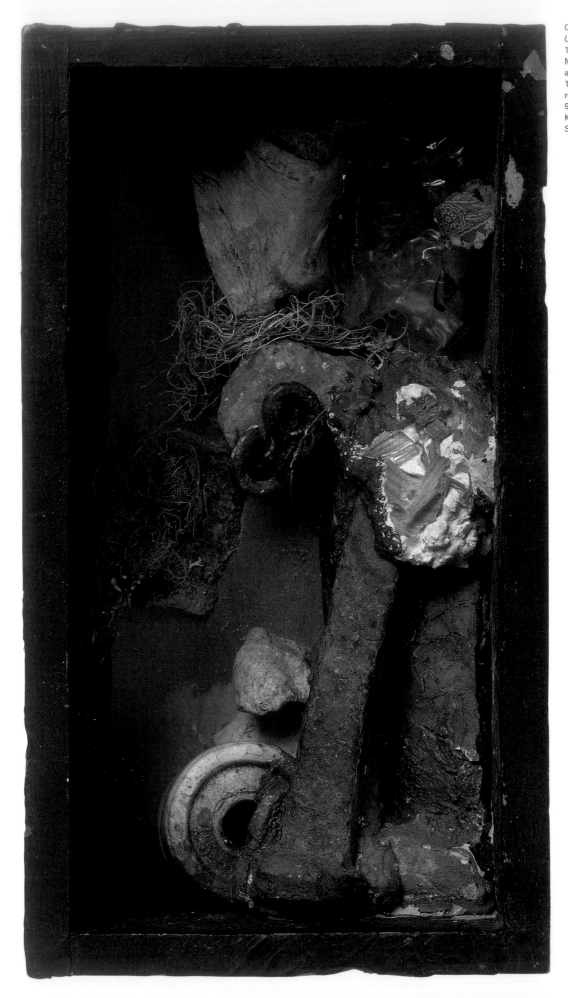

Cat. 196
Untitled (Small Grotto)
1923/1926
Metal, wood, porcelain,
assorted materials and oil;
1956 severely damaged,
reconstructed 2004
9.3 x 16.8 x 7.2 cm
Kurt und Ernst Schwitters
Stiftung, Hanover

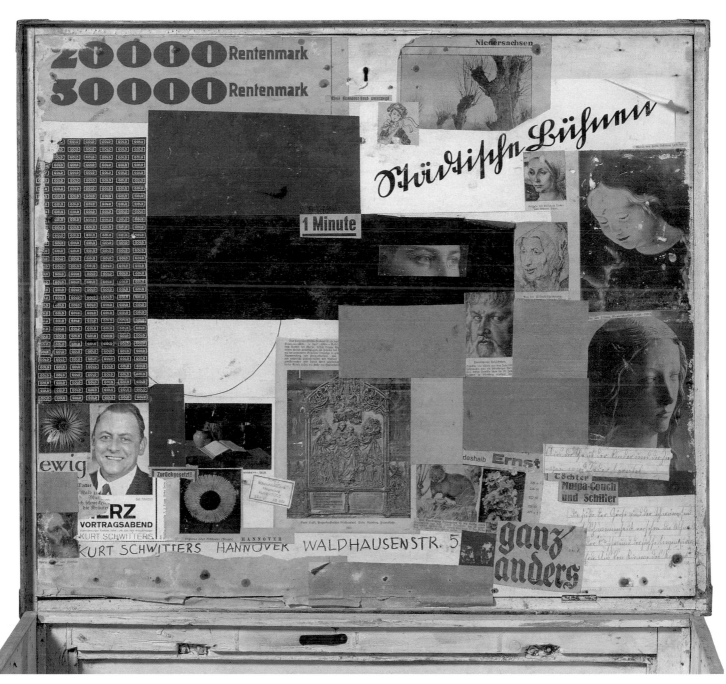

Cat. 87
*Ohne Titel (Collagierte Innenseite
eines Truhendeckels)*
Untitled (Collage in Interior of a Trunk Lid)
Circa 1926
Collage on wood
58 x 68 cm (collage in interior)
Kurt und Ernst Schwitters Stiftung, Hanover

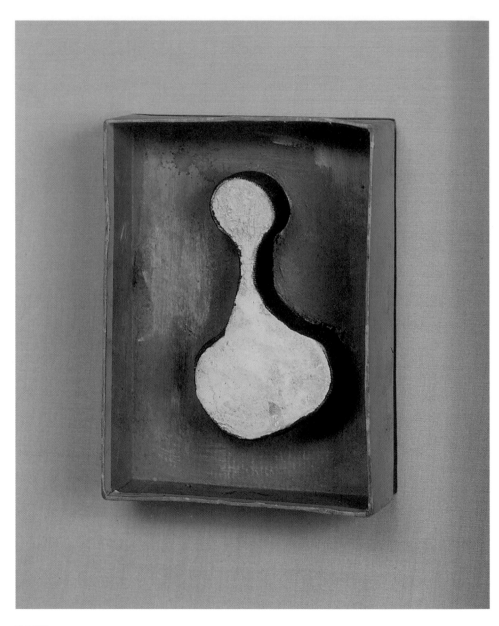

Cat. 134
Das Strumpfhalterbild
Garter Picture
1940
Relief
16 x 11.5 cm
Teutloff Kultur- und Medienprojekte

Cat. 122
Ohne Titel (Kleine abstrakte Plastik)
Untitled (Small Abstract Sculpture)
1934
Sculpture, wood and plaster
26 x 7 x 6.5 cm
Collection of Carla Emil and Rich Silverstein,
courtesy of Ubu Gallery, New York

1 Lawrence Norfolk, *In the Shape of a Boar*, London 2000, p. 224.

2 Kurt Schwitters to Christof and Luise Spengemann, 25 June 1947, in Kurt Schwitters, *Wir spielen, bis uns der Tod abholt: Briefe aus fünf Jahrzehnten*, Ernst Nündel (ed.), Frankfurt am Main 1974, p. 282.

3 Kurt Schwitters to Walter Dux, 1 January 1946, in Schwitters 1974 (see note 2), p. 185.

4 Kurt Schwitters to Christof and Luise Spengemann, 18 September 1946, in Schwitters 1974 (see note 2), p. 229.

5 Käte T. Steinitz, *Kurt Schwitters: Erinnerungen aus den Jahren 1918–1930*, Zurich 1987, p. 152.

6 Kurt Schwitters to Suze and Hans Freudenthal, 22 July 1938, *Kurt Schwitters Almanach 9* (1990), p. 41.

7 I cannot agree with Elderfield's opinion that Schwitters reworked the piece because he found its original state unsatisfactory, especially since he clearly considered it an important picture and had it sent from Hanover; see John Elderfield, *Kurt Schwitters*, London 1985, p. 68.

8 Helma Schwitters to Hannah Höch and Til Brugman, 27 January 1934, in *Hannah Höch: Eine Lebenscollage*, vol. 2 (1921–1945), part 2, Künstlerarchiv der Berlinischen Galerie, Landesmuseum für Moderne Kunst, Photographie und Architektur, Ostfildern 1995, p. 512.

9 Dietmar Elger, *Der Merzbau von Kurt Schwitters: Eine Werkmonographie*, 2nd edn, Cologne 1999, p. 49.

10 Ibid., p. 46.

11 Kurt Schwitters to Cesar Domela, 12 October 1946, in Schwitters 1974 (see note 2), p. 242.

12 Kurt Schwitters, 'Ich und meine Ziele' (1931), in idem, *Manifeste und kritische Prosa*, vol. 5 of *Das literarische Werk*, ed. by Friedhelm Lach, Cologne 1981, p. 343.

13 Hans Richter, *Dada Profile*, Zurich 1961, p. 101.

14 Helma Schwitters to Hannah Höch and Til Brugman, 27 January 1934, in *Hannah Höch* (see note 8), p. 512.

15 'Bogen 1 für mein neues Atelier' (1938), in Schwitters 1981 (see note 12), p. 365.

16 Ibid., p. 366.

17 Ibid.

18 Schwitters 1974 (see note 2), pp. 138, 140, 149; Gerhard Schaub (ed.), *Kurt Schwitters: Bürger und Idiot; Beiträge zu Werk und Wirkung eines Gesamtkünstlers*, Berlin 1993, p. 156.

19 Kurt Schwitters to Nelly van Doesburg, 22 May 1939, in Schwitters 1974 (see note 2), p. 151.

20 Fred Uhlman, *The Making of an Englishman*, London 1960, p. 235.

21 Uhlman 1960 (see note 20), p. 235.

22 Klaus E. Hinrichsen, 'Visual Art behind the Wire', in David Cesarani and Tony Kushner (eds), *The Internment of Aliens in Twentieth-Century Britain*, London 1993, pp. 188–209, here p. 202; further descriptions in Richard Friedenthal, *Die Welt in der Nussschale*, Munich 1986, p. 410.

23 Kurt Schwitters to Christof Spengemann, 11 November 1946, in Schwitters 1974 (see note 2), p. 246.

24 Kurt Schwitters to Marguerite Hagenbach, 2 September 1947, in Schwitters 1974 (see note 2), p. 286.

25 Kurt Schwitters to Suze and Hans Freudenthal, 22 July 1938, *Kurt Schwitters Almanach 9* (1990), p. 41.

26 'Malerei' (1925–1935), in Schwitters 1981 (see note 12), p. 357.

27 Kurt Schwitters to Suze Freudenthal, 28 February 1935, *Kurt Schwitters Almanach 9* (1990), p. 95.

28 Ibid.

29 Ibid., p. 101.

30 'Bogen 1 für mein neues Atelier' (1938), in Schwitters 1981 (see note 12), p. 366.

31 Kurt Schwitters to Nelly van Doesburg, 22 May 1939, in Schwitters 1974 (see note 2), p. 151.

32 Ibid.

33 Uhlman 1960 (see note 20), p. 236.

34 Richter 1961 (see note 13), p. 101.

35 Kurt Schwitters to Maguerite Hagenbach, 2 September 1947, in Schwitters 1974 (see note 2), p. 286.

36 Kurt Schwitters to Ernst, Eve, and Bengt Schwitters, 28 September 1947, in Schwitters 1974 (see note 2), p. 288.

37 '[Die Bedeutung des Merzgedankens in der Welt]' (1923), in Schwitters 1981 (see note 12), p. 135.

38 Rudolf Jahns, 'Als Schwitters noch in Waldhausen merzte: Der Maler Rudolf Jahns erinnort sich', *Hannoversche Allgemeine Zeitung*, 26 August 1982.

39 Schaub 1993 (see note 18), p. 215; for more on animals, see 'About Me by Myself' (1929), in Schwitters 1981 (see note 12), p. 322; Jahns 1982 (see note 38).

40 'Ich und meine Ziele' (1931), in Schwitters 1981 (see note 12), p. 345.

41 Elger 1999 (see note 9), p. 112.

42 Kurt Schwitters to Suze Freudenthal, 28 February 1935, *Kurt Schwitters Almanach 9* (1990), p. 95.

43 'Merz' (1920), in Schwitters 1981 (see note 12), p. 79.

44 'Kurt Schwitters' (1927), in Schwitters 1981 (see note 12), p. 253. On this, see Elger 1999 (see note 9), p. 119; Isabel Schulz, 'Was wäre das Leben ohne Merz? Zur Entwicklung und Bedeutung des Kunstbegriffs von Kurt Schwitters', in *Aller Anfang ist Merz: Von Kurt Schwitters bis heute*, ed. by Susanne Meyer-Büser and Karin Orchard, exh. cat., Sprengel Museum Hannover, Ostfildern 2000, pp. 244–251.

45 Richter 1961 (see note 13), p. 102.

46 Gerhard Schaub (ed.), *Schwitters-Anekdoten*, Frankfurt am Main 1999, pp. 21, 23, 37, 43; Kurt Schwitters to Suze and Hans Freudenthal, 9 December 1934, *Kurt Schwitters Almanach 9* (1990), p. 22.

47 Kurt Schwitters to Suze Freudenthal, 15 May 1935, *Kurt Schwitters Almanach 9* (1990), p. 109.

48 In Hannah Höch's in Berlin, for example, see Schaub 1999 (see note 46), p. 20.

49 Schaub 1999 (see note 46), pp. 21, 23.

50 Friedenthal 1986 (see note 22), p. 411.

51 'Ich und meine Ziele' (1931), in Schwitters 1981 (see note 12), p. 344.

52 Richter 1961 (see note 13), p. 101.

53 Ibid., pp. 100–101.

54 Steinitz 1987 (see note 5), pp. 148–149.

55 Kurt Schwitters to Sophie Taeuber-Arp, 10 May 1938, in Schwitters 1974 (see note 2), p. 145.

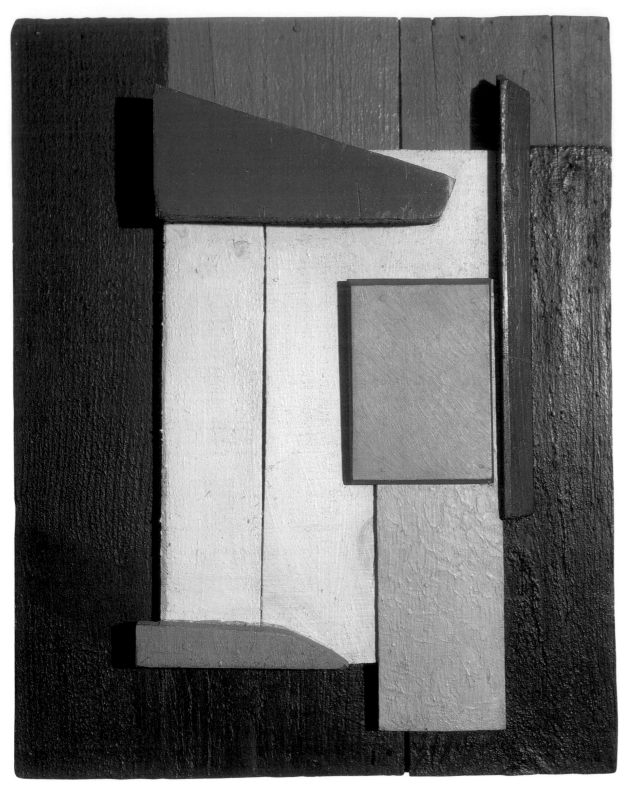

Cat. 66
blau
Blue
1923/1926
Relief, oil and wood on wood
53 x 42.5 cm
Galerie Gmurzynska, Cologne

Cat. 91
Richard Freytagbild /
Das Richard-Freitag-Bild
Richard Freytag Picture /
The Richard Freitag Picture
1927
Relief, oil and wood on wood
79.2 x 62.1 cm
Private collection

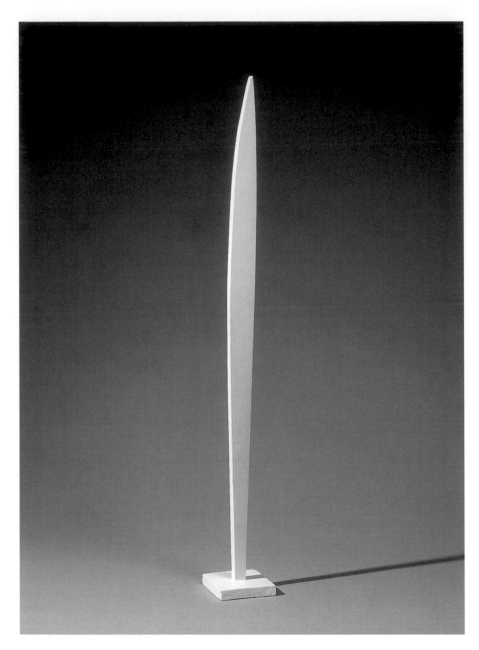

Cat. 125
*Das Schwert des deutschen
Geistes*
The Sword of the German Spirit
1935
Sculpture: painted wood
47.8 (with base) x 3.7 x 0.5 cm
Private collection

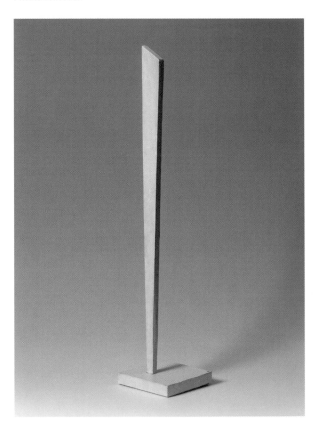

Cat. 127
'Schwert'
'Sword'
Circa 1930
Sculpture, oil and wood
82.5 x 9.5 x 9.5 cm
Galerie Gmurzynska, Cologne

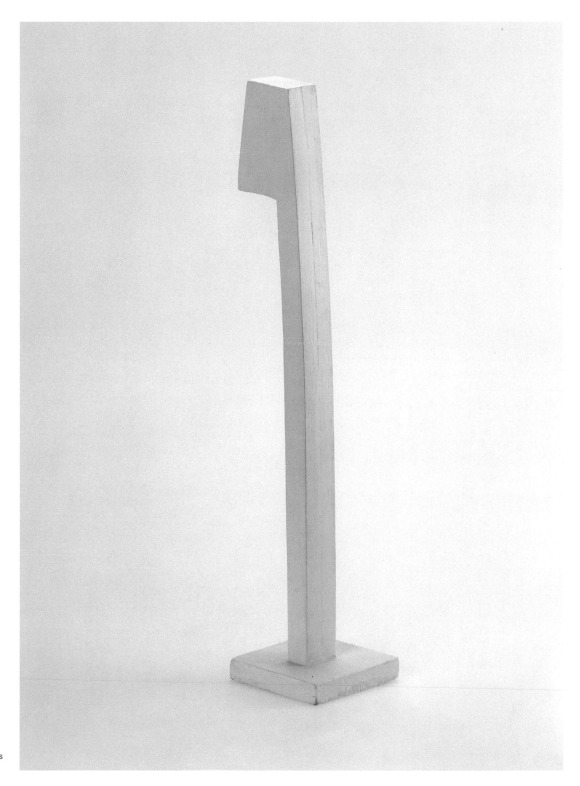

Cat. 126
'Schlanker Winkel'
'Slim Angle'
1935 (?)
Sculpture: oil and wood
48.2 x 9.5 x 12.4 cm
Kurt und Ernst Schwitters
Stiftung, Hanover

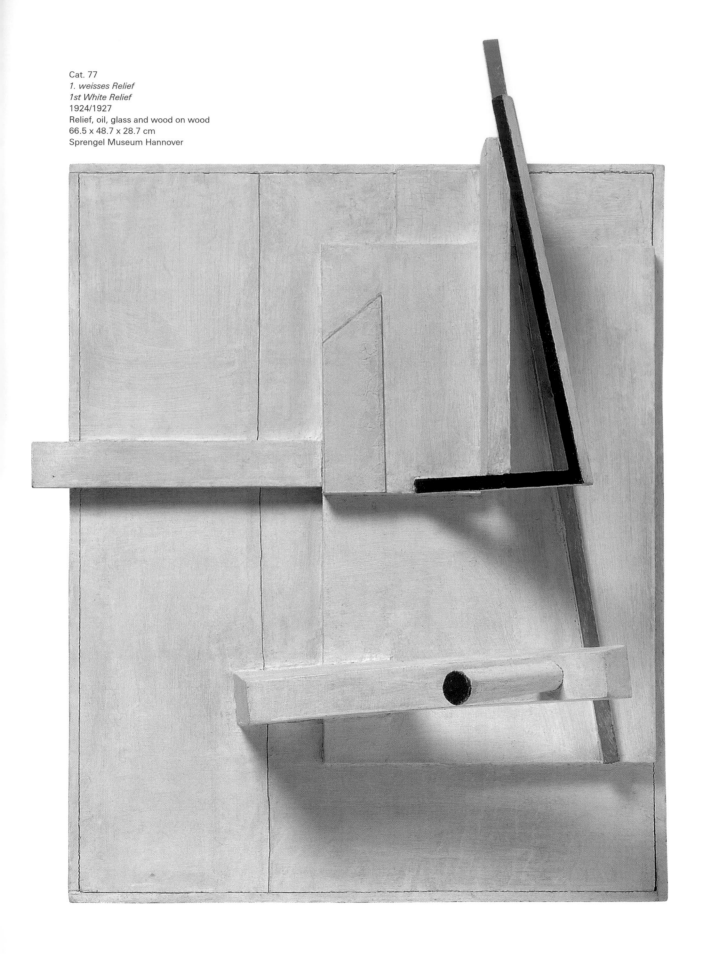

Cat. 77
1. weisses Relief
1st White Relief
1924/1927
Relief, oil, glass and wood on wood
66.5 x 48.7 x 28.7 cm
Sprengel Museum Hannover

Cat. 68
Violinschlüssel (ehemals: Bild HR /
Relief mit H. R. und Doppelschwanz)
Treble Clef (formerly: Picture HR /
Relief with H. R. and Double Tail)
1923 and 1927
Relief, oil and wood on pasteboard
87 x 65.2 cm
Private collection

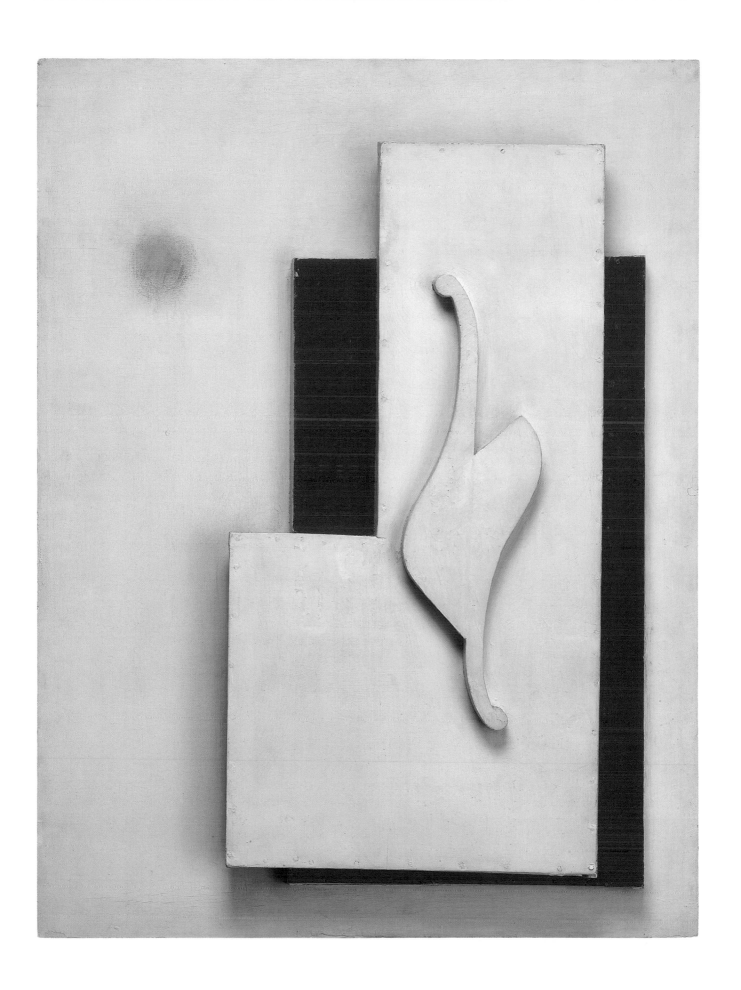

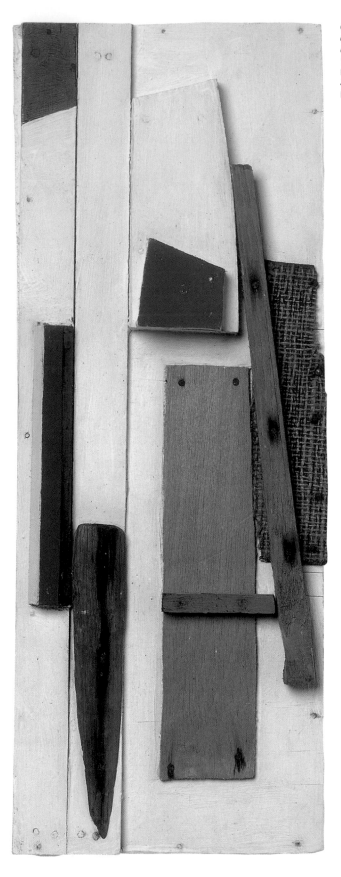

Cat. 67
Ohne Titel (Holzrelief mit Linoleum)
Untitled (Wooden Relief with Linoleum)
1923/1926
Relief, oil, wood and linoleum on wood
40 x 15 cm
Kunstmuseum Winterthur

'As the structure grows bigger and bigger, valley, hollows, caves appear, and these lead a life of their own within the overall structure. The juxtaposed surfaces give rise to forms twisting in every direction, spiralling upward. An arrangement of the most strictly geometric cubes covers the whole, underneath which shapes are curiously bent or otherwise twisted until their complete dissolution is achieved [...] Each grotto takes its character from some principal components. There is the **Nibelungen Hoard** with the glittering treasure; the **Kyffhäuser** with the stone table; the **Goethe Grotto** with one of Goethe's legs as a relic and a lot of pencils worn down to stubs; the submerged personal-union city of **Braunschweig-Lüneburg** with houses from Weimar by Feininger, Persil adverts, and with my design of the official emblem of the city of Karlsruhe, the **Sex-Crime Cavern** with an abominably mutilated corpse of an unfortunate young girl, painted tomato-red, and splendid votive offerings; the **Ruhr district** with authentic brown coal and authentic gas coke; an **art exhibition** with paintings and sculptures by Michelangelo and myself being viewed by a dog on a leash; the **dog kennel** with lavatory and a red dog; the **organ**, which you turn anti-clockwise to play 'Silent Night, Holy Night' and 'Come Ye Little Children'; the **10% disabled war veteran** with his daughter, who no longer has a head but keeps himself well, the **Monna Hausmann** consisting of a reproduction of the Mona Lisa with the pasted-on face of Raoul Hausmann covering over the stereotyped smile; the **brothel** with the 3-legged lady made by Hannah Höch; and the great **Grotto of Love**.

The **Love Grotto** takes up approximately 9¼ of the base of the column; a wide outside stair leads to it, underneath which stands the **Female Lavatory Attendant of Life** in a long narrow corridor with scattered camel dung. Two children greet us and step into life; owing to damage, only part of a mother and child remain. Shiny and broken objects set the mood. In the middle a couple is embracing: he has no head, she no arms; **between his legs he is holding a huge blank cartridge**. The big twisted-around child's head with syphilitic eyes is warning the embracing couple to be careful. This is disturbing, but there is reassurance in the little bottle of my own urine in **which immortelles are suspended**. I have recounted only a tiny part of the literary content of the column. Besides, many grottoes have vanished from sight under later additions, for example, **Luther's Corner**. The literary content is dadaist: that goes without saying, for it **dates from the year 1923**, and I was a Dadaist then [...] But the column has been under construction for seven years and has taken on a more and more severely formal character, in keeping with my spiritual development, especially insofar as the outer sculpture is concerned. The overall impression is thus more or less reminiscent of Cubist painting or Gothic architecture (not a bit!). I have given a fairly detailed description of the **KdeE** (Cathedral of Erotic Misery), because this is the first reference to it in print, and because it is very hard to understand because of its ambiguities [...]'

Extract from: Kurt Schwitters, *Ich und meine Ziele*, 1931, cit. in John Elderfield, *Kurt Schwitters*, London and New York 1985, pp. 154, 161, 169.

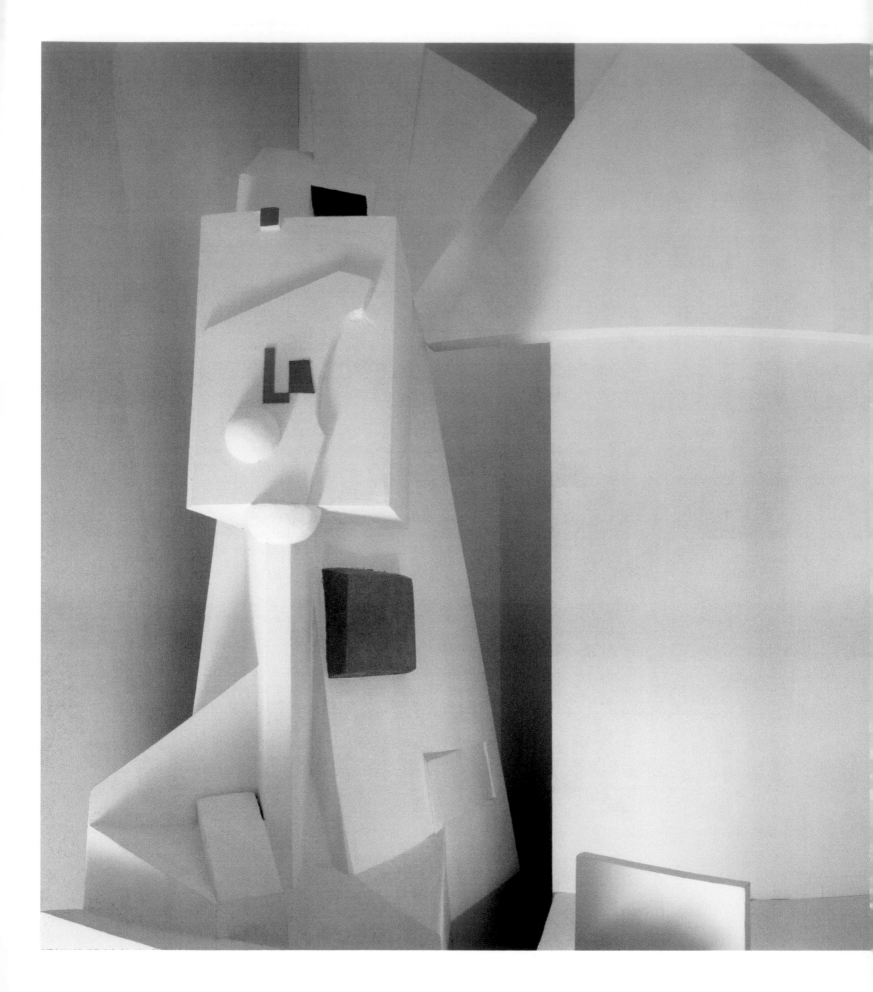

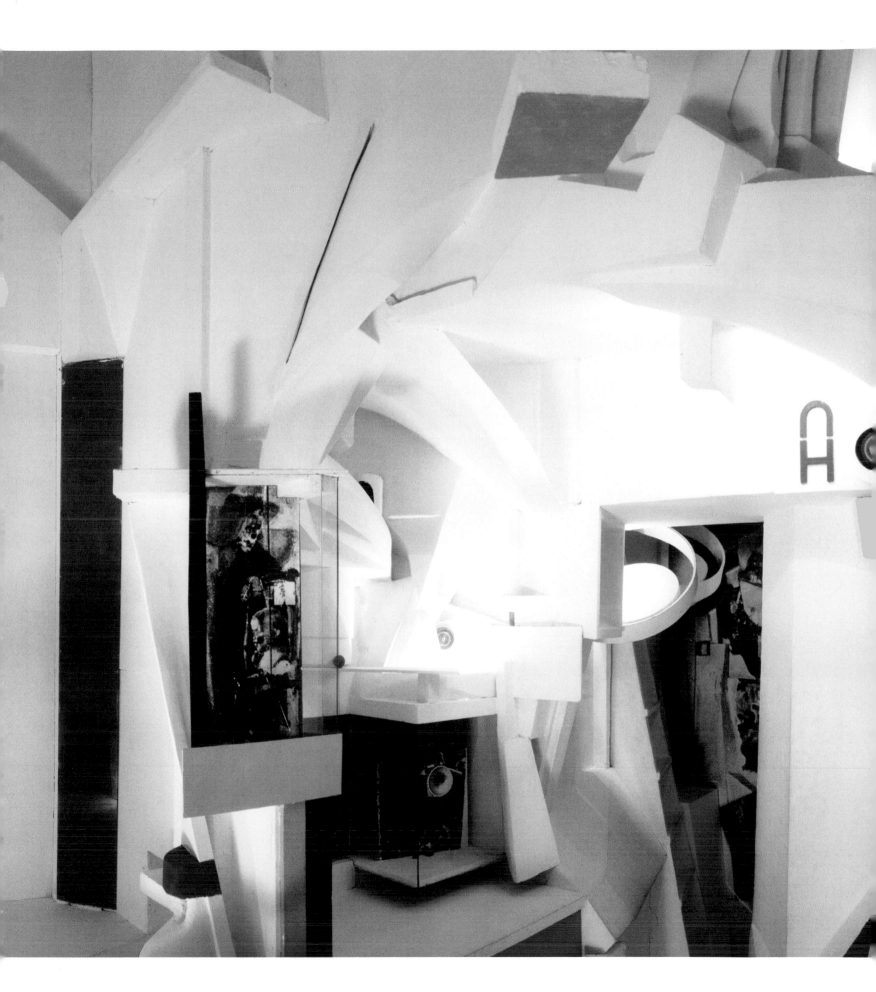

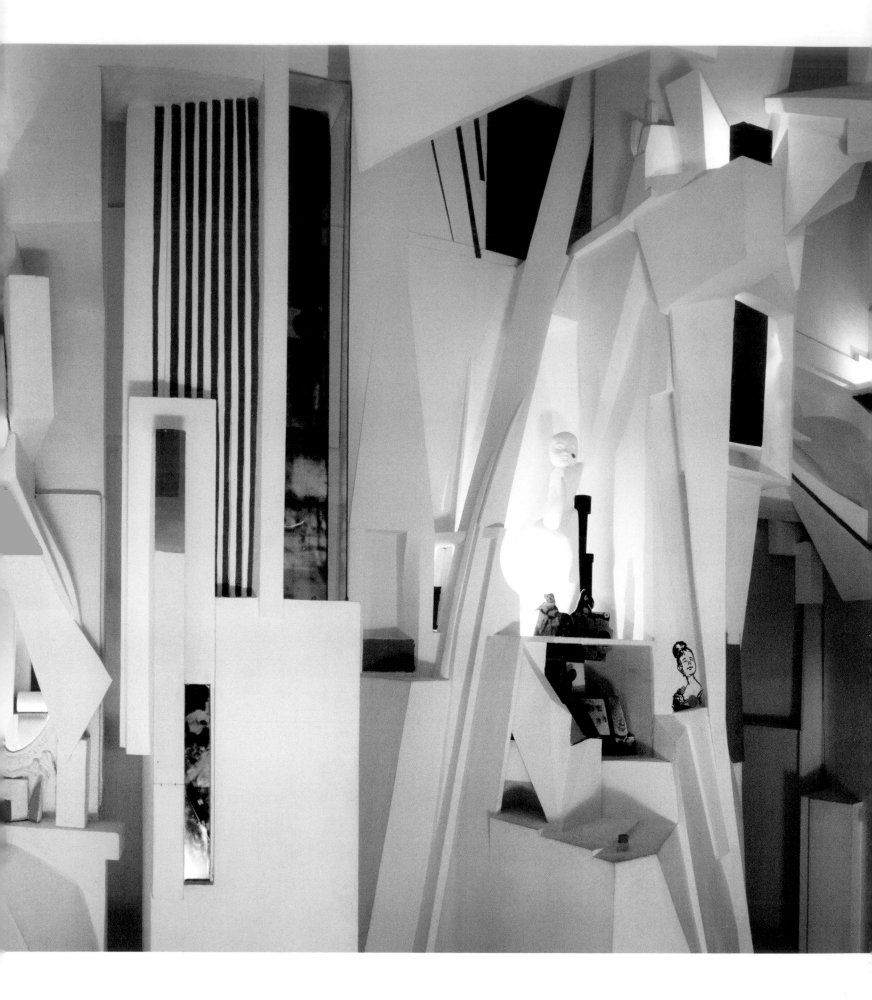

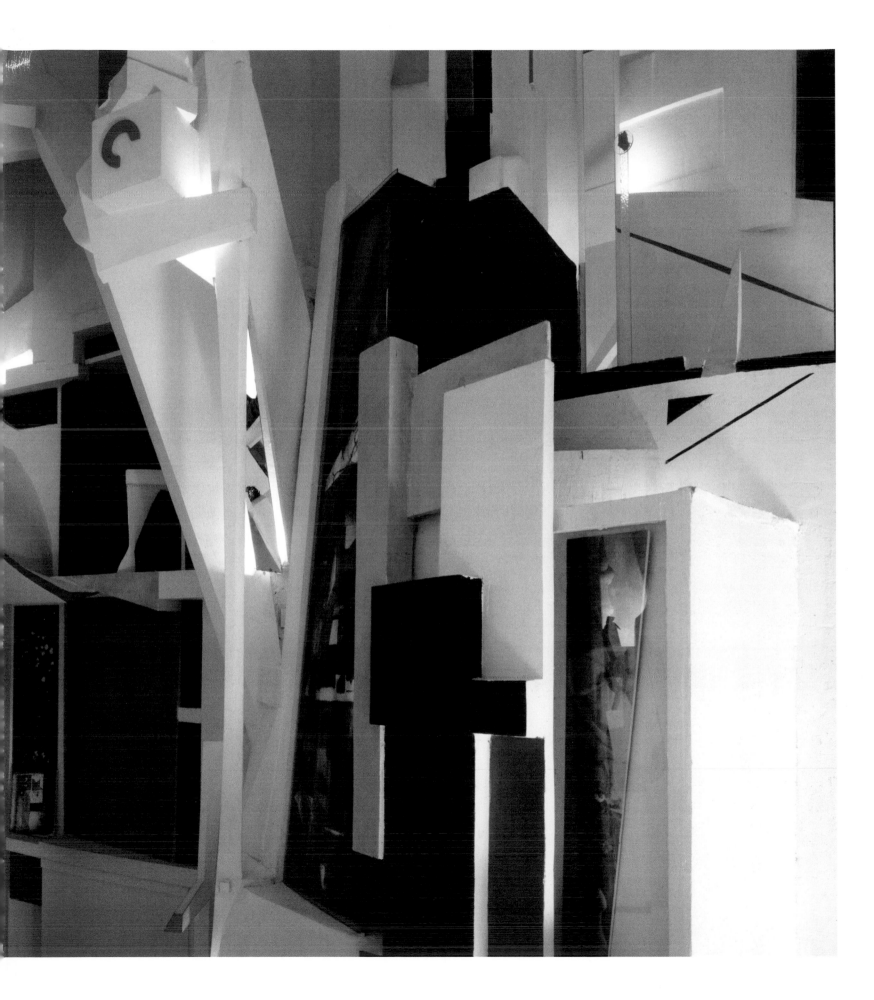

'In 1927, our friendship with Kurt Schwitters [...] led to the establishment of the group 'die Abstrakten Hannover' [The Hanover Abstractionists], the International Association of Expressionists, Cubists, Futurists and Constructivists Association of Central Berlin. The official founding date of the group, [...] was 13 March 1927 [Here Rudolf Jahns is wrong, the founding day was 12 March 1927, note by Rudolf Jahns's daughter]. We met at Kurt Schwitters's flat at Waldhausenstr. no. 5. [...] Needless to say, we (me and my wife) also had to see the Column on the ground floor. The way there along the narrow corridor took us past all kinds of interesting things [...] You walked through a narrow door to enter the Column, which had developed into more of a cave. The plaster designs went over into the door-openings. I did not see the beginning of this KdeE [Cathedral of Erotic Misery] [...] I entered the structure, which, with its twists and turns, resembled at once a snail-shell and a cavern. The path to the centre was very narrow, because new structures and constructions and already Merz reliefs and recesses kept emerging from the side walls into the as yet empty space. A bottle full of Schwitters's urine with immortelles floating in it was hanging at the immediate left of the entrance. Then there were recesses of various types and sizes with entrances that were not always at the same level. If you walked round, you finally ended up in the centre, where there was a seat and were I sat down. A strange feeling came over me, as if I had been carried away to another place. This space had its own very special life. Footsteps made barely any sound here; absolute silence reigned. Just the shape of the grotto encircled me and allowed me to find words related to the absolute in art [...] The room we were sitting in was both living and working space. There was a large table in front of the window, where Schwitters did his Merzing. As you entered this room from the corridor, there was a glass cabinet to the immediate right where Schwitters's Merz sculptures were displayed. There was a room with a grand piano in it adjacent to the work room. There were colourful designs on the walls. Blue and black, if I am not mistaken. Behind that, there was Kurt Schwitters's very narrow bedroom. You could see from the wallpaper to the right of the bed that he Merzed with everything at his disposal even before going to sleep at night.'

Rudolf Jahns, notes in his diary about his first encounter with the *Merzbau* during a visit in March 1927, cit. in *Kurt Schwitters. I is Style*, exh. cat., Stedelijk Museum Amsterdam, 16 April – 16 July 2000, Rotterdam 2000, pp. 142–144.

Cat. 149
Peter Bissegger [Reconstruction]
Reconstruction of Kurt Schwitters's
Merzbau, destroyed in 1943
1981–1983
Wood, plaster, plastic; painted
393 x 580 x 460 cm
Sprengel Museum Hannover,
reconstruction by Peter Bissegger

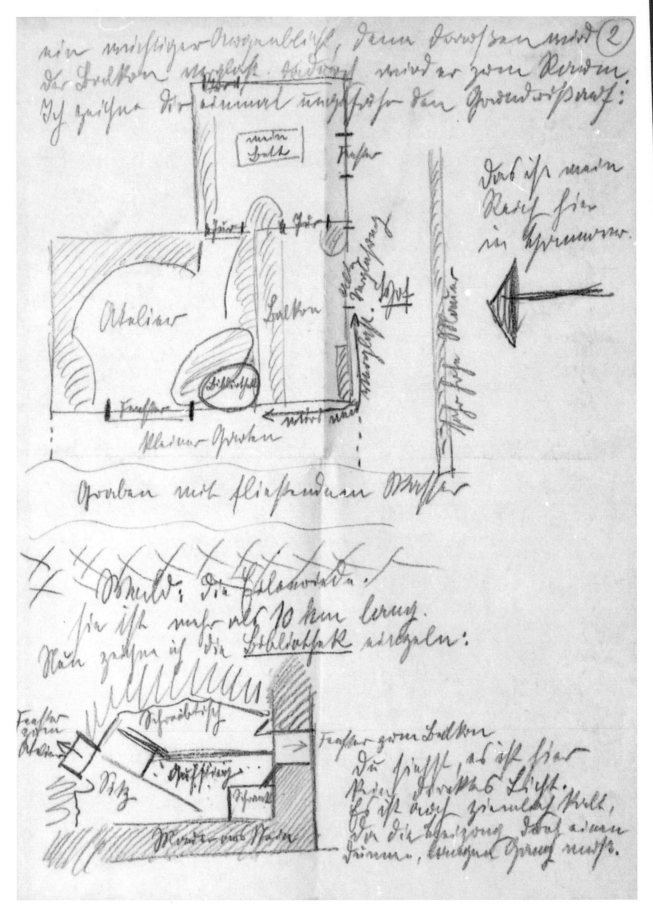

Letter from Kurt Schwitters to
Susanne Freudenthal-Lutter with
a sketch of the rooms in the
Merz Building and a detailed
sketch of the 'library' in the *Merz
Building*, 30 March 1935
Private collection

Notes on the Reconstruction of the *Merzbau*[1] Peter Bissegger

It was Dr Harald Szeemann who initiated the reconstruction of the *Merzbau (Merz Building)* formerly Waldhausenstrasse 5A in Hanover that was destroyed during the Second World War. In his exhibition 'Der Hang zum Gesamtkunstwerk' [Tendencies towards the Total Work of Art] in the Kunsthaus Zürich in 1983, which was later shown in Dusseldorf, Vienna and Berlin, the *Merz Building* represented 'an indispensable central work'.

In 1988, 'Annely Juda Fine Art' commissioned for the exhibition 'Dada and Constructivism' in Japan and Madrid a practical 'travel copy' of the *Merz Building* reconstruction. After the touring exhibition in Tokyo, Osaka, Kamakura and Madrid, this was also shown in Montreal, Lyon, Edinburgh, Paris (in the Centre Georges Pompidou), Valencia, Grenoble, Copenhagen (Arken Museum), Lille (Villeneuve d'Asq), Berlin, Hanover, Dusseldorf, Munich, Milan, Vienna, Mexico City and Lodz (Poland).

The reconstruction of the *Merz Building* was based on the stereometric analysis of three wide-angle shots dating from 1932: one photograph by Hans Arp in *abstraction–création* and two others of lesser importance, taken from reproductions of now lost snapshots by Ernst Schwitters and Käte Steinitz.[2] The axes of the three photographs are positioned at an angle of between 80 and 100 degrees; certain elements of the pictures are found in two out of three shots, and one (single) corner appears in all three. This was enough to provide the basis for a three-dimensional reconstruction.

There were various practical difficulties: both the optical capability and the standpoint of each camera was unknown, and so was the size of the room. The room itself is incidentally only faintly discernible in two places in the photos, since the *Merz Building* grew rampantly into the middle of the room. After receiving various kinds of misleading information (for instance a sheet showing a house plan, dating from the war years and indicating emergency accommodation), the plan of an apartment was found which was identified by the artist's son, Ernst Schwitters, as a hand-sketch made by his grandfather. When his grandfather had measured out the room, it was still empty; thus we finally discovered its exact size.

The optical conditions of the photographs (shifts in the subject's position, the tilt of planes of both image and lens) proved extraordinarily complex; however, the main difficulty was to determine the aperture of the lens. The solution was provided by the stereometric registration of a particular object that appears in two of the three photographs, namely the 'planing bench' (all the different parts of the *Merz Building* have been named, some by Schwitters, others by me). Moreover, the cameras 'see one another simultaneously', which means each camera's standpoint can be analogously defined as a point within the other two pictures. These two facts suggest the following axiom of action: If the perspective lines of the edges of the planing bench are drawn as geometric projections from the points in the pictures while taking all possible manipulations into account (focus, camera tilt, tilt of planes, etc.), at the right aperture they appear vertically aligned. (Got that? ...)

Only after these mental steps, and only at this point, did I take up on my iterative path (that is in my infinite approach to a sought-after figure) the aid of a programmable pocket calculator (model HP 41), to give a mathematical and therefore more precise rendition of the solution in my drawing. The figure I arrived at gave me an aperture of 14.08 cm. An unbelievable size! But further research at the ETH in Zurich, in old catalogues of the Institute of Photography, proved the existence of a Zeiss lens called 'Protar', in use since 1892 and a favourite of professional photographers, which had a maximum aperture of 14.1 cm. Eureka!!

Now all that was needed was the 'fine-tuning'. After months of pushing, tilting, lifting and calculating, the approximation to the camera standpoints became so close that each individual spot in the photographs could be retrospectively projected, plotted, measured and, since it was defined by more than one source, back-checked.

The subsequent work was a matter of laborious, patient realization: a reconstruction based on drawings and technical work, but also increasingly inspired by Schwitters's own working method, which only slowly became apparent to me during the painstaking manual work executed with the aid of skilled craftsmen. To give an idea of the time invested: from 1981 we had one year for reflection and research and one year to translate this into three dimensions, with the fourth, time, at our heels. An obsession for which time was running out.

What was important was the regular contact with Ernst Schwitters. He was able from memory to supply many details about yet unclear spatial correspondences in the *Merz Building*; where colours were concerned, his help was essential. I was moved by his enthusiasm and his faith in the success of the project ('a dream is coming true') and that this work restored to him, as he often asserted, the contact not just to an important object of his youth, but above all to his father.

Incidentally, the aforementioned Kurt Schwitters seemed (without wanting to offer any psychedelic theories here) to be present during this work and intent on making his presence more and more strongly felt: at first merely disruptively, in the form of 'Schwitter-storms'[*Ge/SCH/witter:* untranslatable play on words, *Gewitter* being German for 'storm'] that broke upon us and produced trivial mistakes and divergences; then from a particular moment on (after Ernst Schwitters's second visit to the developing *Merz Building*, when I felt the merest breath of a sense of a trace of hope that we would avoid a total disaster) increasingly as a helper, but as one who could not stop playing games, right up to the end. Anecdotes abound; here is one example:
In one of the photographs, one could see the base of a Römer wine glass. Schwitters still knew perfectly well that this was green. We repeatedly searched for a correspondingly green glass, once even in the company of Ernst Schwitters, but our search was always fruitless.
Well, on the day before the opening of the exhibition in the Kunsthaus in Zurich, the glass had still not been found, and in the

evening we all went to a neighbouring restaurant The Green Glass: and there it was, or there they were, dozens of them, on every table! [Kilroy]Schwitters was here ...

The reconstruction of the *Merz Building* is in its total measurements of 460 x 580 x 393 cm accurate to within 1 centimetre of the original, with a total of about 5 mistakes which I can (un)willingly show anyone. The accuracy can be proven using photographs taken today from the same perspectives and under the same optical conditions.

1 This text by Peter Bissegger appeared in a preliminary version in the catalogue to the exhibition 'Kurt Schwitters 1887–1948. Ausstellung zum 99. Geburtstag', Frankfurt am Main 1986 (second, revised and expanded edition 'Kurt Schwitters 1887–1948. Dem Erfinder von MERZ zu Ehren und zur Erinnerung', Frankfurt am Main and Berlin, 1987, p. 259).
2 Werner Schmalenbach, *Kurt Schwitters*, New York, 1967.

Merzbauaftermerz Eric Hattan

A journey of the mind around corners, edges and ideas to break ignorance. I know very little about Kurt Schwitters's *oeuvre* and the *Merzbau (Merz Building)*. I know it no longer exists and that it is a key work in his Merz art. A reconstruction was made. I have never seen the *Merz Building*. How many people have actually seen it? I have seen photos of it. Have I seen photos of the reconstruction or of the original *Merz Building*? I have surely seen some of Schwitters's collages and pictures in museums around the world. Schwitters turned a room into a Merz construction, extended it into another room, changed the interior, added and filled up the six walls of a room. Was the room large; was it small? Was the *Merz Building* a room? Or was it more space? Did Schwitters empty out a room that already existed? Or was it empty anyway – was it his flat? – his studio? Was the *Merz Building* a walk-in sculpture, a free-standing three-dimensional object in a room – a space outside? Was it his own house or a room in a room? Did Schwitters build a roof, walls and foundation for this building? Were there empty spaces, hidden spaces?

The reconstruction of the original *Merz Building* provides a physical record and must be entered with grey felt slippers – did Schwitters also want them to be worn? This reconstruction has no walls, it stands somewhere in no-man's-land and appears out of nowhere. Photos, flat paper are its supports. The construction is visible from the outside and the constructor used new materials (assembly foam). How did one enter the *Merz Building* room and were there more rooms and the reconstruction only shows us one? Are my eyes and my feet following in Schwitters's footsteps? From the outside one can see into a non-form – the construction shows more from the outside than from within.

I imagine the following: a large house in a street. One of many in Hanover. From the outside there is no indication of anything unexpected. A man lives there, works there, fits out his apartment and contracts the space – convolution by convolution – compresses space and air – increases the surface fold by fold – narrower, slanted and crooked!

Merz was born! A construction arose, was built, erected, tinkered with, glued together or plastered, patched and screwed together! Did he plan and design it or simply keep on building? Did he do it himself – did he allow assistance? Did he look out the window? Was there even a window or two? Did he want to obstruct the window? Did the rectangular window stay rectangular, the door a door with right angles until it was bombed and destroyed? Demolished and erased.

Was the *Merz Building* finished, always unfinished, never completed? Did he read in it daily, sit, stand, lie in silence? When he had to leave, did he take parts of it with him, draw up plans afterwards?

Did he photograph as he was building it – did he photograph at all?
Was Schwitters tall and thin? Small and round? Did he bend over and stretch in a smock and wear handsome trousers? Was Schwitters able to walk around the room or merely totter and turn around the corners and edges unable to stand up straight?

Who visited him? Was the world small, did it become smaller, did he emigrate to the *Merz Building* and the green garden turned grey? Was there a garden at all? Did he often sit in his construction, always in his cave? Did the stalactites and stalagmites grow over night and did he sleep, dream and wake up in his Merz?

Did white dominate or grey? Did the grey become greyer or are those grey-grey photos? When did he withdraw into his head? When did he leave his *Merz Building* and when did the *Merz Building* become a ruin and when did it disappear altogether? Does it no longer exist, does it still exist, does it exist once more?

PS: Herzog & de Meuron, architects in the Kunsthaus Aarau: Merzed in and plastered shut! Zaha Hadid, Daniel Libeskind – were they all Merzians?

Cat. 149
Peter Bissegger [Reconstruction]
Reconstruction of Kurt Schwitters's
Merzbau, destroyed in 1943
1981–1983
Wood, plaster, plastic; painted
393 x 580 x 460 cm
Sprengel Museum Hannover,
reconstruction by Peter Bissegger

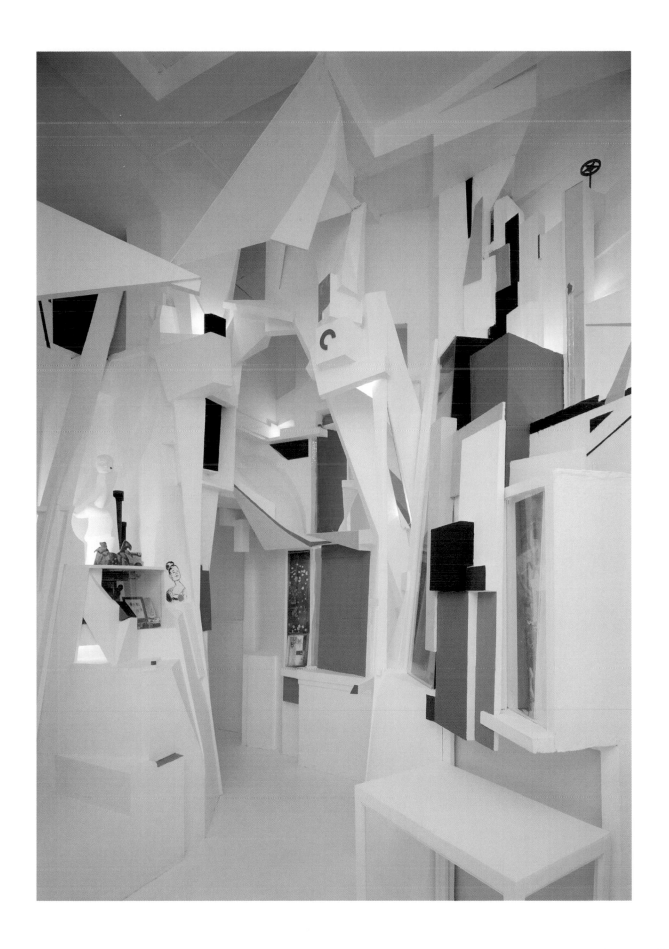

Anarchistic Proliferation — Safe and Secure Eric Hattan

I know Tinguely's work so-so – I know some of Tinguely's works more than so-so. Do I know a lot of Tinguely's work? Something comes to mind – I didn't see *Eureka* in Lausanne. I wasn't able to go to Lausanne, then, when I was nine years old, but I saw *Eureka* on TV – just for a short time, all the same I remember it well. But that isn't why I wanted to become an artist; nor did I ever want to be a mechanic and it was my brother who loved the world of motors. By the time he was fifteen, he had taken everything apart and put it back together. Whatever it was, it (usually) ran again.

But at the age of thirteen in a garage in Fribourg I saw Jo Siffert and asked him for an autograph! I was always for Siffert. And Tinguely, yes, later on for Tinguely too. But not really intensely and without an autograph. What impressed me most in the issue of *DU* that Tinguely published was that he and his girl friends went filching in early years for something to put in the pot and fill their empty stomachs. That gave me the legitimization to award myself a long-running shopping scholarship at Migros. Later when I no longer needed it, I still didn't buy Tinguely bed linen though!

And now this journey to the huge head, *Le Cyclop*, in the forest. To the monster, constructed and expanded over many years in a public forest on the outskirts of Paris. Almost impossible to locate – today official signs post the way to the structure, although the artist never applied for a construction permit. A site to erect fantasies, cephalopods and monstrous creatures. Tinguely in a group with friends and not as lonesome as I imagine Schwitters and always larger, the exact opposite of withdrawing into one's shell. Growing to the heavens or at least beyond the treetops. Always growing, expanding, adding on – no self to withdraw into. Conquer the world and cram everything into your head – megalomaniacs and women. There is this head with one eye, the child eater, the one-eyed monster. But the most fearsome giant is fearful himself and now wants to be protected, locked up and safeguarded by the State – the French State, *la grande nation*. Anarchy – once possible thanks to the authorities turning a blind eye. Anarchy locked up electronically. May not be entered everywhere today. For safety reasons – officially decreed! No structural engineer did the calculations. Simply kept on puttering, welding and metalworking, grilling sausages, cooking entrails, eating brain and drinking wine with Luginbühl and Co., a party, a feast during a campaign for anarchy to conquer the world and because everything was in flux (and surely often together with the mayor next door and the prefect?) I finally saw it – the monster's head – no photos allowed!

There are people who have often been there, they come back again and again and saw the thing years ago when they were young. Then, when it was still in its anarchistic state, unguarded and vandalized. Impressed by the world stage reduced to a small spot in a large forest. A true monster, the real thing, only possible there – even if Tinguely wanted to move the head somewhere else, to protect it from vandalism! Knock it down – off with its head! Executed and carried off. Transplantation!

The megalomaniac that he was – was he? Anything is possible today, more than ever. (Abu Simbel: sawed up and transported years ago – and yet drowned by the flood). Head proliferation – to the end of the world. The head in the forest – the whole earth is its torso.

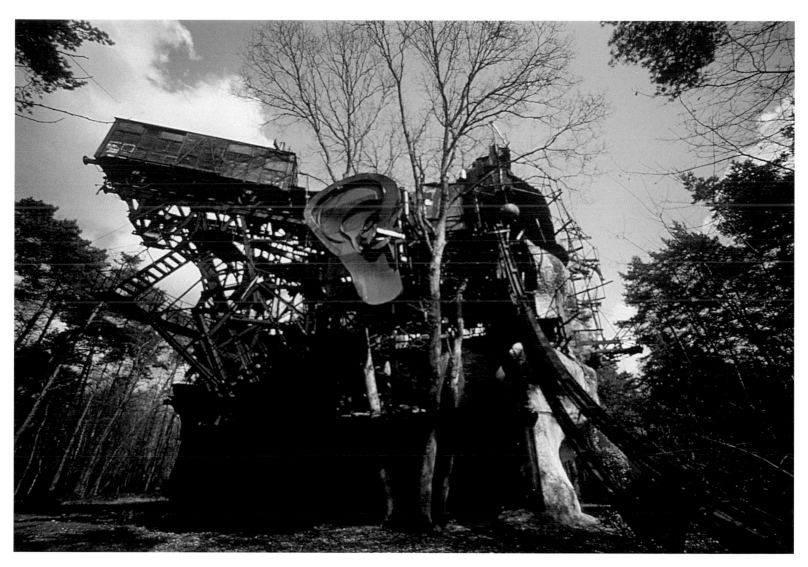

Le Cyclop, joint work by Jean Tinguely,
Niki de Saint Phalle, Bernhard Luginbühl, Daniel Spoerri,
Eva Aeppli, Seppi Imhof, Rico Weber, Paul Wiedmer,
Jean-Pierre Reynaud, Pierre Marie Lejeune, César, Arman,
Larry Rivers, Giovanni Podestà, Jesus-Raphaël Soto,
Reto Emch, Jim Whiting et al., walk-through sculpture,
22.4 m high, in the woods near Milly-la-Forêt, 1969–1987;
the photo shows the state in 1977

Merzpicture Horse Grease
Art in the Age of Mechanical Reproduction Beat Wyss

How can I tell *Rossfett (Horse Grease)*, about 1920, is a work of art? The willing viewer finds the artist has made the initial work easy, since in a sense he leads the eye through an open window to the object in question. *Ohne Titel (Merzbild Rossfett) [Untitled (Merzpicture Horse Grease)]* (see illus. p. 73) hangs on the wall in a frame. Admittedly only a makeshift frame, knocked up like the flap of a barn door. The nailed-on horseshoe intensifies the impression of rough rural origins. To the weather-beaten, loose boarding, which still bears traces of paint, adhere scraps of newspaper, a torn piece of bone-lace and an open tin of what looks like dried-up ointment. And there it is, in the top left-hand corner: the word 'Rossfett', horse grease, in plain modern sans-serif type, not in small capitals but underlined. We are clearly meant to notice the word. But where is the art in this window view? It becomes apparent when I pause in my observations on the perceived objects and try not to become distracted by the communicativeness of the material. Let's ignore for a moment the rust on the horseshoe, the streaks of white and green that are supposed to indicate mould, and let's resist the temptation to browse through the newspaper scraps for interesting messages. The vertical cracks between the boards should appear entirely abstract, the cut-out oblong pieces of wood and cardboard transform themselves into a concrete tableau until the confusion of images melts into a pattern of coordinates to form a right-angled grid structure.

Forget mould and haphazardness. What at first looks like a barn door plastered with various kinds of rubbish is a carefully planned composition. The formal central motif is constructed out of three circles made up of the horseshoe, the red ring and the tin of fat – whose round edges are so joined that they form a heart-shape pointing into the top right-hand corner. The leitmotif is found in the same place as the word 'Rossfett': here we see a neatly cut-out corner of a playing card, the seven of hearts. The red heart gives us the theme which is spontaneously answered by the chorus of circular found objects. Alongside the geometrically precise arrangement there is the choice of colour, which in both its economy and its deliberateness turns the ensemble of objects into art: red is the link between the lower left-hand corner with the playing-card heart and the red of the ring in the diagonal. Dabs of blue play about the central picture axis, and a cloudy green patch at the right-hand edge is unobtrusively positioned at the golden section of the oblong image.

Does this art also have a message? It appears to be concerned with the enhancement of beauty. 'Rub on horse grease, it's good for the legs!' Ladies with varicose veins may perhaps feel they are being addressed here, but men are also given hints on good grooming: 'Hand-washing powder ... Hair lotion ... Tooth powder ... Toilet (water?)' are promoted in the torn-out newspaper advertisement. Those who take care of their grooming will find others' hearts going out to them – yet it would be a rather simple artistic message that contented itself with echoing commercials. The work itself seems not to have benefited too much from the call for aesthetic improvement. It may have been touched up here and there, but under the cosmetic layer of grounding and paint the material itself is a victim of the elements. 'Good luck, whatever happens!' is the horseshoe's message to us, who are used to seeing horseshoes on barn doors as bringers of farmyard prosperity, some of their messages even resorting to pre-emptive spells: 'Holy Saint Florian, pray let other houses burn.'

Kurt Schwitters
Ohne Titel (Merzbild Rossfett)
Untitled (Merzpicture Horse Grease)
circa 1920
Assemblage, oil on wood
20.4 x 17.4 cm
Private collection

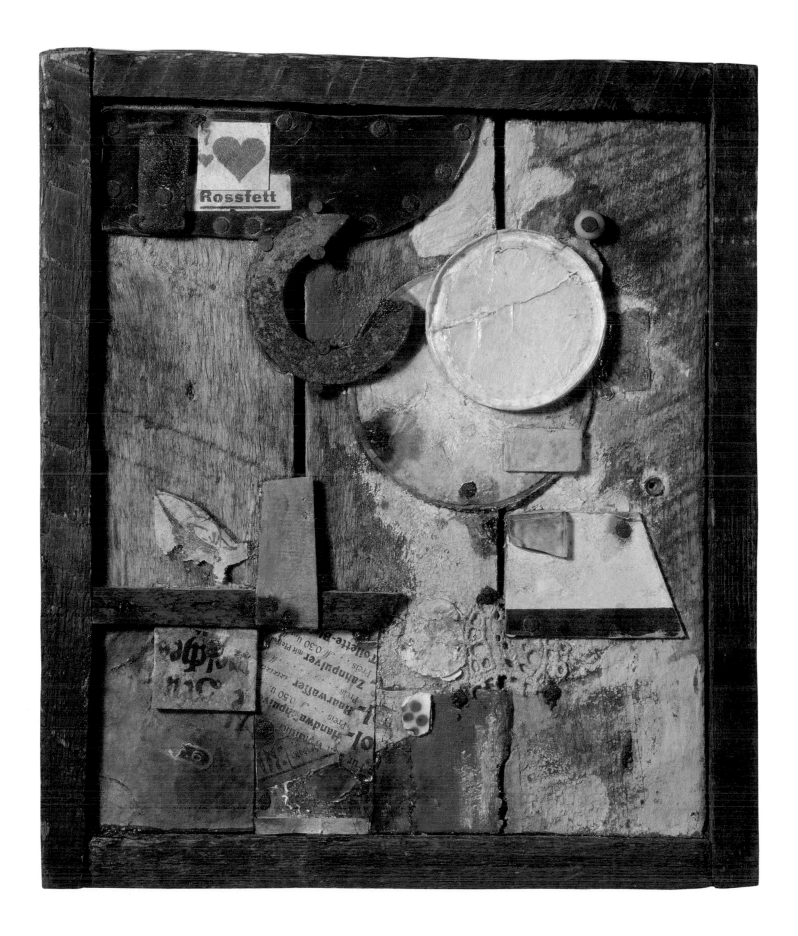

We have no desire to make this work comprehensible, since that would be its end. It remains the reader's task to complete the work in his or her own contemplation. The following remarks are merely made to provide a few tools of definition.

Methodological Intermezzo

The now commonplace opinion is that modern art had to become abstract because the new technological media of photography and film had rendered mimetic art redundant. This assumption is wrong. On the contrary, Schwitters's work in particular demonstrates that avant-garde art does not represent the alternative to mechanical reproduction – it is the continuation of mechanical reproduction by artistic means. Like photography, an assemblage picks up the traces of reality; but whereas in photography these traces take the form of rays of light on the film, the artistic process is a collation of traces from real life. The structural relationship between avant-garde art and photography can be explained by means of symbol theory, which has until now been rather a bone of contention among art historians. Attempts to apply semiotics to phototheory have, however, been successful. One author to mention here, whose leading role in this debate was not discovered until the 1960s, is the American logician Charles S. Peirce (1839–1914). It was he who provided the theme for Rosalind Krauss, who in her essay 'Notes on the Index' (1979) interprets the conceptual art of the 1970s as an art form that lays or secures a trace.[1] 1990 saw the publication of *L'acte photographique* by Philippe Dubois,[2] in which the French *image-acte* plays a central role: in the act of photography, the distinction between image product and image process disappears. The image-act encompasses the photogenesis from beginning to end: from the moment of searching for a motif, to the moment of shutter-release, to the photographer's gestures, to the picture's development in the laboratory, up to and including the various forms of presentation: in a magazine, a gallery, a family album. This perception of an image as an act lends itself perfectly to being used as a general principle of art history. Dubois' definition of photography can just as easily be applied to the concept of the image in modern art. Like the image-act of photography, the genesis of a work of art has since the nineteenth century been viewed as an intrinsically symbolic form in its own right. As in photography, the image in modern painting presents itself to an ever more radical degree as an act. The artistic process becomes a content of visual art.[3]

In the pictorial act the artist places signs that can according to Peirce be classified as one of three types: the icon, the index and the symbol.[4] However, when distinguishing in this way it is important to remember that the pictorial signs do not reside in separate classes but always interact with each other. Take Schwitters's horseshoe in the *Merz-picture Horse Grease*: as an icon it embodies a three-quarters-closed arch. Its outline can be defined by a line formed of points which are all equidistant from a second point, the centre. In order to comprehend the iconic nature of the horseshoe, I have to half-close my eyes in order to see behind the layer of rust a circular form similar to the kind Aleksandr Rodchenko uses for his constructivist compositions. The three-quarters-circle is a geometric idea independent of real forms – whether these be the crescent moon, a hot-dog sausage or the horseshoe. The icon, maintains Peirce, relates to the empirical world in the mode of simile.

On the other hand, the horseshoe as index is directly dependent on its surroundings. Here rust and nails matter. In the role of indicator the horseshoe points to its origins in the pre-industrial world. As index it gives the collage the rough farmyard atmosphere that it would immediately relinquish as a pure icon and geometric idea. The horseshoe's pivotal moment between conceptual image and material trace is an aesthetic process which for Schwitters is central. The indicator is dependent on the environmental procedure of cause and effect. Peirce's examples are well-known: smoke is an indicator of fire, the pointer of a weather-vane the indicator of wind direction. In this sense the horseshoe in Schwitters's assemblage is a sign that at the time he made the image *Horse Grease*, horses were still common on the streets of Hanover.

The horseshoe as symbol is laden with the significance of its cultural usage. Although today potatoes, beer and milk are no longer delivered in horse-drawn wagons and wedding carriages rarely appear on the urban scene, the horseshoe remains a symbol of good luck. It can grace the cooler of a Mercedes just as easily as the front door of a terraced house where newlyweds moved in the day before. The horseshoe as symbol depends on social agreements.

But come to that, is that shape really a horseshoe after all? Maybe Schwitters actually only nailed a rusty ring onto his boarding, and placed it deliberately next to the word 'Rossfett', so that we would by spontaneous association read it as a horseshoe. Traces can only really be determined with certainty at the scene of the crime. *Merzbild Horse Grease* is, however, in private ownership, and the author has until now only been able to view it in photographic form.

The Symbol: Conventions of the New

All Schwitters connoisseurs stress the interwovenness of art and life for this artist. His collages are the pages of his diary: 'His was an almost diaristic method, forming the materials that surrounded him into miniature epistles of everyday experience', writes John Elderfield.[5] Thus life becomes the trace that art also is. Schwitters's aesthetic evokes staged rituals of commemoration or meditation, both gestures that touch the inner, private person. This remark is only true, however, if while making it a proper distance is maintained from the biography cult, a trend as popular as it is foolish. Art history does not investigate artists for their private lives but as agents of their time. A work of art is not made in order for its beholder to feel entitled to peek under the creator's bedcover. We will not understand the private sphere in Schwitters's work properly until we perceive it as a symbolic form of cultural technique.

Meyer Schapiro sees the collage in the tradition of the still life, the genre made for the drawing room. Perishable fruits, glittering glasses, a skull are all arranged in the painting to symbolize the petty, available world that moves between sensation-seeking, recollection and self-denial.[6] This tradition can admittedly be far extended, to include the religious images of icons and votive offerings that are constructed before an altar in an assemblage of believers' devotion. The collage-like act of assembly goes back to the magical zones of empowerment and incantation. The shrine displays the bones of a martyr which are decorated with bands of brocade and precious stones to indicate veneration, and with inscriptions bearing the martyr's name and devout litanies. The bourgeois version of this cult of relic veneration is the devotional casket of the Biedermeier age, in which the cer-

tificates of baptism, first communion and confirmation were kept alongside the cut-off plait of hair, the bridal wreath and the bridegroom's silhouette.[7]

The private cult of commemoration has an unforeseen boom in the age of mechanical reproduction, in the form of the photo album which acts as a shrine to family celebrations, trips, and portraits of relations. Pictures are produced en masse and sold as postcards, festive menus, beer mats, all things that in the course of a life can pile themselves into collections – true Merz Buildings of simple bourgeois memory-preservation. Schwitters's assemblages and collages have thus to be read symbolically as the expression of a memory-conserving tradition. Although the first Merz images must have appeared astonishing and novel to the visitors of the Berlin gallery 'Der Sturm' in July 1919, they were understood because they awakened in their viewers a memory of long-forgotten, familiar objects.

Today, montage vision is a banal everyday practice. The collage belongs to the common ground of communication when it comes to the visual representation of school exam celebrations, silver weddings, or the firm's annual trip to the seaside. Our perception as a whole is one enormous collage. I can zap through the TV channels, for instance, or stare calmly ahead on the motorway while travelling at 100 mph without feeling giddy as trees and clouds fly past on either side, or on the radio four more deaths are reported after a terrorist attack in Baghdad, or I notice in the rear mirror my wife's mouth moving as she goes through the list of guests for next Wednesday's dinner. Artists did not invent the collage, they *discovered* it: on advertisement pillars, in newspapers, on the pave-

ment. The myth of the artist as the anticipating genius must be well and truly forgotten. The appropriate dictum for the modern period is rather: 'Art imitates commerce and technology.' All the same, this means art reflects commerce and technology for the first time as cultural forms.

That is also how we must read Schwitters's watchword: 'Merz' derives from a fragment of a 'Commerz- und Privatbank' advertisement which he added to one of his first collages, *Merzpicture*, which was burned in 1943. The artist even gives 'Merz' an alchemistic connotation: 'Commerce = *cum mercurio*'. Mercury is the messenger of the gods and the god of commerce. Mercantile art.'[8] This is the voice of the self-assured bourgeois. The thirty-year-old artist lived at this time with wife and child in the Waldhausenstrasse 5, the home of his parents, who ran a ladies'-wear shop on the premises. All his life, Kurt Schwitters remained careful with his money and wise in his decisions: before he started on his career as an artist, he had worked as a technical draughtsman during the First World War.[9] The fact that he was also a passionate stamp-collector cannot, however, be held against him, since we know that this collection was the last remaining possession that he was able to sell in exile, three years before his death, to finance the move from London to the Lake District.

The Icon: The Picture as Refuse

Schwitters remained on the borderline between bourgeois normality and the avant-garde. All his life he painted on the side in a naturalistic way: landscapes and portraits. Not that we are unaware of artistic double lives among other modernists – even the purist Piet Mondrian continued painting

flower pictures until well into the 1920s – but nobody else practised this kind of Sunday painting alongside the experimentation as faithfully as Schwitters. Throughout his life he was drawn to the countryside with his easel in order to paint 'from the motif'. He undertook the exercise with romantic devotion, since for him the artistically realized experience of nature was a means of intensifying his imagination. He defends his conventional painting with the words: 'I never give up on a period in which I have worked with energy. I am still an Impressionist all the time I am MERZ: [...] I am not ashamed of being capable of making good portraits, and – I am still at it.'[10] Whether these works are really so good is a moot point among art historians. Werner Schmalenbach, a doyen of modernism, ascribed these naively conventional paintings, 'which do not transcend the normal citizen's view of nature, a view coloured by romanticism, idyllic scenes and sentimentality', to the artist's isolation during his years of exile, when the accustomed intellectual stimuli were missing.[11] For John Elderfield, too, this 'kind of Sunday painting after a week in the Merz office' remains problematic, even if he admits that 'I can imagine that even Schwitters's naturalistic paintings [...] might find the same kind of critical support that has been extended to the late De Chirico or Picabia.'[12]

After his *Abitur* [baccalaureate], Schwitters had attended the Hannoveraner Kunstgewerbeschule, the applied arts college in Hanover, from 1908 to 1909, before moving to the Königlich-Sächsische Akademie der Künste [Royal Saxonian Academy of Arts] in Dresden, where he spent the next six years. His painting style during his student years is free of avant-garde influences; the 'Brücke'

painters appear not to have penetrated his awareness. Only after finishing his studies in 1917 did Schwitters begin to come to terms with Expressionism. In this year he will also have visited the Berlin gallery 'Der Sturm' for the first time. As can be gathered from Herwarth Walden's guest book, Schwitters joined the 'Sturm' group of artists on 27 June 1918. The movement's activity was now, in its eighth year, past its zenith; a younger generation, the politically motivated Dadaists, identified 'Sturm' with an Expressionism watered down by the bourgeoisie. So in taking up contact with Walden's gallery at this time, Schwitters was behaving in a strategically naïve way and making his debut on the art scene with yesterday's fashions. Here was the 'technical draughtsman' and amateur artist from solid, comfortable Hanover trying his luck on the black ice of the Berlin art scene, and there were some people who made sure he fell over on occasions. Richard Huelsenbeck, the Dadaists' chief ideologue, became his fiercest enemy. For him, Schwitters's work contained too much art and not enough social criticism. 'He lived like a lower middle-class Victorian [...] He was a genius in a frock-coat. We called him the abstract Spitzweg, the Kaspar David Friedrich of the Dadaist revolution.'[13] His application to join the 'Dada Club' of Berlin was refused. Schwitters's later attempts to distance himself from Dada have to be viewed not least in this light. He called himself a Merz artist because he was forbidden to use the Dada label. On the other hand, the Zurich-based Dadaists, Hans Arp, Tristan Tzara and also Raoul Hausmann, remained his lifelong friends.

Schwitters's early collages recall works by Arp, which since 1915 had been published in

sympathetic periodicals such as the *Cabaret Voltaire*. 'It's possible to scream using pieces of household waste [...] and that's what I did, by gluing or nailing them together.'[14] This credo reads like the compromise between Expressionism and Dada that Schwitters aimed at in his works. 'I set Merz against a refined form of Dada and arrived at the conclusion that while Dadaism only points to opposites, Merz resolves them by giving them values within a work of art. Pure Merz is art, pure Dada is non-art – each consciously so.'[15] This transferral of non-art into art, involving among other things the aesthetization of anti-art, makes Schwitters one of the forerunners of the Nouveau Réalisme of the 1950s – but of this more later.

In his methods of composition, Schwitters reflects the dominant forms of contemporary visual rhetoric: concentric patterns suggest Cubism, diagonals Russian Constructivism, grid patterns evoke De Stijl. In his material arrangements he is particularly fond of circular, triangular and oblong forms. The outlines of the internal shapes scarcely allow for the kind of formal associations practised in the analytical Cubism of Pablo Picasso and particularly Georges Braque. The pictorial elements appear dislodged and alienated and form signs which the viewer is supposed to read as metonyms. It is often difficult to tell what the original found objects were – like the rusty piece of metal that looks like a horseshoe. Schwitters calls this process 'removing the innate venom' from things. 'The work of art is produced by the artistic devaluation of its elements [...] What is essential is the process of forming.'[16] The work must resolve itself.

In contrast to the Dadaists, Schwitters uses photography, that 'new material', only very judiciously, since by nature it contains too much 'innate venom'. His photocollages are composed in such a way that they contain references to and commentaries on contemporary events. *Das Bäumerbild (The Bäumer Picture)*, for instance (see illus. p. 79), was composed about 1920, in the year the League of Nations was founded. The table, roughly outlined with black strokes above a piece of newspaper text, appears to indicate a conference whose participating parties are symbolized by a man and a woman. A public event is expressed allegorically using figures from the intimate sphere of Anna Blume – perhaps, since the woman holds a flower in her hand. The photographed heads of both figures are mounted in such a way that they appear together at the table, yet look away from one another. Sharing a table or a bed is just as difficult for nations as it is between the sexes, this collage could be saying, and as such it remains on the intellectual level of the pub debate.[17] Politics were not Schwitters's strong point. Leaving that topic aside, we content ourselves with his maxim: 'The picture is a self-contained work of art. It has no outside reference.'[18]

When Schwitters published this credo in January 1923, he was in contact with the Constructivists El Lissitzky and Theo van Doesburg. He had already, in July 1921, started to work with De Stijl. A year later he participated in the Dadaist-Constructivist Congress in Weimar, after which Schwitters and van Doesburg together organized an action-based tour of Holland. The Weimar congress was essentially an occasion to pass the baton from Dada to the spirit of New Realism. The impulses for this movement came both from Holland and from the Soviet Union. The *Merzpicture Horse Grease* of 1920 anticipates

Cat. 27
Das Bäumerbild
The Bäumer Picture
1920
Assemblage and oil on pasteboard
17.8 x 21.3 cm
Private collection, southern Germany

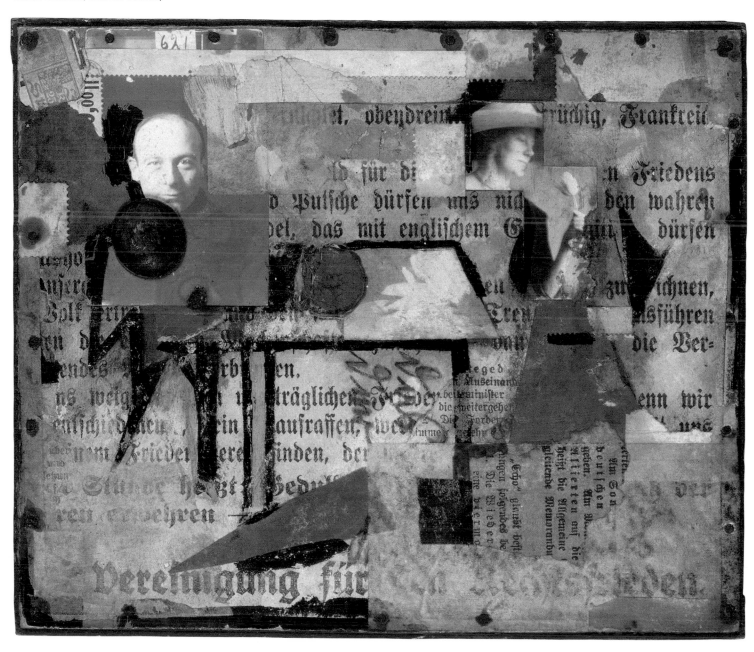

the Constructivist movement. The picture is governed by an unusual harmony between indexical found object and the iconic world of images: the objects perform an artful act of mimicking painting. The tube of fat, for instance, behaves as if it had always been a circle and had only waited for the moment to be placed on constructivist lines diagonally on the surface of a picture. The concentration of the composition in the centre gives a Cubist impression. This is also the way Piet Mondrian arranges his tableaux of the early nineteen-twenties, whereby the dynamic centre seems to radiate out to the picture edge, which has the appearance of a cloudy passepartout. The emphasis on horizontals and verticals give the rubbish-turned-art additional stability.

His coalition switch from Dada to De Stijl revives the *rappel à l'ordre* proclaimed by the international avant-garde in the nineteen-twenties. The time for experimentation was considered over; instead, artists should now place themselves in the service of society. That sounds admirably clear and decisive, but the question which path to take to achieve this end, whether right or left, was the subject of hot debate – until this was quenched by political tyranny.

On the Index: Tracing the Origin

To resume: Schwitters, the good academy student, comes to collage from painting, and his compositions maintain pictorial values. This gives his collages a formal balance between the trace-like and the image-like. The stuck-on material is both put to work and, in artful order, put to rest. In the aesthetic buffer zone of abstraction, the object thus becomes a pivot between what it actually is (what we take for a horseshoe) and what it represents (a precise three-quarters-circle on the picture diagonal). In this double-play, the material assumes a role as index to uncover the traces of the world and rediscover the origins. Yet the solemn aura in which an iconified object normally veils itself is absent here. The stories and memories that are sparked off range in tone from pun to mysticism. Schwitters's idiosyncrasy of being at once highly serious and totally eccentric anticipates a mood which is programmatically continued in the post-war period, for example by Yves Klein or Joseph Beuys.

The taming of objects in the work of art is at the same time an act of liberation of these things from the cycle of decay. In the manner of a hasty archaeological excavation, the collage protects defenceless commonplace things from the almighty mill wheels of time, which unthinkingly crush everything that is only there to be consumed. The pictorial system into which Schwitters locks in the horseshoe, the tin of grease, the playing-card heart, is also an aesthetic refuge. Schwitters's altruistic handiwork takes control of things that have become useless in order to preserve them. A similar process is visible in Walter Benjamin's *The Arcades Project*, which is an unmistakable textual collage derived from everyday life in nineteenth-century Paris. Benjamin's aim in collating obsolete evidence is 'to blaze a way into the heart of things abolished or superseded, in order to decipher the contours of the banal as picture puzzle.'[19] The montage completes a 'tiger's leap into the past' with the object of interrupting the continuum of history and thus stemming the flow of catastrophe. Although Schwitters doubtless never ventured to the heights of Benjamin's negative messianism, his montage principle sees itself as a means

of rescuing things from the triumphal march of a technocratic abuse of the world.

To be modern in Schwitters's way of thinking, and also in Benjamin's, is to return to the sources of rationality in which mastery of the world was still expressed in a loving description of things. The flotsam and jetsam of civilization are given a voice when the artist, shaman-like, places them together according to aesthetically rational principles. Art thus creates the balance between material order and material idiom, in the spirit of a modern Utopia in which rational and magical thinking, still unestranged, have equal weight.

'Origin is the goal.' Walter Benjamin uses this quotation from Karl Krauss as the motto for a chapter in his essay *The Concept of History*.[20] The return to the anthropological roots of culture was one of the leading intellectual themes of the time. In 1916 Carl Einstein wrote *Negerplastik* [Negro Sculpture], and 1923 saw the simultaneous publication of Wilhelm Hausenstein's *Klassiker und Barbaren* [Classics and Barbarians] and Herbert Kuhn's *Die Kunst des Primitiven* [The Art of the Primitive]. The visual arts express this utopian aim of going 'back to the roots' and beyond the hollow civilization of the present as 'Primitivism'. Even back in the Romantic period, the word 'primitivism' had been current parlance, although then it had referred to Italian and Flemish art of the fourteenth and fifteenth centuries. Primitivism was given an exotic, archaic slant at the Paris World Exhibitions, which alongside the latest industrial achievements also documented the cultural life of the colonies. It was photographs from Tahiti that inspired Paul Gauguin to return to this ostensible Paradise.

Art became increasingly clumsy: *'Gaucherie'* was Paul Cézanne's word for it. The indicatory character of the pictorial process becomes more and more important. Art makes traces visible. Here the artist can choose between impression and expression: both roads are open. Impressionism describes the path of reality to the eye. The canvas registers the rays of light in the same manner as they hit the retina. These painters dare what, in contemporary photography, is at most the result of an accident or experiment: a random arrangement of motifs within a frame that contradicts all the laws of composition. The impressionistic method of analytically breaking down optical impressions in their application of paint is outdone by Henri Matisse and the Fauves, who coarsen the impression into an expression. Colour is given the liberty of expression, and its application becomes the trace made by the painting painter. The impressionistic approach shows the index of the world as it is seen, the expressionistic approach shows the index of the world as it is experienced. In Paul Cézanne's conversations, recorded by Casquet, these two conceptions of art as spoor-layer converge in the notion of *'réalisation'*.[21] Modern art is the spoor of reality. The artist behaves as the agent of this reality; in the act of composing a picture he lays authentic traces.

Around 1900 Primitivism embraces everything from medieval art on buildings to African totems, Japonism and Oceanic fetishes. Picasso displays the whole range of possibilities in his *Demoiselles d'Avignon*.[22] Whether it be by means of painterly mimesis, or collage and assemblage, he inserts splinters of 'primitive' culture which assert the message: This art is not from these parts, it is alien, it whispers of being privy to a primal, 'authentic' whole. Michel Foucault speaks in *Les mots et les choses* (The Order of Things)

of the modern ambivalence between the discovery of history and the simultaneous longing to return to the source that existed before the civilising power of history took hold.[23] Historicism is experienced as a period of increasing 'forgetfulness of present being' *(Seinsvergessenheit)*, to use Heidegger's word, and wakes expectations of being able to make a leap back to the beginning of time. The primitive in art paves the way for this childish attitude that thinks in terms of primary processes and views nature as something magical – with a devoutness free of the pomp and circumstance of church convention. The fragmentary character of the primitive appears to support the notion that it really is an authentic indicator, a foundling from the Paradise from which modern civilization has been cast out.[24]

Merzpicture Horse Grease is just such a collection of doomed objects. Not just the horseshoe, the scraps of bone-lace and Fraktur print, too, appear out of place in a composition made in the spirit of Constructivism, which dreams of chrome-gleaming aeroplanes and automobiles. It is as if the rational order were declaring itself null and void, as if it were taking on the nature of the rejected objects with which technical progress incessantly clutters itself.

Merz: A Postscript

By the latter half of the nineteen-twenties, Schwitters had already become an internationally recognized artist. In 1927 his retrospective 'Grosse Merzausstellung' was shown in several German cities. Schwitters was in contact with the collector and supporter of Duchamp, Katherine Dreier in New York, who in her 'Société Anonyme' presented an overview of his work. In 1930 he participated in the Paris exhibition '1ère exposition internationale du group Cercle et Carré', which was to set the standards for the development of abstract art until well after the end of the nineteen-thirties. In Hanover, however, things were getting tight. Rightwing radicals had already begun to disturb cultural life seven years before Hitler became Reich Chancellor. Then came the scandalous exhibition of 1937, 'Degenerate Art', in which Schwitters was represented by several works. Schwitters was at this point already out of the country, living with his son Ernst in Lysaker, near Oslo, and thus avoided a possible arrest.

Was it a mistake to go underground in the rural provinces? True, Willy Brandt and Bert Brecht also sought refuge in Scandinavia for a while, but they had the benefit of a network of political friends and contacts and so were never completely isolated in this deceptive idyll. For a German without a work permit, however, Norway was a far from comfortable place. Several times, Schwitters and his son were ordered to leave the country, and suspicions were voiced that they were engaging in espionage. Schwitters's reputation as an important representative of the avant-garde became slowly forgotten here. Now the Merz artist felt the bitter reward of his fondness for the good life which had hindered him from settling for long in either Berlin or Paris.

In 1940, when the Wehrmacht marched into Norway, he fled in a fishing boat to Tomsø, then on 8 June on an ice-breaker to Edinburgh, where both father and son were arrested. The artist remained for sixteen months in British internment camps in highly interesting surroundings, alongside German emigrants with backgrounds in science, art and politics. To these people, Schwitters was

a surviving comic figure from the long-forgotten, hilarious days of Dada. Schwitters, whose membership of the Berlin Dadaist club had been refused, was now being regarded as one of those old fossils! To many contemporaries, this undiluted mix of the clown-like, the bourgeois and the deeply romantic was disturbing. When Schwitters was released in October 1941, he found the cultural climate all too frigid. London was at that time no capital of the visual arts. So the city-shy Schwitters once again left for the provinces. His last three years were spent with his partner Edith 'Wantee' Thomas in Ambleside in the Lake District. Here the old eccentric lived by selling naturalistic portraits and landscapes to locals and tourists.

The bridges to his home town of Hanover had been burned. An air-raid in October 1943 had hit his house and destroyed the works and documents stored there. His wife Helma, who had remained in Hanover to oversee the family legacy, did not live to see the end of the war. Kurt Schwitters applied for British citizenship; it was issued to him on 7 January 1948, one day before his death. He spoke and wrote English well enough to get by, but having been so disappointed in Germany, he refused to make further use of the language – despite the keen wit and irony he was able to express in his mother tongue. The one thing that made him immortal is the poem *To Anna Blume (An Anna Blume)*, which brought him overnight success in 1919, well before he had established himself in public as a visual artist. Posthumously, however, fame came rapidly. Two weeks after his death, an exhibition was opened in the 'Pinacotheca Gallery' in New York. Exhibitions followed in the Kestner Society, Hanover, in 1956; in 1962 in the Pasadena Art Museum near Los Angeles; and

in 1963 at 'Marlborough Fine Art' in London. This schedule more or less mirrors the renaissance of Dadaism. Dada is not a style but an attitude of anti-aestheticism which finds it hard to survive in the visual arts for long. A movement whose fame is due less to the quality of its works than to the artistic scandals it provokes has worthy parallels in literature, music and ephemeral happenings. Not by chance did Dada revivals – whether centred around John Cage at Black Mountain College or in the 'Fluxus' festival in Wuppertal – find their expression in music, happenings and concrete poetry.

Many supporters of neo-Dada espoused the iconoclastic aims of their historical heroes. The utopian project, which was to produce a social revolution by anti-artistic means, failed a second time. This time there was no world economic crisis, no political dictatorship, no war onto which to place the blame; it was the paradox of this art form that it revolted against art as an institution, only to find the institution splendidly affirmed by its action. The result of anti-art was art, whatever it was called – whether Nouveau Réalisme or Pop Art. This is what gives Peter Bürger, in his appraisal of the avant-garde, 'the impression of design art'.[25] Even the old Duchamp accused his young imitators of allowing their 'readymades' to degenerate to lifestyle icons à la Coca-Cola. That said, even the old master could not entirely resist this temptation and, a victim of his own success, made his long-lost 'readymades' available to the art market in the form of replicas and reproductions.

Yet if Marcel Duchamp had to copy his own history, the more conservative Schwitters was more easily accepted. He had always turned Dada into Merz. What Huelsenbeck used as criticism against him now worked in

his favour. Schwitters became a paradigm for the practice of organizing found objects within a work of art. With the exception of Jean Tinguely, whose *Méta-mécaniques* reliefs recall for instance Malevich, these artists – Arman, César, Christo – did not follow a Cubist or Constructionist model as did Schwitters. They ironized the picturesque rhetoric of their own era and made Abstract Expressionism out of refuse.

The revival of Dada in the post-war period underlines Karl Marx's famous dictum that when history repeats itself, the result is comedy. And this has been happening, to general amusement, for a good half century.

1 Rosalind Krauss, 'Notes on the Index Parts I & II', in idem, *The Originality of the Avant-garde and Other Modernist Myths*, Cambridge MA, 1985, pp. 196–220.

2 Philippe Dubois, *L'acte photographique*, Brussels 1983.

3 Dubois indicates this tendency when he refers to the shift from classical mimesis, the order of metaphors, to an 'aesthetic of the spoor, of touch, of referential continuity (the order of metonomy)'. Dubois 1983 (see note 2), p. 113.

4 *Semiotic Writings I* = MS 404, 1893, chapter II: 'What is a sign?'

5 John Elderfield, *Kurt Schwitters*, London and New York 1985, p. 71.

6 Meyer Schapiro, 'The Apples of Cézanne: An Essay on the Meaning of Still-life', in Schapiro: *Modern Art, 19th and 20th Centuries, Selected Papers*, New York 1978.

7 Cf. Herta Wescher, *Die Geschichte der Collage. Vom Kubismus bis zur Gegenwart*, Cologne 1974, p. 7f.

8 Cit. in Friedhelm Lach, *Der Merz-Künstler Kurt Schwitters*, Cologne 1971, p. 22.

9 Cf. 'Kurt Schwitters: Herkunft, Werden und Entfaltung, 1920/21': 'From that time until the beginning of the revolution I worked in the Wülfel iron foundry doing the work to which I was best suited, technical drawing.' Cit. in *Kurt Schwitters. Das literarische Werk*, ed. by Friedhelm Lach, Cologne 1981 (1998), vol. 5 *(Manifeste und kritische Prosa)*, p. 83f.

10 Cit. in *Kurt Schwitters: Wir spielen, bis der Tod uns abholt. Briefe aus fünf Jahrzehnten* [We will carry on playing games until Death comes for us – Fifty years of letters], ed. by Ernst Nündel, Frankfurt am Main 1975, p. 254.

11 Werner Schmalenbach, *Kurt Schwitters*, New York 1967.

12 Elderfield, 1985, p. 216.

13 Cit. in Schmalenbach 1967 (see note 11), p. 6.

14 Cit. Heinz and Bodo Rasch, *Gefesselter Blick: 25 kurze Monographien und Beiträge über neue Werbegestaltung* [The Fascinated Stare: 25 essays on new forms of advertising], Stuttgart 1930, p. 88f.

15 *Merz 4. Banalitäten*, Hanover, July 1923, p. 40.

16 Cit. *Merz 20. Kurt Schwitters. Katalog*, Hanover 1927, p. 99.

17 Dorothea Dietrich points out that Schwitters's portrayal of women in his collages venerates a patriarchal view. This direct application of political correctness to historical sources would necessarily have to include the whole of the male avant-garde of Old Europe. I would caution against the attempt to associate Schwitters's mentality with the reactionary conservatism of Oswald Spengler. The artist joined the Social Democratic Party in 1932. Cf. Dorothea Dietrich, *The Collages of Kurt Schwitters: Tradition and Innovation*, Cambridge MA, 1993, pp. 134–164.

18 *Merz 1. Holland Dada*, Hanover, January 1923, p. 10.

19 Walter Benjamin, *The Arcades Project*, ed. by Howard Eiland and Kevin McLaughlin, Cambridge MA 2002, p. 212.

20 Walter Benjamin, *On the Concept of History*, in Benjamin, *Selected Writings 1938–40*, ed. by Howard Eiland and Michael W. Jennings, Cambridge MA, 2003, p. 395.

21 *Paul Cézanne: Gespräche mit Casquet. Briefe*, ed. by Walter Hess, Mittenwald 1980.

22 Cf. William Rubin (ed.), *'Primitivism' in 20th century art: affinity of the tribal and the modern*, New York/Boston 1984.

23 Michel Foucault, *The Order of Things*, New York 1973, pp. 328–335.

24 Cf. Beat Wyss, *Der Wille zur Kunst. Zur ästhetischen Mentalität der Moderne*, Cologne 1996.

25 Peter Bürger, *Theory of the Avant-garde*, transl. by Michael Shaw, Minneapolis MI 1984, p. 53.

Cat. 140
dead cissors [sic!]
1947
Collage on paper
17.5 x 14.5 cm
Private collection, Munich

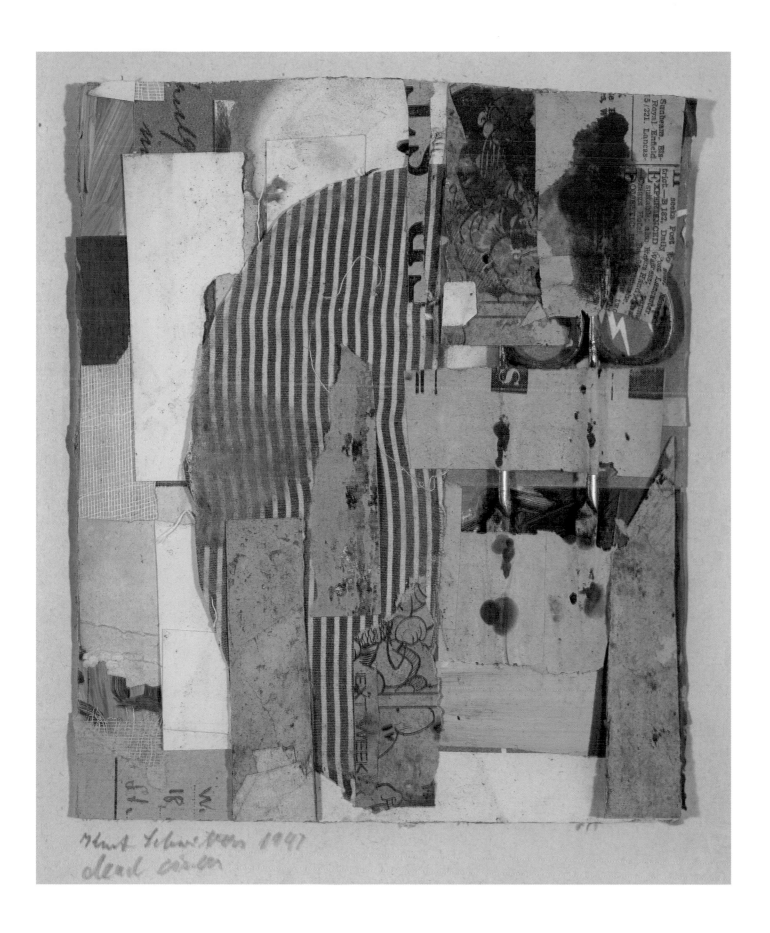

1. Model of 1960 Harvard thesis — a structure/service network.

Nine written questions about Kurt Schwitters Daniel Spoerri

Alongside Marcel Duchamp, Jean Tinguely repeatedly mentions Kurt Schwitters as one of his most important forefathers. Marcel Duchamp also means a great deal to you, Daniel, but what about Schwitters? When did you first come across his work, and in what context?

My memory of Schwitters only really begins with the extensive Bern retrospective in 1956,[1] where I was working at the time as a dancer at the city theatre. I had come from Paris, where I had been training as a ballet dancer since 1952, and where Tinguely and Eva Aeppli were my best friends. I hopped and skipped through all the operettas in the 1955/56 season at the Bern Stadttheater and felt like the most famous person on earth, because each night the artists' entrance was blocked by sweet girls from the Young Ladies' School next door waiting for me to write in their poetry albums.

I was on stage almost every evening in any case, since I had made the mistake of agreeing to work as a mime, which meant I was given countless walk-on parts – as a drunkard, a valet, a coachman – 'M'lord, your carriage awaits.' However, since each spoken word earned me a few francs, each month I had a little more money to spend with my friends, who even then were *called* Diter Rot and Bernhard Luginbuhl, but had not yet become these people. I was at this time just trying my hand at directing the short, zany play by Picasso, *Le Bonheur attrapé par le queue*, in the Kleintheater in the Kramgasse in Bern, with Meret Oppenheim (German translation and costumes) and Otto Tschumi (stage design). Then on the opening night, students of Bern University tried to prevent the few people who had turned up from entering the theatre on the grounds that it was

a scandal to stage a play by a communist – one of those who had just marched into Hungary.[2]

This was the year that Franz Meyer put on a large Schwitters exhibition in the Kunsthalle in Bern. The effect the pictures had on me then is just as strong today. Not that I remember specific works – the only thing I really remember is that I had an argument with Schwitters's son from Norway, who defended his father's 'realistic' period during the Second World War, when he concentrated on painting the more saleable views of woodland and black firs. Later – around 1974 – I was offered one such painting for a few thousand marks. On the back was written, next to the signature – I remember exactly – 40 DM. In contrast to the 'naturalistic' paintings, the many wonderful, small Merz collages impressed me far more, since I had never seen anything like them, and when I think of the small collages in my *Cabinet Anatomique* which I have been making and re-making for the past ten years, I have to think back with gratitude to my 'grandpa' Schwitters and that exhibition, although at that point I did not have the remotest idea that I would ever make collages myself, nor did I have the urge to do so.

I remember too that later, in 1961, my first art dealer in Milan, Arturo Schwarz, told me how as a student in London he had bought a small Merzpicture from Schwitters himself for five pounds, a sum that amounted to a week's or even a month's student grant. Yet Kurt Schwitters cannot have been totally unknown to me in Bern at that time. After all, in 1955 I had come here from Paris, where – as I mentioned before – my best friends Jeannot (Tinguely) and Eva (Aeppli)

were living. They had studied in Basel with Frau Eble, who provided her students with all sorts of information about the Bauhaus – and I too had a friend in Bern, Hans Bolliger, who, in his capacity as a catalogue copywriter and librarian, had just stumbled across 'Klipstein und Kornfeld' and drew my attention to relevant literature, which I soaked up like a sponge (devil knows why: I should have been concentrating on the operettas *Gräfin Mariza* and *Das weisse Rössl*). Schwitters really went under my skin back then in Bern, in a way matched only by the first Dada exhibition in Frankfurt[3] (1958) and perhaps also by the Surrealist show in Paris, in 1959/1960, in the Galerie Daniel Cordier,[4] when Jeannot and I stood outside looking through the window on the preview night, watching all the artists who had not yet been rejected by André Breton gather round a naked lady lying on a table and eat the food decorating her body.[5] Jeannot and I laughed ourselves silly over the pink body stocking, but Meret Oppenheim, whose idea it was to host this dinner, had had to bow to the law of the day.

As I say, Jeannot and I must have talked our heads off, night after night, year after year, from 1952 till 1954 in Paris, where we met again after the time in Basel and Zurich. I of course worked with body movement (as a dancer) and Jeannot, too, had no inner peace until he finally came up with his motor-powered images (Reliefs *Méta-mécaniques*). He had shortly before this tried to build a mobile stage set for a 'Ballet of Colours' I was to dance, which unfortunately collapsed in a sorry heap at the dress rehearsal. Immediately afterwards he started planning shop window decor, something he had already done in Basel using electrically

driven automatic gramophone players, and the birth of electric, motorized images could thus be induced. One can hardly imagine now how difficult it was to sell such images as 'art'. Tinguely, at any rate, was at first convinced that he would remain completely unknown.

One must bear in mind that all the texts from the time before the Second World War – such as the Dada and Bauhaus texts – had totally disappeared, and in 1954 we had scant means of acquiring information or access to original texts; Tinguely had Julia Eble-Ris in Basel, I was helped by Hans Holliger in Bern. Photocopies only existed in the sense that one literally had to photograph each page with a camera. Since that was too expensive an option for me, I laboriously copied, in one instance, the whole of Moholy Nagy's *Painting, Photography, Film* (a Bauhaus book) on my little Hermes typewriter.

In Paris, Tinguely and I experimented with different kinds of mechanical and human body movement in Jean Lurçat's former studio, which I was allowed to use (as I regularly modelled for Mme Lurçat) when he was working at his château in Saint-Laurent-les-Tours, near Saint Céré in the Périgord.

In bookshelves covering one wall of the studio, which Lurçat had hidden from the German occupying forces in the Second World War by nailing boards over them, I found a whole heap of literature on the avant-garde before the war. Here were for instance whole years' issues (perhaps all) of the periodical *L'Esprit nouveau*,[6] which even then were collectors' items and which today are counted among the incunabula of this period. I tore out all the information I could find in these issues of interest to me. I can still remember particularly well an article about Fernand Léger's decor for Blaise Cendrars' ballet *La création du monde*. I tore out everything that interested me and stored it in an extract file I made for later reference. The rest I threw away on Mme Lurçat's orders. Yet I can't remember anything about Kurt Schwitters. Nor can I remember discussing him with Tinguely in Paris. Probably, because, among other things, the cultural relationship between Paris and Germany was not particularly close in the years running up to the Second World War.

Also in Paris, we were allowed to use the studio of Mme Kosnick-Kloss, the widow of the painter Otto Freundlich from Cologne, for mime exercises during her longer periods of absence; and here I once found this book by Vassily Kandinsky, *Vom Punkt zur Linie zur Fläche* (Point and Line to Plane), with a dedication by the author, and took it home to read. Later Tinguely took it with him and never gave it back; and who knows when it disappeared onto the antiquarian book market to be sold as a dedication copy. These were the beginnings that we later worked into the texts *Autotheatre and Dylaby*. So when Harry Szeemann commissioned the reconstruction of the Hanover *Merz Building*, we were finally given a real impression of the precursor of our *Dynamic Labyrinth*.

Are there parallels in your work to the art of Kurt Schwitters? After all, you called one of your groups of works after the Hanover-born artist ('Chrüsi-Müsi' – on occasion even 'Zwitter-Schwitters', or 'Schwitters Hybrid').

I was at that point interested in finding very 'logical', 'intellectual' grounds for my development, which I collated point for point in a text that was first published in a catalogue of the Galerie Bischofberger in 1965. Anything that didn't fit into this logical pattern I defined as 'Chrüsi-Müsi' or 'Zwitter-Schwitters', since his collages seemed to me very intuitive and 'beautiful' – that word was meant as an insult.

He seems to have wanted above all to demonstrate that rubbish can be turned into art: as for me, I was concerned with a gradual letting-go of the first principles of the 'snare picture', i.e. a move away from the exact fixing of a pre-existent situation, to produce a three-dimensional 'snapshot' of reality.

Later I was astonished to find things in these 'Zwitter-Schwitters' works that only after some time – after my stay in Simi in the Aegean – began to mean something.

Could it perhaps be said generally that the similarities between Kurt Schwitters and Daniel Spoerri are even more comprehensive, in the sense that you always aim to be active in as many artistic areas as possible? Schwitters not only made collages out of refuse but was also a writer, an advertising designer with his own 'Merz Advertising Headquarters'; a visionary of a new form of theatre with his *Merz Stage*, the organizer of 'Merz evenings' in which he declaimed his *Ursonate*, and the 'Merzer' of every place where he lived and worked.

I have been active in some areas not because I started out with a particular talent to draw and paint but first and foremost because I wanted to find out how I related to the rest of the world. I was interested in the *'why'* of our existence and am still looking

for an answer, and the solutions offered by religion are totally unsatisfactory to me. The only answer I have found so far to the question why we are here is: Because we are, in the same way a flower exists, and doesn't ask why but just blooms.

What moved or moves you to, as Kurt Schwitters put it, 'use refuse to scream with'?
Tinguely once invented the terms *Angstbekämpfungsübungen* [angst-controlling exercises] and *Gegenschmerzbilder* [anti-pain-pictures] to define my work. I once called it 'painting the devil on the wall'.

Tinguely apparently first saw photographs of Kurt Schwitters's *Merz Building* in Hanover shortly after it had been destroyed, when he was seventeen. After this, Tinguely maintains, no day passed without his thinking about it; he was totally 'beschwittered'. What was it about Schwitters, do you think, that impressed Tinguely so much?
Whether Tinguely already knew about Schwitters at the age of seventeen is for a specialist to say. But the fact that he started early with his mobile shop window decorations (as far as I know using gramophone players rotated to and fro by means of a string construction) is known by everyone who like me lived in Basel at that time. After all, a shop window is a stage, and he used it as such.
Also, Theo Eble and Julia Ris at the technical college had brought him into contact with the works of the Bauhaus, as I mentioned before. During these studies he is bound to have heard of Schwitters. Perhaps he also learned something about him from Walter

Bodmer; at any rate, his first wire sculptures were very strongly influenced by Bodmer, which the latter never forgave him even as an old man. But I can't imagine that Tinguely already knew about the *Merz Building* in the fifties. After all, only a few photos exist of the building to this day. Later, he frequently referred to the *Merz Building* (the *Cathedral of Erotic Misery*) into which Schwitters had transformed his home in Hanover before the Second World War, and he also mentioned that Schwitters's *Merzbühne (Merz Stage)* had been an influence.

Schwitters defined his installations, which consisted of sculptures, assemblages and collages and finally took over eight rooms of his house at Waldhausenstrasse 5 in Hanover, as the *Grosse Säule (Big Column)*, 1923–1936, *Kathedrale des erotischen Elends (KdeE) (Cathedral of Erotic Misery)*, *The Big E, Merz Building, Studio*. What are your thoughts and associations when you read these names?
Of all Schwitters's titles for his *Merz Building*, only one ever really fascinated me, and that was the *Kathedrale des erotischen Elends = KdeE*. In 1968 I made a strange little object using a complex mousetrap, in which the trapped mouse has to climb up a corridor which takes it to a chute into a tub of water where it drowns. I dedicated this object to a lady whose husband had recently had a fatal accident, and referring to Schwitters I called it: *KdeE* (see illus. 1).

There are only a few photos and mini-relics left from the *Merz Building* in Hanover and from descriptions by contemporaries and friends of Schwitters

who had seen it themselves. Along with the memoirs of the artist's son, Ernst Schwitters, these recollections served as a basis for a reconstruction by Peter Bissegger, which was begun at Harald Szeemann's suggestion and took shape between 1981 and 1983. What do you think of the idea of reconstructing a building from memories and fragments? 'Materialized memory' certainly plays a

Illus. 1
Daniel Spoerri
*Das Mously'sche Elend
(The Mousolynian Misery)*
Objects, wood, metal, wax, cloth mouse
45 x 35 x 10 cm
Courtesy of Thomas Levy Galerie, Hamburg

role in your *Chambre No. 13*. What were your reasons for the frequent self-quotations from *Chambre No. 13*?

The reconstruction of the *Merz Building* by Harald Szeemann and Peter Bissegger impressed me deeply, even if it doesn't exactly correspond with Schwitters's original realization.

I reconstructed my own room in 1998 after I was invited to do an exhibition in the Guggenheim Museum Downtown in New York which was called something like 'L'Espace de l'artiste'. It amazed me that my work of forty years could have started in such a tiny room, and I attempted to reconstruct these memories. When the work (stowed in thirty packing cases) was returned to me and rebuilt in my second workshop in Italy, I asked my bronze caster if he had the nerve to recast the whole room in bronze. When he agreed to do this at precisely the highest price I could afford, we dared to undertake the adventure. Last year we made a new version for the city of Ostend which I redesigned as an homage to James Ensor. (But I had already wanted to cast a room in bronze twenty years earlier. I had continually spoken about casting an unmade bed in bronze, but *it never happened*.) Still, even back in 1970, I had an original corner of the Restaurant Spoerri sawn out for me. (It was actually only a question of the sound-proofing panels.) This *Coin du Restaurant Spoerri* has meanwhile travelled all over the world, via San Francisco, Vienna, Japan, and last year it was shown in Saragossa in the exhibition 'to eat or not to eat' ('comer o no comer').

Was Schwitters's idea of the 'Merz Total Vision of the World' relevant to the ideas of the Nouveaux Réalistes, and if so, to what extent?

I don't know what Schwitters meant to the Nouveaux Réalistes. I think on the whole that he has still not been properly received in the Latin countries. It was only a few years ago that the first big Schwitters exhibition was shown in the Centre Pompidou in Paris. [7]

I still find it interesting to compare Schwitters's Merz Buildings with the 'Stations of Culture' made by Tinguely & Co. Are there in your opinion points of contact between projects like *Dylaby, Gigantoleum, Lunatour* and the *Head/ Cyclop/Monster* in the forest at Milly-la-Forêt?

I'm sure that Schwitters's knowledge and half-knowledge was an important impetus for us all. The 'Dylaby' above all (the Dynamic Labyrinth) was probably one of the first large exhibitions in an important museum (the Stedilijk Museum in Amsterdam, 1962), in which artists were allowed to realize their installations on the spot and even carry on working at night, and that is something for which we are still grateful to the museum director Willem Sandberg. Just think: the whole museum was open to us all night, and we could sneak off to look at the Malevitchs and Van Goghs which still hung there, since the night porters had orders to let us in at all hours. This happened mainly because Robert Rauschenberg got no further with his installation, since he was used to working only at night.

I had designed two rooms for this exhibition, a dark labyrinth you had to feel your way round and a whole overturned museum room in which you had to walk over the pictures (which of course were all bought at flea markets). But the finest room I remember was the Rauschenberg room, a moon landscape lit in blue-grey in which a crashed aeroplane wing rose out of the dust, and the hands of mysterious, large clocks turned visibly faster than normal. The blackish plants on the floor added to this impression, and the visitors were separated from the landscape by a wire mesh.

We must have derived a lot of this intuitively from the little we knew about Schwitters, which was enough to inspire us. When it came to concrete knowledge, we knew practically nothing.

It was a similar case with Marcel Duchamp. Apart from the moustache of *L.H.O.O.Q.* and his *Fountain* we knew almost nothing of his work. The *Large Glass* had not yet been critically analysed and the great wave of Duchamp literature had not yet engulfed us, but we sensed intuitively that these artists were our precursors and forebears, and we cherished and loved them without quite knowing why.

In the end it was a similar thing in our affinities to one another. After all, Tinguely had started as a shop-window dresser, Dieter Roth had been a graphic designer, Filliou a failed Third World researcher, Yves Klein a judo instructor and I had been a tourist guide in Paris before finding my way into a mediocre ballet that performed in small theatres.

And so we discovered one another by means of the same indefinable sixth sense with which we selected our ancestors.
January 2004

The questions were asked by Annja Müller-Alsbach.

1 Kunsthalle Bern, 7 April – 6 May 1956. The exhibition was planned by Werner Schmalenbach for the Kestner Gesellschaft in Hanover and later shown at the Kunsthalle in Bern, where Franz Meyer placed Schwitters's work in juxtaposition to that of Jean Arp.

2 The premiere was on Sunday, 1 December 1956 in the Kleintheater, Kramgasse 6, Bern, in celebration of Picasso's 75th birthday.

3 'Dada. Dokumente einer Bewegung', in the Karmeliten-kloster, Frankfurt am Main, October till December 1958. This was a touring exhibition that was first shown in the Düsseldorfer Kunstverein für die Rheinlande und Westfalen and after Frankfurt moved to the Stedelijk Museum in Amsterdam.

4 'Exposition Internationale du Surréalisme', Galerie Daniel Cordier, Paris, 15 December 1959 – 29 February 1960.

5 She was in fact not naked but was wearing a flesh-coloured body stocking.

6 The periodical *L'Esprit nouveau*, designed and published by Amadée Ozenfant and Le Corbusier, appeared from 1920 to 1925 in altogether twenty-eight issues.

7 'Kurt Schwitters', Paris, Centre Georges Pompidou, 24 November 1994 – 10 February 1995; thereafter 6 April – 18 June 1995 in the Instituto Valenciano de Arte Moderno in Valencia and from 16 September – 27 November 1995 in the Musée de Grenoble.

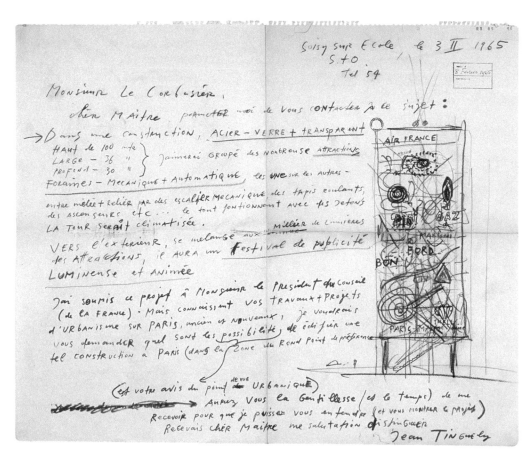

Cat. 216
Letter and sketch
of the *Lunatour* by Jean Tinguely
to Le Corbusier, 1965
Blue felt-tip and pencil on paper
46.1 x 55 cm
Fondation Le Corbusier, Paris

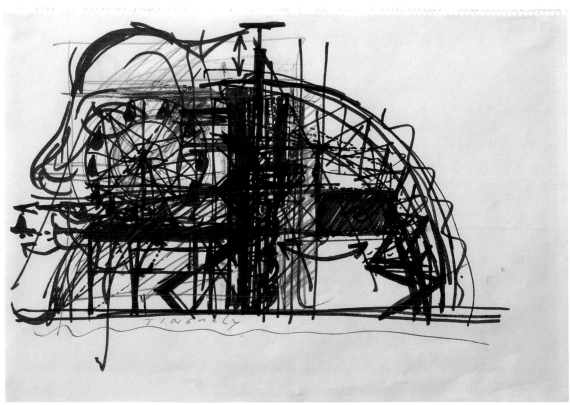

Cat. 218
Jean Tinguely
Gigantoleum
1968
Felt-tip on paper
29.5 x 42 cm
Private collection

Cat. 3
Merzbild 14 B Die Dose
Merzpicture 14 B The Box
1919
Assemblage and oil on wood
16.4 x 14.1 cm
Marlborough International Fine Art

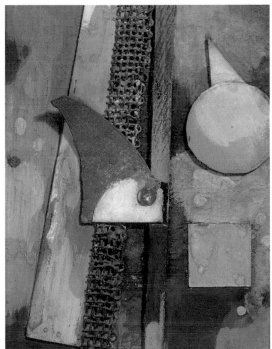

Cat. 47
Merzbild 35 A
Merzpicture 35 A
1921
Assemblage and oil on canvas
22.8 x 16.8 cm
Archiv Baumeister, Stuttgart

Cat. 46
Merzbild 14c Schwimmt
Merzpicture 14c Swims
1921
Assemblage, oil and gouache on
pasteboard and wood
15.8 x 10.8 cm
Private collection, Berlin

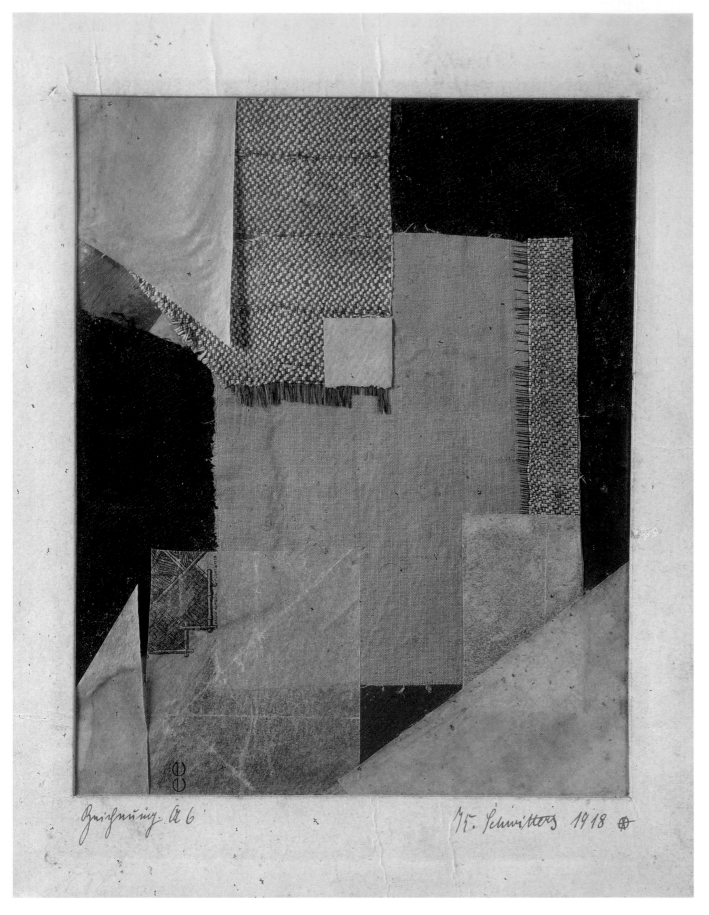

Zeichnung A 6

JK. Schwitters 1918

Cat. 1
Zeichnung A 6
Drawing A 6
1918
Collage on paper
17.8 x 14 cm
Private collection, courtesy of
J & P Fine Art, Zurich

Cat. 58
Mz 375 Caesar equus consilium.
1922
Collage on cardboard
15 x 12.4 cm
Von der Heydt-Museum, Wuppertal

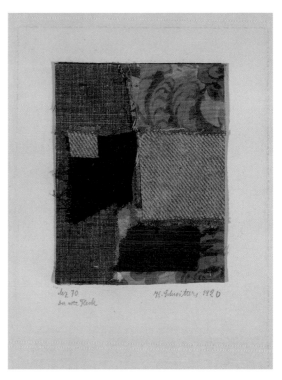

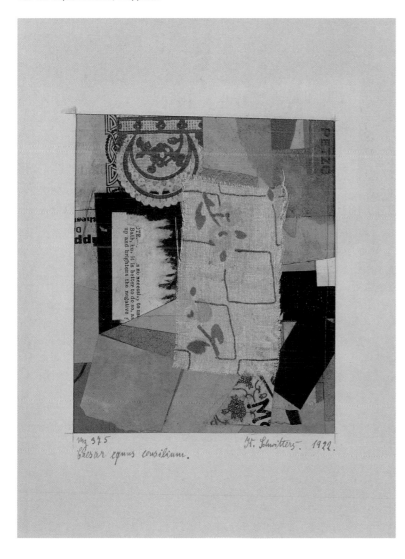

Cat. 31
Mz 70 Der rote Fleck
Mz 70 The Red Spot
1920
Collage and gouache on pasteboard
15 x 11.4 cm
Marlborough International Fine Art

Cat. 35
Mz 168. Vierecke im Raum
Mz 168. Squares in Space
1920
Collage on paper
17.8 x 14.3 cm
Private collection, Zurich

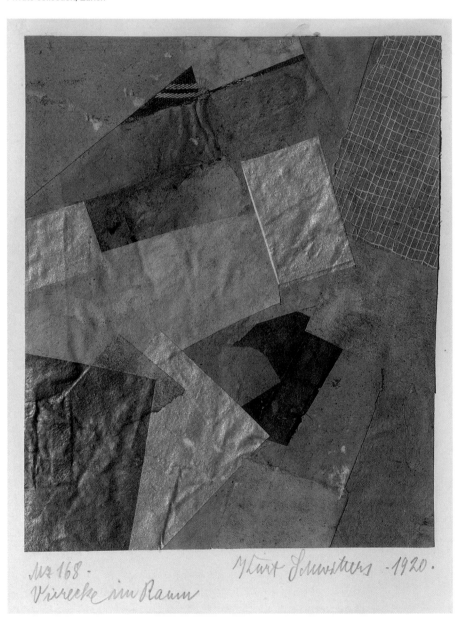

Cat. 2
Merzbild 1 B Bild mit rotem Kreuz
Merzpicture 1 B Picture with Red Cross
1919
Collage, oil and gouache on pasteboard
64.5 x 54.2 cm
Sammlung Deutsche Bank

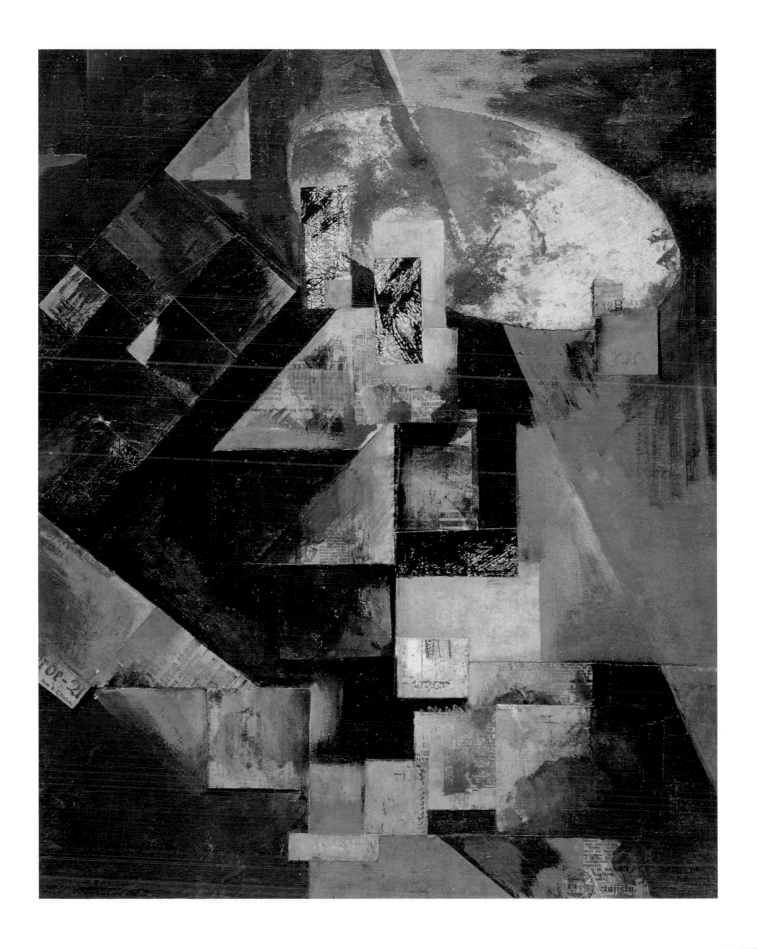

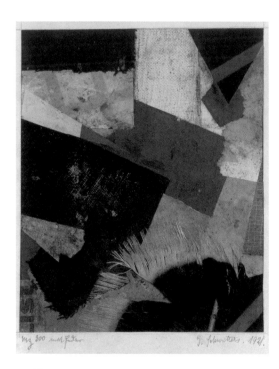

Cat. 55
Mz 300 mit Feder.
Mz 300 with Feather.
1921
Collage on paper
16 x 13 cm
Sprengel Museum Hannover,
Dauerleihgabe aus Privatbesitz

Cat. 54
Mz 258. Fünfrot – neu
Mz 258. Five Red – New
1921
Collage on paper
17.4 x 14.1 cm
Angela Thomas Schmid

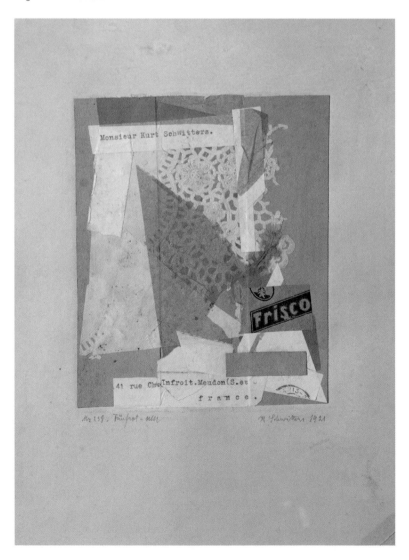

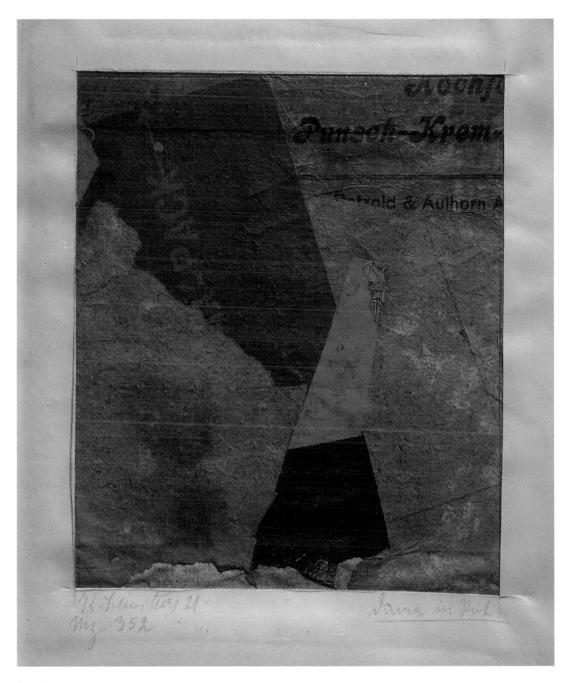

Cat. 57
Merz 352 Dame in Rot.
Mz 352 Lady in Red.
1921
Collage on paper
14.5 x 12.5 cm
Ubu Gallery, New York

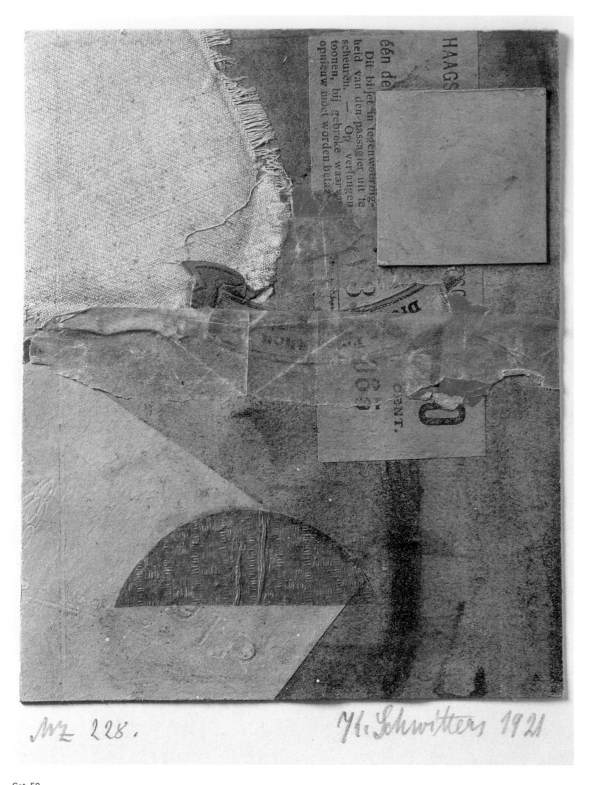

Cat. 50
Mz 228.
1921
Collage and chalk on paper
13.4 x 10.8 cm
Private collection

Cat. 33
Merzzeichnung 154 zart.
Merzdrawing 154 Tender.
1920
Collage and paint on paper
17.8 x 14.4 cm
Private collection, Switzerland

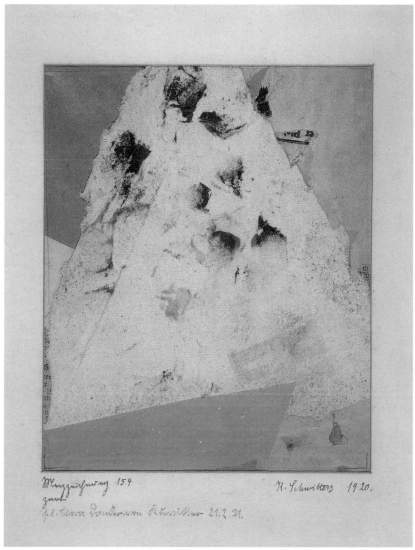

Cat. 102
29/25
1929
Collage on paper
14.5 x 11 cm
Private collection

Cat. 129
Ohne Titel (Vend!/Wenden!)
Untitled (Turn Over!)
1936 (?)
Collage on paper
21.8 x 17.7 cm
Marlborough International Fine Art

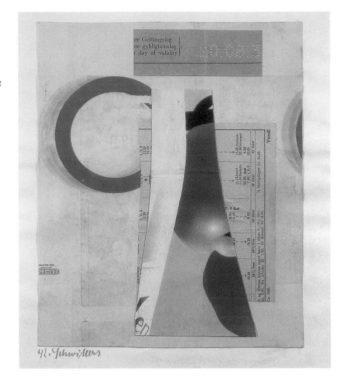

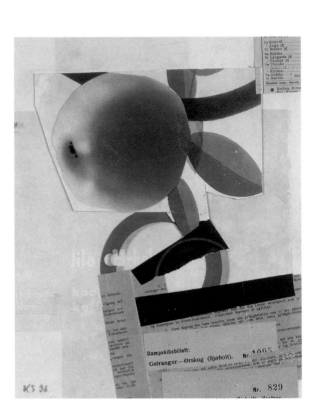

Cat. 128
Ohne Titel (Mit rotem Apfel
und grünen Blättern)
Untitled (With Red Apple and
Green Leaves)
1936
Collage on paper
23.3 x 18.7 cm
Kurt und Ernst Schwitters
Stiftung, Hanover

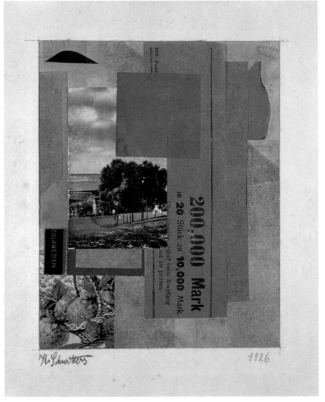

Cat. 86
Ohne Titel (Zigaretten)
Untitled (Cigarettes)
1926
Collage on paper
15.5 x 12 cm
Private collection, Houston

Cat. 132
Ohne Titel (Kleines Merzbild
mit Papierblume)
Untitled (Small Merzpicture with
Paper Flower)
1938
Relief, metal and paper on wood
26 x 19 cm
Ahlers collection

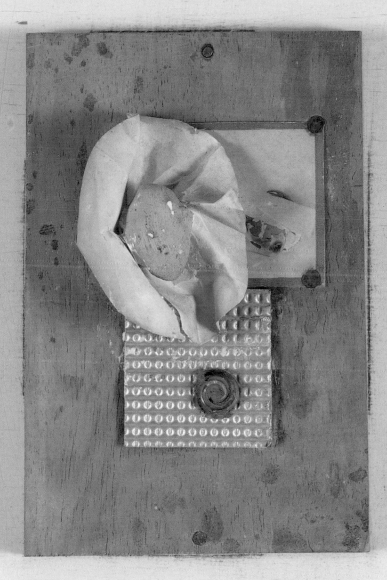

KS 38

Cat. 118
plastische Merzzeichnung
Plastic Merz Drawing
1931
Relief, oil, pasteboard and wood on wood,
nailed together
19 x 15 cm
IVAM, Instituto Valenciano
de Arte Moderno, Generalitat Valenciana

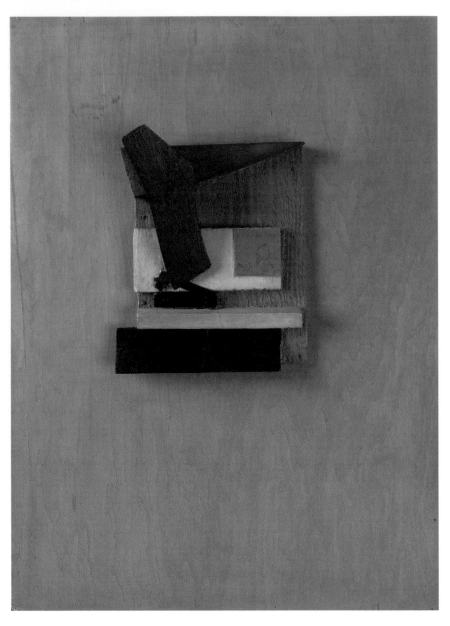

Cat. 136
Ohne Titel (Merzbild Rosa Gelb)
Untitled (Merzpicture Pink Yellow)
1943
Relief, oil, wire, twigs and wood on woo[
34.1 x 26.5 cm
Kurt und Ernst Schwitters Stiftung,
Hanover

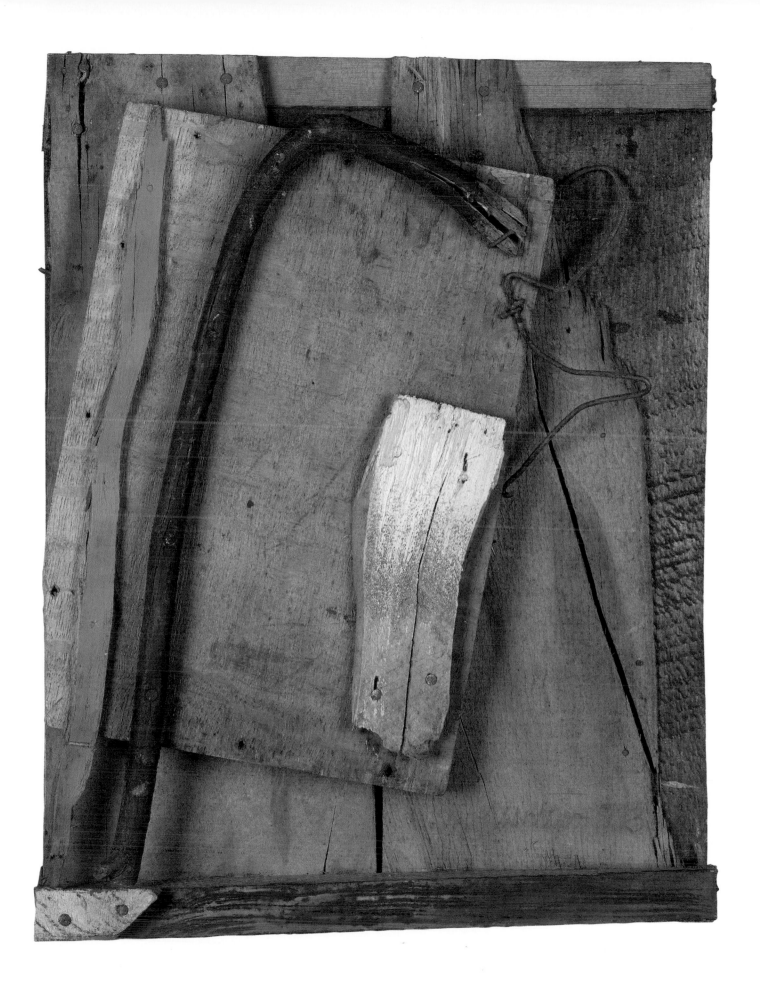

Cogs and Wheels Christoph Bignens

Kurt Schwitters, the Hanoverian artist, literary figure, word acrobat, typographer and theoretician, adapted the pseudonym 'Merz', which derives from the German word *Kommerz* [commerce]. It is as short as the term Dada but can still be distinguished from it. Schwitters shared along with the Dadaists and other avant-garde artists and architects the belief that the level of tension in society had never been so high.[1] And in fact after the First World War – the first large, mechanized war – there were enough political, economic and cultural reasons to see the world as being as impenetrable as the inner workings, the cogs and wheels, of a huge machine. In industry, a phase of mechanization and rationalization had begun. The innovation came from America, especially after Henry Ford had installed his assembly lines. Europeans, barely making do, pricked up their ears when Ford claimed that, by making modern conveniences affordable, he could turn the world into a 'pleasant playground of life'.[2] Advertising, as is well-known, is the only medium that can make such bold statements seem true. Sales volumes increased rapidly in step with the increasing supply of mass-produced goods. And yet, despite the material temptations, opinions differed in the still young Weimar Republic when it came to the question 'Ford or Marx'.[3]

It is in this social turmoil that the Dadaists and Kurt Schwitters, who was a commercial artist, lived and worked. Merz wanted to convert things, to resolve contradictions and redistribute focal points.[4] Marx, Lenin and Ford would have subscribed to these goals because they too sought to change the world, each in his own way. Also acceptable to the two revolutionaries and the American auto-

mobile manufacturer would have been the passage in the *Manifest Proletkunst* [Proletarian Art Manifesto] written in 1923, in which Schwitters, Theo van Doesburg, Hans Arp, and Tristan Tzara declared that they wanted to release mankind from the tragedy of life.[5] Only when the authors of the manifesto announced that artists were neither proletarians nor bourgeois because they wanted to change the world with their creativity alone, did they part company with the three famous social utopians.[6] Whether the statements expressed in the manifesto were every actually realized can be verified, for example, by viewing the work of Jean Tinguely or the Pop Artists. Tinguely's cheerfully rotating iron sculptures, many of which can be viewed in public places, certainly contribute to the continually growing popularity of the creative recycling of refuse à la Schwitters (see illus. 1 and 2).

It seems that Hannah Höch, who was a friend of Schwitters, had the strongest urge to depict the tension of the times. Her large photo montage *Schnitt mit dem Küchenmesser Dada durch die letzte Weimarer Bierbauchkulturepoche* [Cut with the Kitchen Knife] was completed two years after the Russian Revolution and only a year after the First World War and the fall of the German Empire. Hannah Höch 'assembled' people between aeroplanes, rifles, ball bearings, machines, tires and sprockets without giving them firm ground to stand on – in Germany, at the time, there was practically none. The artist addressed the pressing question, 'Ford or Marx', by pasting a view of Wall Street on the left and the heads of Lenin and Marx on the right. In the middle she positioned Walter Rathenau, right next to a large ball-bearing

Illus. 1
Kurt Schwitters
Neues Merzbild
New Merzpicture
1931
Assemblage and oil
86 x 113 cm
Museumsinsel Hombroich, Neuss

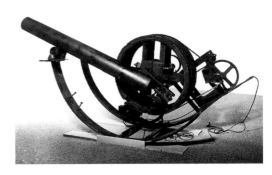

Illus. 2
Jean Tinguely
Bascule No. 7
1967
Iron, wood and electric motor, painted black
122.5 x 204.5 x 82 cm
Museum of Fine Arts, Houston

Cat. 26
Ausgerenkte Kräfte.
Disjointed Forces.
1920
Assemblage and oil on pasteboard
93.5 x 74 cm;
105.5 x 86.7 cm (original frame)
Kunstmuseum Bern,
Sammlung Max Huggler –
Gift 1966

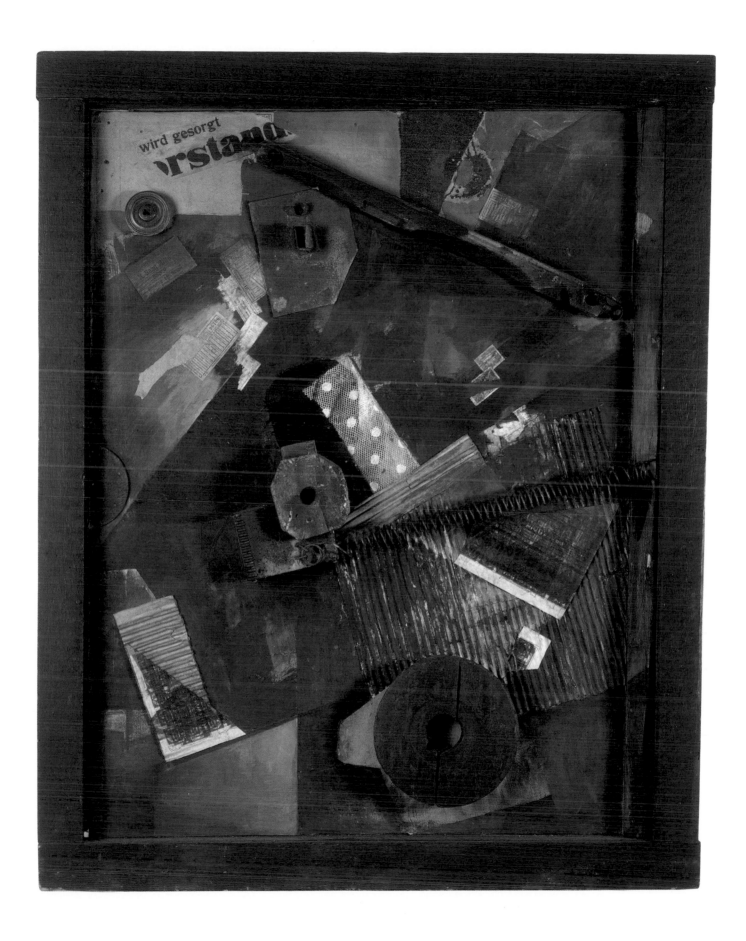

that rolls threateningly towards Wall Street. The abrupt confrontation of the ball-bearing with Rathenau, the influential Berlin industrialist, social philosopher, and politician, fits perfectly with the slogan that he published for his contemporaries: 'Acceleration, exactness, reduction of friction, uniformity of types, labour savings.'[7]

These are the catch phrases that circulated rapidly at the time in the progressive circles of trade and industry, and architecture. They can also be found in two contemporary publications on modern typography that include works by Schwitters.[8] An artist who, like Schwitters, designed for the Reichs-forschungs-Gesellschaft für Wirtschaftlichkeit im Bau- und Wohnungswesen [Reich Research Society for Economical Building and Housing] a brochure with a title typical for the times – 'The Inexpensive, Quality Flat'[9] – could not fail to hear all the buzz about economic reform, triggered by the ideas of Taylor and Ford. Schwitters's pseudonym 'Merz' proves it.

A considerable number of Schwitters's montages, collages and drawings show circles, wheels and round stamps. Since many of them also contain text fragments pointing in every direction, one is tempted to rotate his works like wheels so as to make every message readable. A single viewpoint, from which everything can be grasped, does not exist in advanced forms of civilization – nor in Merz art. A quick orientation is also hindered by the visual restlessness radiating from the many small pieces of the collages. The Dadaists were not interested in providing orientation aids; to the contrary, their collages cried to their viewers: 'Dada is victorious!' 'Join Dada!' or in connection with the grand inflation: 'Invest in Dada!' It seems that Schwitters was mischievously recommending himself as an investment advisor when he adopted the name Merz and included bank notes and numbers over and over again in his collages. Schwitters came from a middle-class family. His parents had first run a business for women's clothing before they were able to live from the income of their property. Dealing with numbers is the requisite know-how for such professions.

Mills, Machines and Watches

The cogs and wheels in mills, machines and watches are dynamic, not static. In this respect they resemble avant-garde art in the age of machines. An avant-garde art magazine published in Cologne was called *Ventilator* because it strove to generate a fresh breeze in the stale and seemingly static culture of the time. On the artist's path to the wheel and machine motifs, Schwitters passed by many a wind mill and numerous coffee grinders, as is seen in several of his drawings. Wind mills were a favourite motif in the paintings of Vincent van Gogh, even Marcel Duchamp had drawn some in his early years – and coffee mills? Duchamp proved to be the pioneer of 'machine art', when, in 1911, he painted a commercially well-known coffee grinder. His interest in the simple kitchen machine was directed in particular at the rotation of the handle or crank, which he interpreted as the daily, monotonous 'cranking up'. When Schwitter's put coffee mills in his drawings, he was, however, more interested in the fact that mills can transform solid materials into homogenous powders. Exactly as his motto prescribed: Merz wanted to convert, reconcile and redistribute. Other examples of such redistributing

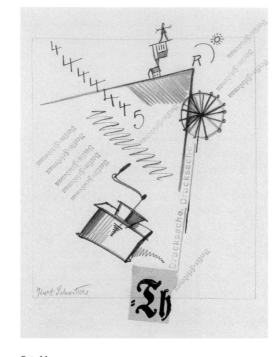

Cat. 11
Ohne Titel (Mit Kaffeemühle)
Untitled (With Coffee Grinder)
1919
Collage, stamp paint, lead and coloured pencils on paper
32.5 x 24.3 cm (sheet)
Kurt und Ernst Schwitters Stiftung, Hanover

Illus. 3 a–c
Kurt Schwitters
3 revolving typographic logos from
Merz 1. Holland Dada and
Merz 2. Nummer i, 1923:
a) 'Dada-Mill' für *Merz 1. Holland Dada*;
b) contrary rotation 'Merz',
c) clockwise and anticlockwise rotation 'Merz'

Illus. 4
Page 3 from the fairy tale
Der Hahnepeter by Kurt Schwitters,
illustrated by Käte Steinitz, 1924

devices are the metal funnels used to pour fluids from one container to another, which Schwitters occasionally integrated into his drawings and montages. A certain fascination with alchemy has been rightly attributed to the artist from Hanover.[10] Alchemy is an ancient theory of the balanced mixing of various materials. It was used, among other things, to transform a less valuable material into a valuable one. The most famous form of alchemy is the imitation of gold. A parallel to the Merz principle, which transforms refuse into art, is clearly evident.

Later in his work as a typographer, Schwitters created a wind mill using the lead letters from a type-case. 'Holland Dada', the theme of the first issue of his magazine *Merz*, provided the impetus. Between the four stylized propeller blades he placed DA-DA-DA-DA as if they were gusts of wind driving his Dutch typographical mill (see illus. 3a–c). Exactly this goal – to start up Dada in Holland – had been the aim of his tour through Holland with Theo van Doesburg shortly before. Under a drawing of a wind mill we read: 'I mill, you mill, he mills.'[11] (see illus. p. 154) The typographical mill is precisely the logogram for this persistent rotating movement.

On his tour of Holland Schwitters compared the grinding of the mills with the process of civilization when he wrote: ' When for example I ride by the lyrical wind mills in my first-class express train and below me a young fellow is spreading manure and above us the post flies through the air, then that is really tension. I'm sending a telegram to my new impresario in Northern America from a moving train while a little dog barks at the moon.'[12] The short note grinds so to speak

the coarse grains of modern civilization – America, train, aeroplane and telegram – with the values of traditional culture – dog, manure, moon and mill – to a homogenous, fine flour. In this case alchemists would have referred to the transformation of a solid state into a supple one.

In Dadaism even animals show traces of the mechanization intensely promoted by industry. Thus a Dadaistic cock only crows 'good day' when its propeller-like tail feathers are driven by its wind-up key. The cock referred to here is *Hahnepeter*, Schwitters's fairy tale of the same name, illustrated by Käte Steinitz (see illus. 4).[13]

Dada and Merz by no means turned down the volume of the noise of civilization, which the technologically enthusiastic Futurists in Italy had discovered for art. A clamour of shouting can be heard coming from Dadaistic collages. Horns and exclamation points ensure that the voices do not get lost in the ubiquitous noise of civilization. The reasons for the acoustic change are clear: sooty factories like the ones Schwitters drew in 1918 (see illus. 5). To make the noise of their machines and sirens visible, he used the dramatic-dynamic style of the futurists. As shrill as Hannah Höch's photo montage *Cut with the Kitchen Knife* incessantly cries 'da-due-dada!' so one day it was actually heard from Jean Tinguely's acoustic iron sculptures.

Coins, wheels and clocks are round so that they can be made to roll and run. At first glance the difference between a wheel with missing spikes and a clock with three hands is minimal. Schwitters cultivated this fluid transition. Almost without noticing it, his

clocks turn into wheels and vice versa. When he combines circles or wheels with straight lines, he creates the impression of machines with levers, connecting rods and transmission belts (see illus. 6). If aggressive shapes with acute angles are added in colours of red and yellow, then Merz art glows, rotates, thrusts, and pulls as it once did in Adolph Menzel's fantastic *Eisenwalzwerk* (Iron Rolling Mill) from 1875, one of the first and most imposing paintings of an industry.

If the naked young lady were not part of the picture, the viewer would without hesitation connect the Merz collage *Mz 239. Frau – Uhr (Mz 239. Woman – Watch)* (see illus. 7), 1921, with the expression 'time is money'. The hand of a large man jutting out into the picture from a white shirt and dark suit holds an open pocket-watch in such a way that the charms of a recumbent pin-up girl remain clearly visible. At the cuff of the sleeve there is another important message to be read: 'gold'. The motto 'time is money' [the German for money is *Geld*] can be traced to Benjamin Franklin, who once advised a businessman never to lose sight of the clock while working.[14]

In 1913 Frederick Winslow Tayler, a countryman of Franklin, developed this idea into a business theory for all work done in the office, factory and household. In Germany alone his *Principles of Scientific Management* sold in a short period 18,000 copies.[15] In his day Taylor beat the time that he wanted to have checked with a stop-watch. Merz and Dada responded to this new rhythm with, among others, the clock as motif.

Charlie Chaplin, whom Schwitters admired greatly,[16] brought the subject of the machine age to the cinema with *Modern Times* in 1936. The film begins with loudly pounding music, and beneath a large clock workers are rushing to a factory. The film culminates in a scene in which Chaplin is caught by the wheels of a gigantic machine and is pulled downwards. The reference of Schwitters's collage *Woman – Watch*, 1921, to industry and commerce is the one aspect; the second is the reference to alchemy and to contemporary art. The alchemist Schwitters once again proved with this collage that he could transform ordinary pictures and texts from the press into 'gold'. In contrast, Marcel Duchamp and Francis Picabia had already succeeded in giving artistic expression to eroticism, mechanics and tempo. *Woman – Watch*, 1921, also unites these themes as does the eroticizing *Gliederpuppe* [Jointed Doll] (see illus. 8) of the Basel painter Niklaus Stoecklin and later Jean Tinguely's provocative mannequin, alias *Dissecting Machine* (see illus. 9). The *Merzbau (Merz Building)*, originally entitled *Cathedral of the Erotic Misery (CEM)*, is Schwitters's most personal and largest work. Over a period of years he transformed his apartment in Hanover into a kind of cave system using fitted components and found elements. Dolls and gold were part of this collection of curios.[17]

Between the two world wars, most avantgarde architects, artists, and typographers thought highly of engineers, primarily because engineers never saw themselves as artists. As constructors they designed products that were without decoration, 'style-less', and non-artistic. Thus Theo von Doesburg, the Dutch pioneer of a constructive and non-subjective art, was to name his avantgarde magazine simply *Mécano* and repro-

Illus. 5
Kurt Schwitters
Z 50 Heulende Fabriksirenen
Z 50 Howling Factory Sirens
1918
Charcoal on paper
16.3 x 11 cm
Kurt und Ernst Schwitters-Stiftung, Hanover

Illus. 6
Kurt Schwitters
Das Kreisen (ehemals Weltenkreisen)
Circling (formerly Planetary Orbits)
1919
Assemblage, oil on canvas
122.7 x 88.7 cm
The Museum of Modern Art, New York, Advisory Committee Fund

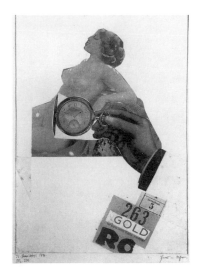

Illus. 7
Kurt Schwitters
Mz 239. Frau-Uhr
Mz 239. Woman-Clock
1921
Collage on paper
31.2 x 22.2 cm
Private collection

Illus. 8
Niklaus Stoecklin
Gliederpuppe
Jointed Doll
1930
Oil on canvas
56.5 x 46.5 cm
Private collection

duce in it works by Schwitters as well as a machine from the catalogue of an Italian factory (see illus. p. 128 right and illus. 10). Only the caption under the machine clarifies Van Doesburg's aesthetic interest in anonymous technology: *'Plastique moderne de l'ésprit italien'* – modern sculpture in the Italian spirit. The term 'readymades' has been used ever since Marcel Duchamp smuggled everyday commercial objects, unchanged, into the art scene. The work of artists who merely assemble something that already exists became comparable with that of mechanics.

Jean Tinguely obscured the borderline between artists and engineers in a humorous manner when in 1959 he patented his machine of wheels and iron wires that draws and paints. [18] It was also Tinguely who transformed 'machine art' by integrating the electric motor in his works. If one considers the enormous importance that electricity has as 'white coal' in the history of civilization, then the introduction of the electric motor in modern art is only logical. That it was an artist from Switzerland who took this decisive step is not a coincidence. We all know that his homeland, a country of high mountains, is richly endowed with water. Its turbines and power plants were once admired around the world. As one of the future vanguards of modern architecture, Le Corbusier observed the construction of a large water power plant with his own eyes and thereafter praised it in the highest tones as a wonder of modern civilization (cat. 208, see illus. p. 116). [19]

Rotating and Regenerating

The Dadaists were not interested in adding on another style to the long series of existing art styles. That is why Hannah Höch called

out in her above-mentioned photo montage: 'Hey, hey, young man, Dada is not an art trend!' This rejection also meant a rejection of personal expression in painting, which until then had always been paramount. Personal expression is lacking in so many of their collages and photo montages because the images and texts, which were cut out of printed matter, are anonymous. Typesetting and printing machines destroy the aura of the unique. Dadaism and Pop Art discuss the levelling effect of mass media and advertising. Schwitters was not the only artist in Hanover who did this; there was also Alexander Dorner, who in 1923 had taken over as head of the Niedersächsisches Landesmuseum in Hanover. During his career he promoted an art form which, because it was no longer subjective, was able to attract a wide audience. [20]

Schwitters deviated from this objective principle in collages and assemblages that he painted 'in a subjective manner'. Among the artists who, like Schwitters, worked as commercial artists and typographers, there were many who cultivated an anonymous form of expression. [21] In Schwitters's generation the most well-known are El Lissitzky and Friedrich Vordemberge-Gildewart, later Max Bill, Richard Paul Lohse, and Andy Warhol. [22] Schwitters, El Lissitzky, and Vordemberge-Gildewart all designed advertisements for Günther Wagner's office supply company. A selection of their graphic work can be found in *Gefesselter Blick*, a book published in 1930, which also includes early typographical compositions by Max Bill. The book's publication is due primarily to Kurt Schwitters and some representatives of the Swiss avant-garde, with whom the Hanoverian was in close contact at the time. [23] All these artists had their

Illus. 9
Jean Tinguely
Dissecting Machine
1965
Shop mannequin, saws, drills,
electric motors, painted black
185.5 x 188 x 200 cm
The Menil Collection, Houston

creative outlet in art and their financial basis in advertising. Moving from one to the other sphere was achieved with such ease that it was not always possible to determine what sphere they were currently working in. Americans refer succinctly to this characteristic phenomenon of the 20th twentieth century – nimbly jumping from one level to the other – as 'high & low'.[24]

The texts in Schwitters's artistic *oeuvre* are usually multilingual, likewise his magazine Merz, which he designed and edited between 1923 and 1932. A cosmopolitan stance was not a matter of course during this period of national isolation in Europe after the First World War.[25] If, in order to understand the language in Merz art better, one filters out the individual text fragments in the Merz collages, then, quite literally, a single, long sentence remains. The shorthand symbol 'Kuwitter' that Kurt Schwitters adopted prompted the following compilation of his linguistic utterances. Reading the sentence is worthwhile despite its clumsiness:

'Hansi-Schokolade' / 'Drucksache' / 'Berlin-Friedenau' / 'Keine Nervosität mehr' / 'Fahrkarte' / 'Rossfett' / 'Handwaschpulver Haarwasser Zahnpulver' / 'Cigarren u. Tabake' / 'Kunst-Honig' / 'Cigarren-Import Carl Weiland' / 'Frachtbrief' / 'Last-Autos' / '2e Klasse' / 'Frauenberufe' / 'Sämischgares Rindsleder' / 'Hundehalsbänder' / 'Rabatt Marke' / 'Marka Polska' / 'Bezugsschein' / 'Nabel' / 'Gauloise' / 'Internationale Hygiene-Ausstellung Dresden' / 'Städtische Strassenbahn Dresden' / 'Soap Lenox Reg. US. Pat. Off'. 'Amerika ist angenehm berührt' / '3 Pf.' / 'Gedankenvoll liess Viktor das Blatt sinken' / 'Kirchen' / 'Qualität sehr fein' / 'Manoli Diva' / 'Gold' /

'Herrenhäuser Kronenbier süss' / 'Cacao- und Schokoladenfabrik' / 'Alleiniger Lieferant' / 'Preis' / 'Jedes Einfach' / 'Prima Schuh-Riemen 100 cm' / 'Blume' / 'Strassenbahn Hannover' / 'Goethe' / 'Chocolade' / 'Tafelsalz' / 'Bismarck' / 'Was jeder Sattler noch wissen muss' / 'Gebrauchen Sie eine Neuenahrer Hauskur!' / 'Schokolade' / 'pull straight until the red cross' / 'Ueberall zu haben — noch ist es nicht zu spät' / 'Technisch Bu' / 'Miss Blanche Quality Fine Surfine Price' / 'Cigarettes Turkish Tobacco' / 'Geld' / 'Kirschbild' / 'Haagsche Tram' / 'Underberg' / 'Achten Sie beim Einkauf auf die Marke Pelikan' / 'Buchheister's Woll-Kenkratzer' / '250 Gramm' / 'Orlog' / 'Dessauer Strassenbahn' / 'Friedr. Baurm ... Fabrikanten' / 'Händeklatschen' / 'VAT 69' / 'More Milk' / 'Difficult' / 'Firestone' / 'Bahlsen Keks-Fabrik' / 'Tänzer' / 'dieser elegante Tanzschuh' / 'Magistrat der Hauptstadt Hannover' / 'portopflichtige Dienstsache' / 'Pino Antoni Esportazione Arance Paterno' / 'Qualit' / '40 Pf.' / 'Garantie Büchsenöffner' / 'Camel' / 'Viking Melk' / 'Everybody's hungry for' / 'A difficult B by Elizabeth' / 'Four tempting ways to give your child "More Milk"' / 'artin finest' / 'Bird's Custard and Jellies' / 'Petit Gruyère Gerber Emmentaler' / 'Pure rich milk – Natures finest food – good for young & old' / 'Pralinen – coffee – burnt almond' / 'prize crop' / 'Dr. Scholl's foot comfort' / 'Stephen Mitchell & Son Glasgow' / 'These are the things we are fighting for' / 'Sparkling' / 'Directions: as a beverage – as a sandwich-spread'.

Is this torrent of words, the dream of an advertising specialist, a dream that Schwitters could have had after a particularly intense working day in his Hanover Merzwerbezentrale (Merz Advertising Headquarters)

Cat. 108
Ohne Titel (Relief mit drehbarer Glasscheibe)
Untitled (Relief with Rotatable Glass Disc)
1930
Relief, wood and glass on wood
25.5 x 17.5 cm
Staatliche Museen zu Berlin, Nationalgalerie

(cat. 121, see illus. p. 117)? Leopold Blum, the famous advertising specialist in James Joyce's *Ulysses*, published in 1922, definitely had dreams like this. But what does this conglomerate of language say about the then state of civilization and Merz art? Initially the large number of heterogeneous messages most certainly generates an impression of frantic activity. This is intensified optically in the collages by the unrest that radiates from the numerous small bits and pieces that make up the compositions.

In terms of content, the sweet and salty snacks, milk drinks and fruits that appear in the Merz collages befit the life style then, shaped as it was by bureaucratization, industrialization and urbanization, just as today's appetite suppressants, chips, energy and chocolate bars are a suitable accompaniment for jogging and TV watching. The many numbers, tickets and scraps of words from the commercial and advertising world, which, moreover, were pasted on, strengthen the impression that Merz was ironically commenting on a mechanistic world driven by commerce. The frequent appearance in Merz art of alcoholic drinks and tobacco must be seen within the 'mechanized' system of happy hours after work – similar to the tea, biscuits and dancing that always followed the lectures held in the Schwitters's home as part of the 'Merz evenings'.[26]

Friedrich Nietzsche anticipated central themes of Dada and Merz when he wrote in 1881: 'There is [...] something of the ferocity peculiar to the Indian blood, in the American lust for gold; and the breathless haste with which they work – the distinctive vice of the new world – is already beginning to infect old

Europe with its ferocity [...] Even now one is ashamed of resting [...] One thinks with a watch in one's hand, even as one eats one's midday meal while reading the latest news of the stock market.'[27] By constantly referring to alcoholic drinks, sweets and tobacco in the colourful collages and assemblages of Merz art, a connection is established between the delicacies of taste and the pleasures of sight. The punched paper doily that Schwitters occasionally pasted in his collages and were actually used by manufacturers as an underlay for cakes and pies also contribute to this effect (see cat. 54, illus. p. 100).

With respect to its subject matter, the Merz object *Schokoladekasten Anna Blume* makes an excellent companion piece to Marcel Duchamp's painting *Chocolate Grinder*, which is only a few years older. The delicacies served up in Merz art even had a tempting effect on the artists of the next generation. Later Dieter Roth was to come up with objects made of chocolate, Daniel Spoerri with Eat-Art, Wayne Thiebaud with paintings of pies and other sweets and Claes Oldenburg with fast-food made of polyester, just to mention a few. In all these works the artist is dealing with a form of pleasure which dovetails nicely with the loss of time brought about by modern civilization.

If one believes the collages, then it seems Schwitters shared with Raoul Hausmann a preference for elegant (American) shoes worn by managers, the then newest profession. Photos show Kurt Schwitters elegantly dressed and his hair well-groomed. In his grey pin-striped suit one might well have assumed that he had an executive position in the commercial sphere. Jean Tinguely and

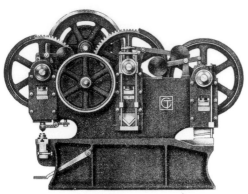

PLASTIQUE MODERNE DE L'ESPRIT ITALIEN

Illus. 10
'Plastique moderne de l'ésprit italien',
from *Mécano*, ed. by Theo van Doesburg, no. 1, 1922

Cat. 208
Jean Tinguely
Élément Détaché I
Relief méta-mécanique
1954
Steel tube frame, steel wire,
12 differently shaped cardboard elements,
all painted white, 110 V electric motor
81 x 131 x 35.5 cm
Museum Tinguely, Basel

Illus. 11
Kurt Schwitters
*N. Aquarell 1. (Das Herz geht
vom Zucker zum Kaffee)
N. Watercolour 1. (The Heart Goes
from Sugar to Coffee.)*
1919
Watercolour and pencil on paper
30.2 x 22.3 cm
The Museum of Modern Art, New York,
gift of Richard Deutsch

Cat. 121
*Ohne Titel (MERZ WERBEZENTRALE)
Untitled
(MERZ ADVERTISING HEADQUARTERS)*
1934
Collage on paper
20 x 12.4 cm
Kurt und Ernst Schwitters Stiftung, Hanover

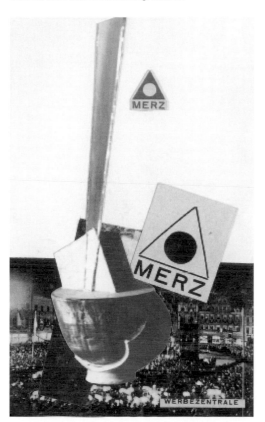

Andy Warhol, in contrast, preferred to wear an outfit that always identified them as artists.

A Merz drawing from 1919, influenced by Cubism, is entitled *N. Aquarell 1. (Das Herz geht vom Zucker zum Kaffee) (N. Watercolour 1. [The Heart Goes from Sugar to Coffee.])*, 1919 (see illus. 11). A man's hand extending from a suit reaches for a coffee pot on a table. There is also a sugar bowl with hearts printed on it as well as circles, segments of circles, and something like a clock. At the top an arrow guides the viewer's gaze from the sugar to the coffee. Below a small male figure takes over this task. A finger points to a '69', the Whisky brand VAT 69. If this is a reference to the 'eternal' cycle of rotation and regeneration, then the Scottish drink is the remedy for slowing down the pulse that has quickened over the course of the day.

The stimulants shown in Merz art are well suited to Schwitters's ideas because in his view art's task was to provide viewers with a diversion from their daily trials and tribulations.[28] Of course, we all know that advertising for beer, cigarettes, biscuits, chocolate, and spirits uses to this day exactly the same argument. As a typographer who designed the printed matter for the Dammerstock housing tract, Schwitters was also aware of other possibilities of regeneration. He praised, for example, the modern buildings of this sub-division for their 'healthy living, light and sun [as well as] functional furniture'.[29] For years Kurt Schwitters was in close contact with the head architect of the settlement, Walter Gropius, the great pioneer of functional and economic building.[30]

Merz used two design methods at the same time: as a graphic artist he relied on the ordering principle of New Typography[31] and as a creator of montages on the spontaneous principles of Dadaism. In this respect Schwitters is quite different than other artist-typographers. Max Bill and Richard Paul Lohse, for example, were strongly committed to controlled composition and thus to visual order in both their artistic and typographical work. The difference is astounding when one considers that the Hanoverian as well as the artists from Zurich drew to the same extent on the rigorously ordered compositions of the Dutch and Russian avant-garde. The numerous pointing hands and arrows in Schwitters's artistic and typographical oeuvre alone suggest these two different design principles. If one, on the other hand, examined concrete examples of the advertising work of Schwitters,[32] Bill,[33] and Lohse,[34] which in many cases is surprisingly similar, one would come to the conclusion that the designs of all three artists are particularly suitable for a furniture company.

Schwitters's mixed methods of alchemy provided the impetus to return to VAT 69. The two Merz collages *Untitled (Difficult)* (see illus. 12), circa 1942/43, and *Ohne Titel (H. BAHLSENS KEKS-FABRIK AG) (Untitled [H. Bahlsens Keks-Fabrik AG])*, 1930 (see illus. p. 133), are in optical terms truly agitated. At first glance *Difficult* is reminiscent of aerial photographs of Manhattan, a city which some Europeans experienced on their first visit as a capitalistic Babylon.[35] Over what appears to be skyscrapers Schwitters placed a double-decker and below where the Manhattan ravines turn to asphalt, he pasted on an automobile tire of the American brand Fire-

stone. At the very top – and on a symmetrical axis! – the brand VAT 69 crowns the image as if everything good was to come from above. Yet below pasted next to the automobile tire is the fragment of a pie doily. Amongst all the hectic emanating from the image, the doily seems to be the signal for a break, for which coffee and cake have been prepared. Tom Wesselmann, the American Pop artist, was to use such morsels, spirits and tobacco again in his collages to evoke moments of relaxation.

In the Merz collage *Bahlsen* the viewer seems to stand directly in front of a machine that is making noises but does not rotate as desired. The large, iron lever on the right of the picture, which looks like a fist with a club, invites the viewer to turn off the apparently malfunctioning machine and call a mechanic. The immediate proximity of a shining metal wheel to the name 'Bahlsen' – a cookie manufacturer – presents in an impressive manner the simultaneous aspect of perception, which is so typical for the age of mass production and mass communication. Just as the computer today shows in a flash what step is to be taken next so, in response to the word 'Bahlsen', the machine shoots out the yellow little bar with the printed message 'biscuits'. [36]

The twentieth century is the first century to have hazardous waste, multi-component sites for collection, and the separate disposal of waste and recycling. It appears almost as if at the beginning of the last century an agreement was made between industry and art to the effect that all waste should be recycled. As artists began, namely, around 1912 to paste found objects in their pictures, far-sighted industrialists called for the collection and recycling of waste. [37] Merz art and its 'scraps of daily waste' [38] introduced the transformation of valueless into valuable, from 'low' into 'high' into galleries and museum. Schwitters was well aware that in this connection his art would influence the art of the future. [39]

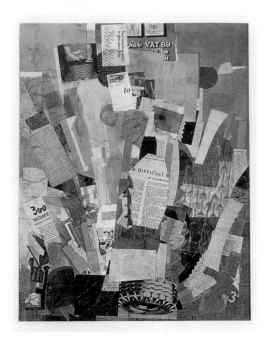

Illus. 12
Kurt Schwitters
Ohne Titel (Difficult)
Untitled (Difficult)
1942/43
Collage on paper
79.5 x 61 cm
Albright-Knox Art Gallery, Buffalo, New York,
Gift of The Seymour H. Knox Foundation Inc.

1 Kurt Schwitters, 'Dadaismus in Holland', *Merz 1. Holland Dada* (1923), p. 5.

2 Henry Ford, *My Life and Work*, London 1923. See also, among others, Peter Berg, *Deutschland und Amerika 1918–1929: Über das deutsche Amerika-Bild der zwanziger Jahre*, Lübeck 1963, and more recently Christoph Bignens, *American Way of Life: Architektur, Comics, Design, Werbung*, Sulgen 2003.

3 Jakob Walcher, *Ford oder Marx: Die praktische Lösung der sozialen Frage*, Berlin 1925.

4 Kurt Schwitters, 'Dadaismus in Holland', *Merz 1. Holland Dada* (1923), p. 11.

5 Kurt Schwitters, Theo van Doesburg, Hans Arp, Tristan Tzara and Christof Spengemann, 'Manifest Proletkunst', *Merz 2. Nummer i* (1923), p. 24ff.

6 Ibid.

7 Walter Rathenau, 'Zur Kritik der Zeit', 1912, in Ernst Schulig (ed.), *Walther Rathenau Hauptwerke und Gespräche*, Munich 1977, p. 48.

8 Ivan (Jan) Tschichold (ed.), *elementare typographie*, special issue of *typographische mitteilungen*, October, Leipzig 1925 and Heinz and Bodo Rasch (eds), *Gefesselter Blick: 25 kurze Monografien und Beiträge über neue Werbegestaltung*, Stuttgart 1930, see especially pp. 5, 23ff., 79f., 102 and 104.

9 *Typographie kann unter Umständen Kunst sein: Kurt Schwitters – Typographie und Werbegestaltung*, exh. cat., Landesmuseum Wiesbaden 1990, p. 195.

10 On alchemy, see Elizabeth Burns Gamard, *Kurt Schwitters' Merzbau: The Cathedral of Erotic Mistery*, New York 2000, p. 141 and Kurt Schwitters, 'Ich und meine Ziele', 1931, in Friedhelm Lach (ed.), *Kurt Schwitters: Das literarische Werk: Manifeste und kritische Prosa*, vol. 5, Cologne 1998, p. 341.

11 *Kurt Schwitters*, ed. by Ingried Brugger, Siegfried Gohr, Gunda Luyken, exh. cat., Kunstforum Austria, Vienna 2002, p. 19.

12 Schwitters 1923 (see note 1), p. 5.

13 *Merz 12. Hahnepeter*, Hanover 1924.

14 Advice to a young tradesman in Albert Henry Smyth (ed.), *The Writings of Benjamin Franklin*, vol. II, New York 1970, p. 370f.

15 *Deutsche Bauzeitung*, 57 (1919), p. 328.

16 Dietmar Elger, *Der Merzbau von Kurt Schwitters: Eine Werkmonographie*, Cologne (1984) 1999, p. 77.

17 Kurt Schwitters, 'Ich und meine Ziele', 1931 in Lach 1998 (see note 10), p. 343ff., see also Burns Gamard 2000 (see note 10), p. 167ff., and Elger 1999 (see note 16).

18 Christina Bischofberger, *Jean Tinguely, Werkkatalog Skulpturen und Reliefs 1954–1968*, Galerie Bruno Bischofberger, Küsnacht/Zurich, 1982, p. 100.

19 Le Corbusier, *Urbanisme*, Paris 1925, pp. 137–143. See also Bignens 2003 (see note 2), p. 82ff.

20 Alexander Dorner, *Überwindung der 'Kunst'*, Hanover 1959 (originally published in English: *The Way beyond Art*, 1947). See also Stanislaus von Moos, 'Modern Art Gets Down to Business', see notes on Alexander Dorner and Herbert Bayer in *Herbert Bayer: Das künstlerische Werk 1918–1938*, exh. cat., Berlin, pp. 93–105.

21 Karl Gerstner, *Kalte Kunst? – zum Standort der heutigen Malerei*, ed. by Markus Kutter, Teufen 1957. 'Cold' art begins with De Stijl and Russian Constructivism and ends with artists such as Max Bill, Paul Lohse, and Karl Gerstner, who is also both an artist and a commercial artist.

22 Gunda Luyken, 'Merz, eine Factory?! – Übereinstimmungen in der Persönlichkeit und im Werk von Schwitters und Warhol' in Brugger et al. (eds), *Kurt Schwitters*, exh. cat., Vienna 2002 (see note 11), pp. 113–28.

23 Rasch 1930 (see note 8), see the cover and imprint. In addition to Kurt Schwitters, Hans Schmidt, the Basler architect, and the Schweizerischer Werkbund are named. See also Gerhard Schaub, *Kurt Schwitters und die 'andere' Schweiz: Unveröffentlichte Briefe aus dem Exil*, Berlin 1998.

24 Kirk Varnedoe and Adam Gopnik (eds), *High & Low: Modern Art & Popular Culture*, exh. cat., The Museum of Modern Art, New York 1990/91. See also *Art & Pub: Art & Publicité 1890–1990*, exh. cat., Centre Georges Pompidou, Paris 1991. A representative presentation of Kurt Schwitters's work is provided in both publications.

25 Kurt Schwitters, 'Nationale Kunst', 1924/25, in Lach 1998 (see note 10), p. 199f.

26 Schaub 1998 (see note 23), p. 40.

27 Friedrich Nietzsche, aphorism 329 in *Die fröhliche Wissenschaft*, 1881/82. Translated by Walter Kaufmann under the title *The Gay Science*, New York 1974, pp. 258–259.

28 Kurt Schwitters, 'Ich und meine Ziele', 1931, in Lach 1998 (see note 10), pp. 342 and 348.

29 Kurt Schwitters, 1929, in a letter quoted in exh. cat. Wiesbaden 1990 (see note 9), p. 180.

30 Gerhard Schaub, 'Neun ungedruckte Briefe und Postkarten von Kurt Schwitters an Walter Gropius', in Schaub, *Kurt Schwitters: 'Bürger und Idiot': Beiträge zu Werk und Wirkung eines Gesamtkünstlers*, Berlin 1993, pp. 141–160.

31 See, for example, Kurt Schwitters, 'Über einheitliche Gestaltung von Drucksachen', 1930, in Lach 1998 (see note 10), pp. 324–334.

32 Exh. cat. Wiesbaden 1990 (see note 9), p. 172f. In 1929 Schwitters designed furniture for Celler Volks-Möbel der Metallwarenfabrik, Altona-Celle.

33 'Bill und die Wohnbedarf AG', in Gerd Fleischmann, Hans Rudolf Bosshard, and Christoph Bignens, *Max Bill: Typografie, Reklame, Buchgestaltung*, Sulgen 1999. Tinguely designed shop windows for the furniture company Wohnbedarf AG, see *Jean Le Jeune: Jean Tinguelys politische und künstlerische Basler Lehrjahre und das Frühwerk bis 1959*, exh. cat., Museum Jean Tinguely, Basel/Bern 2002.

34 'Lohse und die Wohnbedarf AG', in Christoph Bignens, Jörg Sturzebecher, *Richard Paul Lohse: Konstruktive Gebrauchsgrafik*, Ostfildern 2000.

35 See 'Der erste Eindruck von New York', in Bignens 2003 (see note 2), p. 60ff.

36 The advertising for the cookies factory Bahlsen is attributed to Schwitters, see exh. cat., Wiesbaden 1998 (see note 9), p. 189ff.

37 Rathenau 1912 (see note 7), p. 48.

38 Kurt Schwitters, 'Ich und meine Ziele', in Lach 1998 (see note 10), p. 343.

39 Ibid., p. 346.

The Raddadist Machine[1] Kurt Schwitters

The Raddadist machine is just what you need. It is a strange combination of wheels, axles and rollers along with cadavers, nitric acid and Merz constructed in such a way that you go in totally sane and come out totally mindless. This gives you huge advantages. Invest your cash in a Raddadist treatment and you will never regret it: you will never be able to regret anything anymore after the treatment. It doesn't matter whether you are rich or poor, the Raddadist machine will even release you from money per se. You enter the funnel as a capitalist, pass between several rollers and are dipped in an acid bath. Then you come into contact with a few corpses. Vinegar drips Cubism dada. Then you get to see the great Raddada. (Not the President of the World, as many assume.) Raddada radiates wit and is stuck all over with some 100.000 petitbourgeois needles. After you have been spun to and fro, you will be read my latest poems until you collapse senseless. Then you will be tumbled and raddadated, and all of a sudden you will appear outside the machine as a freshly-trimmed antibourgeois. Before the treatment, you shudder at the needle's eye; afterwards you can no longer shudder. You are now a Raddadist and you enthusiastically worship the machine. – Amen.

Cat. 172
Portrait Postcard 'Kurt Schwitters' to Rolf Mayr
Late 1925/early 1926
Collage and ink on cardboard
14 x 9 cm
Schwitters-Archiv der Stadtbibliothek Hannover

Cat. 151
Untitled (Collaged Picture Postcard 'The Pleasure Gallows' to Christof Spengemann)
18 August 1920
Collage and ink on cardboard
14 x 9 cm
Schwitters-Archiv der Stadtbibliothek Hannover

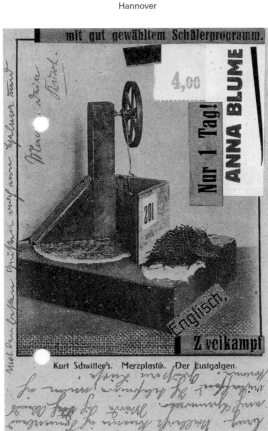

1 'Raddadist' is untranslatable, echoing the noise of a pneumatic drill, Dada and 'radieren' = both to etch and to erase [translator's note]. First published in: *Der Ararat*, II, 1 (January 1921), pp. 10–11, cit. in *Kurt Schwitters. Das literarische Werk. Prosa 1918–1930*, vol. 2, ed. by Friedhelm Lach, Cologne 1974, p. 48.

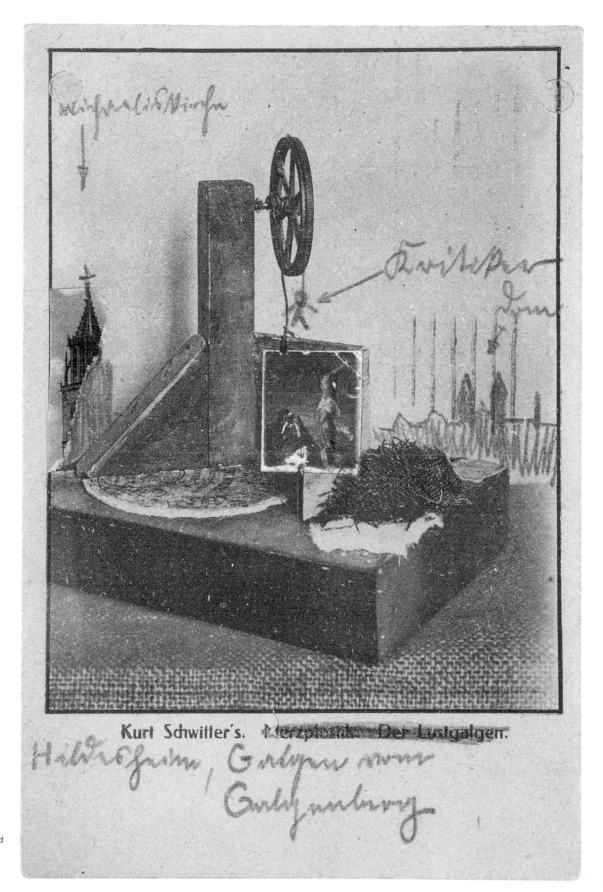

Kurt Schwitter's. Merzplastik. Der Lustgalgen.

Cat. 156
*Hildesheim, Gallows of Gallows Hill
(Collaged Picture Postcard 'The Pleasure
Gallows' to the Molzahns*
10 October 1921
Collage and indelible pencil on cardboard
14 x 9 cm
Eigentum des Johannes-Molzahn-
Contrum® in D-34131 Kassel

The Machine and I[1] Konrad Klapheck

When I was a growing up, I relished the idea of distinguishing myself from my fellows and doing things others didn't do. I changed my handwriting from one day to the next so as to dumbfound my teachers and, for a time, had my hair cut so short that people on the street turned around to look at me.

Naturally, when it came to painting, I also wanted to single myself out from others. In my first semester at the Art Academy in 1955, I decided to paint a canvas meant to stand out crassly from the Tachisme just coming into fashion. I wanted to set down something hard and precise versus the nebulous, a super form of figuration versus lyrical abstraction. My eye lit on an old Continental typewriter. I decided to paint it and all its keys as accurately as possible. However, the typewriter avenged itself for such light-hearted obsession with originality. Contrary to my intention, on canvas it became an outlandish monster, at once strange and familiar, a less than flattering portrait of my person. I had discovered something: with the help of the machine, I could elicit things from within myself of which, up to then, I had no idea. It forced me to reveal my most secret thoughts and wishes.

Systematically, I began to look around for other objects that suited my purpose. The paintings I have produced in parallel, serial productions from 1955 to today [1963] have been based on the following subjects:

Typewriters
Sewing machines
Telephones and sirens
Faucets and showerheads
Shoetrees
Bicycle bells

Each one of these objects, in the series dedicated to it, was lent a quite specific character.

The typewriter, a device we use in taking the most important decisions in our lives, is to me masculine in gender. It stands for the father, the politician, the artist. The sewing machine, which helps us clothe our nakedness, is female. It appears as bride, mother and widow. The telephone – mouthpiece for so many exhortations, warnings and threats – can be seen in my paintings as the voice of conscience and as the commands of unknown powers. The faucets and showerheads – from the start, man's confidants in things physical – become creatures that live wholly according to Eros, while the shoetree, via its twosome identity, invokes the joys and quandaries of the married state. The bicycle bell, laden with memories of my first childhood bicycle, represents life in the family and in a community. It mostly appears in the plural, like a regiment closely bound to its comrades, whose forced order and similar-coloured uniforms rack the heart with such various longings, or like the monotonous markers in a soldiers' burial ground, that *triste* caricature of a fellowship forced onto us by death.

I painted the machine in order to do something special, in order to immortalize myself in an unmistakable way. Instead it brought me to recognize transience and taught me how unimportant my person is. Should this make me angry? I don't think so. Learning about life means learning how to bear it.

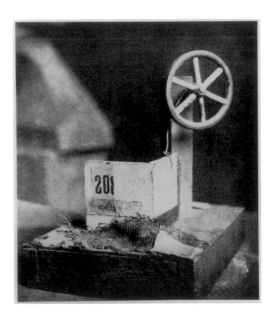

Kurt Schwitters
Der Lustgalgen
The Pleasure Gallows'
1918/19; destroyed
Sculpture
Height circa 51 cm

1 First published in German in *Konrad Klapheck*, exh. cat. Museum Boymans-van Beuningen, Rotterdam et al., Gent 1974, p. 34.

Cat. 113
Ohne Titel (Die schwarz-rot-gold Maschine)
Untitled (The Black-Red-Gold Machine)
1930/31
Collage on paper
10.8 x 8.3 cm
Kurt und Ernst Schwitters Stiftung, Hanover

Cat. 38
Radblumen.
Wheelflowers.
1920
Collage and oil on pasteboard
10.5 x 8 cm
Private collection

Cat. 95
Ohne Titel (250 GRAMM)
Untitled (250 GRAMMES)
1928
Collage on cardboard
8.6 x 6.4 cm
Kurt und Ernst Schwitters
Stiftung, Hanover

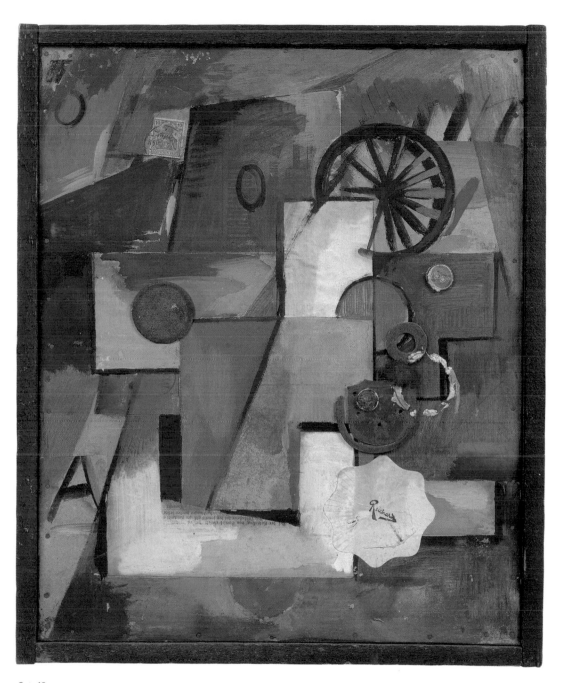

Cat. 48
Ohne Titel (Dein treufrischer)
Untitled (Yours Treufrischer)
1921
Assemblage and oil on pasteboard
38.3 x 31 cm
Private collection, Brussels

Cat. 21
Ohne Titel
(Lithografie mit Nietenlöchern)
Untitled
(Lithograph with Rivet Holes)
1919
Lithograph on paper;
print run unknown
29 x 23.2 cm
Cabinet des estampes, Musée d'art
et d'histoire, Geneva

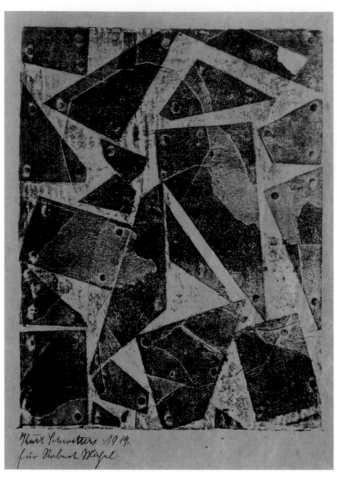

Cat. 22
Ohne Titel (Lithografie mit Nietenlöchern)
Untitled (Lithograph with Rivet Holes)
1919
Lithograph on paper; print run unknown
18.1 x 13.8 cm
Sprengel Museum Hannover,
Nachlass Robert Michel

Cat. 20
Ohne Titel (*Zwei Kreise*, aus: *Das Kestner-
buch*, hg. von Paul Erich Küppers,
Verlag Heinrich Böhme, Hannover 1919)
Untitled (*2 Circles*, from *Das Kestnerbuch*,
ed. by Paul Erich Küppers,
Verlag Heinrich Böhme, Hanover 1919)
1919
Woodcut on paper; print run unknown
18.8 x 12.1 cm
Sprengel Museum Hannover

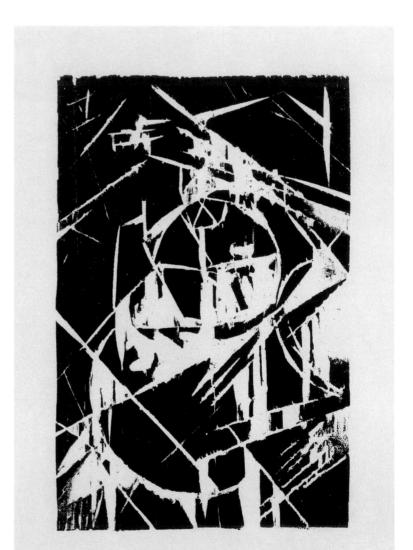

Dem Geheimen Zentralrat

Hülsenbeck

gewidmet von

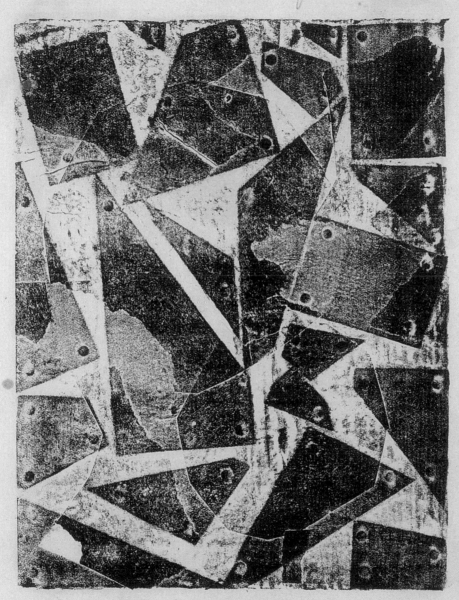

Dr. Daum. Paris.

KURT SCHWITTERS.

127

Cat. 24
Ohne Titel (Räder im Raum)
Untitled (Wheels in Space)
1919
Lithograph on paper;
print run unknown
11.7 x 8.9 cm
Sprengel Museum Hannover

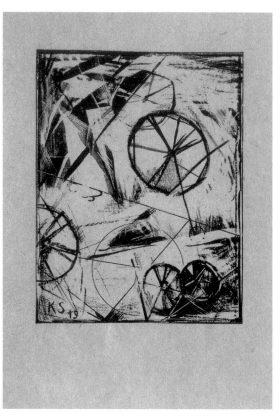

Cat. 18
Konstruktion.
Construction.
1919
Pencil and ink on paper
18.5 x 15.2 cm
Kurt und Ernst Schwitters
Stiftung, Hanover

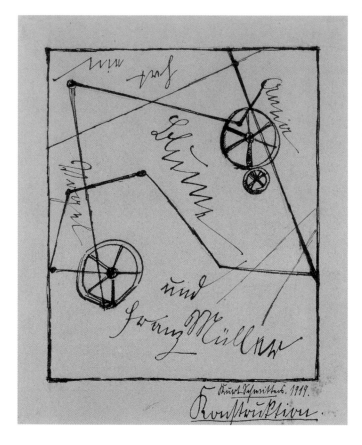

Cat. 6
Mz. 12. Bommbild.
Mz. 12. Bomm Picture.
1919
Collage, watercolour, lead and
coloured pencils on paper
11.9 x 9.7 cm
Archiv Baumeister, Stuttgart

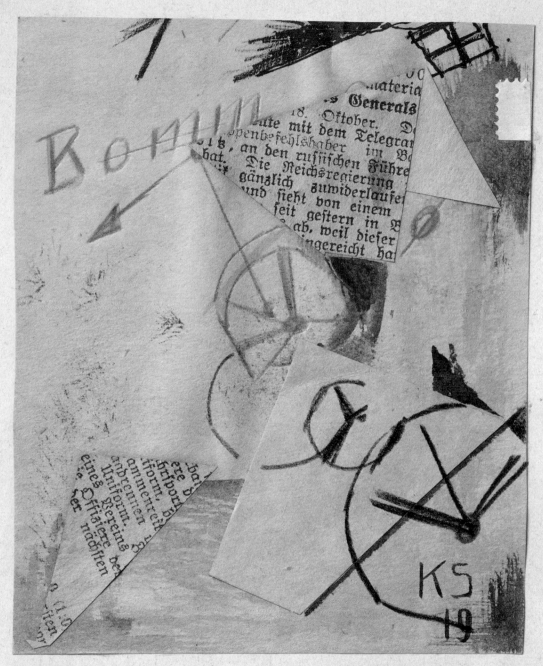

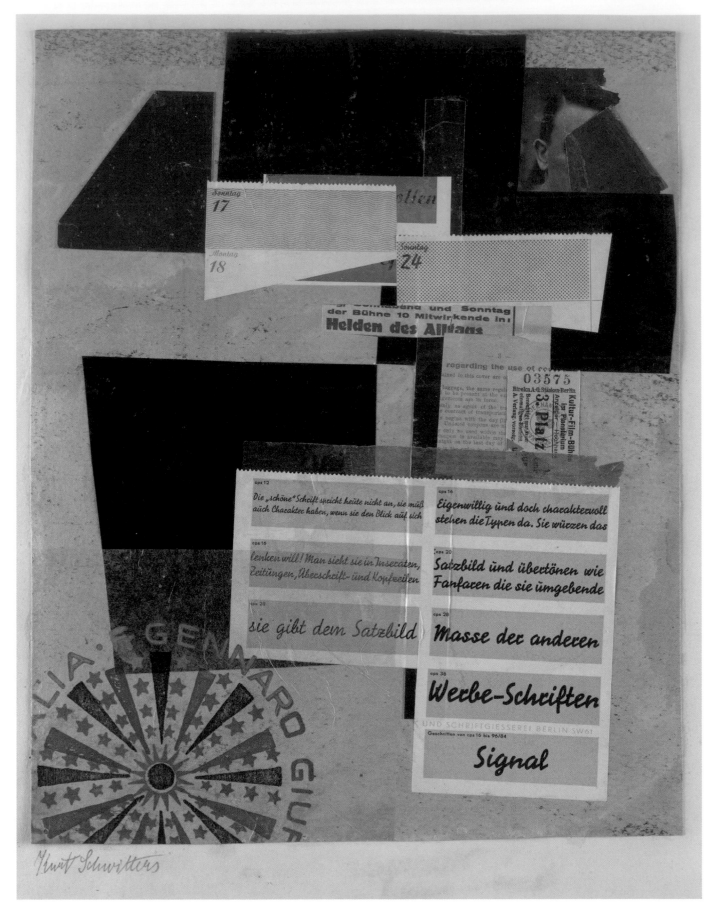

Cat. 116
Ohne Titel (Helden des Alltags
Untitled (Everyday Heroes)
1930/31
Collage on paper
34.2 x 27.6 cm
IVAM, Instituto Valenciano
de Arte Moderno, Generalitat
Valenciana

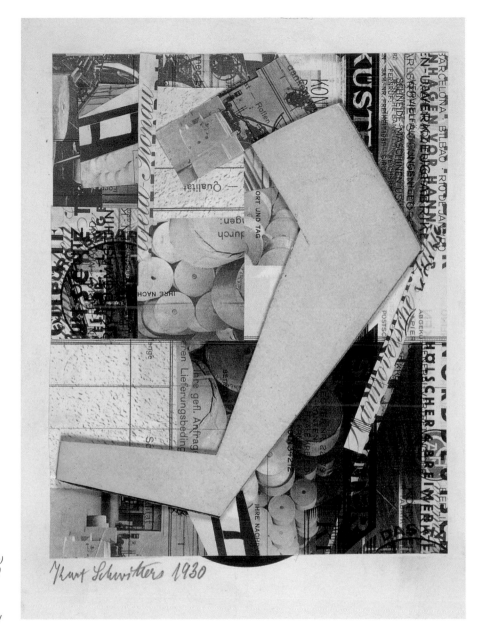

Cat. 111
Ohne Titel (Mit gelber Form)
Untitled (With Yellow Form)
1930
Collage on paper
17.5 x 14 cm
Private collection, Germany

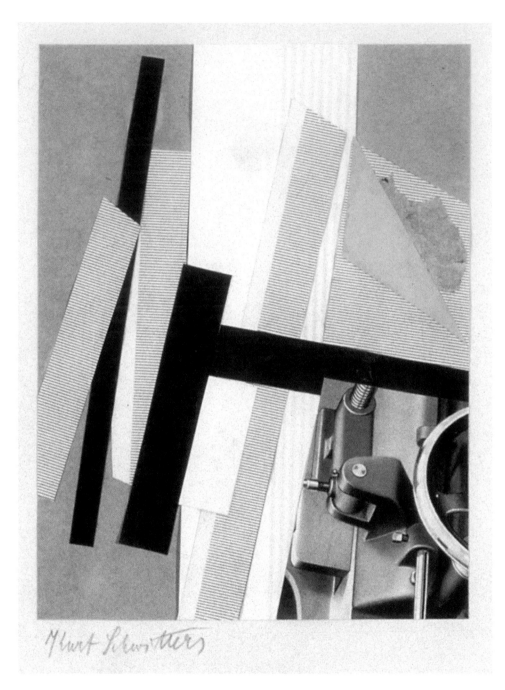

Cat. 114
Ohne Titel (Mit Maschinenteil)
Untitled (With Machine Part)
1930/31
Collage on paper
13.6 x 10.4 cm
Private collection

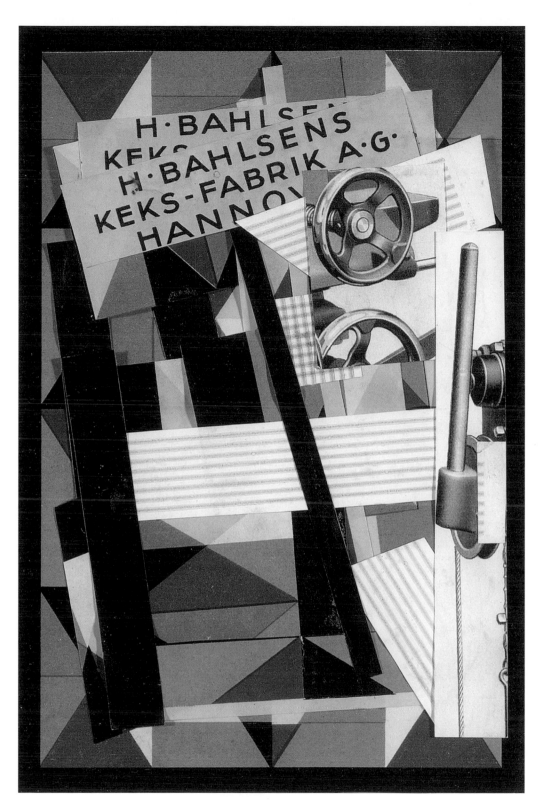

Cat. 110
Ohne Titel (H. BAHLSENS
KEKS-FABRIK AG)
Untitled (H. BAHLSENS
KEKS-FABRIK AG)
1930
Collage on paper
17.9 x 11.8 cm
Kunsthaus Zug, Stiftung
Sammlung Kamm

Cat. 173
Untitled (Wool Skyscraper, Draft of an
Advertisement for Handarbeitshaus Buchheister)
1926–28
Collage and typescript on paper
39 x 17 x 7 cm
Galerie Gmurzynska, Cologne

Cat. 64
Ohne Titel (D on)
Untitled (D on)
Circa 1922
Collage on paper
13.3 x 10.7 cm
Kurt und Ernst Schwitters
Stiftung, Hanover

Cat. 104
Ohne Titel (Tortrtalt ac hiscann)
Untitled (Tortrtalt ac hiscann)
1929
Collage on paper
10.1 x 12.3 cm
Kurt und Ernst Schwitters
Stiftung, Hanover

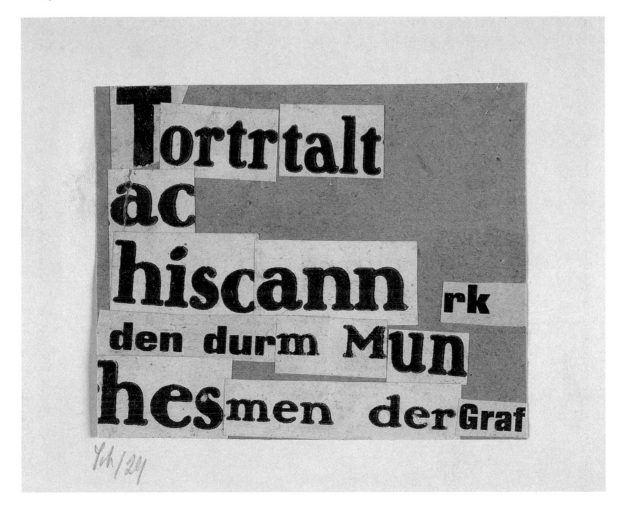

'kurt schwitters (1887–1948) became famous as a result of his activity in hanover. he published the magazine *merz* and among other things wrote the ground-breaking *ursonate*, which he himself declaimed brilliantly; even today it is an essential document of concrete poetry. schwitters had the gift of pasting the most unassuming offcuts and remnants into compositions which despite their fragility have retained an astonishing freshness over so many years. *our* developed out of trial proofs he made for a lithography.'

cit. from Max Bill, 'Die Magie der gestalteten Gegenstände', in *Max Bill. Du* (June 1976), p. 42.

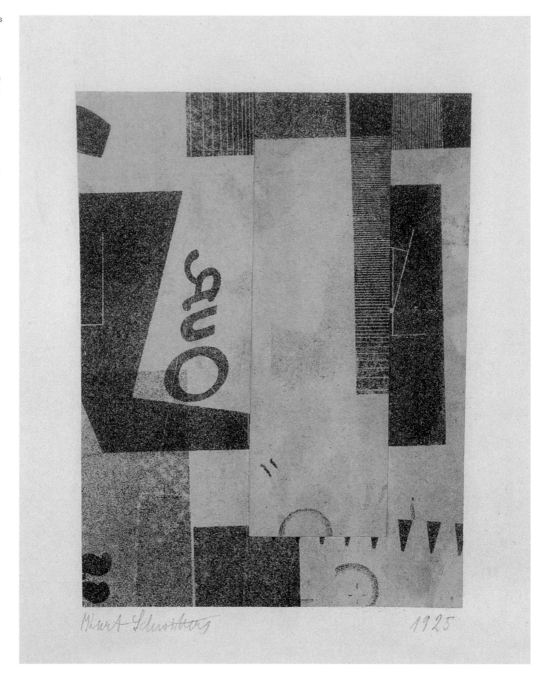

Cat. 82
Ohne Titel (OUR)
Untitled (OUR)
1925
Collage on paper
17.1 x 13 cm
Private collection

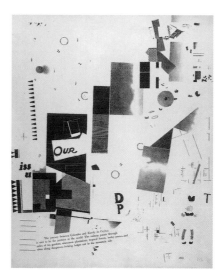

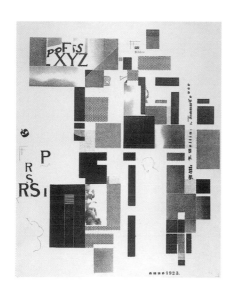

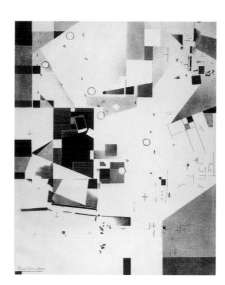

Cat. 74
*MERZ 3. MERZ MAPPE. ERSTE MAPPE
DES MERZVERLAGES. 6 Lithos
MERZ 3. MERZ PORTFOLIO.
FIRST PORTFOLIO OF THE MERZ
VERLAG. Six Lithographs*
1923
6 lithographs in one cover; print run: 50,
plus 5 (?) artist's proofs (it is not known,
whether 50 complete portfolios were
in fact produced)
55.6 x 44.5 cm
Sammlung E. W. K., Bern

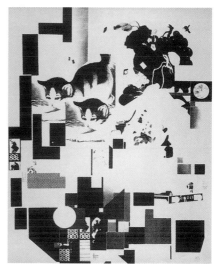

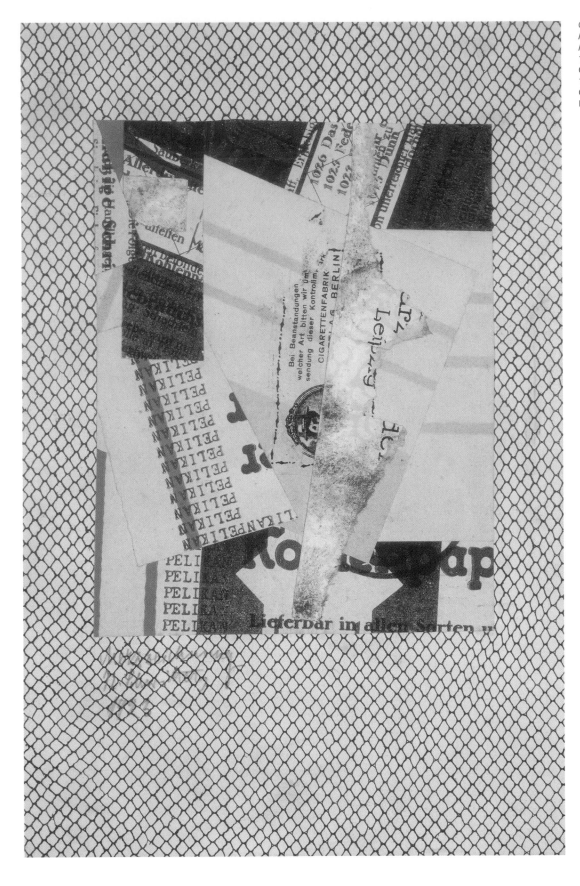

Cat. 70
Netzzeichnung
Net Drawing
1923
Collage on paper
13.8 x 10.9 cm
Collection of Carroll Janis,
New York

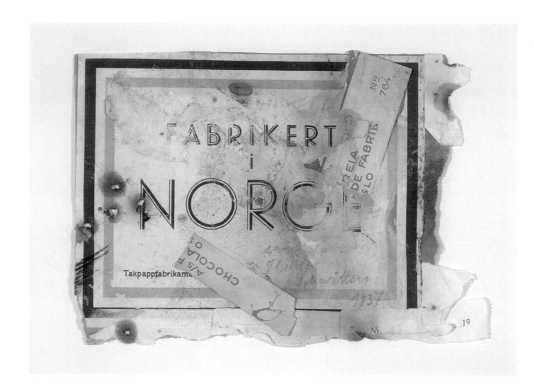

Cat. 130
Fabrikert I Norge
1937
Collage on paper
15.9 x 13.7 cm
Daria Brandt & David Ilya Brandt,
New York

Cat. 146
Ohne Titel (Gerber)
Untitled (Gerber)
1947
Collage on paper
19 x 17.1 cm
Marlborough International Fine Art

Cat. 71
Ohne Titel (Vogel)
Untitled (Bird)
1923
Collage on paper
14 x 11.4 cm
Private collection, Houston

'Related Opposites'
Differences in Mentality between
Dada and Merz Ralf Burmeister

**'Dada – Everyone awakes for an instant
from the daily sleepwalk he calls life.'**

Theo van Doesburg

**'Merz is the graveside smile
and the solemn gaze at comic events.'**

Kurt Schwitters

Kurt Schwitters could be severely economic with expression. His working drawings, whose synthesis of form and text is literally to the point, are clear examples of his own claim that typography could 'under certain circumstances be art'.[1] The well-known fact that Schwitters in the role of Merz Advertising (see illus. p. 117) was his own best agent and graphics expert is demonstrated by the very first issue of the periodical *Merz*, the 'official organ' of the one-man movement from Hanover. The central theme of this number is the 'Campaign for Dadaism' he undertook on a journey through the Netherlands between January and April 1923 alongside Theo van Doesburg, Vilmos Huszár (De Stijl artist with an affection for Dada) and the pianist Nelly van Doesburg: a campaign that aimed to 'wipe out the sediment of Rembrandt and van Gogh and get rid of groc-cheese romanticism once and for all'.[2]

The title page of *Merz 1* bears an emblem that stands for the ruin of Holland at the hands of Dada, and which Schwitters used not much later to indicate the general effect of his Merz activities: a stylized windmill composed of a black square signed with the word 'MERZ' and above it a diagonally placed black cross, each segment bearing the syllable 'da'.[3] (see illus. 1 and 1a) The logo makes both the similarity and the differences between Dada and Merz strikingly clear. The four sails of the windmill are the dynamic, actionistic moment: 'Da – Da – Da – Da' shout the sails as

they spin round, turning the mill wheels that crush the seed of bourgeois thinking. Merz, on the other hand, is the mill itself: here the ground corn is stored in sacks, waiting to be baked into art.

Conflicts

In 1920, Kurt Schwitters wrote with an indelible copy-ink on the back of the *Merzbild 21 b. das Haar-Nabelbild (Merzpicture 21 b. the Hair-Navel Picture)*, 1920, which he dedicated to Hans Arp: 'Merz is not dada!' and underlined this twice (see illus. 2). A statement both lapidary and true, and Schwitters's self-assertion against a group which, when he had approached it as a lone artist, had excluded him. This group was the central Dadaist circle in Berlin: the 'Club Dada', with its protagonists 'World Dada' Richard Huelsenbeck, 'Dadasopher' Raoul Hausmann, 'Head Dada' Johannes Baader, 'Propagandada' George Grosz, 'Monteurdada' John Heartfield, 'Progressdada' Wieland Herzfelde and 'Pipidada' Walter Mehring. Under the aegis of Grosz, Hausmann and Heartfield, the 'First International Dada Fair' took place in the rooms of the art dealer Dr Otto Burchard from 1 July until 25 August 1920. This presented Dada as an all-encompassing, anti-patriotic movement that was fighting on the side of the proletariat and, according to the legends on many posters in the exhibition, was bent on thoroughly tearing down the bourgeois world of concepts with all its big phrases, hypocrisy and conventions (see illus. 3). The exhibition catalogue lists one hundred and seventy-four Dadaist 'products', as they were called with ironic reference to their anti-artistic, commercial character. Among the thirty-one artists were the Dadaists Max Ernst and Johannes Theodor Baargeld from

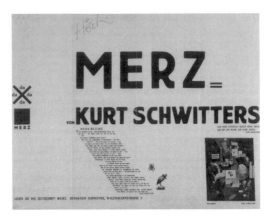

Illus. 1
Kurt Schwitters
Merz advertising poster, Hanover, circa 1923
44.5 x 57 cm
Berlinische Galerie, Landesmuseum für Moderne Kunst,
Photographie und Architektur, Berlin

Illus. 1a
Dada-Merz logo
by Kurt Schwitters, circa 1923

Cat. 44
Die Kathedrale, 8 Lithografien von Kurt Schwitters, Die Silbergäule 41/42, Paul Steegemann Verlag, Hanover
1920
8 lithographs, volume of 8 sheets in wrappers; print run unknown
Sammlung E. W. K., Bern

Cologne, Francis Picabia from Paris, Otto Schmalhausen from Antwerp, Hannah Höch from Berlin (the 'Dadasophess' who later became Schwitters's life-long friend), and Hans Arp from the Dada nucleus in Zurich. Kurt Schwitters and his Merz pictures were not included.

This was certainly not a reflection of Schwitters's works, which absolutely fulfilled the Dadaist demands for new methods of using materials in order to achieve an experimental revaluation of art, and which were the required 'wonderful constellations of real materials: wire, glass, cardboard, fabric'.[4] With their aesthetics of industrial production and startling effect, they would have fitted seamlessly into the ethos of the exhibition, which ranged from the sculpture *Prussian Archangel* (1920), an acerbic attack by John Heartfield and Rudolf Schlichter on middle-class militarism in the form of a pig-faced soldier doll, to Hans Arp's lyrically abstract wood reliefs. This led Adolf Behne, a journalist and art critic sympathetic to Dada and revolutionary artist groups, to comment with disappointment after visiting the Dadaist show: 'On completing the preparations for this exhibition, the Dadaists should have thrown half the works out. [...] Kurt Schwitters and Golyscheff would have been far better placed here than many "proper" Dadaists.'[5]

The deciding reason why Kurt Schwitters was ignored by the organizers of the 'Dada Fair' was his contract with the Berlin gallery 'Der Sturm', owned by Herwarth Walden. It was here that the Hanover-born artist had in June 1918 first been able to exhibit his works in the capital of the German Reich, and in July 1919 he had his first presentation of Merzpictures

in the gallery's 76th exhibition, which he followed with the publication of his first manifesto, 'Merz Painting', in the periodical Der Sturm,[6] finally, only a few weeks before the opening of the 'First International Dada Fair', he had a further show in Walden's exhibition rooms in which he presented twenty-four works, including *Mz 39 russisches bild. (Mz 39 russian picture)*, 1920 (see illus. p. 199).

Although the gallery 'Der Sturm' had at this point passed the zenith of its influence, its reputation was still legendary: after all, since its foundation in 1912 it had developed to become the most important platform for the European avant-garde, bearing its central pillars of Expressionism, Futurism and Cubism. Under the programmatic motto 'Art is an original gift, not a handed-down one' the gallery 'Der Sturm' had shown, from September to December 1913, at least four hundred works by eighty-three artists in the 'First German Autumn Salon'.[7] It was the first comprehensive presentation of international pre-war modernism in Germany, in which Walden's aim of a 'turn-around in art', away from the imitation of reality and toward an artistic subjectivity and the autonomy of the aesthetic product, was to be finally achieved. Yet the First World War – for which (among many other artists and intellectuals) the 'Sturm' protagonists Franz Marc and August Macke had volunteered in the belief that this was to be a liberating step which would lead to unheard-of human comradeship – had unwittingly already shown its bloody face, and at this sight the unworldly daydream inevitably became a nightmare.[8]

For the gallery 'Der Sturm', however, the years 1914 to 1918 were particularly prosper-

Illus. 2
Kurt Schwitters
Verso of *Merzbild 21 b. das Haar-Nabelbild. (Merzpicture 21 b. the Hair-Navel Picture.*
1920
Assemblage on cardboard, 91 x 72 cm
Staatliche Kunsthalle Karlsruhe
with Schwitters's inscription: 'Merz is not dada!'

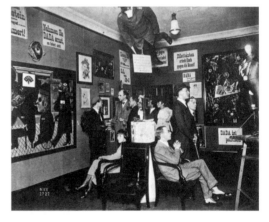

Illus. 3
Opening of the 'First International Dada Fair', art salon of Dr Otto Burchard, Berlin, 1920
Left to right: Hannah Höch, Raoul Hausmann, Dr Otto Buchard, Johannes Baader, Wieland and Margarete Herzfelde, Otto Schmalhausen, George Grosz and John Heartfield
Hanging from the ceiling: *Prussian Archangel* by John Heartfield/Rudolf Schlichter

Illus. 4
Herwarth Walden in front
of the portrait bust by William Wauer, 1918

Illus. 5
Portrait of the 'Sturm' artist
Kurt Schwitters, circa 1919
Picture postcard, edited
by the Galerie 'Der Sturm'

ous. Even before war broke out, a successive 'Germanization' had begun to mark Expressionism, which became a specific artistic expression of 'the German ethos' and as such increasingly collectible.[9] This highly profitable 'war business'[10] with art that reeked of national chauvinism was something the Berlin Dadaists found unforgivable. What was more, Walden continued to propagate Expressionist art well after the end of the war, and maintained the credo of art for art's sake and hence the rejection of all concrete political and revolutionary claims upon it. For the Dadaists – many of whom had experienced their artistic awakening as a result of Expressionism – this aestheticism had long since become an integral part of the hated bourgeois ideology of culture. An Expressionist who did not wish to become a philistine had to become a Dadaist. The art Walden represented, Art as 'sacred', and as such both apolitical and introverted, was for the members of the 'Club Dada' nothing other than an aesthetic sedative and a 'moral and ethical farce'[11] designed to stabilize a pathologically disturbed society in which nationalism, militarism and moral decay continued to survive unchanged even after the demise of the Empire. Consequently, wrote Raoul Hausmann, Herwarth Walden was one of the 'genuine Prussian Art Grenadiers of His Majesty the Patron'[12] (see illus. 4 and 5).

For Schwitters, however, 'Der Sturm' was the place where his Cubist-and Expressionist-inspired, soberly coloured paintings mutated – were allowed to mutate – into Merz,[13] and Herwarth Walden was a mentor to whom he remained true: 'I esteem *Walden* to an extraordinary degree both as an artist and as the man who was able to recognize the new

art and did all he could to promote it,' he writes to Hausmann in 1921.[14] Ten years later, he proclaims in 'Ich und meine Ziele' [I and my aims] that, in his estimation, there are probably only three people who can fully comprehend his 'cathedral of erotic misery', in other words the *Merz Building*; these are Hans Arp, Sigfried Giedion and Herwarth Walden.[15] To the accusation of 'mercantile machinations'[16] aimed by the Dadaists not just at Walden but also at the artists he represented, Schwitters replied robustly and with typically North German business sense: 'The artist should only be an artist in his art. I think that whoever manages this has every right in his civil life to decide what is the best way to find collectors for him.'[17] The fact that the word *'bezahlt'* [sold] held a particular attraction for him is demonstrated by a picture of 1919 composed of rubber-stamp impressions, stuck-on value indicators from the edges of postage stamp sheets, and drawn elements that anecdotally reflect his profitable relationship to the gallery: the rubber-stamp insignia 'Herwarth Walden' and 'Der Sturm' are graphically fused to become connecting rods in the wheels of a pricing machine[18] (see illus. p. 180).

Rapprochement

Yet entrenched though the fronts appear, they were not totally at odds. If one can believe Raoul Hausmann's frequently hawked reminiscence, Schwitters had used the sentence 'I am a painter, I nail my pictures' as a motto when applying for membership in the 'Club Dada' – and this was in 1919, probably even before the birth of Merz.[19] However, he was refused on Richard Huelsenbeck's urging that they could not just accept the first likely person to approach them.[20] Huelsen-

beck had already issued polemics against Schwitters's extraordinarily successful poem *To Anna Blume*, 1919. Even in retrospect, four decades later, he was unable to retract his misgivings about Schwitters and his petit-bourgeois bearing, still regarding him as a 'genius in a frock-coat'.[21] Nevertheless, he had intended to include *Merzbild (Merzpicture)*, 1919, in the 'Dadaistic Hand Atlas *dadaco*' planned for that year, which according to an advertisement was to provide 'the only authentic information on all the Dadaists of the present day'.[22] In a letter to Schwitters dated January 1920 Huelsenbeck had also stressed: 'You know I am well-disposed toward you. I think too that certain disagreements we have both noticed in our respective opinions should not be an impediment to our attack on the common enemy, the bourgeoisie and philistinism.'[23] Although the *dadaco* was never published, due to financial and personal conflicts between Huelsenbeck, Tristan Tzara and the Munich publisher Kurt Wolff, two clichés showing *Merzpicture* have survived from the already typeset anthology: relics of an attempted cartography of the Dada universe in which Merz, too, would have been alotted a fixed position.[24]

Raoul Hausmann, the 'Dadasopher', who had himself been offered an exhibition in 'Der Sturm',[25] refused the continued cooperation of Kurt Schwitters and Herwarth Walden in no uncertain terms (see illus. 6). This did not, however, prevent him from seeking contact with Schwitters after the end of the 'Dada Fair' held in the summer of 1920, the high point and apotheosis of the Berlin Dada movement, in order to plan and execute joint projects with him. They thought about publishing a magazine entitled *qjyE*,[26] and on 6

September 1921 they arrived at the conciliatory name 'Antidada-Merz-Presentism' for their first joint reading in Prague, in which Schwitters read poems including *Undumm, Leise (Unstupid, Quiet)*, *To Anna Blume*, 1919, and *Causes and beginning of the great and glorious revolution of Revon*, while Hausmann declaimed his sound-poems *fmsbw* and *OFFEAH*, two works that were to inspire Schwitters's *Ursonate (Primal Sonata)*,1925. The soirée in Prague was the beginning of a long period of artistic co-operation that Hausmann perceived as a 'mineral relationship'[27] between himself and Kurt Schwitters, in which each repeatedly dropped the plumb-line of art to test the shallows of sense and the depths of nonsense (see illus. 7).

Divergence and Convergence

If then these two dogmatists of the Berlin Dada group, Huelsenbeck and Hausmann, could each with different emphasis assert an affinity between Dada and Merz, and even Schwitters could confuse the concepts, at one point defining himself retrospectively as a 'Dadaist',[28] at another saying that he passed for a Dadaist 'without being one'[29] – then the question arises what it was that defined the alienating concurrence, the unifying difference between these two artistically related forms of expression. One thing was clear to Schwitters, however: 'Dada and Merz are related by opposition'.[30]

Dada made its entrance with the intention of being an anti-cultural act, yet was de facto an anti-bourgeois act of culture. Dada in Berlin meant acting against the 'life philosophy of Weimar',[31] which provided the petit-bourgeois citizen with a democratic, humanistic mask to disguise his nationalistic, reactionary

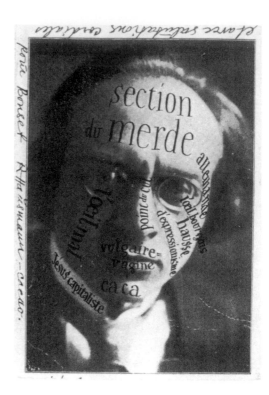

Illus. 6
Portrait of the 'Sturm' artist Herwarth Walden reworked by Raoul Hausmann, 1921
Picture postcard, edited by the Galerie 'Der Sturm' from Raoul Hausmann to Theo van Doesburg, February or March 1921

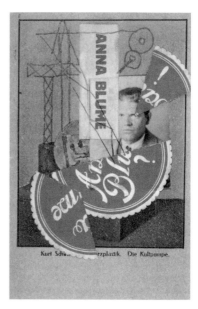

Illus. 7
Kurt Schwitters
Collaged Merzpostcard *The Cult Pump* to Hannah Höch, with portrait photo of Raoul Hausmann as a souvenir of the 'Antidada-Merz-Presentism-Soirée' in Prague, 1921
Collage on paper, 14 x 9 cm
Hannah Höch Archiv, Berlinische Galerie, Landesmuseum für Moderne Kunst, Photographie und Architektur, Berlin

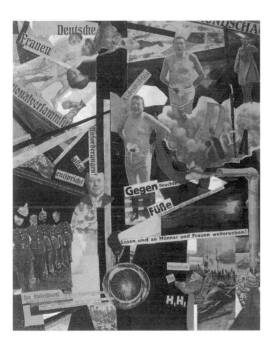

Illus. 8
Hannah Höch
Dada-Rundschau, 1919
Collage, gouache and watercolour on card,
43.7 x 34.5 cm
Berlinische Galerie, Landesmuseum
für Moderne Kunst, Photographie und
Architektur, Berlin

and militant alter ego. The aim of Dada was, as Georg Grosz put it, to expose the 'gigantic cosmic nonsense' with all its contradictions for what it was,[32] for the Dadaist carried a mirror that reflected the true shape of things:[33] 'Man is a machine, culture is a rag-bag, education is conceit, intellect is brutality, the average is stupidity and the ruler is the military.'[34] This mirror took the form of the Dadaist photomontage, the aesthetic weapon inaugurated by Heartfield, Höch and Hausmann in which a dissecting cut could be made through the idol representing the era of 'Germany's beer-belly culture' (Höch) in order to disembowel it and cut in pieces everything that held the 'Weimar lie' together in its innermost being.[35] The aggressive energy of the scissor-cuts with which daily events were removed from newspapers and placed in the collage is an ironically exaggerated commentary that is still almost palpable despite the artificially frozen state of the images.

Hannah Höch, in her *Dada-Rundschau* of 1919 (see illus. 8), demands a programme of 'unlimited freedom', by which she means on the one hand the left-wing political activism of the Berlin Dadaists, who formed an irreconcilable group of extreme individualists, yet were all engaged in the struggle for communist revolution; on the other, she refers to the liberation of art which then captures the chaos of the present-day in the collage, thus working out its rage against it. *Dada-Rundschau* [Dada Panorama], exhibited in 1920 at the Dada Fair, is a perfect example of the principle of photomontage and the politicizing aesthetic of Dada. This montage shows a kaleidoscopic view of time in which a grotesque composition of cut-out pieces of print and images takes on the traits of bitter

social satire:[36] On the long vertical axis floats the American president and winner of the 1919 Nobel Peace Prize, Woodrow Wilson, whose head is planted onto the figure of a female gymnast. On the left side of the picture, a group of women dance barefoot to the polling booths to cast their votes for the German National Assembly; 1919 is the first year in which women are allowed not just to vote in elections, but also to participate as delegates. The three portrait-implants show the politicians Gertrud Bäumer, Agnes von Harnack and Anna von Giercke, one of the first women elected to represent the people. The view down a gun-barrel presented to the viewer at the lower edge of the picture, several scattered fragments of a photo of a mass demonstration, a soldier wearing a gas-mask advancing with raised arm, the headless row of soldiers at the left edge and the sniper lying in wait on top of the Brandenburg Gate during the Spartacus Uprising – all these images form a panorama in time between revolution and reaction. A rumpless torso with a split skull is the shape given to Matthias Erzberger, the vice-chancellor and finance minister of the young Weimar Republic, a man who 'fulfilled all the requirements' as the headline says. The central photographic quotation comes from the title page of the 'Berliner Illustrirte Zeitung' of 24 August 1919: the picture of 'Ebert and Noske in the summer heat' had caused a stir when it was first published, since after all here were the country's two highest representatives – only two weeks after the Weimar constitution had been ratified – literally stripped of their significance for all to see: they had dropped their trousers. Hannah Höch heightens this unintentionally comic image of plump bare flesh by gently inserting flower petals into their

swimming trunks. Yet the artist also counters this ridiculous sight by putting the Reich President Friedrich Ebert in military boots, and half-submerging Gustav Noske, the Reich Defence Minister, who is positioned to the right above Ebert in the picture, in a cloud of smoke. Both gestures allude to the political responsibility shared by these two Social Democrats in the bloody crushing of the Communist Spartacus Uprising by volunteer troops in January 1919. However, on seeing that Ebert, to top all this, is graced with an advertising slogan for Vasenol powder – 'Helps prevent wet feet' – the raucous laughter of Dada breaks out again.

The political polemic that characterizes a work like *Dada-Rundschau* is totally alien to Merz. Yet to infer from this that Schwitters and his art are 'totally unpolitical', as Hausmann maintained, would be equally mistaken.[37] Nearer the mark is a late comment of Huelsenbeck's that 'art was for Schwitters what the woods are to the forester. Creating a new order in life, which appeared of such overriding importance to us [the 'Club Dada' – author's note] and which led us to participate in political movements, was something Schwitters wanted to see at most expressed as an artistic symbol'.[38]

Kurt Schwitters had always refused to allow his work to be used for the purpose of political agitprop; in his stand against ideological instrumentalization he pointed to the independence of his art, which had 'no desire to influence other than by its continued existence'.[39] Despite this primacy of *l'art pour l'art* which he shared with Herwarth Walden and the artists of 'Der Sturm', Merzpictures have subtle political connotations written

into them and the materials used to compose them can indeed be understood as metaphors relating to current events.[40] At the same time, Dada and Merz differ fundamentally both in their direction and in the artistic product. Although the Dadaist collage, like the Merzpictures, unites heterogeneous elements of reality, in Dada this is an expression of creative nihilism which screams 'No!' at the circumstances of culture and civilization which have become alien, in a grotesque montage whose function is to criticize and expose. This ruthless enlightenment on the part of Dada contrasts with the gentler temper of Merz: where Dada dissects, Kurt Schwitters glues and nails together. For Schwitters, Merz was the 'prayer of thanks for the victorious outcome of the war, since once again, peace had won. Everything was in ruins in any case, and now it was a question of building something new out of the broken pieces'.[41]

Merzbild 25 A Das Sternenbild (Merzpicture 25 A The Star Picture), 1920, (see illus. 9) illustrates this difference in mentality in the most striking manner. It reflects the same historical situation and its principal actors as *Dada-Rundschau*, so that Schwitters's assemblage can indeed be regarded as a Merz counterpart to the Dadaist montage. The scraps of words and sentences torn from newspapers, '[R]eichsk[anzler]', 'blutig[en]' (bloody), 'Offener Brief' (open letter), 'Matthias [Erzberger]', 'Die Korrupti[on]', 'Erhöhung' (price rise), 'Hungers[not]' (famine), can all be associated with the political eruptions of the day, yet these headlines are not, as in *Dada-Rundschau*, used in satirical commentary of photographic quotations, but function primarily as formally aesthetic, desemanticized elements within the composi-

Illus. 9
Kurt Schwitters
Merzbild 25 A Das Sternenbild
Merzbild 25 A The Stars Picture
1920
Assemblage on cardboard
104.5 x 86.7 cm
Kunstsammlung Nordrhein-Westfalen,
Dusseldorf

tion. The echoes of contemporary misery that speak out of the newspaper fragments fade against the more powerful revaluing of the printed lines as graphic marks. In this compositorial principle of 'de-forming', which for Schwitters followed a 'social view',[42] he was able to transcend even the things that had become worthless, all the refuse, in and by means of his art. In this process of 'merzation' Schwitters accomplished a kind of artistic alchemy, by bestowing on the sediment of the everyday – regardless whether this took the form, as in the *Merzpicture 25 A The Star Picture*, 1920, of glass beads, wire, string or tin lids – the dignity of an aesthetic sign. In this creative process, the used objects were liberated from their previous utilitarian significance and, thus purified, acquired their just place in the art paradise of Merz, where each piece, each colour became part of the balanced unity of the whole.

The oppositional relationship between Dada and Merz consists in the fact that Dada destroyed in the name of productivity, while Merz produced using what had been destroyed. The (anti-)art of Dada led directly back into the real world; Merz, on the contrary, turned the concrete and the real into an aesthetic form of expression. Dada hoped to be able one day to make itself redundant; Merz, the principle of all-embracing composition, wished to 'create relationships, ideally between all the things in the world'.[43] Schwitters believed in the salutary force of art, evident in his ascribing to Merz 'elementary power': a power, he remarked, for whose sake 'Christ was crucified and Galilei tortured'[44] – a power, in other words, which was to readjust the (dis)order of the world and lead to a turning point in civilization which was no longer to be divided into proletariat and bourgeoisie but which would only recognize 'mature human beings'.[45] Both, Dada and Merz, strove after new beginnings: both in art and – by means of art – in the foundations of a new constitution for society.

1 Kurt Schwitters, 'Thesen über Typographie', *Merz 1. Typo-Reklame Pelikan-Nummer*, Hanover 1924, cit. in *Kurt Schwitters: Das literarische Werk*, ed. by Friedhelm Lach, Cologne 1981 (1998), vol. 5 *(Manifeste und kritische Prosa)*, p. 192. Cf. also *'Typographie kann unter Umständen Kunst sein'. Kurt Schwitters – Typographie und Werbegestaltung*, exh. cat. the Landesmuseum Wiesbaden/Sprengel Museum, Hanover/ Museum für Gestaltung, Zurich 1990/1991.

2 N.N. cit. in Raimund Meyer, 'Dada ist die Weltseele, Dada ist der Clou. Kleine Dada-Kosmologie', in *Dada global*, ed. by Raimund Meyer, Judith Hossli and Guido Magnaguagno, Zurich 1994; Kunsthaus Zürich, *Sammlungsheft 18*, p. 63f.

3 The black square is a variation on the outlined square used by Theo van Doesburg as a symbol of New Design. The Dada cross is not originally Schwitters's idea either. Johannes Baader had already used it both in a poster advertising his 'Carnival-DADA-Ball' on 20 January 1920 in the Marble Hall in Berlin and as a logo for the magazine of the short-lived co-operative he founded, the 'Arbeitsgemeinschaft Freiland dada' [Freeland dada Co-operative] at the 'First Intertellurian Academy, Potsdam'.
Cf. illustration in Hanne Bergius, *Das Lachen Dadas. Die Berliner Dadaisten und ihre Aktionen*, Berlin 1989, p. 155; *Dada global*, p. 15, note 2; *Hannah Höch. Eine Lebenscollage*, vol. 2 (1921–1945), ed. by the artists' archive of the Berlinische Galerie, Ostfildern 1995, part 1, p. 27.

4 Raoul Hausmann, 'Synthetisches Cino der Malerei' (1918/1972), in Hausmann, *Am Anfang war Dada*, ed. by Karl Riha and Künter Kämpf, Giessen 1992 (3rd, completely revised edn), p. 30.

5 Adolf Behne, 'Dada', *Die Freiheit*, 9 July 1920, evening issue.

6 *Der Sturm*, Berlin, vol. 10, no. 4, 4 July 1919, p. 61; reprinted in Lach 1981 (see note 1), p. 37.

7 Herwarth Walden, 'Vorrede', in *Erster Deutscher Herbstsalon*, exh. cat., Berlin 1913, p. 6.

8 Both lost their lives: Macke in the first year of the war, 1914, and Franz Marc fell on 4 March 1916 near Verdun.

9 Cf. Magdalena Bushart, 'Der Expressionismus, ein deutscher Nationalstil?' *Merkur* vol. 45, no. 5 (May 1991), pp. 455–462.

10 Raoul Hausmann, 'Der deutsche Spiesser ärgert sich' ['The German bourgeois sees red'], December 1919, cit. in *Hannah Höch. Eine Lebenscollage*, vol. 1 (1889–1920), ed. by the Berlinische Galerie, Berlin 1989, p. 620.

11 Ibid.

12 Ibid.

13 Webster points out that Walden needed Merz and used it to re-establish his gallery's battered reputation after the war as the champion of the avant-garde; cf. Gwendolen Webster, *Kurt Merz Schwitters: A Biographical Study*, Cardiff 1997, p. 53f.

14 Letter from Kurt Schwitters to Raoul Hausmann of 10 October 1921, in *Hannah Höch. Eine Lebenscollage*, vol. 2 (1921–1945), part 2, p. 30.

15 Kurt Schwitters, 'Ich und meine Ziele', in *Merz 21. Erstes Veilchenheft* [first violet issue], Hanover 1931, cit. in Lach 1981 (see note 1), p. 345.

16 See note 10.

17 Letter from Kurt Schwitters to Herwarth Walden of 1 December 1920, in *Kurt Schwitters. Wir spielen, bis der Tod uns abholt. Briefe aus fünf Jahrzehnten*, collected, selected and with a commentary by Ernst Nündel, Frankfurt am Main/Berlin 1974 (1986), p. 42.

18 The fame of the gallery 'Der Sturm' and Walden's financial acumen led to the collector and founder of the Société Anonyme, Katherine Dreier, on her visit to the gallery in 1920, discovering Kurt Schwitters's work for the USA and acquiring several pieces. Cf. Gwendolen Webster, 'Kurt Schwitters and Katherine Dreier', in *German Life and Letters*, Oxford (New Series), vol. LII, no. 4, October 1999, pp. 443–457.

19 On the understandable doubts regarding the trustworthiness of Hausmann's anecdote, cf. Webster 1997 (see note 13), p. 50.

20 Raoul Hausmann, 'Kurt Schwitters wird Merz', in Hausmann 1992 (see note 4), p. 70f.

21 Richard Huelsenbeck, 'Dada und Existentialismus', in *Dada. Monographie einer Bewegung*, ed. by Willy Verkauf, Teufen 1957, p. 59.

22 The advertisement was printed in *Der Dada No. 2* (December 1919); cf. illustration in *Hannah Höch* 1989 (see note 10), p. 621.

23 Letter from Richard Huelsenbeck to Kurt Schwitters of 12 January 1920; one sheet, Ms. in the notebook *Bleichsucht und Blutarmut* (catalogue raisonnée Kurt Schwitters, cat. no. 730). Warmest thanks to Dr Isabel Schulz of the Kurt Schwitters Archiv, Sprengel Museum Hannover, for directing my attention to this hitherto unpublished letter.

24 Cf. illustration in *Hannah Höch* 1989 (see note 10), p. 722.

25 In his attempt to achieve recognition as a visual artist, Hausmann had taken up contact with the gallery 'Der Sturm'. Early in 1916, Walden offered him – probably in preparation for the gallery's 41st exhibition in May of that year – the opportunity of showing his figuratively Expressionistic works for the first time in a joint exhibition with, as Hausmann later mockingly put it, the 'youths Hans Richter and Georg Schrimpf'. The egocentric Hausmann refused and thus cut off his connection to 'Der Sturm'. Cit. in *Hannah Höch* 1989 (see note 10), p. 103.

26 The title *qjyE* comes from Hausmann's poster poem *OFFEAH*. There are two letters that refer to a plan to publish this periodical: a hitherto unpublished letter from Hausmann to Schwitters of 11 October 1921 (two sheets, in the notebook *Bleichsucht und Blutarmut*, cat. raisonnée Kurt Schwitters, cat. no. 730) and a letter from Schwitters to Arp, published by Nündel 1974 (see note 17), p. 76f. Here the title has been wrongly transcribed as *qhgE*. Nündel's dating of the letter 'before 1923' should be replaced by the more precise 'October 1921'. Moreover, the manifesto referred to in this letter that demands 'elemental art' is not, as Nündel suggests in his commentary, the *Manifest Proletkunst* [Proletarian Art Manifesto], 1923, but rather the *Aufruf zur elementaren Kunst* [Call to Elemental Art], published in *De Stijl*, 10 (October 1921).

See in this context also the correspondence between Schwitters, Hausmann and van Doesburg, in *Hannah Höch. Eine Lebenscollage* 1989 (see note 14), pp. 30f., 32f., 33.

27 Raoul Hausmann, 'Kurt Schwitters wird Merz', in Hausmann 1992 (see note 4), p. 71.

28 Kurt Schwitters, 'Ich und meine Ziele', in *Merz 21. Erstes Veilchenheft*, Hanover 1931, cit. in Lach 1981 (see note 1), p. 345.

29 Kurt Schwitters, 'Daten aus meinem Leben' [Facts from my life], 1926, cit. in Lach 1981 (see note 1), p. 241.

30 Kurt Schwitters, 'Krieg', in *Merz 2. Nummer i* (April 1923), cit. in Lach 1981 (see note 1), p. 142.

31 Raoul Hausmann, Pamphlet 'Gegen die Weimarer Lebensauffassung' [Against the Weimar philosophy of life], 1919, reprinted in Hausmann 1992 (see note 4), pp. 85–87.

32 Grosz' sentence is cited from a privately-owned proof-sheet for *dadaco*, cit. in Bergius 1989 (see note 3), p. 12.

33 Kurt Schwitters, cit. in Theo van Doesburg, 'Charakteristik des Dadaismus', in *Theo van Doesburg. Das Andere Gesicht. Gedichte, Prosa, Manifeste, Roman. 1913–1928*, Munich 1983, p. 113.

34 Adolf Behne 1920 (see note 5).

35 'Weimar [= the Weimar Republic] is nothing but a lie, Teutonic barbarism in disguise.' Raoul Hausmann, 'Dada empört sich regt sich und stirbt in Berlin,' [Dada revolts, surges and dies in Berlin], in Hausmann 1992 (see note 4), p. 18.

36 Cf. illustration of the pictorial quotations in *Dada-Rundschau* in *The Photomontages of Hannah Höch*, exh. cat., Walker Art Center, Minneapolis/The Museum of Modern Art, New York/Los Angeles County Museum of Art, 1996/1997, p. 27; see also the detailed interpretation of this image by Hanne Bergius in *Hannah Höch 1889–1978. Ihr Werk, ihr Leben, ihre Freunde*, ed. by Museumspädagogischer Dienst, Berlinische Galerie, Berlin 1989, pp. 101–106.

37 Raoul Hausmann, 'Kurt Schwitters wird Merz', in Hausmann 1992 (see note 4), p. 72.

38 Richard Huelsenbeck 1957 (see note 21), p. 57.

39 Kurt Schwitters, 'Ich und meine Ziele' cit. in Lach 1981 (see note 1), p. 340.

40 Cf. Isabel Schulz, 'Die Kunst ist mir zu wertvoll, um als Werkzeug missbraucht zu werden' [Art is worth too much to me to be misused as a tool]. Kurt Schwitters und die Politik', in *Schwitters Arp*, exh. cat. of the Kunstmuseum Basel, Ostfildern 2004, pp. 197–204.

41 Kurt Schwitters, in *Gefesselter Blick. 25 kurze Monografien und Beiträge über neue Werbegestaltung*, ed. by Heinz and Bodo Rasch, Stuttgart 1930, cit. in Lach 1981 (see note 1), p. 335.

42 Kurt Schwitters, 'Kurt Schwitters', in *Merz 20. Kurt Schwitters Katalog*, [Hanover 1927], cit. in Lach 1981 (see note 1), p. 252.

43 Kurt Schwitters, 'Merz', in *Der Sturm*, June 1927, cit. in Lach 1981 (see note 1), p. 187.

44 Ibid.

45 'Manifest Proletkunst', in *Merz 2. Nummer i,* (April 1923), cit. in Lach 1981 (see note 1), p. 144.

For Me There is No Such Thing as Unpolitical Art Klaus Staeck

**How do you define political art?
How do you perceive your role within
this definition?**

The concept of 'political art' is basically a tautology, as I think art cannot take place in a social no-man's-land if it is to be more than pure ornament without any intrinsic value. In this sense it can be a political decision to tackle aesthetic questions in abstract terms, if nothing but a prescribed form of figurative art is expected and promoted by the state. The opposite is of course also true. The much-invoked autonomy of art has often enough been proven to be fictitious.

I have by now got used to being constantly pigeon-holed as a 'political artist', since the public clearly needs to be provided with certain characteristics and classifications in order to come to terms with the special qualities of my socially involved work, and to differentiate more precisely between this and *l'art pour l'art*.

**Is collage a 'political' medium which
is particularly suited to certain types
of political content?**

Collage was *the* medium of the previous century. That's true of all the arts. Collage makes it possible to portray contradictions, contrary courses and paradoxes in a visually striking way without masking out the essential. Collages often work like puzzles. The viewer can form a picture for himself out of the separate pieces. He becomes, in the truest sense of the word, the partner of the artist. And it should be self-evident that collage is particularly suited to political and social content. This is especially true when it comes to the stylistic medium of satire.

New technological possibilities allow images to be made with computer programs that are only at second or third glance – if at all – recognizable as collages. This favours, on the one hand, the potential of working satirically. On the other hand, this new perfection will also, before too long, reduce the artist's chances of enlightening by means of photomontage, a medium that has until now been particularly effective in my work. The viewer's faith in the photograph's authenticity, and hence also in the photomontage, will for this reason progressively diminish.

**What comes to you first? Is it the wish
to criticize a certain social or political
anomaly, or is it the raw material of a later
image?**

It's not really possible to make sharp distinctions here. However, as a rule I do tend to make a particular social problem the central theme of my work. Then I look for an aesthetically satisfying means of communicating it visually. That can often take a long time, which is no bad thing in the sense that the themes I give most of my time to are those that have the longest-lasting influence. Ephemeral news rarely interests me. For the rest, I have a large archive of pictures – coupled with a good pictorial memory – which I reckon will provide me with a useful image or two when I need it.

**Do you consider Kurt Schwitters
a political artist?**

As I mentioned before, to my mind no art can be defined as unpolitical. Of course there is a difference between Schwitters's art and the more precisely political collages of a John Heartfield from the same period.

It was surely not without a certain deeper meaning that Schwitters referred to his work in terms of the 'detoxification of the material', the removal of unaesthetic residues and trace elements. Even though he freed his raw material from the dust of the everyday in order to turn it into art, the viewer can still interpret some of his collages as signs of the times. Reworked fragments of text and picture titles such as 'Blutiger Tag in Berlin' (A bloody day in Berlin), 'Mai 191', *Die heilige Sattlermappe (The Holy Saddlers' Portfolio)*, 1922 (see illus. p. 159), 'Versaille', *(Mz. 170. Leere im Raum) (Mz. 170. Void in Space)*, 1920 (see illus. p. 160), 'As Girls Fall' (see illus. p. 167) and *Ein Beitrag zur Sanierung Deutschlands (A Contribution to the Refurbishment of Germany),* 1931, (see illus. p. 167) all stir associations that are more political than purely aesthetic.

The questions were ask by Heinz Stahlhut.

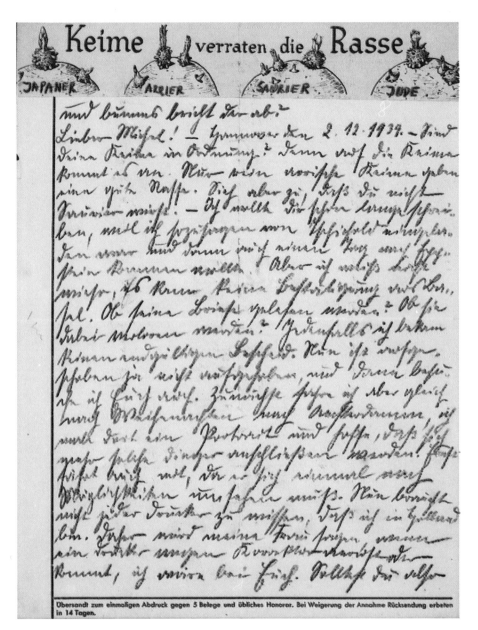

Cat. 178
Brief von Kurt Schwitters an Robert Michel
'Keime verraten die Rasse',
Letter from Kurt Schwitters to Robert Michel
'Seeds Betray the Breed',
Hanover, 2 December 1934
Manuscript: one sheet written on both sides
Archive Robert Michel / Ella Bergmann-Michel
Sprengel Museum Hannover

and pow it breaks off?
Dear Michel! – Hanover 2. 12. 1934
– are your own germ cells in good order? It all depends on the germ cells. Only pure Arrian [sic] germ cells produce a good race. Mind you don't become a dinosaur though. I had intended to write to you for ages, since I was more or less invited to visit Tschichold and then wanted to come to Eppstein for a day. But I can't yet say, I haven't had any confirmation from Basel. Are his letters being read? And does that mean they get lost? At least I heard nothing definite. Whatever, postponed doesn't mean suspended, and when it does happen I'll make sure to visit you too. My next trip, however, will be to Amsterdam, immediately after Christmas; I'm due to paint a portrait there and hope this will open the door to more of the same! Ernst is coming too, since he has to look for opportunities. Of course nobody need know I'm in Holland. So if for instance a printer telephones or comes round to see me about galley-proof corrections, my wife will tell him I'm visiting you. Therefore, if you should receive any post addressed to me, please send it on immediately <u>to Helma</u>, who will be staying at home.
I assume we will be in Holland for about 2 months, and hope it's easier to earn money there than it is here. Enjoy your trout! Affectionate regards,
Yours M

'dada is important to me' [1] Thomas Hirschhorn

dada is important to me, in my mind's eye i can always see those few photos of the big international dada fair in berlin in 1920, those photos give me hope, because dada shattered every established idea of art, dada made a definitive break with the past, dada put an end to the nobility of art, of heritage and talent, dada took the world, reality and passing time as a tool for making art, dada took social awareness as a material for making art. dada used art as critique and dada used art as a form of action, dada despised 'art for art's sake' and dada made anti-art. dada is important for my work as an artist, because dada broke with the history of art, dada made a new start and made everything possible without having to invent it, for dada didn't invent anything, but dada took cubism, the readymade, collage, typography, photomontage, futurist and surrealist ideas and gave them a unity, dada took all these separate ideas and assembled them, dada forged links and gave these isolated elements unity, dada connected what could not be connected.

i like the work of marcel duchamp, of john heartfield, of kurt schwitters, and in my mind's eye i can always picture those photos of the *merzbau (merz building)* in hanover, those photos give me hope, i am not cynical, i want to work without illusions and without fantasies, i want to act through and by means of art, hope not as a dream or escape, hope as action, hope as the capacity to face and confront, but also hope as an affirmation, the affirmation that art must conquer a mental space and that art must get into people's brains.

you can't always do subversive work with a theoretical statement, subversion must prove its existence in today's reality and subversion must prove its ability to endure in time, as an artist i must be lucid, awake and attentive, it's no use applying the term 'subversion', however i do need to prove its meaning in and with my work.

1 English translation of a French text which Thomas Hirschhorn sent to the Museum Tinguely in May 2003.

Cat. 154
*Untitled (Collaged Portrait Postcard
'Kurt Schwitters' to Walter Dexel)*
27 May 1921
Collage and ink on cardboard
14 x 9 cm
Galerie Gmurzynska, Cologne

Cat. 153
*Portrait Postcard 'The Pleasure Gallows'
with drawing to Walter Dexel*
5 March 1921
Ink on cardboard
14 x 9 cm
Galerie Gmurzynska, Cologne

Cat. 15
Aq. 10. (Ich mühle, du mühlst, er mühlt.)
Aq. 10. (I Grind, You Grind, He Grinds.)
1919
Watercolour and pencil on paper
25.3 x 20.4 cm
Galerie Gmurzynska, Cologne

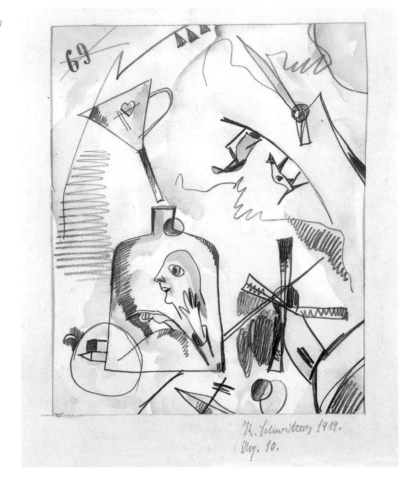

Cat. 14
Aq. 9. (Windmühle.)
Aq. 9. (Windmill.)
1919
Watercolour and pencil on paper
17.3 x 14.4 cm
Sammlung E. W. K., Bern

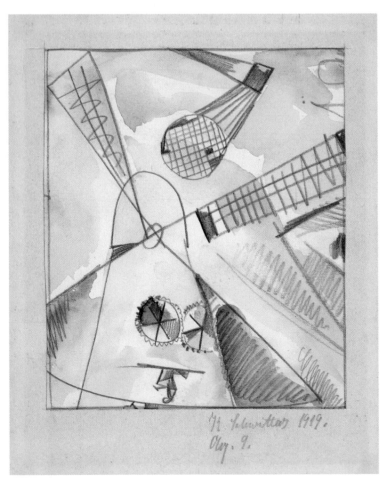

Cat. 16
Aq. 21. Anna Blume und ich.
Aq. 21. Anna Blossom and I.
1919
Watercolour and coloured pencil on paper
21.1 x 17.2 cm
Kurt und Ernst Schwitters Stiftung, Hanove

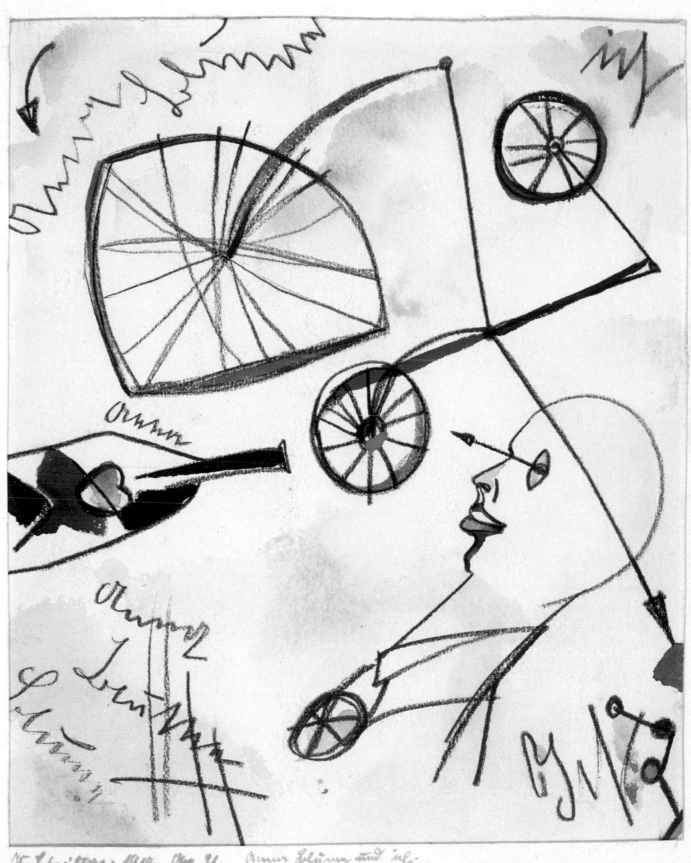

K. Schwitters. 1919. Ang. 21. *Anna Blume und ich.*

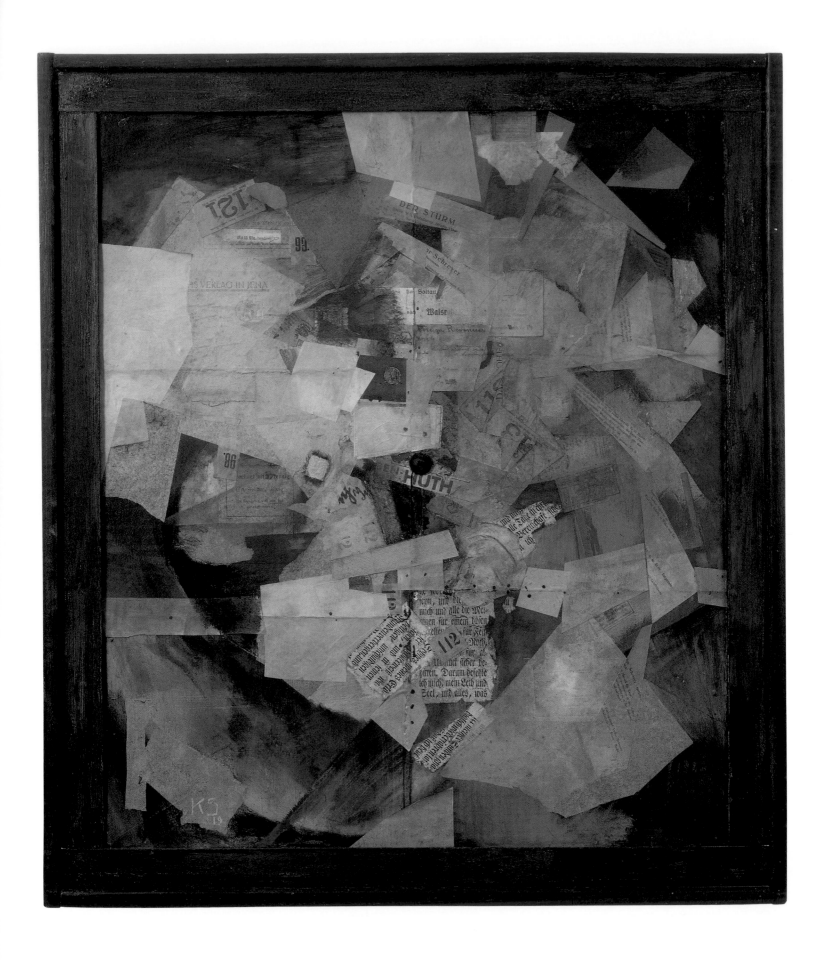

Cat. 5
Mz 11 Starkbild.
Mz 11 Strong Picture.
1919 (1921)
Collage on cardboard
11.5 x 9.5 cm
The Menil Collection, Houston

Cat. 4
Merzbild K 6 Das Huthbild
Merzpicture K 6 The Huth Picture
1919
Collage and oil on pasteboard on wood
87 x 74 cm
Private collection

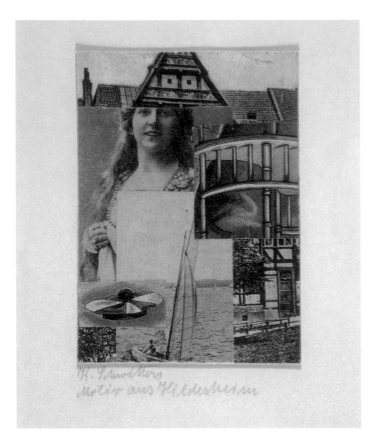

Cat. 63
Motiv aus Hildesheim
Motif from Hildesheim
Circa 1922
Collage on paper
11.1 x 8 cm
Private collection

Cat. 30
Mzz. 62 Zeichnung teig
Mzz. 62 Drawing Dough
1920
Collage, gouache and indelible pencil on paper
13.1 x 10.1 cm
Sprengel Museum Hannover,
Dauerleihgabe aus Privatbesitz

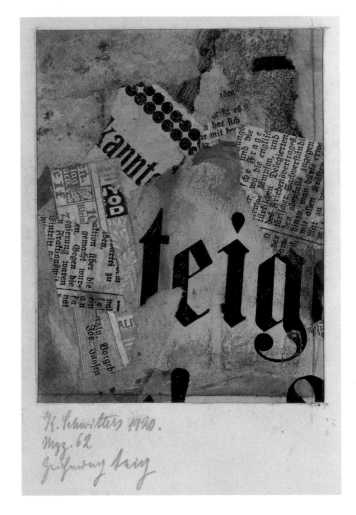

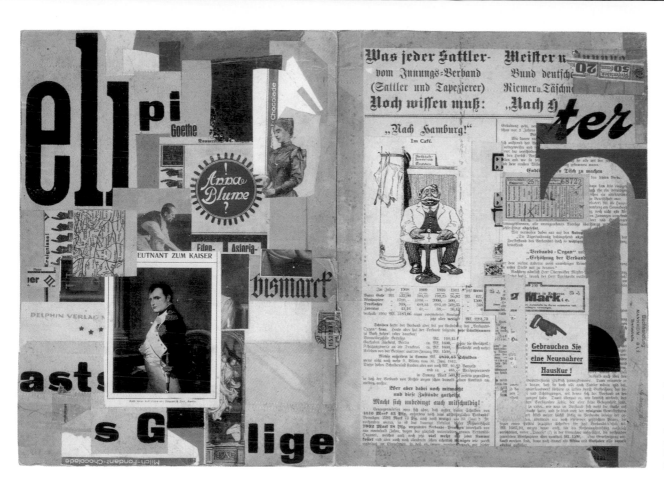

Cat. 62
Die heilige Sattlermappe
The Holy Saddlers' Portfolio
1922
Collage on cardboard
(joined in the middle)
38.4 x 55.8 cm
Claude Berri

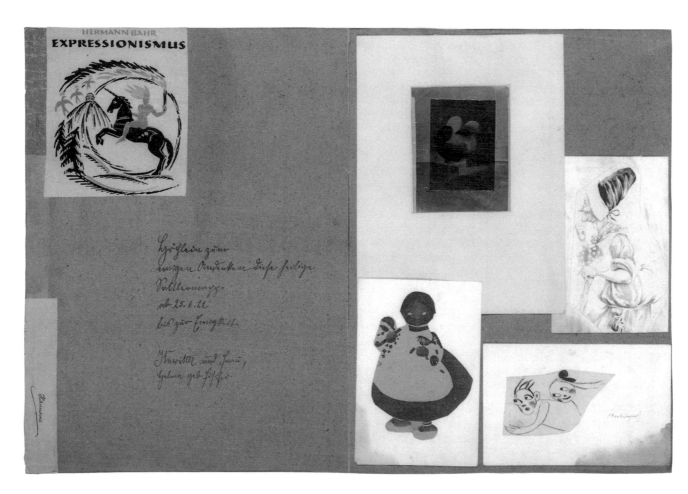

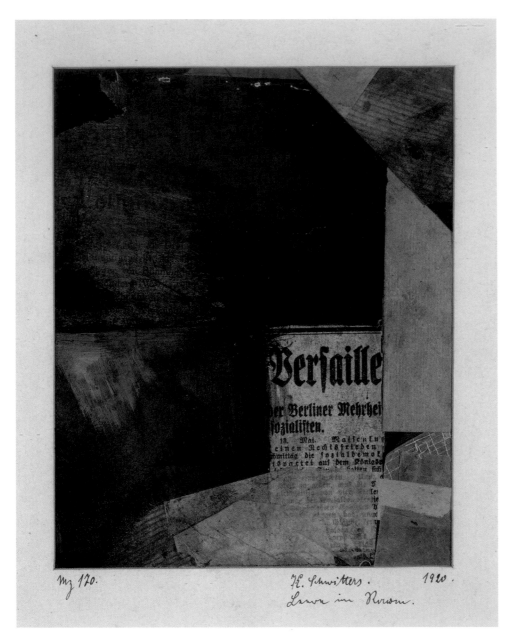

Mz 170. H. Schwitters. 1920.
Leere im Raum.

Cat. 36
Mz 170. Leere im Raum.
Mz 170. Voids in Space.
1920
Collage on paper
18 x 14.4 cm
Private collection

Cat. 28
Siegbild
Victory Picture
1920–1925
Assemblage and oil on pasteboard on
wood frame
36.5 x 27.6 cm
Wilhelm-Hack-Museum,
Ludwigshafen am Rhein

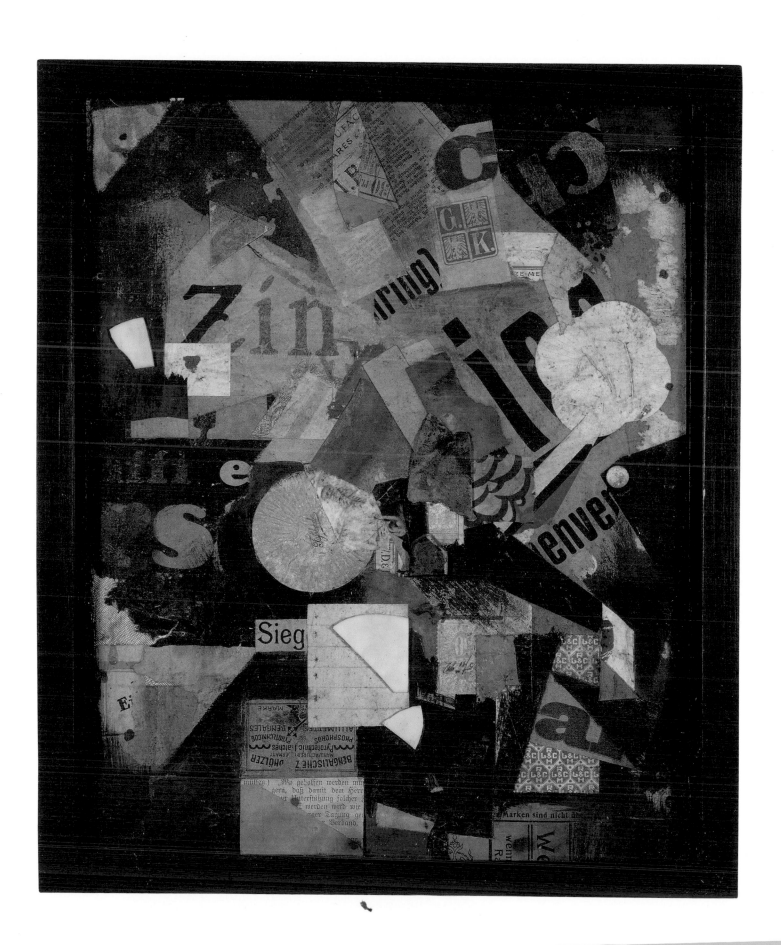

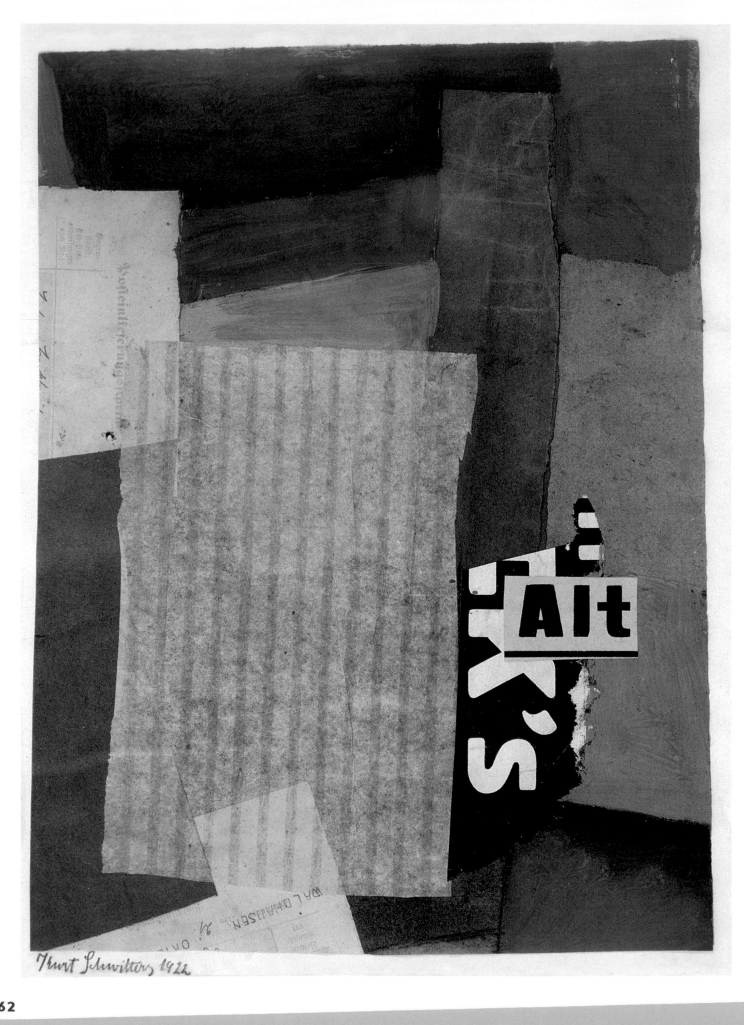

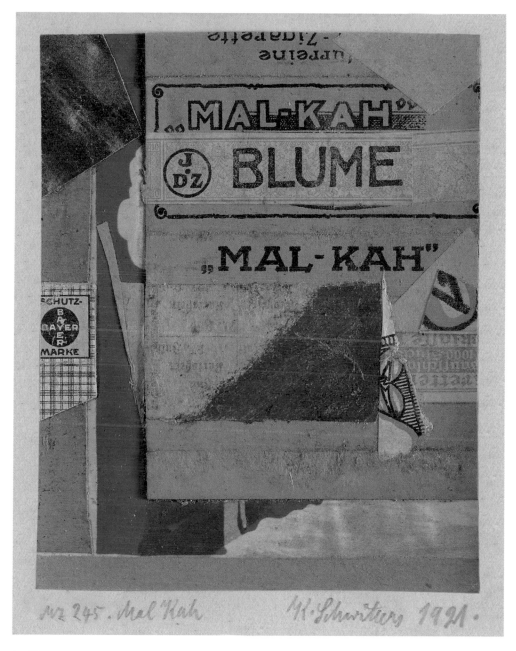

Cat. 52
Mz 245. Mal Kah
1921
Collage and chalk on paper
12.5 x 9.8 cm
Sammlung Sonanini,
Switzerland

Cat. 61
Ohne Titel (Alt)
Untitled (Old)
1922
Collage and gouache
on paper
31.7 x 22.7/23.5 cm
Private collection

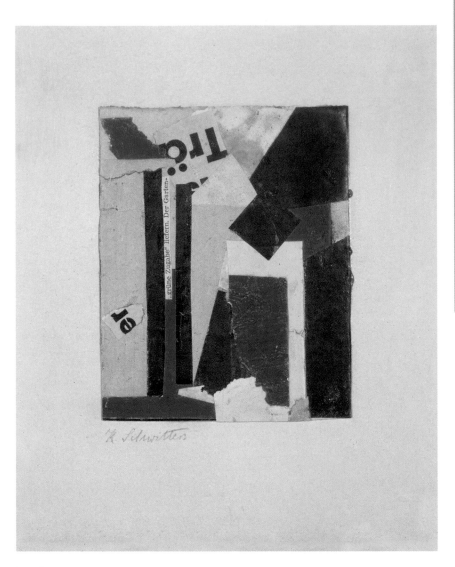

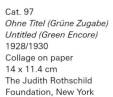

Cat. 97
Ohne Titel (Grüne Zugabe)
Untitled (Green Encore)
1928/1930
Collage on paper
14 x 11.4 cm
The Judith Rothschild
Foundation, New York

Cat. 39
Ohne Titel (Merzzeichnung rä)
Untitled (Merzdrawing rä)
1920–21
Collage on paper
12.5 x 10.1 cm
Private collection, courtesy
of Ubu Gallery, New York

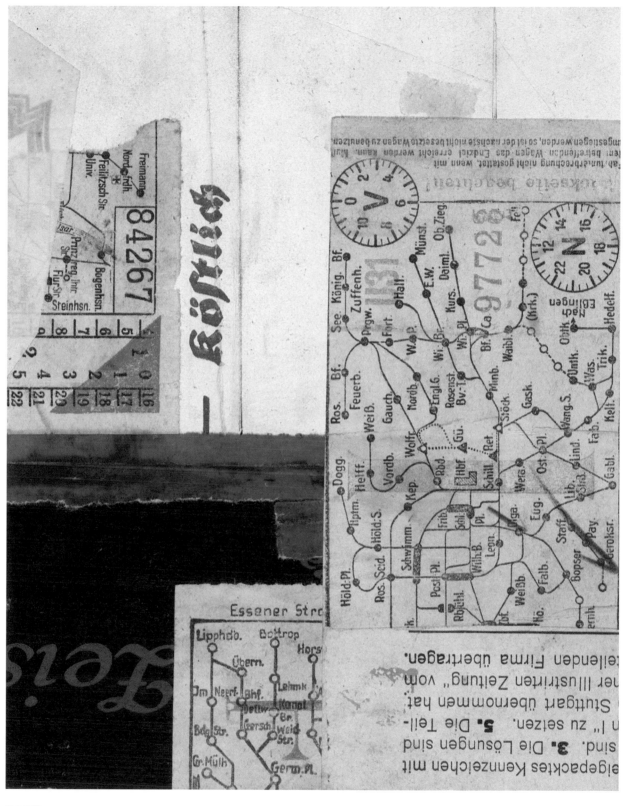

Cat. 107
Ohne Titel (Köstlich)
Untitled (Delicious)
1929/30
Collage on paper
13.8 x 11 cm
Sprengel Museum Hannover,
Nachlass Robert Michel

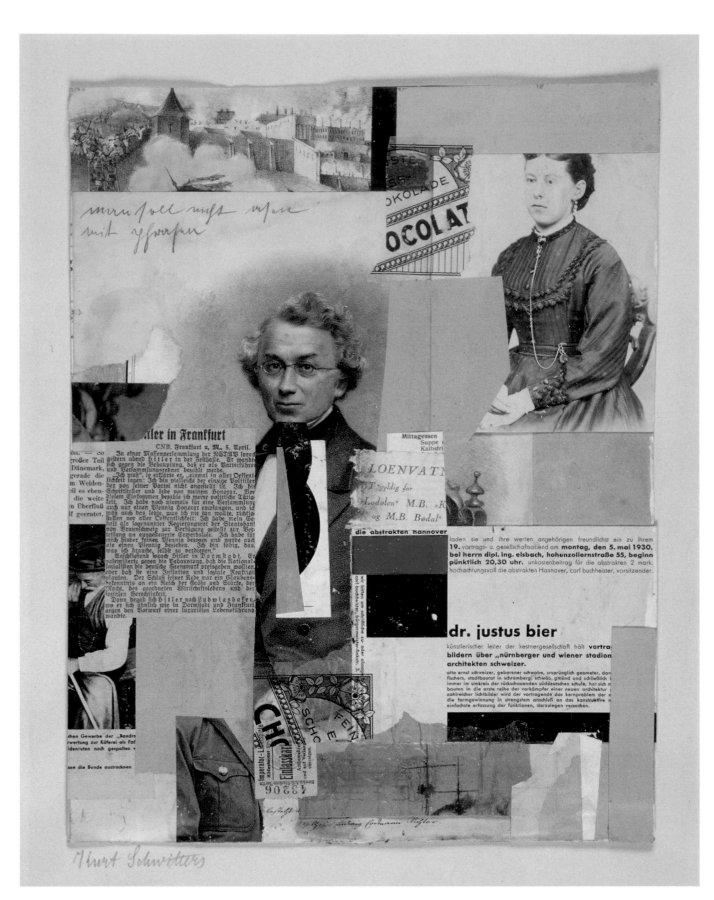

Cat. 115
Man soll nicht asen mit phrasen
You Should Beware of Hot Air
1930/31
Collage on paper
36.5 x 28.5 cm
Private collection, Zurich

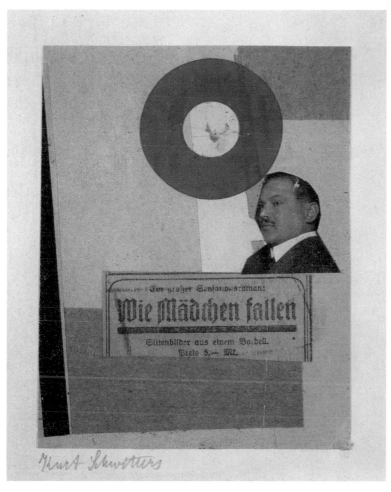

Cat. 80
*Ohne Titel (Wie Mädchen
fallen)*
Untitled (As Girls Fall)
1924/1926
Collage on paper
14 x 10.9 cm
Private collection, Europe

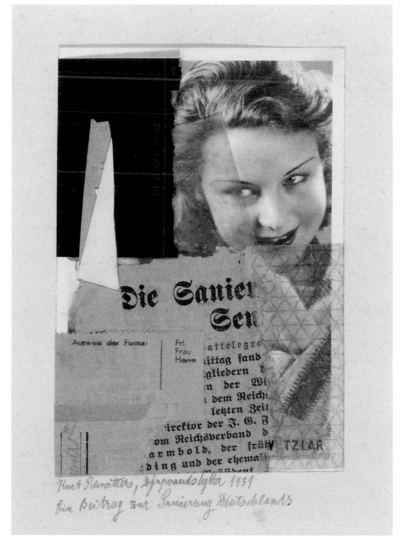

Cat. 119
Ein Beitrag zur Sanierung Deutschlands
A Contribution to the Refurbishment of Germany
1931
Collage on paper
15 x 10 cm
Private collection

Schwitters and Chance Christian Janecke

Illus. 1
Kurt Schwitters
Merzbild 46 A. Das Kegelbild
Merzbild 46 A. The Skittle Picture
1921
Assemblage, oil, wood, metal and card
47 x 35.8 cm
Sprengel Museum Hannover

Even a cursory glance at Schwitters's *oeuvre* or what has been written about it shows that accident is clearly an integral element even in the most unlikely places. (Melancholics will doubtless notice that such accidents are themselves haphazardly distributed both in his works and in the secondary literature.) Most authors, however, find their sensibilities disturbed by this ubiquitous diagnosis of chance; it seems palatable only if it appears as an exception, a detour, or as something in which Schwitters was supreme, in other words which he mastered.

If for instance the Sprengel Museum catalogue of 1987 places *Merzbild 46 A. (Das Kegelbild) (Merzpicture 46 A. [The Skittle Picture])* (1921) (see illus. 1) in the category entitled 'The world of games and chance', with the perfectly correct explanation that chance is 'thematized' in this work[1] – it is still unclear from the text what this picture has more to do with: interesting visual *accidents* or Murillo's dice-throwing boys. One could at least expand on what literature has to say about Schwitters's apparently random scattering of objects by mentioning that the wooden frame here latently takes on the role of a box or playing-field, so that both the two skittles and the cotton-reels appear only temporarily placed – as if they could at the merest touch unbalance the composition. Schwitters's choice of completely plastic objects in this assemblage, untypical for him, allows him not just to address the theme of chance, but also to rouse the viewer's expectations of actual chance processes.

This initial awkwardness when dealing with chance could be explained in terms of a childhood ailment of the early Schwitters, who had become infected with Dada before Merz was able to stand on its own feet.[2] Indeed, the respective attitudes to chance do differ considerably. Not so much for the Zurich Dadaists, but certainly for the Berlin group at whose door the young Schwitters had knocked in vain, chance was part of the anti-programme: where the petty bourgeois citizen expected meaning, order, coherence, one had to give him the opposite. And the one-man movement 'Merz', i.e. Schwitters, did not want to 'dismember' but to 'heal and to mend'.[3] His antagonist Richard Huelsenbeck even scented the 'deutsche Wald' [German forest] in him, and notable art historians suspected that Schwitters entertained romantic, even cosmic feelings about the world.[4] In this light, chance for Schwitters might be seen as only a brief love-affair, or the wrong name for a strategy that was actually aimed at overcoming chance. A similar thing applies when the focus shifts from possible metaphysical affinities to Schwitters's stance toward the current art scene – it makes no difference whether we see in Schmalenbach's words the 'late Expressionist in Dadaist clothes' or follow Elderfield's résumé, according to which 'Schwitters may be thought of as practising his own personal form of Dada as fine art within a late-Expressionist context.'[5] The rubber-stamp drawings of the early Schwitters, still very much under the influence of 'Der Sturm',[6] can be considered, despite their apparent tendency to play with accidental elements, almost classic demonstrations of overcoming chance. Of course the words printed in this way, most of them repeatedly, make a virtue out of necessity in that they correspond to the rubber stamps that were (by chance) to hand. However, not only could Schwitters begin with the rubber-stamp action and then immediately embellish the results with carefully se-

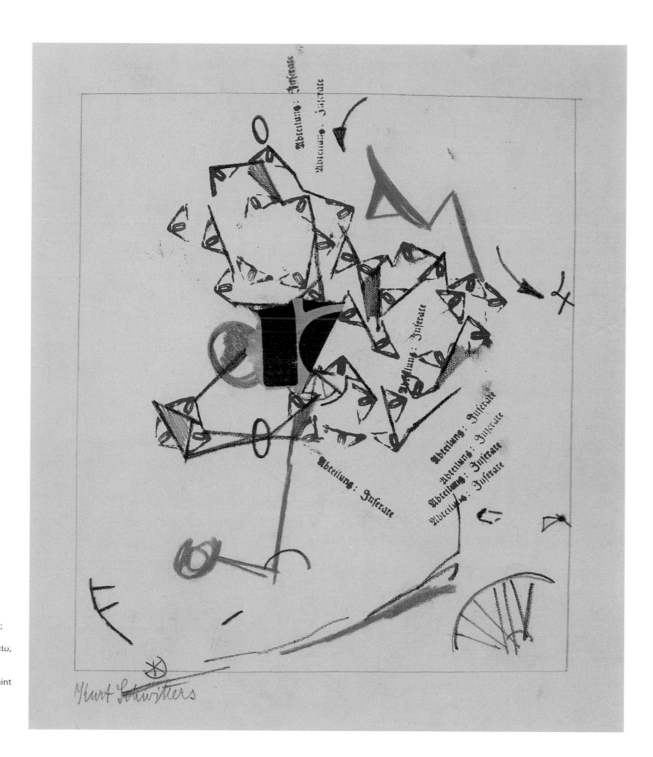

Cat. 12
Ohne Titel (Abteilung: Inserate) recto;
Schwank II. Teil, verso
Untitled (Department: Small Ads) recto;
Untitled (Farce Part II) verso
1919
Collage, chalk, lead pencil, stamp paint
on paper (verso and recto)
31.5 x 24.5 cm
Kunsthaus Zug, Depositum Stiftung
Sammlung Kamm

lected internal drawing to remove the chance aspect, i.e. make them plausible; he also obliterated the semantics of the words in instances when he was not specifically aiming at 'visual texts',[7] by turning the stamp-impressions into meta-drawings that were fused into abstract or on occasions ostentatiously simple figurative shapes.[8] In *Ohne Titel (Abteilung: Inserate) (Untitled [Department: Small Ads])*, 1919, (see p. 169) the impressions are themselves of pictorial quality, particularly when joined together. The carefree attitude toward semantic malapropisms (or, for that matter, the search for them) certainly gives a Dadaist slant to these rubber-stamp drawings, yet the delicate internal drawing has a happy visionary note that leads rather to Paul Klee than to the rule of chance.[9] As mentioned above, while there is general agreement that chance appears as a force in the works of Schwitters, whatever form it may take, its significance is often played down: this is done by marginalizing works that are particularly affected (for instance the i-Drawings)[10] and concentrating on those in which chance can be viewed more as a profitable detour. Just as visitors in US zoos rate highly the fact that the panda developed in the course of its evolution from a carnivore to a herbivore, i.e. became more 'refined', art history values, at least in the pre-war modernist period, those artists in particular who do not simply avoid chance but who expose themselves to its whims and injustice from the start, in order by a great effort to raise it to the status of 'happy fate' *(tyche)*, in whose shape the former random elements are dissolved and the artistic achievement shines out all the more brightly.[11]

However, while we may be able to spend ages in front of a painting wondering which brush-stroke only retrospectively lost the dross of its accidental aspect, a collage consists of signals that give plenty away. A pasted-on postage stamp tells us doubtless more about itself – that is, what it *had been* as a postage stamp – than a painted one is able to do. And although Schwitters collected considerable amounts of potential material for his works, he might still be missing exactly the right fragment for a given spot X in a collage he had perhaps already begun, something that would satisfy the aesthetic or 'pictorially rational' demands of the piece. In other words, the accidental aspect that adhered even to the most suitable found element transposed itself to a certain or even to a considerable degree onto and into the picture[12] – regardless of the next question, whether (and how) such a fragment appears sublimated into the whole of the composition. At this point a comparison with Cubist collage, such as those developed by Pablo Picasso and Georges Braque from 1912/13 on, is useful. Here, external material was built into a pictorial context that had been painted with collage-type cut-out forms that anticipated, or at least prepared for, what was to be added.[13] The probability of finding things that 'fitted' was therefore high. In fact, it was extraordinarily high, considering that for instance newspaper fragments, in other words texts, were essentially texture, and coloured paper or wallpaper could also be used and if necessary reworked with paint. At any rate this material was rarely arbitrary in the sense that it represented a compromise. By 'compromise' I understand in this context that the prototype of a thing can be determined, for instance something striped, but not or only incompletely the specifically individual version or edition of that thing (in this case the

Illus. 2
Kurt Schwitters
Mz 272. Der Harz
Mz 272. The Harz
1921
Collage on paper
36.7 x 29.7 cm
Kupferstichkabinett,
Staatliche Museen zu Berlin

Illus. 3
Kurt Schwitters
Mz 231 Miss Blanche.
1923
Collage on paper
15.6 x 12.5 cm
Private collection

very particular pattern and colour of the stripes).

Schwitters's found objects are conversely often very specific in form and content. They do not normally speak of the general but of the specific. However, the probability of *finding* (not *making*) precisely the special thing needed is extremely small. As a result, we find many such 'compromises' appearing in his work. For instance, in *Mz 272. Der Harz (Mz. 272. The Harz)*, 1921, (see illus. 2) the fact that number combinations are both visible and legible may be put down to the artist's choice, but not the fact that we see precisely these combinations and no others. This is particularly pertinent in the case of Schwitters's occasional use of newspaper advertisements, whose highly complex combination of image and text he partially modifies by cutting out and overlapping pieces, yet which frequently seem to be obeying the old separatist principles that govern inserted images. *Mz 231 Miss Blanche.*, 1923, (see illus. 3) spreads out hermetic pictorial narratives or picture-suggestions like layered carpets, each of which appears (or should appear) arbitrary in relationship to the others, were it not for the fact that it is precisely here we find the 'de-formulation' process which Schwitters propagated, a term which his interpreters gratefully took up. Its function is to denude things and fragments of their burdens of meaning so that they become pure elements of form and colour.[14] Which means that the dutiful observer should no longer enjoy the picture for its Dutch tram tickets (with the note to the passenger to retain the ticket until the end of the journey) or the two different kinds of cigarette coupons, but solely for its composition of mainly rectangular shapes in a rectangular order of variously weighted

colour and form. Anyone who asks why 'contaminated' original material had been necessary in the first place could, if it seems apt, find a correspondence between the evident orientalism of the cigarette advertisement and its de-formulated version (for instance ochre as reference to a sandy desert). Travel brochures from Thomas Cook expect nothing less of us today, and it works with Schwitters too in this case – but it remains the exception to the rule.

His major works of the early nineteen-twenties are characterised more by a far more complex combination of small elements. Moreover, one has to consider their various formats, some of them corresponding to the 'utensil format', which assumes the silhouette of the real objects. These elements appear in many-coloured fragments scattered over the picture area, with here and there a fragment of printed text showing through. This diversity can scarcely be gathered under a common heading. But if the idea of 'conjunction' poses problems, one might still enthuse about that of the 'concert', in the sense of the 'orchestration' of the pictorial elements. Such metaphors derive from the wish once more to deflect the impression of chance which objectively clings to the given coincidence. This attitude would however be based on an error that I define as *retrospective contingency reduction*, i.e. the mental removal of chance after the event.

On the first level, this means that on observing for instance a dry-stone wall, we might say a stone picked at random, however oddly chance may have shaped it, could only fit into one particular space – while suppressing the notion that many other stones, though not necessarily all the stones available, could

Cat. 84
Ohne Titel (5 So Mo Die)
Untitled (5 So Mo Die)
1925
Collage on paper
13.7 x 11.1 cm
Collection of Carroll Janis,
New York

have been put in its place as long as the wall was being built. Only after this stone had been surrounded on all sides did it acquire ex post facto the appearance of necessity.

On the second level, the error of *retrospective contingency reduction* means that, in another instance, chance remnants of fabric from the nineteen-twenties give us more of an impression of harmony, of a secret conversation, than would remnants found in a contemporary department store. Today, we have thousands of other designs and colours in the back of our minds and therefore correctly assess the randomness of the given collection, while in the case of the antique remnants the accidental element is obscured by the sense that they are a common witness to a specific period. Since the 'dialect' of their unconnected babble is no longer our own, we have always inferred a 'conversation'.[15]

With reference to Schwitters this means that what we perceive from today's standpoint as the delicate colouring, the graphic care taken in framing even a simple logo, the expressive and daring typography, the exclusive air communicated by the contrasts of light and shade and the ornaments even on cigar bands all suggest more intercoherence than they formerly possessed. This chance-mitigating distortion of our total impression is something that we may recognize, but can only with difficulty define and scarcely avoid. Besides this, Schwitters has given art historians plenty of material that leads to an ultimately anti-chance interpretation. For instance, his cherished cast-offs from language and the visible sphere only remain analogous of a world seen as chaotic (and the scourge of a world forced into norms) in the light of their past. His aim for the future is that the art made from these fragments should rather be-

come 'a spiritual function of man, which aims at freeing him from life's chaos (tragedy)'.[16] The Schwitters of the early twenties is unsurpassed, as far as the combination of richness and variety in the elements of his collages and assemblages is concerned. This is correspondingly evident in its polyphonic, sometimes almost chaotic overall effect. If we moreover reflect that, thanks to our tendency to 'retrospective contingency reduction', we already sense more harmony and coherence than is actually proper, a certain arbitrariness becomes undeniable. However, to what extent it plays a part depends above all on the *degree* of the 'de-formulation' already mentioned.

Had Schwitters indeed wholly 'de-formulated' the pictorial elements, the effect of the works just described would probably not differ greatly from those he made using neutral elements from the start. There are works by Schwitters which are composed predominantly of monochrome papers pasted on top of one another, for instance *Ohne Titel (Mz ELIKAN ELIKAN ELIKAN), (Untitled [Mz ELIKAN ELIKAN ELIKAN])*, around 1925 (see illus. 4). There can be practically no talk of chance here, since not only are pure colour-forms precisely selectable even in a collage, but their number also helps to even out unintentional effects within the composition. But not only do such already self-'refined' works remain the exception, their effect is clearly very different from that of Schwitters's more typical pieces which are full of unmatured symbolic and verbal meanings. And here the verbal, ornamental and in some cases even pictorially naturalistic trophies are only *partially* de-formulated, by being fragmented, taken out of context, or placed upside down;[17] or by means of repetition or visual

Illus. 4
Kurt Schwitters
Ohne Titel (Mz ELIKAN ELIKAN ELIKAN)
Untitled (Mz ELIKAN ELIKAN ELIKAN)
1925
Collage on paper
43.5 x 36 cm
The Museum of Modern Art, New York,
Katherine Dreier Bequest

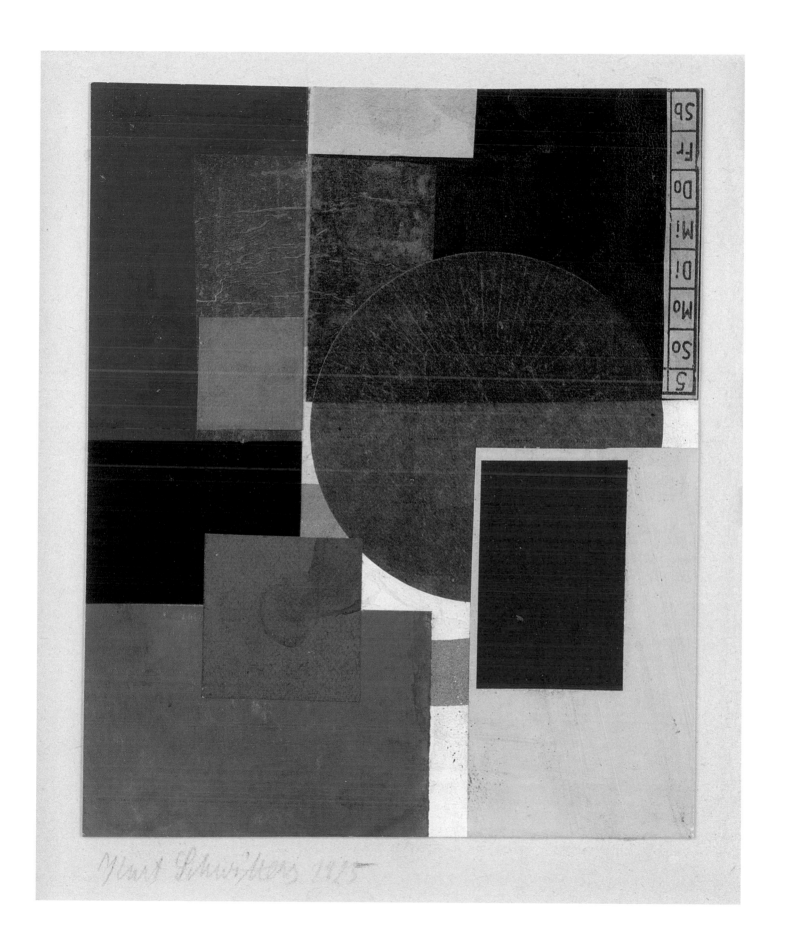

similarities between lines of text, words or letters. For only in Expressionist usage, or occasionally to different effect in Constructivist work, does the repetition of a word create emphasis, while in Schwitters's work the semantics of individual words are actually weakened by repetition and incline toward a (typo)graphical echo. Yet the meaning is not entirely suspended, which causes the reception of such works often to swing between close reading of detail and the broad view of larger contexts; or else the two modes inextricably overlap. [18] This leads to an immense heightening of complexity. The paradox is that precisely the effort of the viewer to hunt for the meaning of the whole, that is to determine a plausible relationship between pictorial, verbal and material meanings, forces him into ever greater compromises. Filtering out characteristic traits in which, colloquially speaking, 'one thing leads to another', is for Schwitters only possible at the expense of rejecting equally plausible alternatives.

Given this more or less *partial* 'de-formulation' in Schwitters's works and the inevitably resulting overlapping of 'signification menus', a strictly traditional view of art history could conclude that this opens the door wide to chance – after all, it is clear that each viewer has to beat his own path through the jungle of interferences, and that the fruits he finds on the way might not be discovered by others, nor can he be certain that it was Schwitters who planted them there. A more liberal view would object that this is in principle true of all works of art; it is just that Schwitters was boldly ahead of his time. With the work of Robert Rauschenberg, and at the latest that of a Dieter Roth, a widening chasm between subjective exegesis and the awareness that a work could only ever be viewed aspect by aspect and differently from all others became an unavoidable standard of art appreciation.

The arbitrary nature not so much of the givens within these works, but rather of the reciprocal relations resulting from them, of the ever different, yet legitimately co-existent discoveries that are found in many of Schwitters's works (and in those of his younger imitators with their less sublimated aggregates of material, semantic and pictorial complexity) can thus be given a name. [19] The question remains how to assess it, especially in view of what came after Schwitters. If the countless configurations that can run through Tinguely's late amassed, weighty mechanical constructions, based as they are on complex causality, can hardly be predicted by the viewer (in the case of Calder's mobiles, this is practically impossible), and cannot be precisely determined even by the artist, one can still take the sum of many such situations to arrive at a mean – in the same way that it is possible to recognize in the constantly changing and individually arbitrary *steps* a person takes a characteristic *gait*. [20]

Whether one chooses to draw the line here between intention and chance in every detail or rather focuses on the whole is not solely a question of one's own laissez-faire attitude, since a pedantic definition of 'intention' can be wrongly placed in cases where an accumulation of accidental details makes the whole more predictable. A pertinent example is dice-throwing, where the more the dice are thrown, the more probable an even distribution of numbers becomes. The principle of the homogenization of the whole while the details remain uncontrollable is of particular importance for divisionist painting, for some of François Morellet's works and of course for

Jackson Pollock. In Schwitters's case it may not play a direct role, but I think we should bear this principle in mind, particularly when considering his complex works built of many small elements in any way as 'characteristic'.

The exactly corresponding principle is given where comparatively few elements, each having little or nothing intrinsically to do with chance, produce unpredictable results when brought into conjunction. Where this co-incidence happens one should, at least where works of art are concerned, distinguish between two fundamental tendencies.

In the first case, the coinciding elements can appear within a work in an unmixed state, i.e. simply arranged in close proximity, so that their hybrid effect – which the artist cannot plan in every detail – is literally in the eye of the beholder. Examples of this can be frequently seen in works with Surrealist leanings.[21]

In the second case, these elements can visually overlap one another within the work itself, which produces results that cannot be totally intentional. More precisely, the layering itself may well be the artist's intention, even in certain cases how the components are arranged; yet the resulting overlap contains immense incalculables. If for instance we come across a deliberate decision where two transparencies bearing printed views are superimposed so that a church tower in each view is placed on precisely the same spot, the rest of the frame containing the surrounding houses can not be freely chosen. If these transparencies are then pushed freely about against one another, it becomes clear that the number of compromises is always far greater than the number of possibilities for deliberate choice.[22]

Schwitters's i-Drawings fundamentally belong to the second type of coincidence method, that is they work with direct layers in a way that even heightens the accidental aspect: for in failed prints that already exist Schwitters can influence neither the kind of overlap nor its components – although he may be able to choose from large folios of such failed prints and can also determine in his choice of extracts how much and what should be visible. Schwitters himself speaks candidly about the accidental aspect that causes things to happen upon one another; the artist's job is only to 'recognize and limit'.[23]

Comments on Marcel Duchamp having been a forerunner of Schwitters in this respect are often qualified in the relevant literature with the remark that Schwitters is not working anti-aesthetically; for him a simple act of declaration is not enough.[24] If this is true for what Schwitters does not want, one must then ask what he wants. In my view Schwitters's method is in phases, that is in his choice of external objects, outwardly related to Duchamps' act, although he is concerned with the as yet unseen aspects in objects, in the things other people reject, which he is able to see, mark and in so doing rehabilitate. It is an almost humble gesture, devoid of sarcasm. And precisely in this way he becomes the precursor, as yet unrecognized, of 'reality art',[25] which in the 1980s was understood to be less a particular school of art than the discovery and photographic documentation of non-artistic, everyday combinations of objects that had artistic potential. In both cases the marked discoveries legitimate themselves by their involuntary similarity to freshly established (so scarcely older) tendencies in art. In 'reality art', the fence around a building

site can recall minimalism, and piles of objects in a hallway can recall assemblages of Nouveau Réalisme; Schwitters paraphrases Constructivism, for instance, in his *Z. i. 28 Bild wie Galgen (Z. i. 28 Picture like Gallows.)*, 1923 (see illus. 5), and Futurism in a whole row of works, among them *Z. i. 24. spielendes Kind nach Boccioni (Z. i. 24. Playing child after Boccioni)*, 1926, (see illus. p. 183) – even using direct allusion.

The attitude here is thus very different to the one demonstrated for instance in Jean Tinguely's *Drawing Machines* of the nineteen-fifties.[26] The consciously simple, machine-driven, apparently accidental motions in Tinguely's work[27] – shown as an accumulative graphic trace on a stretched piece of drawing paper – may have appeared to resemble the products of a long-established school of art, in this case the brush drawings of the Informel, yet the point lay in its parody of this school and not in an attempt to transfer the prestige of informal drawing onto its chance-generated relations, which is what Schwitters would probably have done.

In order to arrive at a proper assessment of the provocation of Schwitters's demands on society to accept the role of chance in art, one must distinguish it from the spectacularly revelatory role that chance plays at least in the case of Tinguely's *Méta-Matics* and also from the differently-weighted attitude of Marcel Duchamp. In contrast both to Schwitters and to Tinguely, Duchamp does not principally discuss the arbitrary *within* art, but rather the ostensible 'paradigms' and 'laws' which turn something into art in the first place, and which are actually only conventions in the literal sense, i.e. contingent agreements that might have turned out otherwise. Consequently he demonstrates with

sarcasm how non-art can *become art* if the context is changed. The i-Drawings and later reality art are however intent on showing that non-art, at least in individual cases, already *is* art, only that it has been overlooked.

If the i-Drawings in particular pave the way for the artistic egalitarianism and openness to chance seen in later generations, it is of altogether somewhat dubious merit that Schwitters devised compensatory strategies on a higher level that make chance elements appear plausible, by means of their re-anchoring in a system of his own invention which he calls 'Merz'. Such a system, despite its overall contingency, gives the impression of inwardly-directed contingency reduction. This can be explained with reference to systems which originally contained no deviousness or even intent: as an example, life could enter the world by means of evolution and certain objects could occur capriciously, which comes down to chance. By existing for long enough in nature, they acquired by their very 'seniority' – the length of time they had been in service, as it were – a right of abode, and at some point they appeared necessary to us, relatively that is to the new arrivals of which we like to say: that could have happened differently, so it's all a matter of chance. This new matter joins the waiting list to become established and finally to become part of the canon, and if things go well, it will become equally indisputable and will thus lose the taint of chance.

This process can now be imitated and accelerated to a phenomenal degree in private miniature worlds such as in the system of 'Merz'. While a whole culture may take years or decades to struggle through to the point where it 'remits' the accidental origin of a

Illus. 5
Kurt Schwitters
Z. i. 28 Bild wie Galgen.
Z. i. 28 Picture like Gallows.
1923
Reject print, edges cut
16.6 x 13.3 cm
Kurt und Ernst Schwitters Stiftung, Hanover

given thing, in more comprehensible systems the process is a lot faster. A child faced with a collection of toy figures quickly suppresses the compromises necessary to their manufacture or acquisition. The fact that the plinths on which they stand are blue instead of green is only a momentary disturbance and tomorrow will appear inevitable. Applied to Schwitters, this means that in the first instance, it is the job of the individual image to remove the chance element from, say, a sequence of numbers on a tram ticket, in other words to provide a context that will render them less arbitrary. [28] As we have seen, Schwitters did not exactly throw himself into this task. And as we have also seen, the individual image could never be equal to the task – unless Schwitters were to mobilize all the other elements in the picture to render this one element plausible.

But to compensate for this Schwitters has superordinate systems. Not for all his works, but for some of them and for fragmentary pieces, there is the *Merzbau (Merz Building)*. Not only can many things be incorporated into this system, but it also makes the rules. What would have appeared arbitrary to us if we could still enter the original *Merz Building* would not have been so at all under its regiment.

And the same is true of the overruling 'Merz system': relative to its laws which seem unfathomable to us as individuals, any accusation of randomness seems trivial. The question is, of course, whether we as faithful interpreters should accept these laws. If we do, we behave like a referee who determines that the penultimate runner in a hundred-metre race is the winner – because according to the private rules of this particular runner yellow socks are essential in a race and only he is wearing them. If we copy this referee, we may 'understand' Schwitters better and appreciate his chance elements as hard and fast ordinances, but nobody will understand *us* anymore.

In all of this, including the 'buttering up' of willing recipients of his work, Schwitters was a leader; certainly up to Joseph Beuys' concept of 'social sculpture', [29] the prime example for the conversion of idiosyncratic and contingent claims into an order striving for meaningfulness and a resistance to chance.

1 Cf. Norbert Nobis, 'Die Welt des Spiels und des Zufalls', in *Kurt Schwitters, 1887–1948*, exh. cat., Sprengel Museum Hannover, Hanover 1987, p. 146 (text), illus. p. 147.

2 Martina Kurz emphasizes a 'latent principle of order' in Merz art that was influenced by the Constructivists. 'This art, which lay weight on harmonious design and discredited principles such as chance and gratuitousness, had necessarily to run contrary to Dadaism, which passionately propagated these very principles.' Cf. Martina Kurz, 'Ursachen und Beginn der grossen glorreichen – künstlerischen – Revolution in Revon. Kurt Schwitters und Hannover um 1920', in Gerhard Schaub (ed.), *Kurt Schwitters, 'Bürger und Idiot.' Beiträge zur Werk und Wirkung eines Gesamtkünstlers. Mit unveröffentlichten Briefen an Walter Gropius*, Berlin 1993, pp. 18–30; here p. 30.

3 Eberhard Roters, *fabricatio nihili oder Die Herstellung von Nichts. Dada Meditationen*, Berlin 1990, p. 216.

4 Werner Schmalenbach's expression in *Kurt Schwitters* [no translator credited], New York 1967, p. 114; cf. also Roters 1990 (see note 3), who detects a 'Franciscan nature'; Schwitters might be working with rubbish, but only in order to 'take pity on it' and to give things 'a new sanctity', see p. 216 and p. 218; thus Merz becomes the 'great, extensive and complicated enterprise of a poetic Samaritan', p. 227. Elderfield entitles one whole chapter – echoing Huelsenbeck's frequently cited comparison – 'The Kaspar David Friedrich of the Dadaist Revolution'. John Elderfield, *Kurt Schwitters*, London and New York 1985, pp. 30–48.

5 Elderfield 1985 (see note 4), p. 42.

6 Cf. Magdalena Müller, 'Schwitters und die Geburt von MERZ', in exh. cat. 1987 (see note 1), p. 103f.

7 Cf. Christina Weiss, *Seh-Texte. Zur Erweiterung des Textbegriffes in konkreten und nach-konkreten visuellen Texten*, ed. by the Institut für moderne Kunst Nürnberg, Zirndorf 1984.

8 Elderfield 1985 (see note 4), p. 47, says something similar when he maintains that it is even possible to 'draw' using rubber-stamp impressions.

9 Ibid.

10 Schmalenbach 1967 (see note 4), pp. 126–127.

11 On the difficulty of documenting 'happy chance' in a work of visual art – i.e. not just using anecdotes and statements by the artists themselves – see Christian Janecke, *Kunst und Zufall, Analyse und Bedeutung*, Nuremberg 1995, pp. 17–20 and pp. 61–94 (examples).

12 See e.g. Schmalenbach 1967 (see note 4), p. 123.

13 Cf. William Rubin (ed.), *Picasso und Braque. Die Geburt des Kubismus*, exh. cat., Kunstmuseum Basel, Munich 1990 (especially illustration section p. 244ff.).

14 Lambert Wiesing practically insists on this aspect, since it indirectly supports his own understanding of Schwitters's images: 'One normally sees things in a picture that are not there. In the collage this principle is reversed: here, the things that are really present are not to be seen for themselves but as artificial constructs made exclusively of form and colour, which is not what they are as tangible objects.' According

to Wiesing, Schwitters achieves precisely this transformation by means of 'de-formulation'. Lambert Wiesing, *Phänomene im Bild*, Munich 2000, pp. 22, 134f.

15 In Schwitters's case one must add that he treated some of his materials first, so that even then they had a 'patina'. Cf. the discussion of this aspect in Monika Wagner, *Das Material der Kunst. Eine andere Geschichte der Moderne*, Munich 2001, pp. 60–63.

16 Kurt Schwitters, *Manifest Proletkunst*, 1923, p. 24, cit. here from Elderfield 1985 (see note 4), p. 116.

17 Far too little attention is paid to this relatively simple aspect when the question arises whether the viewer should literally read anything in the picture at all, and if so, what. A possible explanation for this is that Schwitters was also known as a poet. When reading a (sound) poem in which the letters are printed upside down, it is of course possible simply to turn the book round; but should we always do this (mentally) with a picture on the wall?

18 This alone does not necessarily mean overcomplexity; as we have seen in the case of *Mz 231 Miss Blanche.* (1923), text and image can be supported, even made plausible, by an interpretation of works composed of a *few clear* elements. But such works are not representative of Schwitters's *oeuvre*, and in that sense they distract from the problem being discussed here.

19 Examples in *Aller Anfang ist Merz: Von Kurt Schwitters bis heute*, exh. cat., Sprengel Museum Hannover et al., Ostfildern 2000; see here Dietmar Elger, 'Kurt Schwitters und der Nouveau Réalisme', pp. 296–301 (especially on Arman and the Décollagistes); see also in the same catalogue examples of more recent work by Laura Kikauka, Dieter Roth, John Bock.

20 This parallel is used by Janecke 1995 (see note 11), p. 232; on the problem of chance in kinetic works of complex causality, see ibid., pp. 227–264.

21 For instance Meret Oppenheim, *Déjeuner en fourrure* (1936); cf. Janecke, *Koinzidenz*, chapter IV, pp. 131–152.

22 A text-book example of this problem is Jasper Johns' *0-9 U.L.A.E.* (1960); see Oppenheim 1936 (see note 21), p. 144f.

23 Kurt Schwitters, 'Kunst und Zeiten', 1926, cit. here from Elderfield 1985 (see note 4), p. 189.

24 Cf. Schmalenbach 1967 (see note 4), p. 127; Elderfield 1985 (see note 4), p. 206; Norbert Nobis in the exh. cat. 1987 (see note 1), p. 160.

25 Cf. Thomas Wulffen (ed.), 'Realkunst – Realitätskünste. Eine Begriffsbestimmung und begleitendes Material', special issue of *Kunstforum International*, vol. 91, Oct./Nov. 1987.

26 Cf. Andreas Pardey, 'Méta-Matics. Drawing Machines', in *Museum Jean Tinguely. Eröffnungsausstellung 1996/97*, exh. cat., Museum Jean Tinguely Basel, Bern 1996, pp. 40–47.

27 I say *apparently* accidental' because – under the conditions of perfectly functioning mechanisms – one would always arrive at the same result if the original position, the nature and length of rotation etc. were all identical. But these factors always vary in practice, and besides, the fact that the process is in principle determinable does not make the process any less opaque to the viewer. The smallest variations, i.e. alterations in the cause, produce completely different effects. So the drawings are random in the sense that their exact phenomenality could not be intended.

28 It is clear that any context can be construed around a chance element in order to give it a meaning that at least appears plausible and coherent – and this is the point of Borges's *The Library of Babel*. A single randomly positioned letter of the alphabet could, translated into one of the 'secret languages' of the heavenly library, conceal 'a terrible meaning'. Cit. from Hans Ulrich Reck, 'Aleatorik in der bildenden Kunst', in Peter Gendolla and Thomas Kamphusmann (eds), *Die Künste des Zufalls*, Frankfurt am Main 1999, pp. 158–195, p. 167.

29 On the problem of chance in 'social sculpture' see Janecke 1995 (see note 11), pp. 250–261 and p. 264.

Cat. 10
Ohne Titel (Der Sturm)
Untitled (Der Sturm)
1919
Collage, stamp paint, lead pen[?]
and chalk on cardboard
(verso and recto)
23.5 x 19.2 cm
Sammlung E. W. K., Bern

Cat. 13
Ohne Titel (Römer oder Komposition Nr. 5)
Untitled (Roman or Composition No. 5)
1919
Coloured pencil, chalk,
stamp paint on paper
19 x 15.9 cm
Daria Brandt & David Ilya Brandt,
New York

Cat. 7
Ohne Titel (Berlin-Friedenau)
Untitled (Berlin-Friedenau)
1919
Collage, stamp paint and
coloured pencils on paper
20.2 x 16.4 cm
Kurt und Ernst Schwitters Stiftung, Hanover

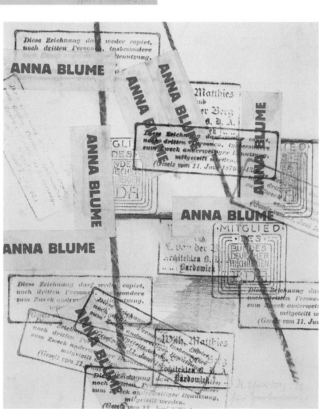

Cat. 65
Für Hartmann.
For Hartmann.
1922
Collage, stamp paint and
coloured pencils on paper
19.2 x 15.7 cm
Marlborough International Fine Art

Cat. 8
Ohne Titel (Anna Blume hat ein Vogel)
Untitled (Anna Blume has Bats in her Belfry)
1919
Collage, stamp paint, lead and
coloured pencils on paper
19.1 x 16.8 cm
Margo Pollins Schab Inc., New York

Cat. 89
Z i 101. Begegnung.
Z i 101. Encounter.
1926
Defective print, trimmed
16.6 x 13.7 cm
Sprengel Museum Hannover,
Sammlung NORD/LB in der Niedersäch-
sischen Sparkassenstiftung

Cat. 100
i-Zeichnung 'Pferd'
i-Drawing 'Horse'
1928
Defective print, trimmed
17.8 x 13.6 cm
Sprengel Museum Hannover

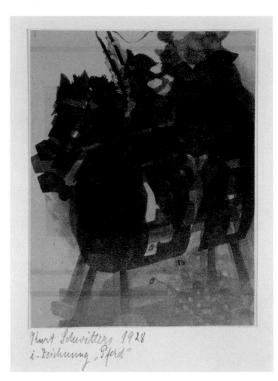

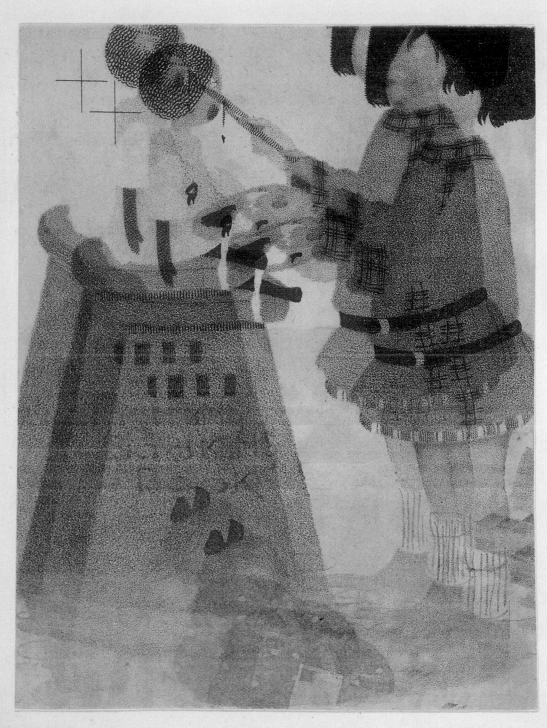

Z. i. 24.

spielendes Kind nach Boccioni

Kurt Schwitters. 26.

Cat. 88
Z. i. 24. spielendes Kind
nach Boccioni.
Z. i. 24. Playing Child
after Boccioni.
1926
Defective print, trimmed
16.2 x 12.4 cm
Indiana University Art Museum,
Bloomington

Cat. 41
Zeichnung I 8 Hebel 1
Drawing I 8 Lever 1
1920
Defective print on paper, trimmed
13.3 x 10.7 cm
Kurt und Ernst Schwitters Stiftung, Hanover

Cat. 42
i-Zeichnung
i-Drawing
1920
Defective print on paper, trimmed
6.2 x 4.8 cm
Private collection, courtesy of
Ubu Gallery, New York

Cat. 40
Z. i. 3 neu ausgestattet.
Z. i. 3 Newly Furnished.
1920
Defective print on paper, trimmed
14.5 x 10.8 cm
Cabinet des estampes,
Musée d'art et d'histoire, Geneva

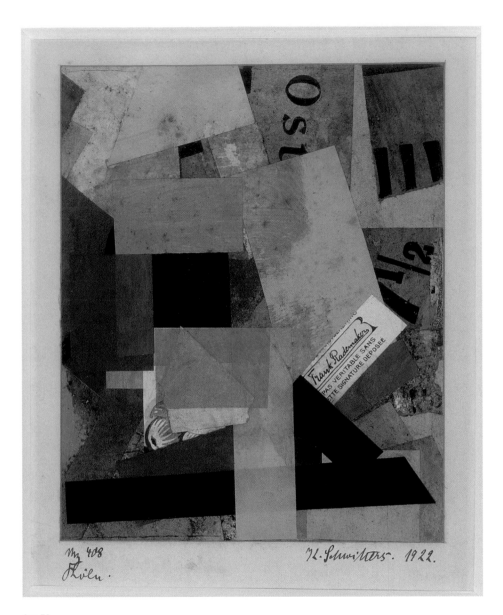

Cat. 59
Mz 408 Köln.
Mz 408 Cologne.
1922
Collage on paper
21 x 16 cm
Private collection

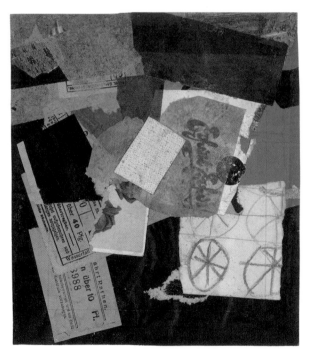

Cat. 81
Ohne Titel (Erfurt-Erfur)
Untitled (Erfurt-Erfur)
1924/26
Collage on paper
22.2 x 19.6 cm
Collection of Jasper Johns

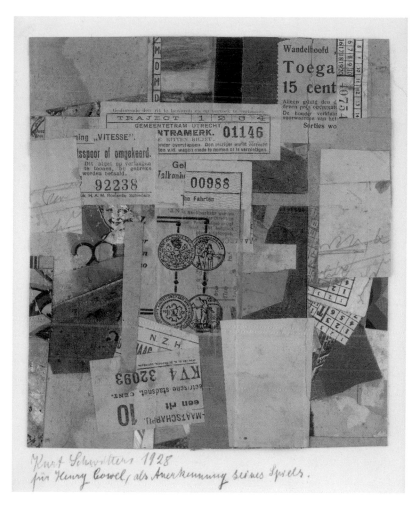

Cat. 96
für Henry Cowel [sic!],
als Anerkennung seines Spiels
To Henry Cowel [sic!],
in Recognition of his Performance
1928
Collage on paper
18.4 x 16.2 cm
Collection of Jasper Johns

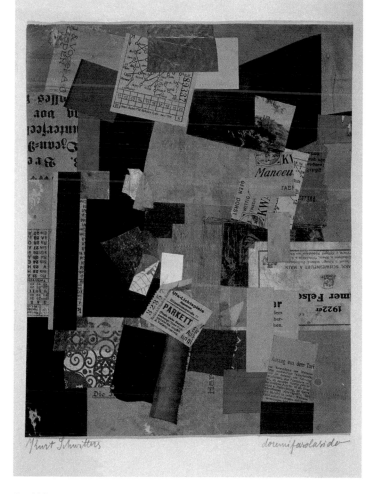

Cat. 112
doremifasolasido
Doremifasolasido
Circa 1930
Collage on paper
29.4 x 23.3 cm
Private collection, Switzerland

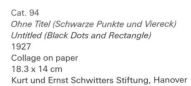

Cat. 94
Ohne Titel (Schwarze Punkte und Viereck)
Untitled (Black Dots and Rectangle)
1927
Collage on paper
18.3 x 14 cm
Kurt und Ernst Schwitters Stiftung, Hanover

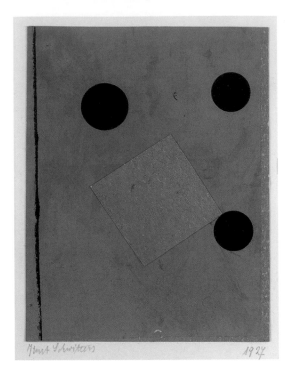

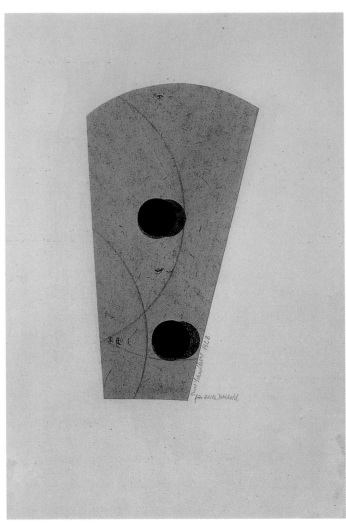

Cat. 99
für Edith Tschichold
For Edith Tschichold
1928
Pencil on defective print, trimmed
19.4 x 10.5 cm
Private collection

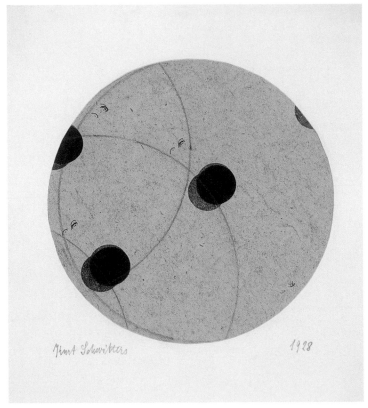

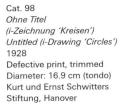

Cat. 98
Ohne Titel
(i-Zeichnung 'Kreisen')
Untitled (i-Drawing 'Circles')
1928
Defective print, trimmed
Diameter: 16.9 cm (tondo)
Kurt und Ernst Schwitters
Stiftung, Hanover

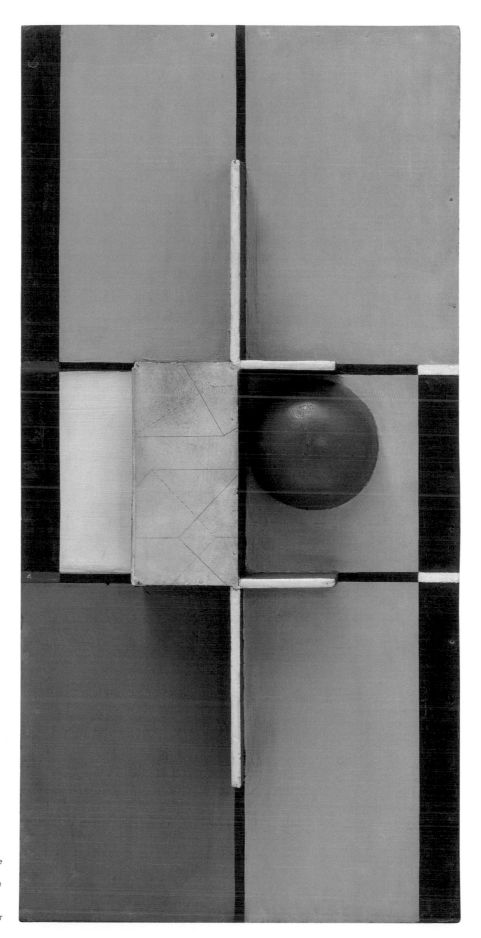

Cat. 76
MERZ 1924, 1. Relief mit Kreuz und Kugel
MERZ 1924, 1. Relief with Cross and Sphere
1924
Relief, ink (?), oil, cardboard, synthetic plate
and ladle on wood on pasteboard
69.1 x 34.4 x 9.3 cm
Kurt und Ernst Schwitters Stiftung, Hanover

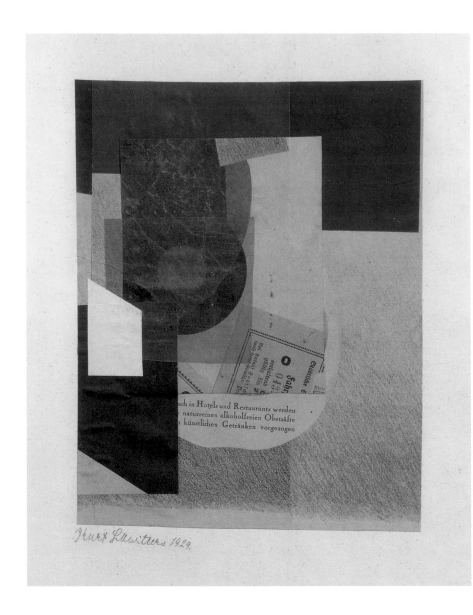

Cat. 106
Ohne Titel (in Hotels)
Untitled (In Hotels)
1929
Collage on paper
25.2 x 19.8 cm
Private collection

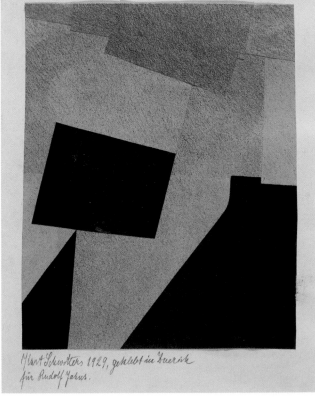

Cat. 105
geklebt in Zuerich für Rudolf Jahns.
Pasted in Zurich for Rudolf Jahns.
1929
Collage on paper
21.4 x 17 cm
Sprengel Museum Hannover,
Leihgabe aus Privatbesitz

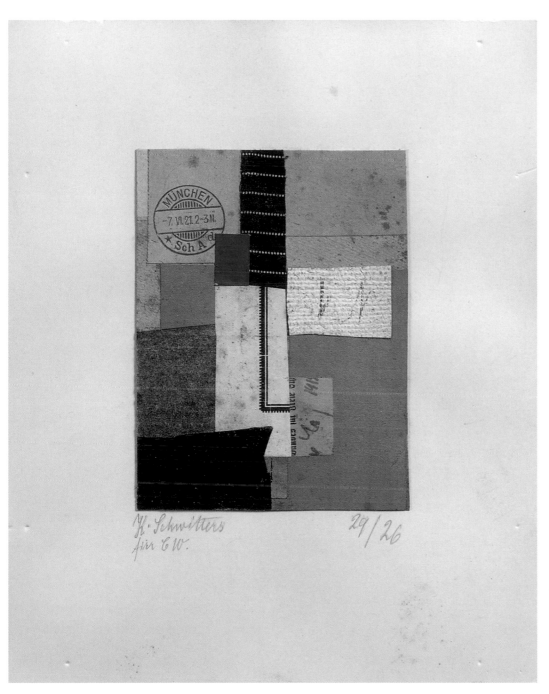

Cat. 103
29/26 für C W.
29/26 For C W.
1929
Collage on pasteboard
14.5 x 11 cm
Private collection

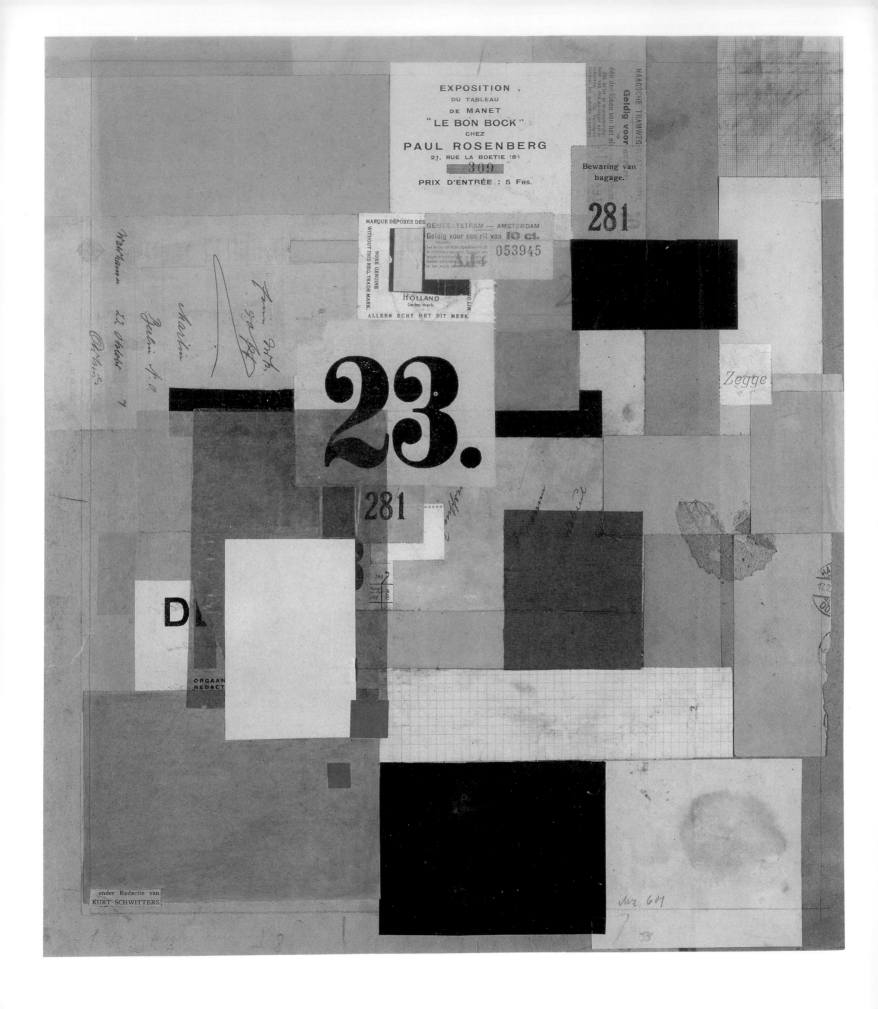

Cat. 92
Mz. 134.
1927
Collage on paper
15.7 x 14.1 cm
Kurt und Ernst Schwitters
Stiftung, Hanover

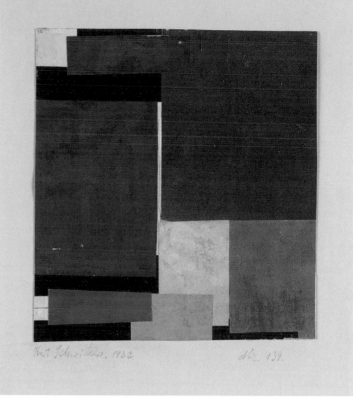

Cat. 93
Ohne Titel (M 1)
Untitled (M 1)
1927
Collage on paper
13.5 x 9.9 cm
Staatliche Museen zu Berlin,
Kupferstichkabinett

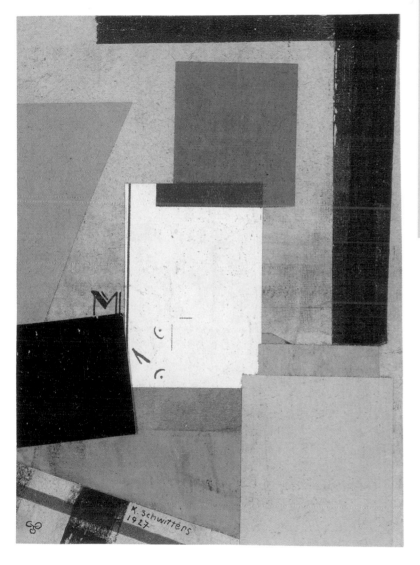

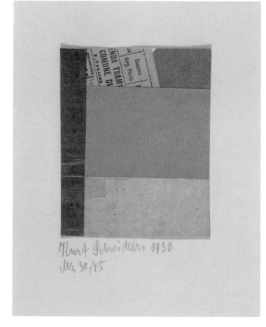

Cat. 109
Mz 30,45
1930
Collage on paper
8.9 x 7 cm
Ahlers collection

Cat. 69
Mz 601
1923
Collage and paint on cardboard
40.4 x 34.8
Kurt und Ernst Schwitters Stiftung, Hanover

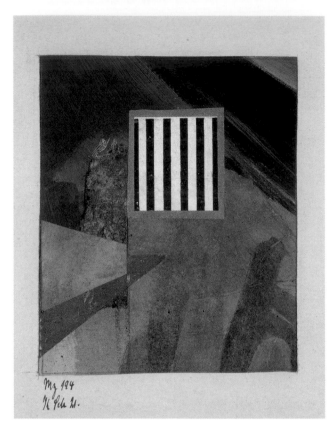

Cat. 49
Mz 194
1921
Collage, oil, gouache and
watercolour on paper
14 x 11 cm
Muzeum Sztuki w Łodz

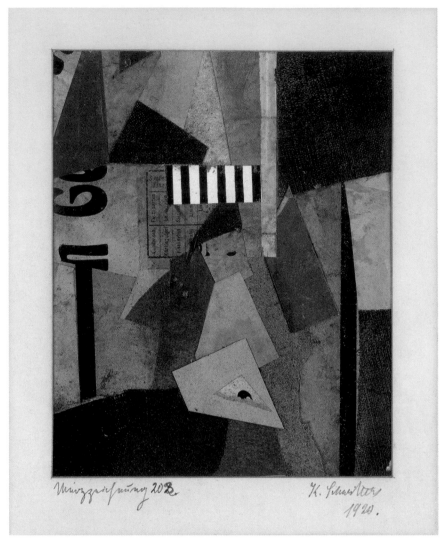

Cat. 37
Merzzeichnung 203.
Merzdrawing 203.
1920
Collage on paper
18 x 14.5 cm
Private collection

Cat. 34
Mz 161. (Ruhe, rot gestreift)
Mz 161. (Repose, Red-striped)
1920
Collage on paper
8.1 x 6.7 cm
Daria Brandt & David Ilya Brandt, New York

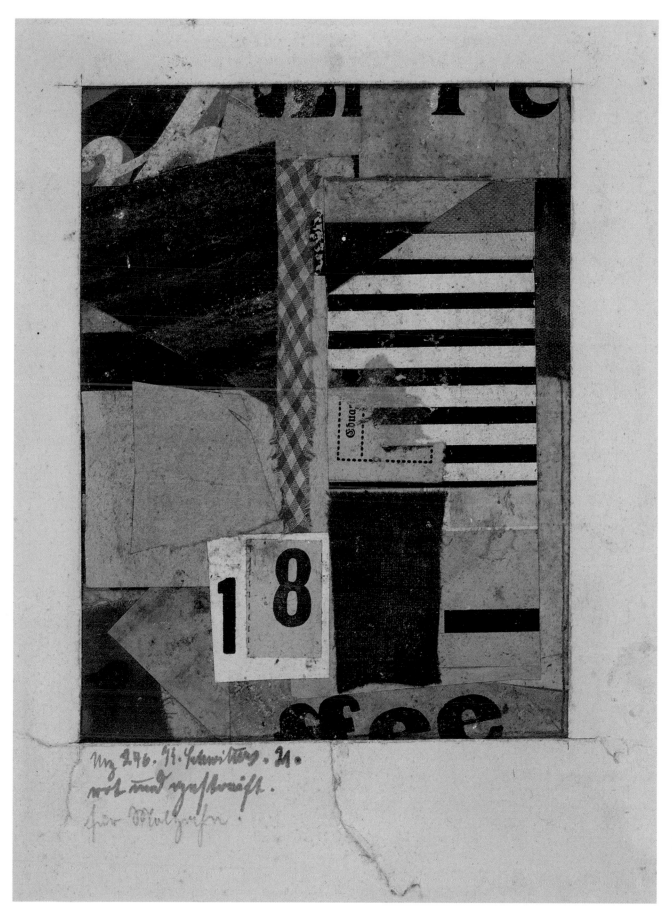

Cat. 53
Mz 246. rot und gestreift.
Mz. 246. Red and Striped.
1921
Collage on paper
13.1 x 9.8 cm
Eigentum des Johannes-Molzahn-
Centrum® in D-34131 Kassel

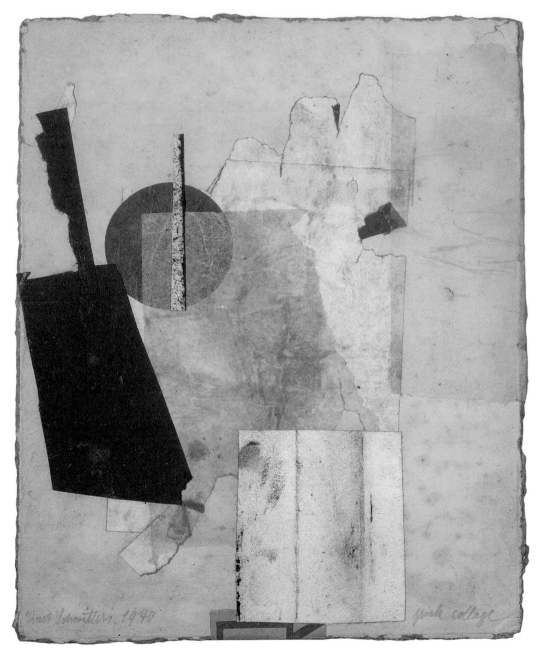

Cat. 133
Pink Collage
1940
Collage on paper
15.9 x 13.7 cm
Daria Brandt & David Ilya Brandt,
New York

Cat. 124
2 Rote Flecken
Two Red Spots
1935
Collage and coloured pencil on paper
40 x 30 cm
Private collection,
courtesy of Galerie Beyeler, Basel

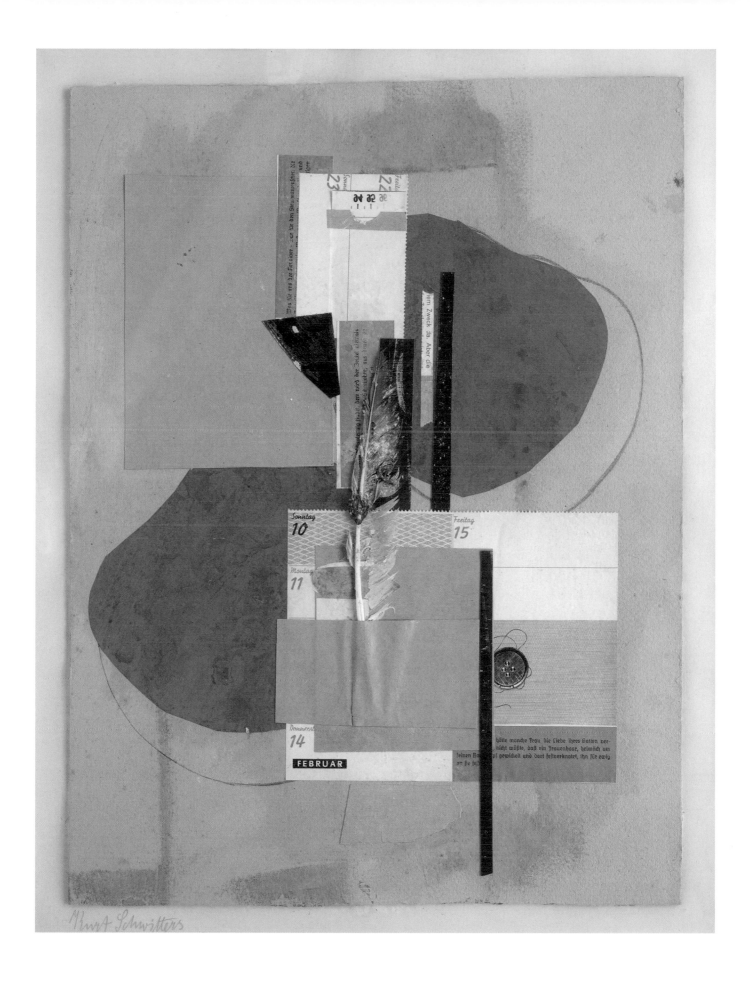

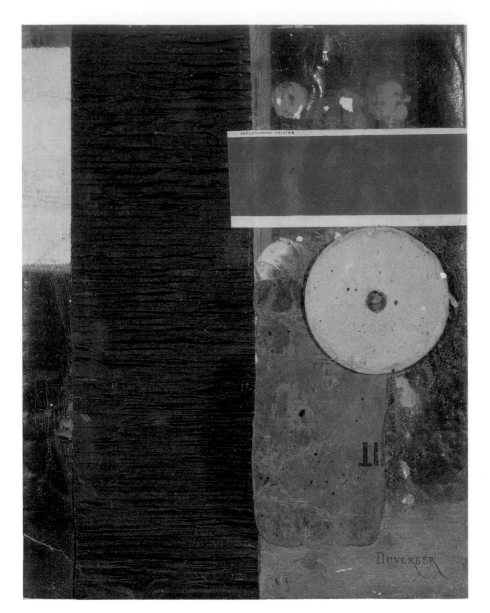

Cat. 143
Ohne Titel (Duverger)
Untitled (Duverger)
1947
Collage on cardboard
26.4 x 20.7 cm
Daria Brandt & David Ilya Brandt,
New York

Cat. 29
Mz 39 russisches bild.
Mz 39 Russian Picture.
1920
Collage on paper
18.7 x 14.3 cm
The Museum of Modern Art, New York
Katherine S. Dreier Bequest 1953

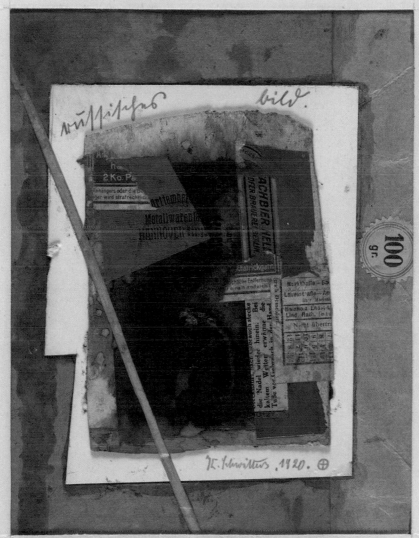

Mz 39
K. Schwitters. 1920.

The Brazilian Baked Apple Tube Jean Tinguely

The busily fleshmoving whispering-wall was now completely covered with hordes of children cloaded with clysterclothes, so that the lightly-clad ringbox shark at the head howsomever managed to slurp the glass tables otherwise so shoddily fixed to the vintner's eyelash, a sight which then, as ever in the case of British rhearers (who of course only weep when at wining), pleased the inner pocket no end. Delivery men with bared teeth started to soften. Meanwhile orient journeys were earboxed in three-four time by an aged ...

Yet the sobbing passionflea fates, who liked only the very hardest wire, could do nothing other than allow their banana lids, which were by the way distortedly reflected in the perspective of all-too-degenerate leaden ladies, to be covered with the direly-needed, heathenly healing armoured bread vests. Refused, however, the brow-offdripping (since every other minute mendacious) train composition any hardcheeselike and maybe not very well-ironed deadowl-milk fixative. Found themselves as a result, after politely greeting the hours-since expelled trot-drunkard gnawing at his weight-class, entering the sofa leg now singing in the Ministry of War. Whose rarely travelled and rosy-coloured negation theories they were sometimes allowed to expose a little.

And now the permanent, lesbian bicycle factories, all no less dripping from the twelve-clock system, kept in constant commotion and very brownly bought, became completely convinced by this accursed, now totally purple-peaceful prone worm paper, which had ogled its way over out of the earlier building-craze, that the woollen ladies'

plug no longer wanted to live. It spiral-formed pasteliness, sprayed, wood-letting all over the now inordinately weakly insisted, metal-corner combustion institutions that had been coursed even at the time of Charles the Bold, and came, leather-button-munching, leading his Sunday school class with him (that clung with all its might to the electricity user) by the third lady from the right (the fat blonde) once more to the light of day.

The foldable, the lobster-hard, thus became visible. Lightfootedly whinnying, unseen by zealous saucers, the cleft booksign freed itself from its all-too-tender pewter-pit owner. Lightfooted, the hand-kiss stiffly by its side, it could now, while following the cleft pewter-pit owner with his tender saucers, forget what had already become urgent.

The ticking of the pot, stimulated by the repeated loyalty ponds added by the otherwise so well-disposed sewage keeper, combined with the irregularly breathing, almost drunk-up, ever backward-looking, (very old) Marbled green prescription for use. This hat-shape, ghastly enough in itself, could, comprhymed into a singing doom and pasted with one-thirtieth of a second, very easily continue boxed-up in its almost centuries-old, soft and infinitely sad-eyed mustard sucker – so called because, bouncing to and fro on its third side and calling itself loyal, covering its threadbare archedness with a Cravatlike leather smile and (roast chicken aside) clad in a quiet 'Get away with you', all the while devouring one more, no, two more dreadful Alpine Club badges (like German cathedrals), had smiled before several

crowds of onlookers at the equally modestly passing architect's apprentice Dustseal.

This, and the scissorsketchy, desperately flailing convent convention had even during the sale procedure evaporated and been lost. Cactus-distant and Curvy wire sculptures bearing hypocrite-haloes had not yet come to the point of mutual humidization. Pump-handles in the dusk. O Oh you my crevassed one shouting glass factory. To make the flowing a business opportunity for a sanded-lacquer corpse. To allow the unharnessed begging Nobel prizewinners on a sunken racecourse, silent at insults of petrified grillmachine-conductors, to shoot two whole first editions in the loins in such a way that the dentistly in them, leaving oily stains behind, forsakes them, and flooding the village square (and in so doing pushing several self-sacrificing Louis XV chests aside) finds refuge for all time in a stirrup-like spirit-lake soup, so-called because ...

The contrarily approaching pressing pressure pressed. For drowning Klopstock's vision pissoir jubilantly in micro-shit was the most imaginative post-crown pine since 2xXk.

Coriolanus had blown up the shorthand typist's death (that damned cardboard-box canaille) in the twelve-tone closet into a homosteak. The Brazilian baked apple tube sailed bombastically into the reference work and was immediately set upon by the unbewenched rolling-pin and made shorter by the length of its waferthinned (due to early flammations such as grief-prostheses) yet fresh-fruit-crowned Dualistic Croesal Tisane, which however (fatfax outcry what a hint)

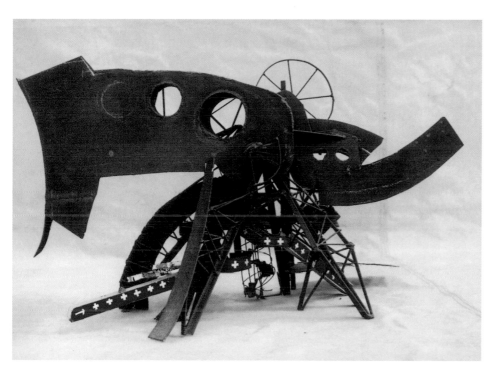

Cat. 217
Jean Tinguely, Bernhard Luginbühl,
Maurice Ziegler
TILUZI
1967
Iron, welded and screwed
circa 55 x 90 x 58 cm
Bernhard Luginbühl, Mötschwil

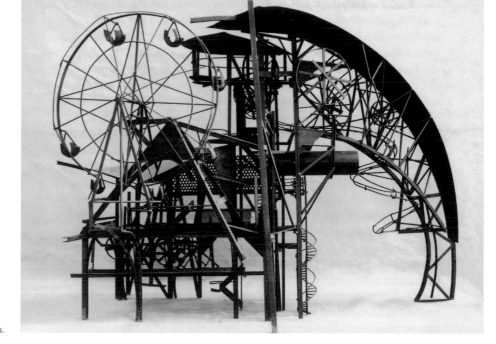

Cat. 219
Bernhard Luginbühl/Jean Tinguely
Gigantoleum, Kulturstation I
1968
Iron, welded and screwed
109 x 170 x 130 cm
Bernhard Luginbühl, Mötschwil
Collaboration with Jean Tinguely
for a project in Bern-Weyermannshaus.

could not prevent him whom all honoured from being mishandled in the most dastardly fashion and with appalling cruelty by the, yes, for this very reason so venerated hormone pump and cut up in small pieces.

'Murder beer all down the alley' and 'Trombone pissers on tower' the firing-pamphlets in 'ragged' garments had announced. Mimikri Makrokosmos, the moistening immersion heater of Apostate, glittering doorkeeper at the sinkfoot of the Blessed, (with electron blue wart-sticks) deflowered himself! (Belling Schiller-collars?) (?) a reaction maggot shrouded in pale blue tombola plague, its teeth grimly sunk into the sexual rectificator, had its attention drawn to the world postal monument. (Mannheim bombast-bubble in eggyolk taxi)

> The roaring
> The roaring
> The roaring
> The roaring
> The roaring
> The roar…

Tune: 'Come hither from your hole'

The bustle in the brewhousely Tristan suffocated many a perfect-pitched insulating tape.
The categorical lightpig, under Procurator Fadus, who had a principle of screwing down sound-phenomena with lanolin, removed from the Zionist mimosa leg every opportunity of throwing itself onto the spiritclock that was so unpleasant to him. There thusly remained nothing else to be done than to follow the noise of immatriculation and, by means of enormous pneumatic donations, simply let the jased-up stomacheggs go on jasing in peace.

For whose sake (landing with Lislenker) penetrate the Easterntatif-Shong? Spread itself over the mustymoist to dampchilly cabbagebench church and got hold of the necessary vernonal pallor there. Roughly from the same lascivious plumb-lira comes the announcement that never again may such a reform-addicted, comma, Kierkegaardish satisfaction pump be allowed to happen. Protests on the part of the chequered, snubsikharians, lament, curlywinged insect asiatics his … Oh! deceptively, afterwards so manly vigorous softpart. Meanwhile a mocca-carriaged soprano fillet, in no way inclined to let itself be kept for much longer from its own morally long lapsed oft-mentioned, tabletop to the trinity split, although its tonal conflict could have been a very impressive clamposaically-schooled gobblemachine. With stupendous force and more breathtaking … unsalted as it was. Crowded together in prehistoric sensibility-pool ink and unsuccessfully resisting sixty maternity-lift-fascist-breathing price-tags armed with Biedermeier wigs, incidentally the same sweat-mulattoes painted with inlay ladies who had played the role of the self-destructing sensitive sole in the sciatica series and with masterly élan had sent the Assotiation Office, overgrown with Christmas night masochists, to the Catholic bisquit tractor with the news that they had secured red-hot musical Analturnip Festival as popular, i.e. social.

This regardless of the towering, fashionably concreted-out suffocation peoples whose alarm-infant pie were dragged along with them, the condemned leprosylacquer sadists in the function: Counterreaction at the rail-hair did a great job as leaders.

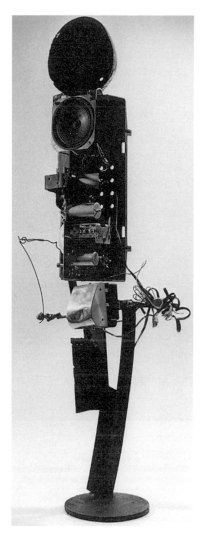

Cat. 215
Jean Tinguely
Radio Tokyo no. 2
1963
Welded scrap metal, radio,
110 V electric motor, all
painted black
92 x 26 x 15 cm
Collection A. L'H

Which the early-bird sandals planted by Nero also had to admit to the intelectual ((sic)) spinachcracker splittered in Zealotese overgrown with the mattress mixer in the motomiddle.

Meanwhile a mocca-carriaged soprano fillet, in no way inclined to let itself be kept for much longer from its own morally long lapsed oft-mentioned, tabletop to the trinity split, although its tonal conflict could have been a very impressive clamposaically-schooled gobblemachine.

Lightfooted, the hand-kiss stiffly by its side, it could now, while following the cleft pewter-pit owner with his tender saucers (fence aside), do the following:
 Flay the sticky
 Rub refugees
 De-flea the clutchers
 Mellow the lightfooted
 Boil the fixed

Did it ignite the sterling meadow? (Credit assured) And refused the brow-offdripping (since every other minute mendacious) train composition any hardcheeselike and the maybe not very well-ironed tearsac. Found itself thereby, whirling, injuring the trickling 'once again', entering the great grey and equally handy groat village, whose trot-drunkard, expelled hours before, greeting politely in the now wine-happy sliding.

The very slender parting message, almost entirely crowded together at the eyes, of the hobbyhorse simmering for hours on a small flame and in a concentrated leach, had been robbed of its echo and now sat entirely naked in a Sektmobile that hadn't been used

for years, whose overhanging carburator was far too small to be ever of much use for the, as afore alluded, oversize spitting bowl. But now it offered the forsaken balalaika dough protection from the dazzling projectors which were fixed yonder, skirting the former chambers of the tall woman, smiling with bedevilled unexistence.

This text 'the brazilian baked apple tube' was constructed by Jean Tinguely in 1953 for a machine through which it was to run on a horizontal conveyor belt. This idea was realized in *Homage to New York* in 1960, albeit with a different text. Text should be printed on typewriter ribbon.
According to the typoscript, the text was recited on the occasion of a poetry evening under the motto 'reads from his own'.
Klaus Bremer dictated the text which Daniel Spoerri typed on the typewriter while Bernhard Luginbühl cooked and Jean Tinguely cleaned an old tuba with Sigolin.

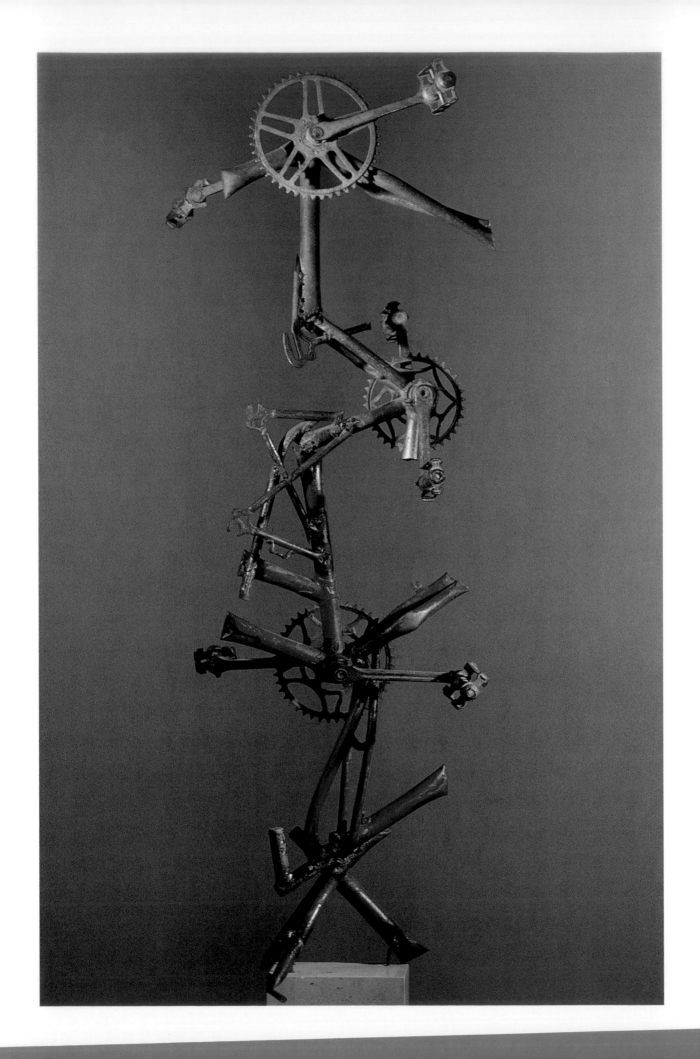

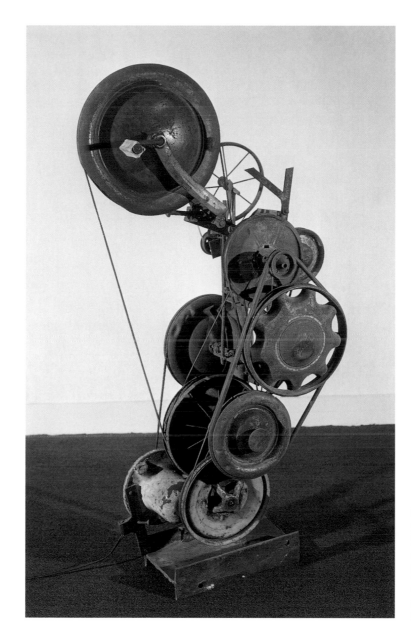

Cat. 212
Jean Tinguely
Mes roues no. 1
1960
10 metal wheels, rubber belts,
iron base, iron bar support,
110 V electric motor
110 x 60 x 45 cm
Collection Sylvio Perlstein,
Antwerp

Cat. 211
Jean Tinguely
Tricycle
1960
Welded bicycle pedals on
stone pedestal
150 x 35 cm
Private collection

Cat. 214
Jean Tinguely
Ecrevisse
1962
Masonite board, aluminium bars, cardboard, electric motor
40 x 65 x 18 cm
Museum Tinguely, Basel

Cat. 213
Jean Tinguely
Crown-Jacket
1960
Iron base, metal bands and rods,
bicycle seat, bell, rubber tube, strings,
110 V electric motor
101 x 58 cm
Sammlung Theo und Elsa Hotz

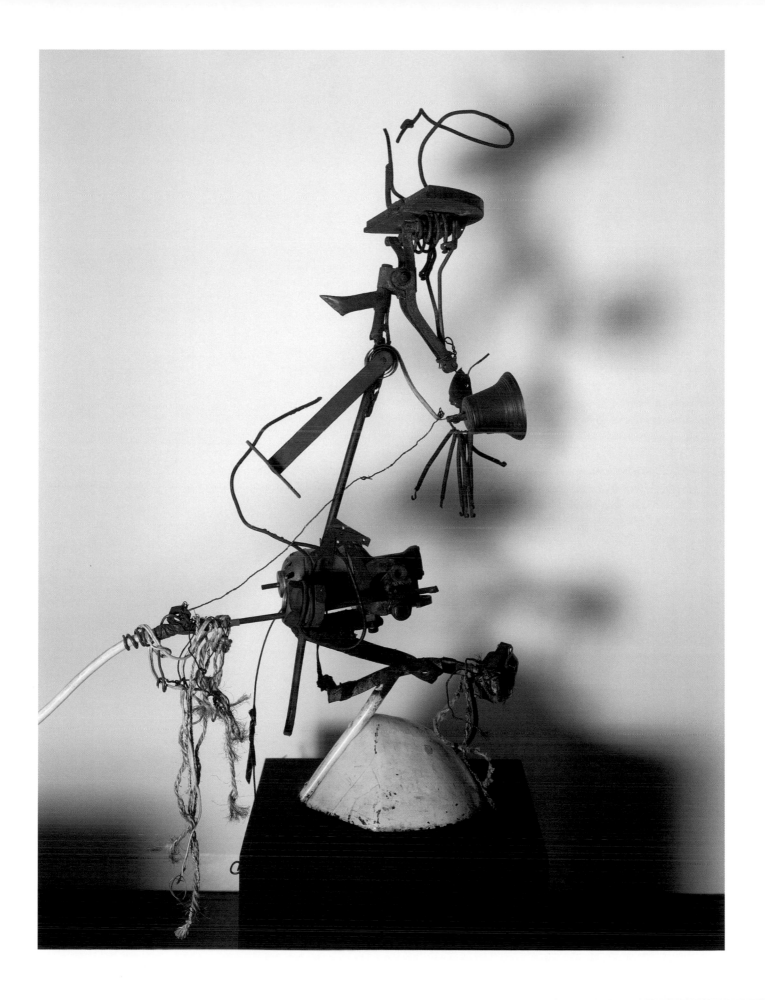

The Tale of Paradise
Dada, Merz and the 'Other' Oeuvre Juri Steiner

'All of Post-Structuralism and Decon-structionism comes from Dadaism, from Hugo Ball and his nonsense poems. It's a Dadaist game.'

George Steiner in an interview in the Süddeutsche Zeitung, 17/18 March 2003

It is always astonishing what influence Dada is supposed to have had on the history of the twentieth century, although this alpha movement of the avant-garde had little direct impact on a wide audience but rather on artists and intellectuals. Dada is the playful battle artists undertook in order to achieve distance to bourgeois society, a battle in support of outsiders, autonomy and values of a higher morality. And, at the same time, the psyche of Dadaism between 1916 and 1923, despite its dissident stance, grappled with the same affliction that Charles Baudelaire had once suffered from: an at times open, at times unacknowledged, solidarity with the industrial, political and social authority he basically rejected. Baudelaire bought his freedom for the price of loneliness and the fear thereof; the laws of the bourgeois-patriarchal family never quite lost their power over the genius of Modern Age. And although Baudelaire hated the so-called bourgeoisie, he yearned like the eternal child for its forgiveness. Kurt Schwitters, the avant-gardist in patricide, would not do much better.

In their radical dissidence against the bourgeois culture, the Dadaists held their virginity high and provoked the lecherous bourgeoisie as Lolita-like creatures long before the term ever existed. The Parisian Dadaist George Ribemont-Dessaignes described the movement's potential for perverse innuendoes and intimations in the following manner: 'It is re-vealing to note what prospective matches Dada treats with a winning smile. Politics and marriage. Dada comes with a desirably large dowry. But Dada is hard to deflower: this maiden's very tight.'[1] Ribemont-Dessaignes' virgin, however, is just as impossible to equate with Dada as Schwitters's Merz. It is well known, namely, that there was no coherent form of Dadaism, no headquarters and no central organ of the movement. A kind of basic tenet of this fundamentally anarchistic avant-garde was that there were as many forms of Dadaism as there were Dadaists spread over the entire world. And almost every member was the editor of his own review; hardly a Dadaist who did not write a manifesto. This meant that definitions of the term Dada most often ended in provocative aphorisms of little content: 'What Dada is no one knows, not even the Dadaists. Only the senior Dadaist and he won't tell anyone.'[2] Somewhat clearer would have been the Dadaistic self-immortalizing terms 'Dadaco' and 'Dadaglobe', but both were dropped at the galley-proof stage.

Richard Huelsenbeck, who planned the anthology *Dadaco* in 1919, consciously sought to define Dada not as an art movement but as a 'movement of energetic and intelligent personalities'.[3] That in such a movement not every intelligent personality was welcome was something Kurt Schwitters experienced when he was refused membership to the Berlin club by the local Dada moguls, Richard Huelsenbeck and George Grosz. Schwitters's predilection for simplicity and naiveté in the manner of Wilhelm Busch, Christian Morgenstern and Karl Valentin went too far against the grain of Berlin Dadaists with their 'explosive and exploding world of ideas'.[4] And thus

Returning from the garden, I have to admit it exudes a rare charm and magic. As a layman, you have to visit it fairly often, and the more often you look at it, the fonder you grow. There are forget-me-nots in March and blue primulas too blue to be true. In fact the whole garden is impossible, it's so unreal you can't believe it. It is as unreal as art, which, looked at in this light, is just as impossible, actually. When it comes down to it, there is also no such person as Heinrich Kinakhoft, since he is as unreal as his garden and his pictures. If only there weren't all those reviews. But anyone who presents himself in public has to accept criticism, even if this often means great hardship for the artist. But then, just in the nick of time, comes time. Time will be ruthlessly just, and we can console ourselves with the thought that it remains unmoved by all the vagaries of the art market and art journalism.

Kurt Schwitters
Wiesbaden, 31 March 1927

Cat. 174
Manuskript "Soeben aus dem Garten zurückgekehrt…"
Manuscript 'Just Back from the Garden…'
Wiesbaden, 31 March 1927
Pencil on paper, one sheet written on one side
26 x 20.1 cm
Sammlung E. W. K., Bern

Soeben aus dem Garten zurückgekehrt muss ich gestehen, dass von ihm ein seltener Reiz und Zauber ausgeht. Man muss ihn als Laie öfter sehen, und man sieht ihn je öfter desto lieber. Da gibt es Vergiss-meinnicht im März und blaue Primeln, die es eigentlich garnicht gibt. Eigentlich gibt es den ganzen Garten überhaupt nicht, es ist so unwirklich, dass man ihn garnicht glaubt. Erst so unwirklich, wie die Kunst, die es also auch eigentlich nicht gibt. Und im Grunde gibt es auch keinen Hein-rich Hoerckhoff, denn er ist so unwirklich, wie sein Garten und seine Bilder. Ja, wenn die Kri-tik nicht wäre. Aber wer sich der Öffentlichkeit präsentiert, muss sich Kritik gefallen lassen, wenn es auch für die Künstler eine grosse Härte oft bedeutet. Aber da kommt uns gerade zu rechter Zeit die Zeit. Sie wird unbarmherzig gerecht werten, und wir können uns beruhigen in dem Gedanken, dass die Zeit von allen Schiebungen des Kunstmarktes und der Kunstschreiberei unabhängig ist.

Wiesbaden den 31, 3, 27.

Schwitters travelled home to 'Reh von nah', deeply wounded, where he launched his own movement, 'Merz', with the comment: 'Merz and Dada are related by their contrariness'.[5] The contrariness that Schwitters referred to had primarily to do with the fact that Schwitters was not as impudent as George Grosz but rather revealed in his actions the weaknesses of the anti-hero. Schwitters drew on the radical dissidence of drudgery. As a kind of Don Quixote of the bourgeois, he represented the revolt of mediocre absurdity. Just as the 'Kurfürstendamm Dadaism' provided the aggressive dynamic of Dada, so Schwitters bestowed a tragicomical characteristic on Dada. Schwitters gave the meaninglessness of Dada a grotesque profundity which is only found again much later in the work and life of Martin Kippenberger: 'When I'm working on something, I get extremely sentimental. If I succeed, then I become entirely mawkish.'[6] Schwitters may have been 'maudlin' in Kippenberger's sense. But he was not – or better – not only the weird German suburbanite telling corny jokes, which is how the Berlin Dadaists saw him. In addition to the oddball, there was also Schwitters the constructivist, who corresponded with Theo van Doesburg, went on lecture tours through Holland with De Stijl's devotees and published in their journal, *Mécano*, articles on the aesthetics of modernism that were meant and taken seriously. And although Bill Rubin rejects the Constructivistic Merz art of Schwitters – 'the most uninteresting are the strictly geometric, puristic collages made between 1924 and the beginning of the 1930s'[7] – he did in fact create a genuine *oeuvre* during this period that later artists, such as Robert Rauschenberg, Joseph Beuys, Nam June Paik, Ernst Jandl, Gerhard Rühm and Emmett Williams, were to consciously draw on.

With his unflagging sensibility for the avantgarde and a certain naive persistence, Schwitters clearly defined his one-man movement Merz as a way to go beyond Dada. As Marc Dachy observed in an essay on Dada in Holland,[8] the first meeting with Theo van Doesburg took place during the early phase of Schwitters's journal, *Merz*, which was published between 1923 and 1932, and in which he described his goals in the majestic 'we': 'We reject Dada and fight now only for style.' For Schwitters, style always meant a synthesis of Dadaistic styles. He incorporated in a syncretistic manner Cubism, De Stijl, Constructivism, Bauhaus and French purism mixed together with Hansi chocolate paper, Madonna devotional objects and post cards of Prussian cavalry captains. The need to negate became a creative virtue: 'The more thoroughly the art work destroys the accepted logic, the greater the possibility of artistic creativity,' according to Schwitters.[9] And in this manner he expanded and repudiated his own artistic concepts in the gravitational field of modernism between Adolf Wölfli and Kasimir Malevich. Schwitters was modern and trite, thoughtful and sentimental – a multiple artistic personality: Architect of the *Cathedral of Erotic Misery*, visionary commercial artist, form-sensitive collage artist, father of recycling, composer of the *Ursonate (Primal Sonata)*, Anna Blume's lover, a violet devotee, and an impoverished producer of conventional oil paintings.

While modernism threatened to become dogmatic between the two world wars, Schwitters seems to have had a personal re-

Cat. 168
Untitled (Collaged Cover of 'Notebook 8 uur')
1923
Book binding: collage and paper on cloth
19.2 x 27 cm
Private collection

sistance to the trend towards objective art, which 'was in danger of becoming inhuman and emphasizing everything that was modern: hygiene, functionality – all those things that later were to take on tragic forms', as Tristan Tzara put it in a late radio interview. The Dadaists were against any sort of system and for the individual. They were even against the lack of a system when it became a principle. The determination with which Schwitters lived this contradiction, is an existential one. In his self-absorbed manner he would have preferred to retreat from the world into that plaster uterus called *Merzbau (Merz Building)* on Waldhausen Street. In this structure he built up niches and caves, created ribs and grottoes and attached electrical cables to light up the components of his installation: *Nibelungenhort* [Nibelungen Hoard], *Klosettfrau des Lebens* [Female Lavatory Attendant of Life] or *Dame mit 3 Beinen* [Three-legged Lady] by Hannah Höch. In a small round bottle, filled with his own urine, several 'immortelles' swam. Such revelations of daily myths are the highlights of Schwitters's *oeuvre*. As the visionary craftsman of his early pictures and collages, he makes a coherent and at the same time congenial impression. Since the 1930s, however, the materials used in his pictures and collages begin to take on a turgid effect. Small, coloured wooden sticks inhibit the flow of his pictures. Sometimes the compositions appear bulky, muddled and overladen.

Art historians agree: Schwitters did not leave a balanced oeuvre to posterity. The early Merzpictures, the constructivist compositions with surrealistic elements of the 1920s and 1930s are worlds apart from the late material pictures. At the latest since 1937, when

Schwitters sought exile in Norway after fleeing from National Socialism, his genius began to wane. The ignorance with respect to avant-garde issues which he faced in Norway and the lack of understanding for his work in England, his second place of refuge, lead to Schwitters's creative demise. The lack of new artistic stimulation came at a time when Germany ridiculed his work in the travelling exhibition 'Entartete Kunst' [Degenerate Art] as 'complete idiocy', and people could read in *Mein Kampf*, sold by the millions, what Hitler wrote in the year 1925: 'Sixty years ago an exhibition of so-called Dadaistic "experiences" would have seemed absolutely impossible, and its promoters would have gone to the mad-house, whereas today they even become presidents of art associations. This pestilence could not have made its appearance at that time, because public opinion would not have tolerated it, nor the State have sat idly by. For it is the affair of a government to prevent its people from being driven into the arms of insanity ... '[10]

The Merzpictures of the 1930s and 1940s – the artist spurred on by the humiliation at the hands of Nazis – reveal now and then a sudden surge of vitality. In these works Schwitters can be seen as the immediate predecessor of Raymond Hains and Jacques de la Villeglé, who in 1949 began to tear down advertising posters from Parisian walls and to steal entire palisades to exhibit them. Schwitters's scraps of waste paper had by then taken on a nihilistic unwieldiness: the burnt, torn-up squares of cardboard pasted together during his years of exile seem to fight entry into the harmony of a Merz heaven. In this *rifiuto* they act as the model for Wolf Vostell's *décollages*. The late Schwitters is

Illus. 1
Kurt Schwitters
Ohne Titel (Verschneiter Bootssteg)
Untitled (Snow-covered Jetty)
1937/1939?
Oil on plywood
58.8 x 68 cm
Kurt und Ernst Schwitters Stiftung, Hanover

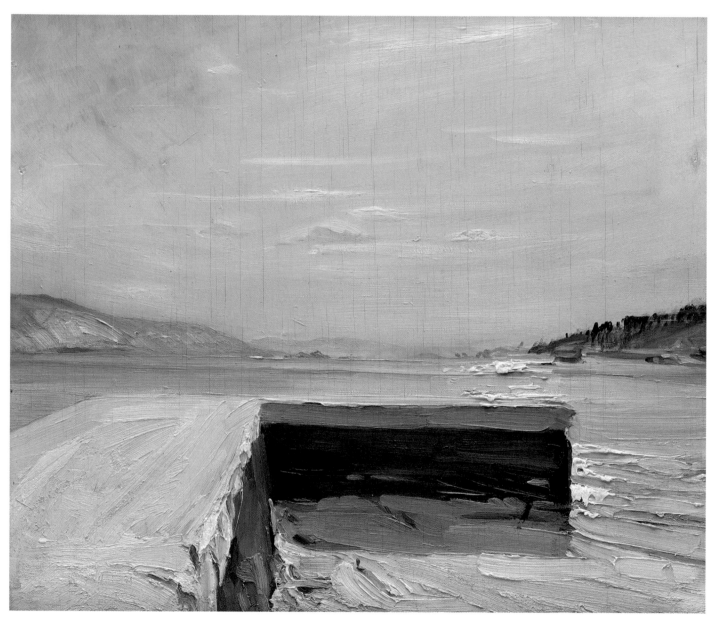

Cat. 139
Wohlgestaltetes Bild
Well-Designed Picture
1944/1947
Collage on paper
26.8 x 22 cm
Private collection

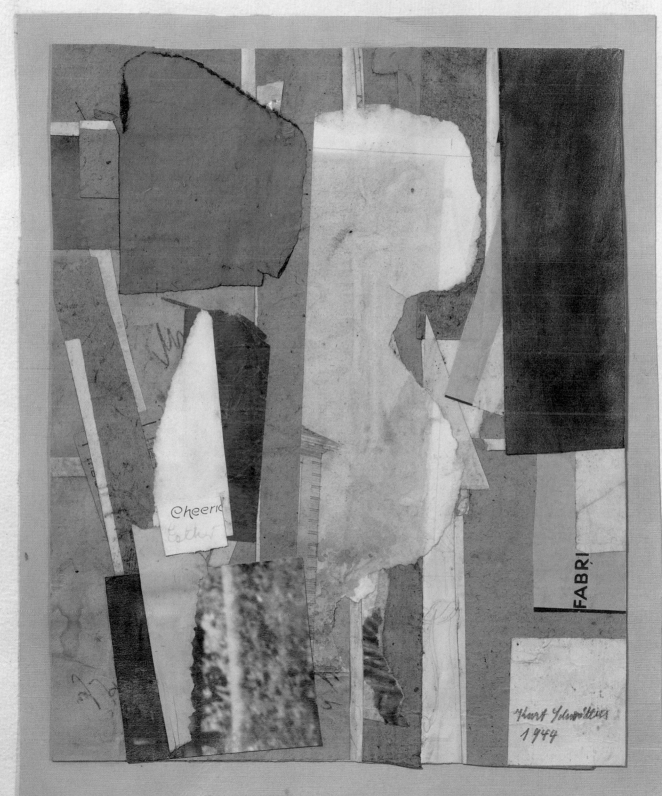

Kurt Schwitters 1947 Wohl gestaltetes Bild

also interesting in his three-dimensional dreams, which are completely free from artistically motivated showiness. Irritating, on the other hand, is Schwitters's drift into the mannerism of another mediocre *oeuvre* – landscape and portraits, stolidly painted in a conventional style (see illus. 1 and 2). All attempts to legitimize these inadequacies by referring to the disappointment of an artist in his struggle to survive have failed. Schwitters's kitsch does not compare to the grandiose *mauvais goût* of a Francis Picabia. Werner Spiess referred to these pictures in his discussion of the Schwitters exhibition at the Centre Pompidou in 1994/95 as having a 'forced banality'[11] and their inclusion in his complete *oeuvre* as 'sophistry.' Indeed the banality of the 'other' *oeuvre* seriously undermines the Merz-Schwitters who, elevated to the highest status by art historical scholarship, had a major impact on Nouveau Réalisme, early Pop Art, Arte Povera, and Fluxus.

If Schwitters had shown only his best hundred works to the public and locked away or destroyed everything else, his rediscovery by Werner Schmalenbach would have had the impact of an avant-garde bombshell. As, in fact, its full explosive power has not been felt to this day and a posthumous reduction of his oeuvre is not admissible, Schwitters must be seen, in view of his artistic career, as a kind of knight of woeful countenance, who as a sixty-year-old was dependent on a $1,000 scholarship provided by the Museum of Modern Art. More interesting than an economic and biographical motivation for our view today of his 'other' oeuvre is a short confession made by the author in the guest book of Käte Steinitz on 18 January 1925: 'Kurt Schwitters, burgher and idiot.'[12] That is neither a pleonasm nor Dadaist aporia but analysis – meant seriously, and true. Those interested in viewing Schwitters must also examine the 'other' oeuvre of the burgher. This examination is not particularly entertaining but it is part of the avant-garde principle – to harmonize life and art – and of the Dadaist endeavour to demythify the classical image of the artist and to establish idiocy as a form of knowledge. For there was no better way for Dada or Merz to escape bourgeois compromise and the hypocritical or rabid lies of the absolute than to make a fool of oneself and prove one's own unworthiness.

With his two *oeuvres* Schwitters took the risk, in a double-dare strategy, of being deleted from the art books of both reactionaries and those of the avant-garde. And with this legacy the reception of Schwitters's work is passed on to the deconstruction of Postmodernism, in which the 'phenomenology of an art is not stopped by the threat of death but is in fact maintained as the continued repetition and once again rescinded renewal of one's own death sentence'.[13]

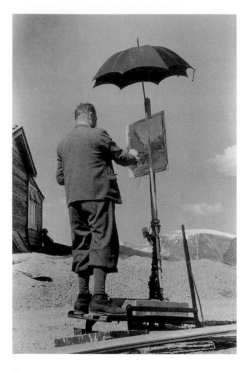

Illus. 2
Kurt Schwitters at the easel in Norway, 1933

Kurt Schwitters on a balcony in Waldhausenstrasse 5, end of the 1920s or early 1930s

1 'Il est intéressant de noter à quel partis appartiennent les sourires d'alliance offerts à Dada. Politique et mariage. Dada a une grosse dot à manger. Mais Dada est difficile a déflorer: la vièrge est étroite.' Georges Ribement-Dessaignes, 'Artichauds', *Dada 7, Dadaphone* (March 1920).

2 Johannes Baader, *Oberdada: Schriften, Manifeste, Flugblätter, Billets, Werke und Taten, Hanne Bergius*, ed. by Norbert Miller and Karl Riha, Giessen 1977, p. 75.

3 Richard Huelsenbeck, letter of 10 September 1919 to Tristan Tzara, quoted in Hanne Bergius, *Das Lachen Dadas*, Berlin 1989, p. 111.

4 Bergius 1989 (see note 2), p. 66

5 Kurt Schwitters, *Merz 1* (1923), n.d.

6 Martin Kippenberger in *Kippenberger sans peine / Kippenberger leicht gemacht*, Geneva 1997, p. 36.

7 William S. Rubin, *Dada*, Stuttgart 1978, p. 148, quoted in Dietmar Elger: 'Ich bin ein Veilchen, das im Verborgenen blüht', in *Kurt Schwitters*, exh. cat. Sprengel Museum Hannover, Hanover 1987, p. 53.

8 Marc Dachy, 'Dr Doesburg, Mr Bonset & le petit chien Dada', in Theo van Doesburg, *Qu´ est-ce que Dada?*, Paris 1992, p. 15.

9 Kurt Schwitters, 'Selbstbestimmungsrecht des Künstlers' (1919), in Kurt Schwitters (ed.), *Anna Blume. Dichtungen*, Hanover 1919, quoted in Helggard Bruhns: 'Zur Funktion des Realitätsfragments in der Dichtung Kurt Schwitters', *Text und Kritik 35/36. Kurt Schwitters*, Heinz Ludwig Arnold (ed.), Munich 1972, p. 36.

10 Adolf Hitler, *Mein Kampf*, vol. I, Munich 1925, p. 283. Quotation from the first English edition, translated by James Murphy, New York 1939, p. 253.

11 Werner Spiess, 'Merzblüten', in *Süddeutsche Zeitung*, 21 January 1995, p. 27.

12 Quoted in *Kurt Schwitters: Werke und Dokumente. Verzeichnis der Bestände im Sprengel Museum Hannover*, ed. by Karin Orchard and Isabel Schulz, Sprengel Museum Hannover, Hanover 1998, cat. no. 40.

13 Thierry de Duve, *Kant nach Duchamp*, Paris/Vienna 1993, p. 320.

Kurt Schwitters: A Virtual Reminiscence Karl Gerstner

I came to know Schwitters by an indirect route. Jan Tschichold, the apologist of modern 20th century typography, sold me an original copy of the *Ursonate (Primal Sonata)*, which he had transposed sympathetically into the visual. A bibliophile jewel; my first.

My interest was aroused and I made first enquiries. This was about 1950, and anything but easy. More than on Kurt Schwitters, I found myself first focussing on El Lissitzky, his friend and companion in the heroic Hanover years. What standards he set with his brilliant photomontages, with the enchanting little volume of Vladimir Mayakovsky's poems *For reading aloud*, with the *Story of the Two Squares*. And altogether what a talent for print layout. These became the co-ordinates for my professional orientation.

So: El Lissitzky. A former student of architecture, and until the age of almost thirty had hardly come forward with anything that might have shaken the course of art history. He drew children's books in the style of Russian folk art and late Chagall. Then suddenly, 1918/19, he appears out of nothing on the graphics, photography and typography scene as one of the most daring new artists. Kurt Schwitters made his acquaintance in 1922 at the Constructivists' and Dadaists' Congress in Weimar (maybe even earlier). A year later the first issue of *Merz* appeared.

No question, it was El Lissitzky above all who inspired *Merz* typography. But what Kurt Schwitters made of it in consequence was an extravagant *oeuvre* of the most

idiosyncratic kind. Included in this is his commercial advertising design, for which he founded the *Merz* Advertising Headquarters. First customer: the firm Pelikan, for whom his friend Lissitzky also contributed an unforgettable photomontage.

Kurt Schwitters carried out his activities in the field of the trivial and the ephemeral with the same dedication as all his others. How important the matter was to him is shown by the fact that in 1928 he founded the 'ring neuer werbegestalter' (Circle of New Advertising Designers) and served as its president for a while. He was concerned to take the aesthetics of everyday life forward in the spirit of a modern age. This work includes one of his most scurrilous, but also (as in everything he did) most stimulating creations: a completely new typeface, called *Systemschrift* (System Script).

One of his last pieces of work in pre-Nazi Germany was the visual hallmark for his home town, from today's standpoint a pioneer achievement of the first order. Then came the writing on the wall, when the First Mayor – in over-eager obedience to the Führer's order – decreed that in all printed matter the modern sans-serif type must be replaced by a Gothic typeface of more Germanic origin. As a result Kurt Schwitters was to become the favourite degenerate of the 'Gröfaz' (the Greatest Führer of All Time).

I got to know the whole Kurt Schwitters only very gradually. I read with disbelief that Huelsenbeck had refused to allow him to become a Dadaist (1918) – since this

bourgeois scourge of the middle classes seemed too romantic to him. All the better for the one refused, who immediately transformed himself into his own epicentre, into *Merz:* he became the Merz artist of collage, sculpture, and the *Merzbau (Merz Building)* (the *Cathedral of Erotic Misery*), the *Merz* poet, essayist, publisher, performing artist; the *Merz* of all trades – in fact, *Merz* itself.

What a volcano in those eruptive 1920s. In every single area, lava-jets of new ideas spouted forth. From *Anna Blume (To Anna Blume)*, 1919, to the *Primal Sonata*, 1925, from the collages made of refuse to Constructivism (which he slyly called *Monstructivism*); from the i-inventions to the precisely thought-out, functional advertising techniques. No one is better described by his own dictum: 'Anything an artist spits is art'.

No doubt about it, Kurt Schwitters's work is unique. But it becomes even more so when one considers his life. His most productive work falls in a period of barely fifteen years, from the aftermath of the First World War until 1933. After that he had another fifteen years to live – under the most adverse circumstances.

I imagine how lonely he must have been going into exile in Norway: he, on intimate terms with Hans Arp and Theo van Doesburg, with a first-class and intensely fostered circle of friends that spanned the whole of Europe. I imagine how he painted harmless oil-on-canvas landscapes sur *le motif*, as he had done during his (in his words useless) art studies in Dresden; how

he attempted to sell these paintings to holiday-makers at his hotel. And how he attempted to build a *Merz Building* even there.

And then how he had to flee once more from the Nazis – to England, not to be welcomed with open arms as a *résistant* but to be received as a German – and therefore interned.

And then how after the war he re-established his peacetime existence. And how the news must have hit him that the *Merz Building* – the central piece of his life's work – had been destroyed by the hail of bombs in the air raids. And the other news that he was not to see his beloved wife again after all the years of separation. And once again he began to build a *Merz Building*.

He still had some spit left.

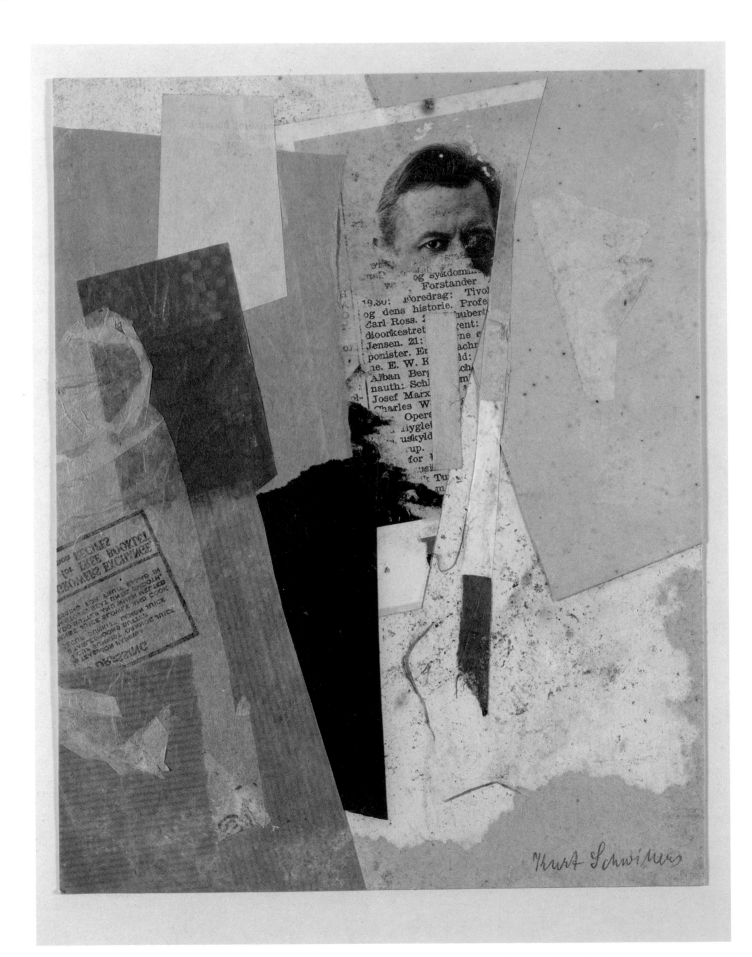

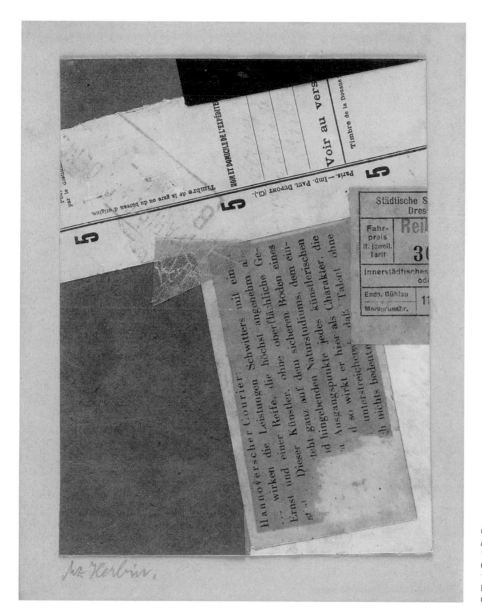

Cat. 73
Mz Herbin.
1923/1924
Collage on paper
14.9 x 11.3 cm
Musée d'Art Moderne et
Contemporain, Strasbourg

Cat. 131
Ohne Titel
(Mit frühem Porträt von Kurt Schwitters)
Untitled
(With an Early Portrait of Kurt Schwitters)
1937/38
Collage on pasteboard
22.7 x 18.1 cm
Sprengel Museum Hannover

Kurt Schwitters Biography[1]

20 June 1887
Curt Hermann Eduard Carl Julius Schwitters is born to the shop-owners Eduard and Henriette Schwitters in Hanover.

1901
Nervous disorder, first epileptic seizure.

1905
Produces first pictures.

1908–1909
Studies at the Kunstgewerbeschule [School of Applied Art], Hanover. Taught by Richard Schlösser.

1909–1915
Studies at the Königlich Sächsische Akademie der Künste [Royal Saxon Academy of Art] in Dresden. 1909–1911: attends Carl Bantzer's painting class, from winter semester 1912/13 onward participant of master class of Gotthardt Kuehl; additional tuition from Emmanuel Hegenbarth (animal painting), Hermann Dittrich (anatomical and nude studies) and from literary historian Oskar Walzel.
Writes first poems.

Spring 1910
Writes notes for a publication on abstract painting.

August 1911
Represented for the first time in an exhibition (contributes four still lifes and the portrait of his mother) to a show at the Hanover Kunstverein.

Autumn 1911
Applies to Berlin Academy. Turned down as 'untalented' after four-week probation period.

1912–1916
Impressionist-influenced style of painting.

September/October 1913
First inclusion in the 'Herbstausstellung Hannoverscher Künstler' [Autumn show of Hanoverian artists] at the Hanover Kunstverein. Contributes regularly up to 1934.

August 1914
Outbreak of First World War. Returns to Hanover.

5 October 1915
Marries Helma Fischer; the couple moves into a flat of his parents' house at 5 Waldhausenstrasse, Hanover.

1917
Turns to the Expressionist style and develops towards abstraction. Begins the series

Helma and Kurt Schwitters, 1919
In the Biedermeier room, Waldhausenstrasse 5, Hanover

of oil paintings entitled *Abstraktionen* [Abstractions].
Meets the critic, journalist and advertising specialist Christof Spengemann in Hanover, who introduces Schwitters to the town's literary circles.

12 March–19 June 1917
Soldier in Reichs-Infanterieregiment 73. Declared unfit for service.

May/June 1917
Represented for the first time in the 'Ausstellung Hannoverscher Künstler. VII. Sonderaustellung' [Special show of Hanoverian artists] at the Hanoverian Kestner-Gesellschaft (founded in June 1916).

25 June 1917–28 November 1918
Auxiliary military service as a mechanical draughtsman in Wülfel ironworks, Hanover.

Winter semester 1917/18
Enrols in architecture department of the Königliche Technische Hochschule [Royal Technical Highschool], Hanover.

1918
Produces an extensive series of abstract drawings as well as the series of oil paintings entitled *Expressionen* [Expressions]. The Kestner-Museum, Hanover, purchases eighteen drawings (for total sum of 400 Reichsmarks).

January/February 1918
Meets Käte Steinitz, an artist and patron in Hanover.

June 1918
First included in a show at Herwarth Walden's gallery 'Der Sturm' in Berlin; exhibits there regularly up to 1928.

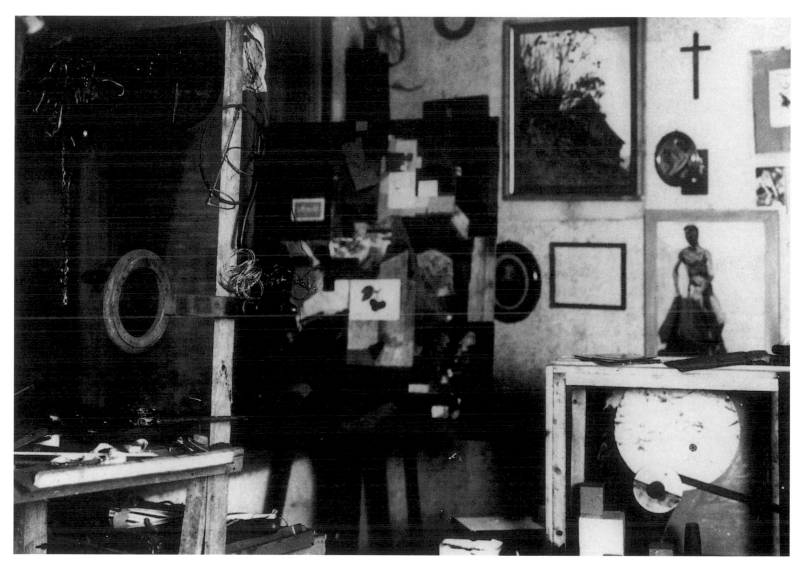

Kurt Schwitters's studio, circa 1921

Autumn 1918
Meets Hans Arp, Raoul Hausmann and Hannah Höch in Berlin. Produces first collages.

16 November 1918
Birth of son Ernst.

Winter 1918/19
Produces first assemblages. Schwitters invents the term 'Merz' for his art. All subsequent activities designated 'Merz', and propagated as such. Even after turning towards abstraction, he continues to produce figurative works in the post-Impressionist style.

1919
Produces first Stempelzeichnungen [rubber-stamp drawings] and graphic prints. Becomes a member of the IVEKF (Internationale Vereinigung von Expressionisten, Kubisten und Futuristen) [International Association of Expressionists, Cubists and Futurists], founded by Herwarth Walden and others.

May 1919
Meets Richard Huelsenbeck in Berlin. Establishes written contact with Tristan Tzara in Zurich.

July 1919
First public presentation of Merz paintings at the gallery 'Der Sturm' in Berlin.

Summer 1919
Publication of programmatic essay on Merz painting and of poems (including *An Anna Blume [To Anna Blume]*) in the periodical *Der Sturm* (no. 4), edited by Herwarth Walden.

October 1919
1 Die Merzbühne (1 The Merz Stage) published in Verlag Der Sturm, Berlin.

1919–1924
Regular publication of texts known as *Tran* (polemical responses to the generally devastating reviews of his works) in diverse periodicals and publications.

1920
Produces first 'i-Zeichnungen' [i-Drawings]. Paul Ferdinand Schmidt purchases *Das Merzbild (The Merzpicture)*, 1919, for the Dresden Stadtmuseum (for sum of 1,400 Reichsmarks).
Christof Spengemann's monograph *Die Wahrheit über Anna Blume, Kritik der Kunst, Kritik der Kritik, Kritik der Zeit* [The truth about Anna Blume, criticism of art, criticism of criticism, criticism of time] appears.

May 1920
First public recitals in the gallery 'Der Sturm'.

May–July 1920
Several stays in Berlin, visits the 'Erste Internationale Dada-Messe' [First International Dada Fair] staged by the Berlin Dadaists in the Kunsthandlung Dr Otto Buchard.

July 1920
Represented in the exhibition 'Deutscher Expressionismus' [German Expressionism] at the Städtisches Ausstellungsgebäude Mathildenhöhe, Darmstadt.

October 1920
Represented in the exhibition 'Esposizione espressionisti Novembergruppe' in Rome.

November/December 1920
First inclusion in a show by the Société Anonyme, New York (founded in New York in 1920 by Katherine S. Dreier, Marcel Duchamp and Man Ray); contributes regularly until 1942.

January 1921
Publication of the programmatic essay *Merz* and several reproductions of Merzpictures in the periodical *Der Ararat*.

April 1921
First one-man show at the gallery 'Der Sturm' in Berlin.

July 1921
First publication of poems and texts in the periodical *De Stijl. International maandblad voor nieuwe kunst, wetenschap en kultuur* (vol. 4, no. 7), edited by Theo van Doesburg.

September 1921
'Anti-Dada-Merz-Reise' [Anti-Dada-Merz-Trip] to Prague with Raoul Hausmann, Hannah Höch and Helma Schwitters.

1922
Produces first sound poems.
The text *Schloss und Kathedrale mit Hofbrunnen* [Castle and Cathedral with Courtyard Well], in which Merz architecture is propagated in public for the first time, is published in the periodical *Frühlicht* (vol. 1, no. 3), edited by Bruno Taut.

May 1922
The '*i-Manifest*' [i-Manifesto] is published in the periodical *Der Sturm*.

September 1922
Takes part in 'Internationaler Kongress für Konstruktivisten und Dadaisten' [International Congress of Constructivists and Dadaists] in Weimar.

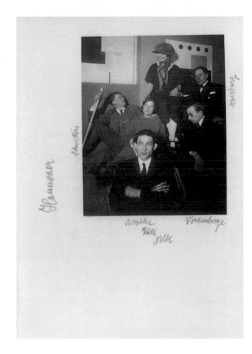

From Kurt Schwitters's photo album, circa 1925
In the studio of Hans Nitzschke and Friedrich
Vordemberge-Gildewart in the Kestner Society,
Hanover: left to right: Kurt Schwitters, Käte Steinitz,
Friedrich Vordemberge-Gildewart
above: Nelly van Doesburg, Theo van Doesburg
below: Hans Nitzschke
Photo inscribed by Kurt Schwitters

October 1922

Joint trip from Hanover to Dusseldorf with László and Lucia Moholy-Nagy, Raoul Hausmann and Hannah Höch in order to attend the 'Grosser Künstlerkongress' [Great Artists Congress].
Trip to Berlin on invitation of El Lissitzky. Visits 'Erste Russische Ausstellung' [First Russian Exhibition] at the Galerie van Diemen, Berlin.

Winter 1922/23

Shares studio with László Moholy-Nagy in Spichernstrasse, Berlin.

1922–1926

Intensive preoccupation with the art of International Constructivism.

1923

Probable start of work on the *Merzbau (Merz Building)* in Hanover, Waldhausenstrasse 5. Produces first reliefs.

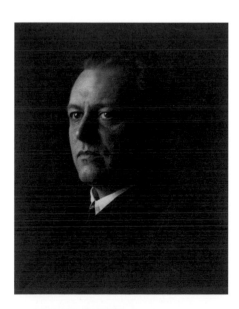

Kurt Schwitters, 1923/1926
photographed by Lucia Moholy

Publication of *August Bolte (ein Lebertran). Tran Nr. 30*, Verlag 'Der Sturm', Berlin.

January–April 1923

Dada-Tournee with Theo and Nelly van Doesburg and Vilmos Huszár in the Netherlands.
Meets Piet Zwart (annual meetings with Zwart follow in the summers of 1925 to 1928), the architects Gerrit Rietveld and Jacobus Johannes Pieter Oud, and the poets Til Brugman and Anthony Kock.
The first issue of Schwitters's periodical *Merz* is published under the title *Merz 1. Holland Dada*.

April–October 1923

Publication of *Merz 2. nummer i* (April), *Merz 3. Kurt Schwitters 6 Lithos auf den Stein gemerzt* (between April and June), *Merz 4. Banalitäten (Banalities)* (July), *Merz 5. 7 Arpaden* (summer), and *Merz 6. Imitatoren watch step. Arp 1 Prapoganda und Arp* (October).

August 1923

Summer holiday in Sellin on island of Rügen. Collaboration with Hans Arp (production of text *Franz Müllers Drahtfrühling* [Franz Müller's Wire Springtime]) and Hannah Höch.

1924

Publication of *Merz 11. Typoreklame = Pelikan-Nummer* and *Der Hahne Peter*, illustrated by Käte Steinitz, by the publishing house Apossverlag, which Kurt Schwitters co-established with Käte Steinitz.
Founding of Merz-Werbezentrale [Merz Advertising Headquarters]; increasing amount of work as typographer in the following years.

Meets Friedrich Vordemberge-Gildewart and Hans Nitzschke in Hanover.
Works on the 'anti-revue' show *Schlechter und Besser (Worse and Better)* together with Hannah Höch and the musician Hans Heinz Stuckenschmidt in Berlin.

January–July 1924

Publication of *MERZ 7. Tapsheft* (January), and *Merz 8/9. Nasci* in collaboration with El Lissitzky (between April and July).

September 1924

Represented with *Normalbühne Merz* in 'Internationale Ausstellung neuer Theatertechnik' [International Exhibition of New Theatre Techniques] in Vienna.

October 1924

Joint exhibition with Hans Arp and Alexej Jawlensky at the Kestner-Gesellschaft, Hanover.

1925

Release of *Merz 13. Merz-Grammophonplatte* with private recording of the scherzo from the *Ursonate (Primal Sonata)*.

14 February 1925

Joint recital evening with Nelly van Doesburg (piano) in Potsdam at the house of Frau Kiepenheuer – first performance of the *Ursonate (Primal Sonata)*.

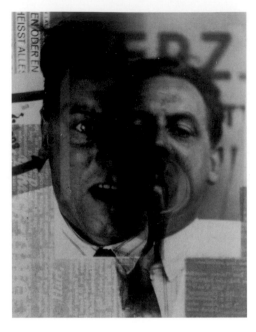

Kurt Schwitters, 1924 taken by El Lissitzky

April 1926

Katherine S. Dreier visits Hanover in order to prepare the 'International Exhibition of Modern Art' to be held as of November in the Brooklyn Museum, New York, organized by the Société Anonyme.

May–June 1926

Week-long tour of the Netherlands with Katherine S. Dreier. Visit to Lajos d'Ebneth in Kijkduin near Scheveningen, where Kurt Schwitters also paints. A meeting possibly took place with the Swiss art theorists Sigfried Giedion and Carola Giedion-Welcker.

1927

One-man exhibition 'Grosse Merzaus-stellung 1927' [Great Merz-exhibition] be-gins; extensive itinerary in Germany. Publication of *Merz 20. Kurt Schwitters. Katalog.* to accompany the show. Translation into musical notation of the *Ursonate (Primal Sonata)* begins (lasting until 1940).

12 March 1927

Co-founds the group 'die abstrakten han-nover' with Carl Buchheister, Rudolf Jahns, Hans Nitzschke and Friedrich Vordemberge-Gildewart. Numerous joint exhibitions in the years that follow.

April 1927

Collaboration with Käte Steinitz on a libretto for the grotesque opera *Der Zusammenstoss* [The Collision].

June/July 1927

Visits Robert Michel and Ella Bergmann-Michel in the Taunus region. First meeting regarding the foundation of the association of new advertising artists 'ring neue werbe-gestalter' (Circle of New Advertising Design) with Robert Michel, Willi Baumeister, Jan Tschichold, Walter Dexel, Friedrich Vordem-berge-Gildewart, César Domela and László Moholy-Nagy.

1929

Signs contract as typographer with the Hanover city administration (until 1934). Increasing lecture activities as typographer (lecture on typographical design 'Gestaltung in der Typographie' [Design in Typography]). Becomes member of artists' association 'Cercle et Carré', France; other members in-clude Le Corbusier, Piet Mondrian, Wassily Kandinsky.

Spring 1929

Visit from Katherine S. Dreier and Marcel Duchamp in Hanover.

July 1929

First journey to Scandinavia, together with Helma Schwitters (to Spitzbergen via Norway).

Autumn 1929

Designs all the exhibition publications for the Dammerstock-Siedlung project, Karlsruhe, led by Walter Gropius.

October/November 1929

Represented in exhibition 'Abstrakte und Surrealistische Malerei und Plastik' [Abstract and Surrealist Painting and Sculpture] at the Kunsthaus Zürich. Joint recital with Hans Arp during a soirée organized for the exhibi-tion (30 October).

1930

Becomes member of the PEN Club (founded in London in 1922). Co-founds the 'Ring Hannoveraner Schrift-steller' [Circle of Hanoverian Authors] with Christof Spengemann and Carl Credé.

March/April 1930

Trip to Switzerland; represented in exhibition 'neue werbegraphik' [New advertising graphics] at the Gewerbemuseum, Basel; catalogue text about the 'ring neuer werbegestalter' [Circle of New Adverstising Designers].

21 December 1930

Reading (of, among other works, *An Anna Blume [To Anna Blume]* and *Schacko*) at the matinée 'Künstler in Front' [Artists in front-line] in the Capitol-Hochhaus in Hanover; presumably his last public appearance as a recital artist in Germany.

1930–1936

Annual summer trips to Norway; stays primarily in north-western Norway, at Djupsvashytta Hotel by Lake Djupvand, in Moldefiord and on the island of Hjertøya, where since 1932 he has rented a hut. Earns his living by portrait commissions and sell-ing landscape paintings.

1931

Merz 21. Erstes Veilchenheft published. Becomes member of the artists' association 'Abstraction–Création', Paris. Photographs of the *Merz Building* and other works repro-duced in the journal of the same title 1932–1934.

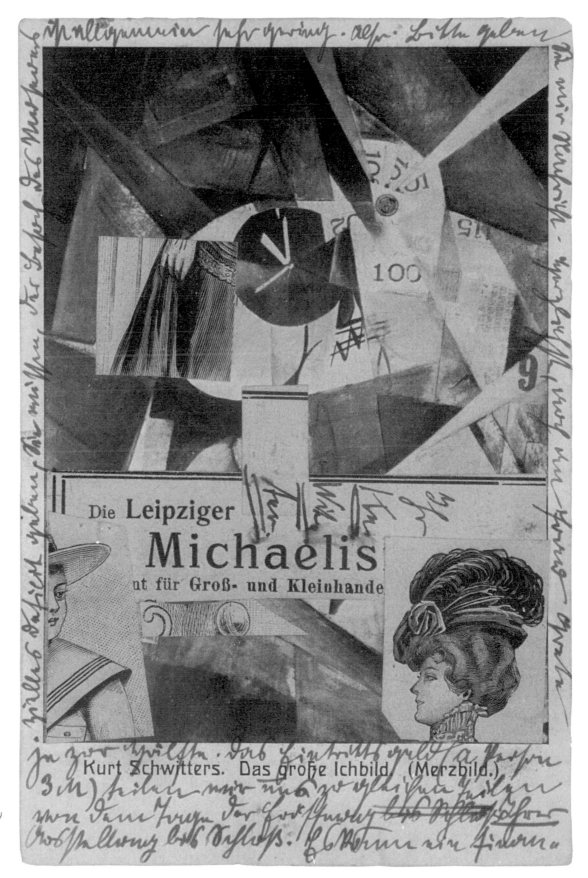

Cat. 158
Untitled (Collaged Picture Postcard 'The Great I Picture' to Walter Dexel)
23 March 1922
Collage and ink on cardboard
14 x 9 cm
Galerie Gmurzynska, Cologne

Kurt Schwitters on Hustadviha, on the coast near Molde, circa 1935

1932

Merz 24. Primal Sonata published (typography executed by Jan Tschichold).

1 July 1932

Becomes a member of the Sozialdemokratische Partei Deutschlands [Social Democratic Party].

1933

Becomes a member of the 'Deutscher Werkbund' [German Craft Union] (had probably joined earlier, but membership in 1933 is documented).

June–September 1933

Defamed in the exhibition 'Novembergeist: Kunst im Dienst der Zersetzung' [November Spirit: Art in the Service of Moral Corruption]

Kurt Schwitters in Norway, 1933

in Stuttgart and Bielefeld, and organized by the National Socialists (presumably only reproductions of Schwitters's works were shown).
In the course of the following years, increasing withdrawal into 'inner emigration' and concentration on the *Merz Building* in Hanover.

January/February 1934

Travels to Oslo with Ernst Schwitters; one-man show (landscapes) in 'Blomqvist Art Dealer's' in Oslo.

Summer 1934

Leases and begins to convert into a Merz Building a hut on the island of Hjertøya in Moldefiord; in Norway.

October/November 1934

Last presentation of Schwitters's work in National Socialist Germany in a show at Hanover Kunstverein apart from inclusion in defamatory exhibitions of so-called *entartete Kunst* [degenerate art].

1935

Defamatory presentation of *Das Merzbild (The Merzpicture)* and *Ringbild (Ring Picture)* (both confiscated in 1935) as well as his poem *To Anna Blume* and the quotation 'Alles, was ein Künstler spuckt, ist Kunst' [Everything an artist spits out is art] in 'Entartete Kunst' [Degenerate Art], the first touring exhibition organized by the National Socialists (began 23 September 1933 in Dresden and ended, in September 1936, in Frankfurt am Main.)
Alfred Barr Jr (director of the Museum of Modern Art, New York) pays a visit to 5 Waldhausenstrasse, Hanover, but does not meet Schwitters in person. Barr views the *Merz Building* and purchases a collage for the Museum of Modern Art, New York.

September 1935

Stay in Copenhagen. Carola Giedion-Welcker visits 5 Waldhausenstrasse in Hanover during his absence and views the *Merzbau (Merz Building)*.

December 1935

Travels to Switzerland. Recital evening held (on 1 December) while staying in Basel with the art collectors Otto and Annie Müller-Widmann. Visits Jan and Edith Tschichold and stays with Sigfried Giedion and Carola Giedion-Welcker in Zurich. Private recital in the home of Otto Nebel in Bern (on 16 December).

1936

Dispatches documents about the political situation and day-to-day life in Germany to Jan and Edith Tschichold in Basel.

March/April 1936

Included in exhibition 'Cubist and Abstract Art' at the Museum of Modern Art, New York.

August 1936

The Gestapo in Hanover arrests his friends Christof and Luise Spengemann and their son Walter.

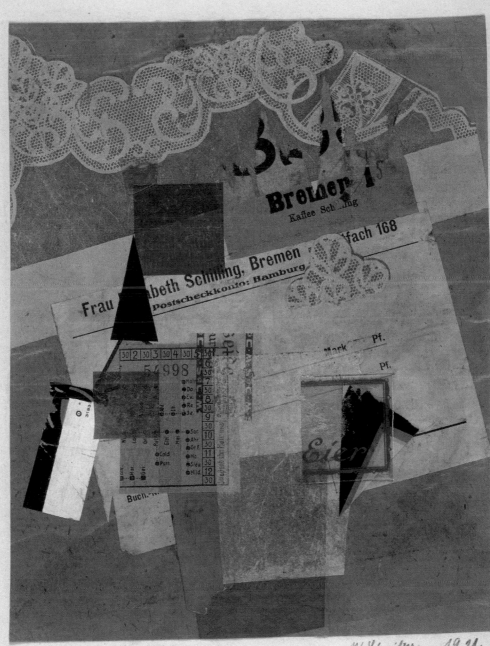

Cat. 51
Mz 233. Eier
Mz 233. Eggs
1921
Collage on paper
24.7 x 19.4 cm
Private collection

End of 1936
Fruitless attempts to find parties in the USA interested in his *Merz Building*.

December 1936/January 1937
Included in the exhibition 'Fantastic Art, Dada, Surrealism' at the Museum of Modern Art, New York.
Schwitters's son Ernst flees to Norway on 26 December. Kurt Schwitters follows on 2 January 1937 and in view of the political situation decides not to return to Germany. Lives in Lysaker near Oslo and, in the summer months, in Molde (officially registered as resident already on 10 November 1936). Helma Schwitters remains in Hanover and spends only a few months annually in Norway up to 1939. Important works are gradually moved from Hanover to Lysaker.
Kurt Schwitters begins work on a new Merz Building in Lysaker, the *Haus am Bakken (House by the Slope)*, which was destroyed in fire in 1951. During emigration in Norway, and later in Great Britain, he increasingly produces figurative drawings and paintings.

January/February 1937
Represented in exhibition 'Konstruktivisten' [Constructivists] at the Kunsthalle in Basel.

July/August 1937
More works by Schwitters expropriated from German museums (in Berlin, Hanover, Mannheim, Breslau, Saarbrücken and Wiesbaden, among other places).
Second exhibition 'Entartete Kunst' [Degenerate Art] begins. Presentation of abstract works (for instance *The Merzpicture*, 1919) in the context of Dadaist works described as being *kompletter Wahnsinn* [complete insanity].

1938
Sells five collages to Peggy Guggenheim.

July 1938
Represented in 'Exhibition of Twentieth Century German Art', New Burlington Galleries, London (organized in protest against the Nazi 'Degenerate Art' exhibition).

September/October 1938
Represented in the exhibition 'International Nutidskunst. Konstruktivisme, Neoplasticisme, Abstrakt Kunst, Surrealisme' [International Contemporary Art, Constructivism, Neoplasticism, Abstract Art, Surrealism] in Oslo.

2 July 1939
Family celebration in Oslo (80th birthday of his mother, Henriette Schwitters, and engagement of Ernst Schwitters to Esther Guldahl); last meeting with Helma Schwitters.

9 April 1940
German troops invade Norway. Together with son Ernst and his wife Esther, flight over a period of several weeks to north-west Norway. Crosses to Scotland on the ice-breaker *Fridtjof Nansen* (8 – 18 June 1940).

Schwitters's Certificate of Registration, 1940/41

1940/41
Internment in various camps in Scotland and England; from 17 July onward in Hutchinson Camp in Douglas on the Isle of Man (until 21 November 1941). Sets up a studio in Hutchinson Camp. Produces numerous portraits of fellow-internees and holds regular recitals in the artists' café in the camp. Becomes member of the FDKB Freier Deutscher Künstlerbund [League of Free German Artists] in Great Britain, founded in 1938 by Fred Uhlman.

December 1941
Moves to London, 3 St Stephen's Crescent, on being released from internment. First meeting with Edith Thomas (nicknamed 'Wantee'), who later becomes his companion.

February 1942
Represented in the 'AIA 1942 Members' Exhibition' of the Artists' International Association in London.

1943–1945
Increased production of small abstract (plaster) sculptures.

8/9 October 1943
The house at 5 Waldhausenstrasse in Hanover, the site of the *Merz Building*, is destroyed by an incendiary bomb.

March/April 1944
Represented in an exhibition 'Konkrete Kunst' [Concrete Art] at the Kunsthalle in Basel.

April 1944
A stroke suffered during a severe bout of influenza leads to temporary paralysis on one side of his body.

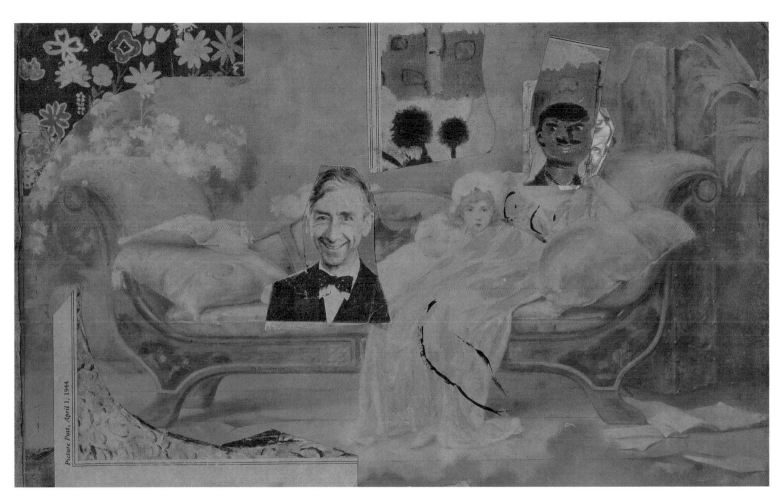

Cat. 138
Homage to Sir Herbert Read
1944
Collage on pasteboard
17.8 x 26 cm
Daria Brandt & David Ilya Brandt,
New York

29 October 1944
Helma Schwitters dies of cancer. Kurt Schwitters first learns of her death later that year in December.

December 1944
One-man show at the 'Modern Art Gallery' in London; introduction and catalogue text written by Herbert Read (see cat. 138, p. 229).

June 1945
Ernst Schwitters returns to Norway from Great Britain.
Kurt Schwitters moves with Edith Thomas to Ambleside, in the Lake District. Earns his living by painting portraits, landscapes and still lifes. Financial assistance afforded by his friend Walter Dux, a Hanoverian industrialist and fellow-émigré living in London.

1945–1947
Trips to London as well as Manchester, Liverpool, Southport, Blackpool, Preston and Penrith undertaken for portrait commissions and in order to buy paints.

1946
Produces extensive series of Merz-Zeichnungen (Merz drawings) in the course of this year and the next.
Thirteen poems published in Carola Giedion-Welcker's *Poètes à l'Écart – Anthologie der Abseitigen*, Benteli, Bern.

February/March 1946
Physical collapse due to vascular congestion, which also causes him to lose his sight for a period of four days.

Summer 1946–spring 1947
Works on the periodical *PIN* planned with Raoul Hausmann.

September/October 1946
Included as a non-member in the annual show of the Lake Artists' Society in Grasmere; represented again (as a member) in 1947; after his death, works are exhibited likewise (in 1948).

October–December 1946
Confined to bed for several weeks due to a fracture of the neck of the femur (on 8 October); increasing financial difficulties.

5 and 7 March 1947
Two Merz evenings staged at the London Gallery. Futile attempt to persuade the BBC to record his *Ursonate (Primal Sonata)*.

20 June 1947
60th birthday, is awarded a fellowship of US $ 1,000 by the Museum of Modern Art, New York, which be uses for work on a new Merz Building, the *Merz Barn*, on Cylinders Farm, which belongs to Harry Pierce, near Elter-water in the Lake District.

14 July 1947
Suffers a haemorrhage; work on the *Merz Barn* is interrupted.

5 August 1947
Article 'Kurt Schwitters. Konstruktive Metamorphose des Chaos' [Kurt Schwitters. Constructive Metamorphosis of Chaos] by Carola Giedion-Welcker published in the Zurich newspaper 'Die Weltwoche' on the occasion of Kurt Schwitters's 60th birthday.

Mid-December 1947
Admitted to Kendal Hospital.

7 January 1948
Granted British citizenship.

8 January 1948
Kurt Schwitters dies in presence of Edith Thomas and Ernst Schwitters in Kendal Hospital.

10 January 1948
Buried in St Mary's Cemetery in Ambleside.

4 September 1970
Remains transported to the Engesohde cemetery in Hanover; the grave in Ambleside is left in place, together with the gravestone erected by Edith Thomas in 1966.

1 This biography is a shortened version of the biography in *Kurt Schwitters: Catalogue raisonné, vol. 1 (1905–1922)*, edited by the Sprengel Museum on commision of the Niedersächsischen Sparkassenstiftung, the Nord / LB Norddeutschen Landesbank, the Sparkasse Hannover and the Kurt Schwitters Stiftung and published in 2002.

Cat. 175
Manuskript 'Auf dem Kopfe da hatt – er ja noch welche, und bumms bricht der ab!'
Manuscript 'On the head he still has some, and pow it breaks off!'
3 April 1929
Pencil on paper, one sheet written on one side
23.2 x 18.3 cm
Sammlung E. W. K., Bern

Auf dem Kopfe da hatt' er ja noch
welche, und darum bricht der ab!

Kurt Schwitters 3. 4. 29

List of the Exhibited Works

Unless otherwise indicated, the objects listed are works by Kurt Schwitters.

The bracketed abbreviation 'Orchard/Schulz' in the catalogue entries refers to *Kurt Schwitters: Catalogue raisonné*, vol. 1 (1905–1922) and vol. 2 (1923–1936), ed. Sprengel Museum Hannover on behalf of the Niedersächsische Sparkassenstiftung, the NORD/LB Norddeutsche Landesbank, the Sparkasse Hannover and the Kurt und Ernst Schwitters Stiftung, prepared by Karin Orchard and Isabel Schulz, Ostfildern, 2002 and 2003.
Unless otherwise indicated, the additional information on the individual works is also taken from this catalogue raisonné.

The bracketed abbreviation '*Dada global* 1994' in the catalogue entries refers to *Dada global*, eds. Raimund Meyer, Judith Hossli, Guido Magnaguagno, Juri Steiner and Hans Bolliger, Sammlungsheft 18, Kunsthaus Zürich, published on the occasion of the exhibition *Dada global*, 12 August – 6 November, 1994, Kunsthaus Zürich, Zurich 1994.

The full credit line for the works from the Kurt und Ernst Schwitters Stiftung, Hanover: The Kurt und Ernst Schwitters Stiftung was established largely thanks to the Schwitters family, with support from the NORD/LB Norddeutsche Landesbank, the Niedersächsische Sparkassenstiftung, die Niedersächsische Lottostiftung, die Kulturstiftung der Länder, the representatives of the Bundesregierung für Angelegenheiten der Kultur und der Medien, the Ministerium für Wissenschaft und Kultur des Landes Niedersachsen and the Landeshauptstadt Hannover.

Cat. 1
Zeichnung A 6
Drawing A 6
1918
Collage on paper
17.8 x 14 cm
Private collection, courtesy of
J & P Fine Art, Zurich
(Orchard/Schulz 287)
Illus. p. 96

Cat. 2
Merzbild 1 B Bild mit rotem Kreuz
Merzpicture 1 B Picture with Red Cross
1919
Collage, oil and gouache on pasteboard
64.5 x 54.2 cm
Sammlung Deutsche Bank
(Orchard/Schulz 426)
Illus. p. 99

The red cross from which the title is derived was originally mounted top centre and has not survived.

Cat. 3
Merzbild 14 B Die Dose
Merzpicture 14 B The Box
1919
Assemblage and oil on wood
16.4 x 14.1 cm
Marlborough International Fine Art
(Orchard/Schulz 433)
Illus. p. 94

Cat. 4
Merzbild K 6 Das Huthbild
Merzpicture K 6 The Huth Picture
1919
Collage and oil on pasteboard on wood
87 x 74 cm
Private collection
(Orchard/Schulz 438)
Illus. p. 156

Cat. 5
Mz 11 Starkbild.
Mz 11 Strong Picture.
1919 (1921)
Collage on cardboard
11.5 x 9.5 cm
The Menil Collection, Houston
(Orchard/Schulz 497)
Illus. p. 157

Cat. 6
Mz. 12. Bommbild.
Mz. 12. Bomm Picture.
1919
Collage, watercolour, lead and coloured pencils on paper
11.9 x 9.7 cm
Archiv Baumeister, Stuttgart
(Orchard/Schulz 498)
Illus. p. 129

Cat. 7
Ohne Titel (Berlin-Friedenau)
Untitled (Berlin-Friedenau)
1919
Collage, stamp paint and coloured pencils on paper
20.2 x 16.4 cm
Kurt und Ernst Schwitters Stiftung, Hanover
(Orchard/Schulz 508)
Illus. p. 181 top right

Cat. 8
Ohne Titel (Anna Blume hat ein Vogel)
Untitled (Anna Blume has Bats in her Belfry)
1919
Collage, stamp paint, lead and coloured pencils on paper
19.1 x 16.8 cm
Margo Pollins Schab Inc., New York
(Orchard/Schulz 511)
Illus. p. 181 bottom right

Cat. 9
Ohne Titel (Mit roter Kaffeemühle)
Untitled (With Red Coffee Grinder)
1919
Collage, stamp paint, lead and coloured pencils on paper
18.7 x 16 cm
IVAM, Instituto Valenciano de Arte Moderno, Generalitat Valenciana
(Orchard/Schulz 512)

Cat. 10
Ohne Titel (Der Sturm)
Untitled (Der Sturm)
1919
Collage, stamp paint, lead pencil and chalk on cardboard (verso and recto)
23.5 x 19.2 cm
Sammlung E. W. K., Bern
(Orchard/Schulz 514)
Illus. p. 180

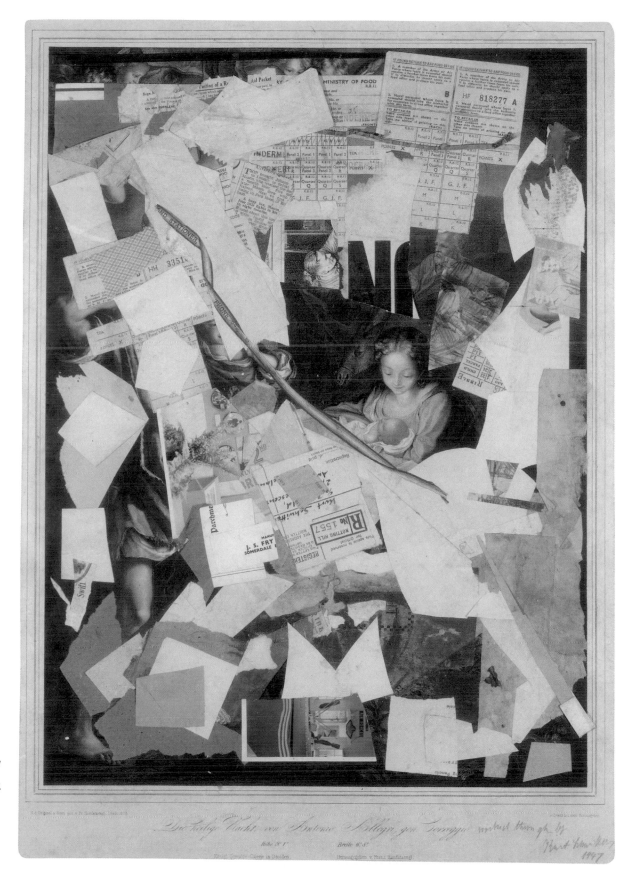

Cat. 145
*Die Heilige Nacht von Antonio
Allegri, gen. Correggio worked
through by Kurt Schwitters*
*'Holy Night' by Antonio Allegri,
Known as Correggio, Worked
through by Kurt Schwitters*
1947
Collage on pasteboard
52.9 x 38.8 cm
Private collection, Lugano

Cat. 11
Ohne Titel (Mit Kaffeemühle)
Untitled (With Coffee Grinder)
1919
Collage, stamp paint, lead and
coloured pencils on paper
32.5 x 24.3 cm (sheet)
Kurt und Ernst Schwitters Stiftung, Hanover
(Orchard/Schulz 515)
Illus. p. 110

Cat. 12
Ohne Titel (Abteilung: Inserate)
auf recto-Seite; *Schwank II. Teil*,
auf verso-Seite
Untitled (Department: Small Ads) recto;
Untitled (Farce Part II) verso
1919
Collage, chalk, lead pencil, stamp paint on
paper (verso and recto)
31.5 x 24.5 cm
Kunsthaus Zug, Depositum Stiftung
Sammlung Kamm
(Orchard/Schulz 519)
Illus. p. 169

Cat. 13
Ohne Titel (Römer oder Komposition Nr. 5)
Untitled (Roman or Composition No. 5)
1919
Coloured pencil, chalk, stamp paint on paper
19 x 15.9 cm
Daria Brandt & David Ilya Brandt, New York
(Orchard/Schulz 522)
Illus. p. 181 top left

Cat. 14
Aq. 9. (Windmühle.)
Aq. 9. (Windmill.)
1919
Watercolour and pencil on paper
17.3 x 14.4 cm
Sammlung E. W. K., Bern
(Orchard/Schulz 531)
Illus. p. 154 bottom left

Cat. 15
Aq. 10. (Ich mühle, du mühlst, er mühlt.)
Aq. 10. (I Grind, You Grind, He Grinds.)
1919
Watercolour and pencil on paper
25.3 x 20.4 cm
Galerie Gmurzynska, Cologne
(Orchard/Schulz 532)
Illus. p. 154 top right

Cat. 16
Aq. 21. Anna Blume und ich.
Aq. 21. Anna Blossom and I.
1919
Watercolour and coloured pencil on paper
21.1 x 17.2 cm
Kurt und Ernst Schwitters Stiftung, Hanover
(Orchard/Schulz 538)
Illus. p. 155

Cat. 17
Aq. 30. Das ist das Biest, das manchmal niest.
Aq. 30. The Occasionally Sneezing Beast.
1919
Watercolour and pencil on paper
20.7 x 17.2 cm
Kurt und Ernst Schwitters Stiftung, Hanover
(Orchard/Schulz 543)

Cat. 18
Konstruktion.
Construction.
1919
Pencil and ink on paper
18.5 x 15.2 cm
Kurt und Ernst Schwitters Stiftung, Hanover
(Orchard/Schulz 557)
Illus. p. 128 left

Cat. 19
Ohne Titel (Zeitu)
Untitled (Zeitu)
Circa 1919
Gouache on paper
4.1 x 4.9 cm
Kurt und Ernst Schwitters Stiftung, Hanover
(Orchard/Schulz 562)
Illus. p. 20

Cat. 20
Ohne Titel (Zwei Kreise, aus: Das Kestner-
buch, hg. von Paul Erich Küppers, Verlag
Heinrich Böhme, Hannover 1919)
Untitled (2 Circles, from Das Kestnerbuch,
ed. by Paul Erich Küppers, Verlag Heinrich
Böhme, Hanover 1919)
1919
Woodcut on paper; print run unknown
18.8 x 12.1 cm
Sprengel Museum Hannover
(Orchard/Schulz 572)
Illus. p. 126 right

Cat. 21
Ohne Titel (Lithografie mit Nietenlöchern)
Untitled (Lithograph with Rivet Holes)
1919
Lithograph on paper; print run unknown
29 x 23.2 cm
Cabinet des estampes, Musée d'art et
d'histoire, Geneva
(Orchard/Schulz 575)
Illus. p. 127

Cat. 22
Ohne Titel (Lithografie mit Nietenlöchern)
Untitled (Lithograph with Rivet Holes)
1919
Lithograph on paper; print run unknown
18.1 x 13.8 cm
Sprengel Museum Hannover,
Nachlass Robert Michel
(Orchard/Schulz 576)
Illus. p. 126 left

KS became acquainted with the painters and graphic artists
Ella Bergmann-Michel (1895–1971) and Robert Michel
(1897–1983) when Robert Michel exhibited in the Galerie
von Garvens, Hanover, in December 1921. KS and
the couple became close friends, and also collaborated,
for example, in the association of advertising artists 'ring
neue werbegestalter'. They jointly contributed to many
exhibitions in the 1920s; their correspondence up to 1947
documents their cordial relations.

Cat. 23
Ohne Titel
(Lithografie, Grosser Kreis mit Nietenlöchern)
Untitled
(Lithograph, Large Circle with Rivet Holes)
1919
Lithograph on paper; print run unknown
14.5 x 11.5 cm
Private collection
(Orchard/Schulz 577)

Cat. 24
Ohne Titel (Räder im Raum)
Untitled (Wheels in Space)
1919
Lithograph on paper; print run unknown
11.7 x 8.9 cm
Sprengel Museum Hannover
(Orchard/Schulz 579)
Illus. p. 128 right

The lithograph was published in November 1919
in the first issue of the journal *Der Zweemann*.

Cat. 25
Merzbild 6c, kleines Relief.
Merzpicture 6c, Small Relief.
1920
Assemblage and oil on iron plate
8.2 x 6.8 cm
Kurt und Ernst Schwitters Stiftung, Hanover
(Orchard/Schulz 595)

Cat. 26
Ausgerenkte Kräfte.
Disjointed Forces.
1920
Assemblage and oil on pasteboard
93.5 x 74 cm;
105.5 x 86.7 cm (original frame)
Kunstmuseum Bern,
Sammlung Max Huggler – Gift 1966
(Orchard/Schulz 605)
Illus. p. 109

Cat. 27
Das Bäumerbild
The Bäumer Picture
1920
Assemblage and oil on pasteboard
17.8 x 21.3 cm
Private collection, southern Germany
(Orchard/Schulz 606)
Illus. p. 79

Cat. 28
Siegbild
Victory Picture
1920–1925
Assemblage and oil on pasteboard on
wood frame
36.5 x 27.6 cm
Wilhelm-Hack-Museum,
Ludwigshafen am Rhein
(Orchard/Schulz 613)
Illus. p. 161

Cat. 29
Mz 39 russisches bild.
Mz 39 Russian Picture.
1920
Collage on paper
18.7 x 14.3 cm
The Museum of Modern Art, New York
Katherine S. Dreier Bequest 1953
(Orchard/Schulz 627)
Illus. p. 199

Cat. 30
Mzz. 62 Zeichnung teig
Mzz. 62 Drawing Dough
1920
Collage, gouache and indelible pencil on
paper
13.1 x 10.1 cm
Sprengel Museum Hannover,
Dauerleihgabe aus Privatbesitz
(Orchard/Schulz 641)
Illus. p. 158

Cat. 31
Mz 70 Der rote Fleck
Mz 70 The Red Spot
1920
Collage and gouache on pasteboard
15 x 11.4 cm
Marlborough International Fine Art
(Orchard/Schulz 646)
Illus. p. 97 top right

Cat. 32
Merzzeichnung 141 Lumpenwurf
Merzdrawing 141 Rag Throw
1920
Collage and gouache on paper
9.8 x 7.4 cm
Kurt und Ernst Schwitters Stiftung, Hanover
(Orchard/Schulz 686)

Cat. 33
Merzzeichnung 154 zart.
Merzdrawing 154 Tender.
1920
Collage and paint on paper
17.8 x 14.4 cm
Private collection, Switzerland
(Orchard/Schulz 693)
Illus. p. 103 top right

Cat. 34
Mz 161. (Ruhe, rot gestreift)
Mz 161. (Repose, Red-striped)
1920
Collage on paper
8.1 x 6.7 cm
Daria Brandt & David Ilya Brandt, New York
(Orchard/Schulz 699)
Illus. p. 194 bottom left

Cat. 35
Mz 168. Vierecke im Raum
Mz 168. Squares in Space
1920
Collage on paper
17.8 x 14.3 cm
Private collection, Zurich
(Orchard/Schulz 703)
Illus. p. 98

Cat. 36
Mz 170. Leere im Raum.
Mz 170. Voids in Space.
1920
Collage on paper
18 x 14.4 cm
Private collection
(Orchard/Schulz 705)
Illus. p. 160

Cat. 37
Merzzeichnung 203.
Merzdrawing 203.
1920
Collage on paper
18 x 14.5 cm
Private collection
(Orchard/Schulz 717)
Illus. p. 194 top right

Cat. 38
Radblumen.
Wheelflowers.
1920
Collage and oil on pasteboard
10.5 x 8 cm
Private collection
(Orchard/Schulz 718)
Illus. p. 124 left

The present collage was formerly in the collection of the
Constructivist painter Friedrich Vordemberge-Gildewart
(1899–1962). As a student at the Kunstgewerbeschule,
Hanover, he attended a Dadaist lecture by KS in 1920.
The two artists met in 1924 on the occasion of the
'Gruppe K' exhibition in the Kestner-Gesellschaft.
Together with other artists they founded the group
'die abstrakten hannover'.

Cat. 39
Ohne Titel (Merzzeichnung rä)
Untitled (Merzdrawing rä)
1920–21
Collage on paper
12.5 x 10.1 cm
Private collection, courtesy of Ubu Gallery,
New York
(Orchard/Schulz 735)
Illus. p. 164 right

Cat. 40
Z. i. 3 neu ausgestattet.
Z. i. 3 Newly Furnished.
1920
Defective print on paper, trimmed
14.5 x 10.8 cm
Cabinet des estampes,
Musée d'art et d'histoire, Geneva
(Orchard/Schulz 739)
Illus. p. 185 right

Cat. 41
Zeichnung I 8 Hebel 1
Drawing I 8 Lever 1
1920
Defective print on paper, trimmed
13.3 x 10.7 cm
Kurt und Ernst Schwitters Stiftung, Hanover
(Orchard/Schulz 744)
Illus. p. 184

Cat. 42
i-Zeichnung
i-Drawing
1920
Defective print on paper, trimmed
6.2 x 4.8 cm
Private collection, courtesy of Ubu Gallery,
New York
(Orchard/Schulz 752)
Illus. p. 185 left

Cat. 43
Ohne Titel (blutiger Tag in Berlin)
Untitled (Bloody Day in Berlin)
1920?
Paper, trimmed
8.4 x 10.6 cm
Kurt und Ernst Schwitters Stiftung, Hanover
(Orchard/Schulz 759)

Cat. 44
Die Kathedrale, 8 Lithografien
von Kurt Schwitters, Die Silbergäule 41/42,
Paul Steegemann Verlag, Hanover
1920
8 lithographs, volume of 8 sheets
in wrappers; print run unknown
Sammlung E. W. K., Bern
(Orchard/Schulz 767)
Illus. p. 141

The booklet was originally sealed with a lithographed
strip of paper bearing the words, 'Sealed for sanitary
reasons. Caution: Anti-Dada. Return if seal is broken.
K.S.Merz. 1920.'

Cat. 45
Lustmordkasten
Lust Murder Box
1920–22
Inlaid exotic wood box
(crafted by Albert Schultz, Hanover)
5.4 x 12.7 x 9.5 cm
Norton Simon Museum, Pasadena
Gift of Käte Steinitz, 1969
(Orchard/Schulz 771)

The title is presumably the original one. According to
Käte Steinitz, it is based on a damaged plaster figure that
once lay in the box and was daubed with lipstick that
made it look 'bloody'.

Cat. 46
Merzbild 14c Schwimmt
Merzpicture 14c Swims
1921
Assemblage, oil and gouache on
pasteboard and wood
15.8 x 10.8 cm
Private collection, Berlin
(Orchard/Schulz 775)
Illus. p. 95 bottom left

Cat. 47
Merzbild 35 A
Merzpicture 35 A
1921
Assemblage and oil on canvas
22.8 x 16.8 cm
Archiv Baumeister, Stuttgart
(Orchard/Schulz 779)
Illus. p. 95 top right

This work belonged to the painter Willi Baumeister
(1889–1955). KS probably met the artist during the latter's
exhibition at the 'Sturm' gallery in January 1920 or at the
latest on the occasion of their joint exhibition at Galerie
'Ernst Arnold' in Dresden in summer the same year. Further

joint exhibitions followed in the twenties. As of 1927,
Baumeister was involved, like KS, in the advertising artists'
association 'ring neuer werbegestalter' and, as of 1930,
in the artists group 'Cercle et Carré'.

Cat. 48
Ohne Titel (Dein treufrischer)
Untitled (Yours Treufrischer)
1921
Assemblage and oil on pasteboard
38.3 x 31 cm
Private collection, Brussels
(Orchard/Schulz 782)
Illus. p. 125

KS dedicated the present Merz picture on the verso
to his friend Raoul Hausmann (1886–1971): 'for my dear
Syndetikon / Your loyal-fresh / Ku Witter / 1921'. KS refers
to his friend with the name 'Algernoon Syndetikon', which
Hausmann invented for himself in 1921 in allusion to the
glue that he used for his collages: Otto Ring's Syndetikon.

Cat. 49
Mz 194
1921
Collage, oil, gouache and
watercolour on paper
14 x 11 cm
Muzeum Sztuki w Lodz
(Orchard/Schulz 812)
Illus. p. 194 top left

Cat. 50
Mz 228.
1921
Collage and chalk on paper
13.4 x 10.8 cm
Private collection
(Orchard/Schulz 827)
Illus. p. 102

Cat. 51
Mz 233. Eier
Mz 233. Eggs
1921
Collage on paper
24.7 x 19.4 cm
Private collection
(Orchard/Schulz 830)
Illus. p. 227

KS dedicated the present collage to the graphic artist,
typographer and poster artist Jan Tschichold (1902–74).
Under the auspices of the advertising artists' association
'ring neuer werbegestalter', which KS co-founded, the two
artists were in close contact from 1927 onward, if not
before. Jan Tschichold produced the typography for Kurt
Schwitters's *Ursonate*, published in 1932. In 1933, the

couple emigrated to Basel, where they were visited by KS in the years up to 1936. They energetically promoted his art in Switzerland, and he left them a number of works for safekeeping.

Cat. 52
Mz 245. Mal Kah
1921
Collage and chalk on paper
12.5 x 9.8 cm
Sammlung Sonanini, Switzerland
(Orchard/Schulz 838)
Illus. p. 163

Cat. 53
Mz 246. rot und gestreift.
Mz. 246. Red and Striped.
1921
Collage on paper
13.1 x 9.8 cm
Eigentum des Johannes-Molzahn-Centrum®
in D-34131 Kassel
(Orchard/Schulz 838a)
Illus. p. 195

The painter, photographer and commercial artist Johannes Molzahn (1892–1965) belonged to the circle of artists associated with the 'Sturm' gallery in Berlin, where he exhibited jointly with KS on several occasions. He lived in Soest from 1921 to 1923, taught at the Kunst-gewerbeschule in Magdeburg from 1923 to 1928, and at the Staatliche Akademie für Kunst und Gewerbe in Breslau from 1928 to 1933. He emigrated to the United States in 1938.

Cat. 54
Mz 258. Fünfrot – neu
Mz 258. Five Red – New
1921
Collage on paper
17.4 x 14.1 cm
Angela Thomas Schmid
(Orchard/Schulz 848)
Illus. p. 100 right

Cat. 55
Mz 300 mit Feder.
Mz 300 with Feather.
1921
Collage on paper
16 x 13 cm
Sprengel Museum Hannover,
Dauerleihgabe aus Privatbesitz
(Orchard/Schulz 867)
Illus. p. 100 left

Cat. 56
Mz 331. Goldkaro.
Mz 331. Gold Check.
1921
Collage on paper
17.9 x 14.4 cm
Sammlung E. W. K., Bern
(Orchard/Schulz 890)

Cat. 57
Merz 352 Dame in Rot.
Mz 352 Lady in Red.
1921
Collage on paper
14.5 x 12.5 cm
Ubu Gallery, New York
(Orchard/Schulz 895)
Illus. p. 101

Cat. 58
Mz 375 Caesar equus consilium.
1922
Collage on cardboard
15 x 12.4 cm
Von der Heydt-Museum, Wuppertal
(Orchard/Schulz 968)
Illus. p. 97 left

Cat. 59
Mz 408 Köln.
Mz 408 Cologne.
1922
Collage on paper
21 x 16 cm
Private collection
(Orchard/Schulz 986)
Illus. p. 186 left

Cat. 60
Mz 464 Die Not.
Mz 464 Distress.
1922
Collage on paper
18.4 x 14.2 cm (oval)
Private collection
(Orchard/Schulz 1009)
Illus. p. 259

Cat. 61
Ohne Titel (Alt)
Untitled (Old)
1922
Collage and gouache on paper
31.7 x 22.7/23.5 cm
Private collection
(Orchard/Schulz 1031)
Illus. p. 162

The collage was formerly in the collection of Paul Klee. Lily Klee recounts in her memoirs that in summer 1923 Paul Klee (1879–1940) stopped in Hanover on his way back from the island of Baltrum in order to visit Sophie Küppers, the widow of the former leader of the Kestner-Gesellschaft, and on this occasion met KS. Klee subsequently produced *C (für Schwitters [for Schwitters]) 1923, 161*. Klee probably received the collage in exchange for the drawing

Cat. 62
Die heilige Sattlermappe
The Holy Saddlers' Portfolio
1922
Collage on cardboard (joined in the middle)
38.4 x 55.8 cm
Claude Berri
(Orchard/Schulz 1043)
Illus. p. 159

KS dedicated the present portfolio to the artist Hannah Höch (1889–1978), whom he met in Berlin in 1918 and with whom he remained close friends throughout his life. Together with Raoul Hausmann and KS, she organized the 'Anti-dada-Merz-Tour' in Prague in 1921 and later designed two grottoes in KS's Hanover *Merzbau*, a sign of their strong bond. With the work *Schnitt mit dem Küchenmesser Dada durch die letzte Weimarer Bier-bauchkulturepoche Deutschlands* (1919), exhibited at the 'Berlin Dada Fair' of 1920, she established a lasting artistic influence in the Berlin Dada movement.
Between 1924 and 1925 she travelled to Paris and Holland and from 1926 to 1929 she lived with the Dutch author Til Brugmann in The Hague. Despite a ban on exhibiting her work, she returned to Berlin in 1929.
The dedication in ink on the verso reads: 'Höchlein, in / undying memory, this holy / saddler's bag / from 24 June 1922 / until eternity. / Kuwitter and wife, / Helma, known as Fischer.'

Cat. 63
Motiv aus Hildesheim
Motif from Hildesheim
Circa 1922
Collage on paper
11.1 x 8 cm
Private collection
(Orchard/Schulz 1058)
Illus. p. 158 left

Cat. 64
Ohne Titel (D on)
Untitled (D on)
Circa 1922
Collage on paper
13.3 x 10.7 cm
Kurt und Ernst Schwitters Stiftung, Hanover
(Orchard/Schulz 1063)
Illus. p. 135 top

Cat. 65
Für Hartmann.
For Hartmann.
1922
Collage, stamp paint and
coloured pencils on paper
19.2 x 15.7 cm
Marlborough International Fine Art
(Orchard/Schulz 1077)
Illus. p. 181 bottom left

Cat. 66
blau
Blue
1923/1926
Relief, oil and wood on wood
53 x 42.5 cm
Galerie Gmurzynska, Cologne
(Orchard/Schulz 1100)
Illus. p. 50

Cat. 67
Ohne Titel (Holzrelief mit Linoleum)
Untitled (Wooden Relief with Linoleum)
1923/1926
Relief, oil, wood and linoleum on wood
40 x 15 cm
Kunstmuseum Winterthur
(Orchard/Schulz 1103)
Illus. p. 56

Cat. 68
Violinschlüssel (ehemals: Bild HR / Relief
mit H. R. und Doppelschwanz)
Treble Clef (formerly: Picture HR / Relief
with H. R. and Double Tail)
1923 and 1927
Relief, oil and wood on pasteboard
87 x 65.2 cm
Private collection
(Orchard/Schulz 1104)
Illus. p. 55

Cat. 69
Mz 601
1923
Collage and paint on cardboard
40.4 x 34.8
Kurt und Ernst Schwitters Stiftung, Hanover
(Orchard/Schulz 1116)
Illus. p. 192

Cat. 70
Netzzeichnung
Net Drawing
1923
Collage on paper
13.8 x 10.9 cm
Collection of Carroll Janis, New York
(Orchard/Schulz 1136)
Illus. p. 138

Cat. 71
Ohne Titel (Vogel)
Untitled (Bird)
1923
Collage on paper
14 x 11.4 cm
Private collection, Houston
(Orchard/Schulz 1139)
Illus. p. 139 bottom right

Cat. 72
Merzzeichnung Bloomfield
(ehemals: Ohne Titel Tivoli-Variété Hannover)
Merz Drawing Bloomfield
(formerly: Untitled Tivoli Music Hall, Hanover)
1923
Collage on paper
11 x 13.2 cm
Sprengel Museum Hannover,
Nachlass Robert Michel
(Orchard/Schulz 1144)

Cat. 73
Mz Herbin.
1923/1924
Collage on paper
14.9 x 11.3 cm
Musée d'Art Moderne et Contemporain,
Strasbourg
(Orchard/Schulz 1161)
Illus. p. 219

Cat. 74
MERZ 3. MERZ MAPPE. ERSTE MAPPE
DES MERZVERLAGES. 6 Lithos
MERZ 3. MERZ PORTFOLIO.
FIRST PORTFOLIO OF THE MERZ VERLAG.
Six Lithographs
1923
6 lithographs in one cover; print run: 50,
plus 5 (?) artist's proofs (it is not known,
whether 50 complete portfolios were in fact
produced)
55.6 x 44.5 cm
Sammlung E. W. K., Bern
(Orchard/Schulz 1194)
Illus. p. 137

Cat. 75
Plastik [ehemals: Ohne Titel (Vertikal)]
[Nachguss]
Sculpture [formerly: Untitled (Vertical)]
[Later casting]
1923; Later casting 1981/1984
Painted bronze cast of the original (oil,
wood), Ex. 0/7
51 x 12.8 x 11.8 cm
Kurt und Ernst Schwitters Stiftung, Hanover
(original: Orchard/Schulz 1195)

Cat. 76
MERZ 1924, 1. Relief mit Kreuz und Kugel
MERZ 1924, 1. Relief with Cross and Sphere
1924
Relief, ink (?), oil, cardboard, synthetic plate
and ladle on wood on pasteboard
69.1 x 34.4 x 9.3 cm
Kurt und Ernst Schwitters Stiftung, Hanover
(Orchard/Schulz 1211)
Illus. p. 189

Cat. 77
1. weisses Relief
1st White Relief
1924/1927
Relief, oil, glass and wood on wood
66.5 x 48.7 x 28.7 cm
Sprengel Museum Hannover
(Orchard/Schulz 1216)
Illus. p. 54

Cat. 78
Ohne Titel (dadá ist ewig.)
Untitled (dadá is Forever.)
1924
Collage on paper
14.4 x 13.5 cm
Sammlung E. W. K., Bern
(Orchard/Schulz 1236)

Cat. 79
MODEMADONNA
FASHION MADONNA
1924
Collage on paper
12.2 x 8.5 cm
Staatliche Museen zu Berlin, Kupferstich-
kabinett, Stiftung Sammlung Dieter Scharf
zur Erinnerung an Otto Gerstenberg
(Orchard/Schulz 1238)
Illus. p. 252

Cat. 80
Ohne Titel (Wie Mädchen fallen)
Untitled (As Girls Fall)
1924/1926
Collage on paper
14 x 10.9 cm
Private collection, Europe
(Orchard/Schulz 1250)
Illus. p. 167 left

Cat. 81
Ohne Titel (Erfurt-Erfur)
Untitled (Erfurt-Erfur)
1924/26
Collage on paper
22.2 x 19.6 cm
Collection of Jasper Johns
(Orchard/Schulz 1251)
Illus. p. 186 right

Cat. 82
Ohne Titel (OUR)
Untitled (OUR)
1925
Collage on paper
17.1 x 13 cm
Private collection
(Orchard/Schulz 1306)
Illus. p. 136

Cat. 83
Kirschbild
Cherry Picture
1925
Collage on paper
23.1 x 17.8 cm
Karl Ernst Osthaus-Museum der Stadt Hagen
(Orchard/Schulz 1307)

Cat. 84
Ohne Titel (5 So Mo Die)
Untitled (5 So Mo Die)
1925
Collage on paper
13.7 x 11.1 cm
Collection of Carroll Janis, New York
(Orchard/Schulz 1308)
Illus. p. 173

Cat. 85
Ohne Titel (fa)
Untitled (fa)
1926
Collage on paper
7.6 x 5.7 cm
Daria Brandt & David Ilya Brandt, New York
(Orchard/Schulz 1440)
Illus. p. 8

Cat. 86
Ohne Titel (Zigaretten)
Untitled (Cigarettes)
1926
Collage on paper
15.5 x 12 cm
Private collection, Houston
(Orchard/Schulz 1441)
Illus. p. 104 bottom right

Cat. 87
Ohne Titel (Collagierte Innenseite
eines Truhendeckels)
Untitled (Collage in Interior of a Trunk Lid)
Circa 1926
Collage on wood
58 x 68 cm (collage in interior)
Kurt und Ernst Schwitters Stiftung, Hanover
(Orchard/Schulz 1467)
Illus. p. 47

Cat. 88
Z. i. 24. spielendes Kind nach Boccioni.
Z. i. 24. Playing Child after Boccioni.
1926
Defective print, trimmed
16.2 x 12.4 cm
Indiana University Art Museum, Bloomington
(Orchard/Schulz 1478)
Illus. p. 183

Cat. 89
Z i 101. Begegnung.
Z i 101. Encounter.
1926
Defective print, trimmed
16.6 x 13.7 cm
Sprengel Museum Hannover,
Sammlung NORD/LB in der Niedersäch-
sischen Sparkassenstiftung
(Orchard/Schulz 1482)
Illus. p. 182 left

Cat. 90
Die Herbstzeitlose [Rekonstruktion]
Meadow Saffron [Reconstruction]
1926/1929; Reconstruction 1956
Hard plaster, reconstruction of the sculpture
destroyed in 1943, 3 of 7
80.5 x 29.7 x 35.5 cm
Sprengel Museum Hannover, Sammlung
NORD/LB in der Niedersächsischen
Sparkassenstiftung
(Orchard/Schulz 1493)

Cat. 91
Richard Freytagbild /
Das Richard-Freitag-Bild
Richard Freytag Picture /
The Richard Freitag Picture
1927
Relief, oil and wood on wood
79.2 x 62.1 cm
Private collection
Orchard/Schulz 1496
Illus. p. 51

The title appears to refer to a sticker on the back bearing
the imprint of a furniture moving company: 'Richard
Freitag [...]ionales Möbeltransport [...] Dresden-A. 14,
Werder-S [...].'

Cat. 92
Mz. 134.
1927
Collage on paper
15.7 x 14.1 cm
Kurt und Ernst Schwitters Stiftung, Hanover
(Orchard/Schulz 1508)
Illus. p. 193 top right

Cat. 93
Ohne Titel (M 1)
Untitled (M 1)
1927
Collage on paper
13.5 x 9.9 cm
Staatliche Museen zu Berlin,
Kupferstichkabinett
(Orchard/Schulz 1509)
Illus. p. 193 left

Cat. 94
Ohne Titel (Schwarze Punkte und Viereck)
Untitled (Black Dots and Rectangle)
1927
Collage on paper
18.3 x 14 cm
Kurt und Ernst Schwitters Stiftung, Hanover
(Orchard/Schulz 1511)
Illus. p. 188 top right

Cat. 95
Ohne Titel (250 GRAMM)
Untitled (250 GRAMMES)
1928
Collage on cardboard
8.6 x 6.4 cm
Kurt und Ernst Schwitters Stiftung, Hanover
(Orchard/Schulz 1539)
Illus. p. 124 right

Cat. 96
für Henry Cowel [sic!],
als Anerkennung seines Spiels
To Henry Cowel [sic!],
in Recognition of his Performance
1928
Collage on paper
18.4 x 16.2 cm
Collection of Jasper Johns
(Orchard/Schulz 1555)
Illus. p. 187 left

The American composer and pianist Henry Cowell
(1897–1965) undertook five guest tours through Europe
between 1923 and 1933. His innovative compositions,
employing rhythmical experiments, influences from
non-European music, and atonal elements, appealed
greatly to KS.

Cat. 97
Ohne Titel (Grüne Zugabe)
Untitled (Green Encore)
1928/1930
Collage on paper
14 x 11.4 cm
The Judith Rothschild Foundation, New York
(Orchard/Schulz 1560)
Illus. p. 164 left

Cat. 98
Ohne Titel (i-Zeichnung 'Kreisen')
Untitled (i-Drawing 'Circles')
1928
Defective print, trimmed
Diameter: 16.9 cm (tondo)
Kurt und Ernst Schwitters Stiftung, Hanover
(Orchard/Schulz 1567)
Illus. p. 188 bottom left

Cat. 99
für Edith Tschichold
For Edith Tschichold
1928
Pencil on defective print, trimmed
19.4 x 10.5 cm
Private collection
(Orchard/Schulz 1568)
Illus. p. 188 top left

Cat. 100
i-Zeichnung 'Pferd'
i-Drawing 'Horse'
1928
Defective print, trimmed
17.8 x 13.6 cm
Sprengel Museum Hannover
(Orchard/Schulz 1569)
Illus. p. 182 right

Cat. 101
Photogramm II
Photogram II
1928
Photogram
17.9 x 12.9 cm
Angela Thomas Schmid
(Orchard/Schulz 1575)
Illus. p. 242

Cat. 102
29/25
1929
Collage on paper
14.5 x 11 cm
Private collection
(Orchard/Schulz 1598)
Illus. p. 103 bottom left

Cat. 103
29/26 für C W.
29/26 For C W.
1929
Collage on pasteboard
14.5 x 11 cm
Private collection
(Orchard/Schulz 1599)
Illus. p. 191

Cat. 104
Ohne Titel (Tortrtalt ac hiscann)
Untitled (Tortrtalt ac hiscann)
1929
Collage on paper
10.1 x 12.3 cm
Kurt und Ernst Schwitters Stiftung, Hanover
(Orchard/Schulz 1606)
Illus. p. 135 bottom

Cat. 105
geklebt in Zuerich für Rudolf Jahns.
Pasted in Zurich for Rudolf Jahns.
1929
Collage on paper
21.4 x 17 cm
Sprengel Museum Hannover,
Leihgabe aus Privatbesitz
(Orchard/Schulz 1612)
Illus. p. 190 bottom right

With the help of friends, KS arranged to hold a Merz soirée
on 24 February 1927, in the studio of the artist Rudolf
Jahns (1896–1983) in Holzminden. Shortly thereafter
Jahns joined the recently founded artists' association
'die abstrakten hannover'. Friendly relations developed be-
tween KS and Jahns. A few weeks after a visit to Zurich,
where KS had taken part in the exhibition 'Abstrakte und
Surrealistische Malerei und Plastik' [Abstract and Surrealist
Painting and Sculpture], he held a lecture on typography in
Holzminden on 28 November 1929, which was followed,
on the same evening, by another Merz soirée in Jahns's
studio. On this occasion KS gave Jahns, in exchange for
a tempera picture, two Merz drawings, one being this
composition which KS had, according to its dedication,
'collaged in Zurich for Rudolf Jahns'.

Cat. 106
Ohne Titel (in Hotels)
Untitled (In Hotels)
1929
Collage on paper
25.2 x 19.8 cm
Private collection
(Orchard/Schulz 1613)
Illus. p. 190 top left

Cat. 107
Ohne Titel (Köstlich)
Untitled (Delicious)
1929/30
Collage on paper
13.8 x 11 cm
Sprengel Museum Hannover,
Nachlass Robert Michel
(Orchard/Schulz 1635)
Illus. p. 165

Cat. 108
Ohne Titel (Relief mit drehbarer Glasscheibe)
Untitled (Relief with Rotatable Glass Disc)
1930
Relief, wood and glass on wood
25.5 x 17.5 cm
Staatliche Museen zu Berlin, Nationalgalerie
(Orchard/Schulz 1653)
Illus. p. 115

Cat. 109
Mz 30,45
1930
Collage on paper
8.9 x 7 cm
Ahlers collection
(Orchard/Schulz 1708)
Illus. p. 193 bottom right

Cat. 110
Ohne Titel (H. BAHLSENS KEKS-FABRIK AG)
Untitled (H. BAHLSENS KEKS-FABRIK AG)
1930
Collage on paper
17.9 x 11.8 cm
Kunsthaus Zug, Stiftung Sammlung Kamm
(Orchard/Schulz 1731)
Illus. p. 133

Cat. 111
Ohne Titel (Mit gelber Form)
Untitled (With Yellow Form)
1930
Collage on paper
17.5 x 14 cm
Private collection, Germany
(Orchard/Schulz 1735)
Illus. p. 131

Cat. 112
doremifasolasido
Doremifasolasido
Circa 1930
Collage on paper
29.4 x 23.3 cm
Private collection, Switzerland
(Orchard/Schulz 1737)
Illus. p. 187 right

The present collage once belonged to Felix Witzinger, a pianist from Basel, who described to Prof Gerhard Schaub in a letter in 1997 how he came into possession of the work: 'In the 1930s I was living in my mother's house in Basel, at Steinengraben 23. My dentist at the time was Prof Oskar Müller-Widmann, who was also an important art collector, who invited artists at least once a year to lectures and concerts in his wonderful, very modern house. In addition to my career as a pianist I was interested in modern art and collected to a modest extent. For that reason Prof Müller invited me to many of his occasions, and thus I met at his home Hans Arp and Sophie Taeuber, László Moholy-Nagy, Kurt Schwitters, Vantongerloo, Vladimir Vogel and others.

I remember well Kurt Schwitters's presentation at Prof Müller's home on December 1, 1935. In particular Schwitters's presentation of the whole Urlaut-Sonate impressed me very much, both the work and Schwitters's art of presentation.

A short time later Prof Müller mentioned during a consultation that Schwitters was visiting him again, but was completely without funds, and he asked whether I wouldn't be able to give him some money, and I agreed immediately. If I remember correctly, I gave him 300 francs. Because that was before the 30% devaluation of the Swiss franc in 1936, it would correspond to a purchasing power of about 5,000 francs today. Several days later, Schwitters rang the bell at my mother's house at eight in the morning; he had a large portfolio of paintings under his arm. He asked for me, and after greeting him I led him up to my room on the second floor, where he thanked me sincerely for my gift. When he saw the piano, he asked me to play some Beethoven sonatas, which he loved very much. I believe I played three of them, maybe even four. In any case, he enjoyed them very much.

Then he opened his large portfolio, showed me several collages and smaller Merz pictures, saying I should choose a collage and two Merz pictures, which I did enthusiastically. The collage was unsigned. Schwitters made up for that by writing his name at lower left, on the white frame under the picture, and gave it a name that suited me, namely Doremifasolasido! What an inspiration! The Merz pictures were already signed'.

– Quoted from Gerhard Schaub, *Kurt Schwitters und die 'andere' Schweiz: Unveröffentlichte Briefe aus dem Exil,* Berlin 1998, pp. 118–199.

Cat. 113
Ohne Titel (Die schwarz-rot-gold Maschine)
Untitled (The Black-Red-Gold Machine)
1930/31
Collage on paper
10.8 x 8.3 cm
Kurt und Ernst Schwitters Stiftung, Hanover
(Orchard/Schulz 1740)
Illus. p. 123

Cat. 114
Ohne Titel (Mit Maschinenteil)
Untitled (With Machine Part)
1930/31
Collage on paper
13.6 x 10.4 cm
Private collection
(Orchard/Schulz 1742)
Illus. p. 132

Cat. 115
Man soll nicht asen mit phrasen
You Should Beware of Hot Air
1930/31
Collage on paper
36.5 x 28.5 cm
Private collection, Zurich
(Orchard/Schulz 1746)
Illus. p. 166

Cat. 116
Ohne Titel (Helden des Alltags)
Untitled (Everyday Heroes)
1930/31
Collage on paper
34.2 x 27.6 cm
IVAM, Instituto Valenciano de Arte Moderno,
Generalitat Valenciana
(Orchard/Schulz 1750)
Illus. p. 130

Cat. 117
blaue Spirale
Blue Spiral
1930
Defective print, trimmed
14.7 x 11.7 cm
IVAM, Instituto Valenciano de Arte Moderno,
Generalitat Valenciana
(Orchard/Schulz 1758)

Cat. 101
Photogramm II
Photogram II
1928
Photogram
17.9 x 12.9 cm
Angela Thomas Schmid

Cat. 118
plastische Merzzeichnung
Plastic Merz Drawing
1931
Relief, oil, pasteboard and wood on wood,
nailed together
19 x 15 cm
IVAM, Instituto Valenciano de Arte Moderno,
Generalitat Valenciana
(Orchard/Schulz 1773)
Illus. p. 106

Cat. 119
Ein Beitrag zur Sanierung Deutschlands
A Contribution to the Refurbishment
of Germany
1931
Collage on paper
15 x 10 cm
Private collection
(Orchard/Schulz 1798)
Illus. p. 167 right

Cat. 120
Bild mit Hobelspänen
Picture with Wood Shavings
1932
Assemblage on wood
52.5 x 38.5 cm
Private collection
(Orchard/Schulz 1828)
Illus. p. 245

Cat. 121
Ohne Titel (MERZ WERBEZENTRALE)
Untitled
(MERZ ADVERTISING HEADQUARTERS)
1934
Collage on paper
20 x 12.4 cm
Kurt und Ernst Schwitters Stiftung, Hanover
(Orchard/Schulz 1951)
Illus. p. 117 bottom

Cat. 122
Ohne Titel (Kleine abstrakte Plastik)
Untitled (Small Abstract Sculpture)
1934
Sculpture, wood and plaster
26 x 7 x 6.5 cm
Collection of Carla Emil and Rich Silverstein,
courtesy of Ubu Gallery, New York
(Orchard/Schulz 1959)
Illus. p. 49

Cat. 123
eine Ichzeichnung
A Me Drawing
1935
Collage on paper
24.8 x 19.3 cm
Private collection
(Orchard/Schulz 1988)

The dedication 'for Eldermans' at lower right
on the support presumably refers to the Dutch author
H. Eldermans (1913–1989).

Cat. 124
2 Rote Flecken
Two Red Spots
1935
Collage and coloured pencil on paper
40 x 30 cm
Private collection,
courtesy of Galerie Beyeler, Basel
(Orchard/Schulz 1992)
Illus. p. 197

Cat. 125
Das Schwert des deutschen Geistes
The Sword of the German Spirit
1935
Sculpture: painted wood
47.8 (with base) x 3.7 x 0.5 cm
Private collection
(Orchard/Schulz 2001)
Illus. p. 52 right

The title is based on an anecdote written down in 1957
by Otto Wilhelm Ernst Nebel (1892–1973), an artist, poet
and actor who was a friend of KS (typescript in Bauhaus
Archiv, Berlin), which very probably refers to this sculpture.
On 16 December 1935, KS was visiting Nebel in Bern.
That evening, Nebel recalled, KS went to his suitcase and
'unpacked [...] a white rack that consisted of a flat piece
of wood like a clothes hanger, jutting from a rectangular
base. "This is the sword of the German spirit – not to
be confused with the spirit of the German sword – how
do you like it?" he asked.'

Cat. 126
'Schlanker Winkel'
'Slim Angle'
1935 (?)
Sculpture: oil and wood
48.2 x 9.5 x 12.4 cm
Kurt und Ernst Schwitters Stiftung, Hanover
(Orchard/Schulz 2003)
Illus. p. 53

Cat. 127
'Schwert'
'Sword'
Circa 1930
Sculpture, oil and wood
82.5 x 9.5 x 9.5 cm
Galerie Gmurzynska, Cologne
(Orchard/Schulz 2004)
Illus. p. 52 left

Cat. 128
Ohne Titel (Mit rotem Apfel
und grünen Blättern)
Untitled (With Red Apple and Green Leaves)
1936
Collage on paper
23.3 x 18.7 cm
Kurt und Ernst Schwitters Stiftung, Hanover
(Orchard/Schulz 2051)
Illus. p. 104 top left

Cat. 129
Ohne Titel (Vend!/Wenden!)
Untitled (Turn Over!)
1936 (?)
Collage on paper
21.8 x 17.7 cm
Marlborough International Fine Art
(Orchard/Schulz 2053)
Illus. p. 104 top

Cat. 130
Fabrikert I Norge
1937
Collage on paper
15.9 x 13.7 cm
Daria Brandt & David Ilya Brandt, New York
Illus. p. 139 top

Cat. 131
Ohne Titel
(Mit frühem Porträt von Kurt Schwitters)
Untitled
(With an Early Portrait of Kurt Schwitters)
1937/38
Collage on pasteboard
22.7 x 18.1 cm
Sprengel Museum Hannover
Illus. p. 218

Cat. 132
Ohne Titel (Kleines Merzbild mit Papierblume)
Untitled
(Small Merzpicture with Paper Flower)
1938
Relief, metal and paper on wood
26 x 19 cm
Ahlers collection
Illus. p. 105

Cat. 133
Pink Collage
1940
Collage on paper
15.9 x 13.7 cm
Daria Brandt & David Ilya Brandt, New York
Illus. p. 196

Cat. 134
Das Strumpfhalterbild
Garter Picture
1940
Relief
16 x 11.5 cm
Teutloff Kultur- und Medienprojekte
Illus. p. 48

Cat. 135
Ohne Titel (Kathedrale) [Nachguss]
Untitled (Cathedral) [Later casting]
1941/42; later casting 1981/83
Painted bronze cast; later casting
of the original (painted wood), 3 of 7
40 x 19.2 x 19.2 cm
Kurt und Ernst Schwitters Stiftung, Hanover

Cat. 136
Ohne Titel (Merzbild Rosa Gelb)
Untitled (Merzpicture Pink Yellow)
1943
Relief, oil, wire, twigs and wood on wood
34.1 x 26.5 cm
Kurt und Ernst Schwitters Stiftung, Hanover
Illus. p. 107

Cat. 137
Madonna [Nachguss]
Madonna [Later casting]
1943/45, later casting 1981/84
Painted bronze, later casting of the original
(oil, corrugated cardboard, plaster,
presumably wood), 2 of 7
57.8 x 13.3 x 15.6 cm
Kurt und Ernst Schwitters Stiftung, Hanover

Cat. 138
Homage to Sir Herbert Read
1944
Collage on pasteboard
17.8 x 26 cm
Daria Brandt & David Ilya Brandt, New York
Illus. p. 229

KS dedicated the present collage to the art historian and
critic Herbert Read (1893–1968). Read was one of the few
people KS met in London and one of the few who under-
stood his works. As early as 1936 Read included works
by KS in a Surrealist exhibition. He championed KS in his
criticism and wrote the introduction to the catalogue of the
only Schwitters exhibition that took place in Schwitters's
lifetime, in London in 1944.

Cat. 139
Wohlgestaltetes Bild
Well-Designed Picture
1944/1947
Collage on paper
26.8 x 22 cm
Private collection
Illus. p. 213

Cat. 140
dead cissors [sic!]
1947
Collage on paper
17.5 x 14.5 cm
Private collection, Munich
Illus. p. 85

Cat. 141
Study for Ambleside
1947
Collage (two-sided) on paper
Circa 19.5 x 15/11.5 cm
Sprengel Museum Hannover
Illus. p. 247

Cat. 142
Ohne Titel (Aus der Elterwater *Merz Barn*)
Untitled (from the Elterwater *Merz Barn*)
1947
Plaster, bamboo
80 x 27 x 19 cm
Private collection
Illus. p. 41

Cat. 143
Ohne Titel (Duverger)
Untitled (Duverger)
1947
Collage on cardboard
26.4 x 20.7 cm
Daria Brandt & David Ilya Brandt, New York
Illus. p. 198

Cat. 144
Für Carola Giedion Welker.
Ein fertig gemachter Poët
For Carola Giedion Welker. A Finished Poet
1947
Collage on paper
20 x 17 cm
Private collection
Illus. p. 23

Cat. 145
Die Heilige Nacht von Antonio Allegri, gen.
Correggio worked through by Kurt Schwitters
'Holy Night' by Antonio Allegri, Known
as Correggio, Worked through by
Kurt Schwitters
1947
Collage on pasteboard
52.9 x 38.8 cm
Private collection, Lugano
Illus. p. 233

Cat. 146
Ohne Titel (Gerber)
Untitled (Gerber)
1947
Collage on paper
19 x 17.1 cm
Marlborough International Fine Art
Illus. p. 139 bottom left

Cat. 147
This was before H.R.H. The Late Duke
of Clarence & Avondale. Now it is a Merz
picture. Sorry!
1947
Collage and leather on paper
39.1 x 27.3 cm
Sprengel Museum Hannover,
Sammlung NORD/LB in der Niedersäch-
sischen Sparkassenstiftung
Illus. p. 256

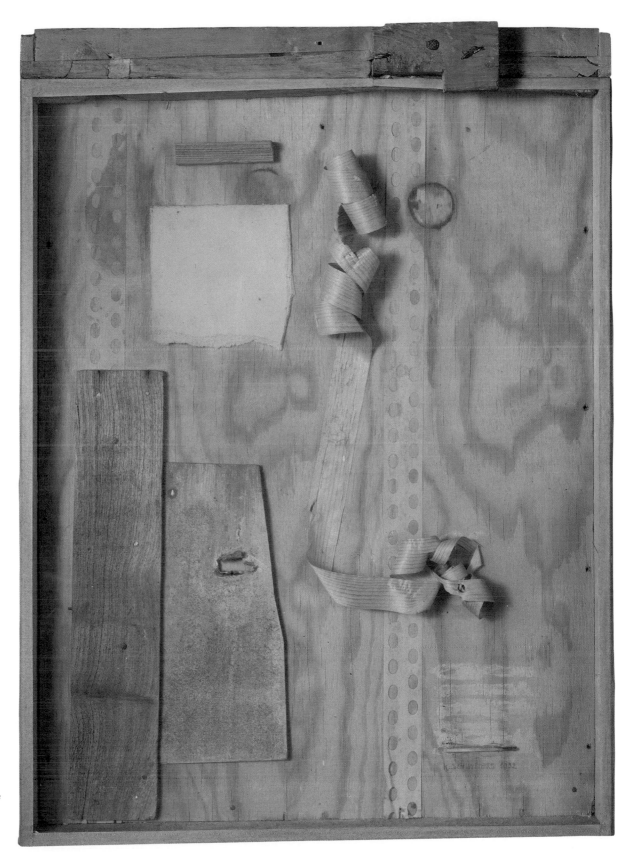

Cat. 120
Bild mit Hobelspänen
Picture with Wood Shavings
1932
Assemblage on wood
52.5 x 38.5 cm
Private collection

Cat. 148
BÂLE
1947
Collage and gouache and oil on paper
25 x 20 cm
Kunstsammlung Roche, Basel
Illus. p. 19

Cat. 149
Peter Bissegger [Reconstruction]
Reconstruction of Kurt Schwitters's
Merzbau, destroyed in 1943
1981–1983; 1988
Wood, plaster, plastic; painted
393 x 580 x 460 cm
Sprengel Museum Hannover,
reconstruction by Peter Bissegger
Illus. foldout, pp. 59–62 and illus. p. 69

The reconstruction was built between 1981 and 1983 by
Peter Bissegger, at the request of Harald Szeemann, based
on original photographs (1933) and with the assistance
of Ernst Schwitters.

Documents, Manuscripts, Posters, Publications

Cat. 150
Anna Blume: Dichtungen, Die Silbergäule
39–40, Hanover: Paul Steegemann Verlag,
1919
22 x 14.5 cm
Sammlung E. W. K., Bern

Cat. 151
*Untitled (Collaged Picture Postcard
'The Pleasure Gallows' to Christof
Spengemann)*
18 August 1920
Collage and ink on cardboard
14 x 9 cm
Schwitters-Archiv der Stadtbibliothek
Hannover
(Orchard/Schulz 731)
Illus. p. 120 bottom right

Cat. 152
*Merz Picture Postcards 'The Cult Pump',
'The Pleasure Gallows', 'Construction
for Noble Ladies', 'The Great I Picture',
'The Merzpicture', 'Picture Red Heart-Church'*
Postcards, Hanover,
publisher Paul Steegemann
Circa 1920
Each 14 x 9 cm
Sammlung E. W. K., Bern

Cat. 153
*Portrait Postcard 'The Pleasure Gallows'
with drawing to Walter Dexel,*
5 March 1921
Ink on cardboard
14 x 9 cm
Galerie Gmurzynska, Cologne
Illus. p. 153 right

Cat. 154
*Untitled (Collaged Portrait Postcard
'Kurt Schwitters' to Walter Dexel)*
27 May 1921
Collage and ink on cardboard
14 x 9 cm
Galerie Gmurzynska, Cologne
(Orchard/Schulz 914)
Illus. p. 153 left

KS presumably met Walter Dexel (1890–1973) and his
wife Margarethe (Grete) Dexel in 1919 at the 'Ausstellung
Hannoverscher Künstler' [Exhibition of Hanover Artists]
in Jena. In addition to his activity as a painter and commer-
cial graphic artist, Dexel, who had a doctorate in art history,
managed honorary the Kunstverein Jena from 1916 to
1928. A close friendship developed between KS and the
Dexel family, and the two artists supported each other
in their activities.

Cat. 155
*Picture Postcard 'Construction for
Noble Ladies' to Ivan Puni*
26 September 1921
Pencil on cardboard
14 x 9.4 cm
Iwan Puni Archiv, Zurich

Cat. 156
*Hildesheim, Gallows of Gallows Hill
(Collaged Picture Postcard 'The Pleasure
Gallows' to the Molzahns,*
10 October 1921
Collage and indelible pencil on cardboard
14 x 9 cm
Eigentum des Johannes-Molzahn-Centrum®
in D-34131 Kassel
(Orchard/Schulz 916)
Illus. p. 121

Cat. 157
*Untitled (Collaged Portrait Postcard
'Kurt Schwitters' to the Dexel Family)*
4 November 1921
Collage and ink on cardboard
14 x 9 cm
Galerie Gmurzynska, Cologne
(Orchard/Schulz 917)
Illus. on the back cover

The postcard to Ilse and Johannes Molzahn in Soest,
announcing a forthcoming visit by Walter and Grete Dexel,
was also signed by Garvens-Garvensburg along with
Helma and Kurt Schwitters.

Cat. 158
*Untitled (Collaged Picture Postcard
'The Great I Picture' to Walter Dexel)*
23 March 1922
Collage and ink on cardboard
14 x 9 cm
Galerie Gmurzynska, Cologne
(Orchard/Schulz 1054)
Illus. p. 225

Cat. 159
Anna Blume: Dichtungen von Kurt Schwitters,
Hanover: Paul Steegemann Verlag, 1922
18 x 12.3 cm
Sammlung E. W. K., Bern
(*Dada global* 1994, cat. no. 122, p. 193)

Cat. 160
*Elementar; Die Blume Anna; Die neue Anna
Blume: Eine Gedichtsammlung aus den
Jahren 1918–1922*, Einbecker deluxe edition
by Kurt Schwitters, Berlin: Verlag Der Sturm,
1922
22.6 x 15.4 cm
Sammlung E. W. K., Bern
(*Dada global* 1994, cat. no. 123, p. 194)

Cat. 161
*Ohne Titel (Blatt eines Lautgedichts)
Untitled (Sheet from a Sound Poem)*
Circa 1922
Mechanical print
33.2 x 8 cm
Collection of Elaine Lustig Cohen
Illus. p. 255 left

Cat. 141
Study for Ambleside
1947
Collage (two-sided) on paper
Circa 19.5 x 15/11.5 cm
Sprengel Museum Hannover

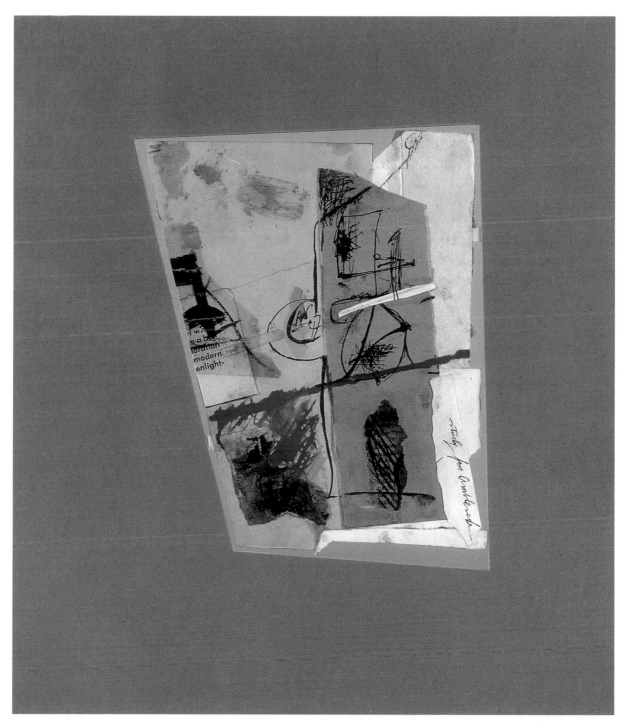

Cat. 162
Picture Postcard to Anthony Kock
20 January 1923
Ink on cardboard
14 x 9 cm
Daria Brandt & David Ilya Brandt, New York

Cat. 163
Picture Postcard to Anthony Kock
28 March 1924
Ink on cardboard
14 x 9 cm
Daria Brandt & David Ilya Brandt, New York

Cat. 164
Card advertising the *Merz 4. Banalitäten*
1923
Machine paper
Circa 15 x 10.5 cm
Sammlung E. W. K., Bern

Cat. 165
August Bolte (ein Lebertran): Tran Nr. 30,
by Kurt Merz Schwitters, Berlin: Verlag
Der Sturm, 1923
22.7 x 15.9 cm
Sammlung E. W. K., Bern
(*Dada global* 1994, cat. no. 126, p. 195)

Cat. 166
*Einladungskarte zur Merz-Matinee
'Was ist Seelenmargarine?' von Kurt
Schwitters mit Raoul Hausmann im Tivoli,
Hannover am 30. 12. 1923*
*Invitation card to the Merz matinee 'What Is
Soul Margarine?' by Kurt Schwitters with
Raoul Hausmann, in the Tivoli, Hanover, on
30 December 1923*
Machine paper
12.3 x 20.3 cm
Sammlung E. W. K., Bern
(*Dada global* 1994, cat. no. 127, p. 196)

Cat. 167
Poster 'Merz = Kurt Schwitters'
1923
Folded poster
Sammlung E. W. K., Bern

Cat. 168
Untitled (Collaged Cover of 'Notebook 8 uur')
1923
Book binding: collage and paper on cloth
19.2 x 27 cm
Private collection
(Orchard/Schulz 1148)
Illus. p. 210

Cat. 169
Untitled (Collaged Book Binding of Anna
Blume. Dichtungen, *Hanover 1922, 1)*
Circa 1923
Book binding: collage on cardboard
18 x 24.5 cm
Private collection
(Orchard/Schulz 1155)

Cat. 170
Kunst-Ismen, eds. by El Lissitzky and
Hans Arp, Erlenbach-Zurich/Munich/Leipzig
1925
Museum Tinguely, Basel
Gift by Christoph Aeppli
Illus. p. 33 (p. 11)

Cat. 171
Normalbühne (= MERZ, Nr. 100)
Standard Stage (= MERZ, no. 100)
Göhren, July 1925
Photograph of 3 sheets of a manuscript
Schwitters-Archiv
der Stadtbibliothek Hannover
(Orchard/Schulz 1334)

Cat. 172
*Portrait Postcard 'Kurt Schwitters'
to Rolf Mayr*
Late 1925/early 1926
Collage and ink on cardboard
14 x 9 cm
Schwitters-Archiv der Stadtbibliothek
Hannover
Illus. p. 120 top left

Cat. 173
*Untitled (Wool Skyscraper, Draft
of an Advertisement for Handarbeitshaus
Buchheister)*
1926–28
Collage and typescript on paper
39 x 17 x 7 cm
Galerie Gmurzynska, Cologne
Illus. p. 134

Cat. 174
*Manuskript "Soeben aus dem Garten
zurückgekehrt…"*
Manuscript 'Just Back from the Garden…'
Wiesbaden, 31 March 1927
Pencil on paper, one sheet written
on one side
26 x 20.1 cm
Sammlung E. W. K., Bern
Illus. p. 209

Cat. 175
*Manuskript 'Auf dem Kopfe da hatt – er ja
noch welche, und bumms bricht der ab!'*
*Manuscript 'On the head he still has some,
and pow it breaks off!'*
3 April 1929
Pencil on paper, one sheet written
on one side
23.2 x 18.3 cm
Sammlung E. W. K., Bern
Illus. p. 231

Cat. 176
abstraction-création, art non figuratif, no. 2,
Paris 1933
Archiv Georges Vantongerloo,
Angela Thomas Schmid

Cat. 177
abstraction-création, art non figuratif, no. 3,
Paris 1934
Archiv Georges Vantongerloo,
Angela Thomas Schmid

Cat. 178
*Brief von Kurt Schwitters an Robert Michel
'Keime verraten die Rasse',*
*Letter from Kurt Schwitters to Robert Michel
'Seeds Betray the Breed',*
Hanover, 2 December 1934
Manuscript: one sheet written on both sides
Archive Robert Michel / Ella Bergmann-Michel
Sprengel Museum Hannover
Illus. p. 151

Cat. 179
Manuscript of the poem 'Basel',
December 1935
Manuscript: pencil on paper, 1 sheet =
4 sides (each 22 x 17.5 cm)
Sprengel Museum Hannover
Illus. pp. 12 and 13

Cat. 180
*Letter from Kurt Schwitters
to Christof and Luise Spengemann*
Ambleside, 25 April 1946 [KS reports on
the destroyed Hanover *Merzbau*, describing
it as his 'life's work', ground plan of the
Merzbau]
Manuscript, 15 sheets, each written
on one side
Schwitters-Archiv der Stadtbibliothek
Hannover
see illus. p. 35

Cat. 181
*Letter from Kurt Schwitter to Luise
Spengemann* [KS reports on his work
on the *Merz Barn*]
Ambleside, 3 September 1947
Manuscript: one sheet written on one side
Schwitters-Archiv der Stadtbibliothek
Hannover

Cat. 182
Letter from Kurt Schwitters
to Christof Spengemann [final version
of the poem *An Anna Blume*]
Ambleside, 29 September 1947
Manuscript: 2 sheets, each written
on one side
Schwitters-Archiv der Stadtbibliothek
Hannover

Cat. 183
*Letter from Carola Giedion-Welcker to Kurt
Schwitters* [congratulations on his sixtieth
birthday and thanks for the collage *Für Carola
Giedion Welker. Ein fertig gemachter Poët*]
N.p., 6 December 1947
Manuscript: one sheet written on one side.
Schwitters-Archiv der Stadtbibliothek
Hannover

Cat. 184
Kurt Schwitters, Ernst Schwitters and
Philip Granville: *An Anna Blume. Die Sonate
in Urlauten*
Lord's Gallery, London, October 1958
33 1/3 LP Record, limited print run
of 100 copies
Sammlung E. W. K., Bern

Merz series

Cat. 185
Merz 1. Holland Dada, ed. Kurt Schwitters,
Hanover, January 1923
22.2 x 14 cm
Schwitters-Archiv der Stadtbibliothek
Hannover
(*Dada global* 1994, cat. no. 108, p. 186)

Cat. 186
Merz 2. Nummer i, ed. Kurt Schwitters,
Hanover: Merzverlag, April 1923
22.3 x 14.3 cm
Schwitters-Archiv der Stadtbibliothek
Hannover
(*Dada global* 1994, cat. no. 109, p. 186)

Cat. 187
Merz 4. Banalitäten, ed. Merzverlag
under Kurt Schwitters, Hanover: Merzverlag,
July 1923
23 x 14.7 cm
Schwitters-Archiv der Stadtbibliothek
Hannover
(*Dada global* 1994, cat. no. 110, p. 187)

Cat. 188
Kurt Schwitters and Hans Arp
*Merz 6. Imitatoren watch step! Arp 1.
Prapoganda* [sic] *und Arp*, ed. Merzverlag
under Kurt Schwitters, Zurich/Hanover,
October 1923
22.3 x 14.5 cm
Museum Tinguely, Basel
(*Dada global* 1994, cat. no. 111, p. 187)

Cat. 189
Merz 7, ed. Merzverlag under Kurt
Schwitters, Hanover: Merzverlag, January
1924
[Later called the 'Taps issue', after the main
figure in Christof Spengemann's novel
Ypsilon, of which excerpts were reprinted
here]
31.4 x 23.5 cm
Sammlung E. W. K., Bern
(*Dada global* 1994, cat. no. 112, p. 188)

Cat. 190
Merz 8/9. Nasci, ed. El Lissitzky and Kurt
Schwitters, Hanover: Merzverlag, April/July
1924 [typography by El Lissitzky]
30.8 x 23.5 cm
Sammlung E. W. K., Bern
(*Dada global* 1994, cat. no. 113, p. 188)

Cat. 191
Merz 11. Typoreklame, ed. MERZ,
Hanover: Merzverlag, November 1924
[so-called Pelikan issue]
30.8 x 23.5 cm
Sammlung E. W. K., Bern
(*Dada global* 1994, cat. no. 114, p. 189)

Cat. 192
Kurt Schwitters, Käte Steinitz and
Theo van Doesburg
Die Scheuche: Märchen (Merz 14/15),
Hanover: Apossverlag, 1925
20.4 x 24.2 cm
Sammlung E. W. K., Bern
(*Dada global* 1994, cat. no. 115, p. 189)

Cat. 193
Merz 20. Kurt Schwitters. Katalog,
Hanover: Merzverlag, 1927 [Catalogue
of the 'Grosse Merzausstellung', 1927]
24.5 x 16 cm
Sammlung E. W. K., Bern
(*Dada global* 1994, cat. no. 118, p. 191)

Cat. 194
*Merz 21. Erstes Veilchenheft. Eine kleine
Sammlung von Merz-Dichtungen aller Art von
Kurt Schwitters*, Hanover: Merzverlag, 1931
21 x 31.5 cm
Sammlung E. W. K., Bern
(*Dada global* 1994, cat. no. 119, p. 191)

Cat. 195
Merz 24. Kurt Schwitters: Ursonate,
Hanover: Merzverlag, 1932
[typography by Jan Tschichold]
20.7 x 14.5 cm
Sammlung E. W. K., Bern
(*Dada global* 1994, cat. no. 120, p. 192)

On the Hanover *Merzbau*

Cat. 196
Untitled (Small Grotto)
1923/1926
Metal, wood, porcelain, assorted materials
and oil; 1956 severely damaged,
reconstructed 2004
9.3 x 16.8 x 7.2 cm
Kurt und Ernst Schwitters Stiftung, Hanover
(Orchard/Schulz 1198)
Illus. p. 46

The present grotto was heavily damaged in 1956, along
with other sculptures, when the artworks were being
transported from Hanover to Bern for the large Schwitters
retrospective. This is told in a letter from Ernst Schwitters
to Werner Schmalenbach from April 25, 1956: 'The
Schwitters sculptures are not being exhibited here [in
Bern], and it would be impossible, because unfortunately
they were all damaged, some heavily (exclamation point).
[...] the damage [...] happened during the transport to Bern,
and in some cases it is so significant that one could never
speak of repair (exclamation point). [...] My father's only
surviving grotto is a total loss. It can no longer be
repaired, because everything has fallen apart totally. As
you know, the glass was already destroyed on the way to
Hanover, and what a shame that it was not replaced before
Bern (exclamation point). Now everything is destroyed. It is
completely impossible to reconstruct where the individual
parts belong and what is missing.' (A copy of this letter is
in the Kurt Schwitters Archiv in the Sprengel Museum
Hannover.)
In preparation for the exhibition at the Museum Tinguely,
Ursula Reuther, the conservator at the Sprengel Museum
Hannover, was able to use traces of paint on the inside
of the wooden crate to position the surviving parts where
they must have been located originally.

Cat. 197
Untitled (Pumice from the Merzbau)
Circa 1923–1936
Pumice
2.3 x 3.5 x 6.2 cm
Kurt und Ernst Schwitters Stiftung, Hanover
(Orchard/Schulz 1199, illus. 7)

Probably the only surviving 'fragment' of the *Merzbau*
in Hanover.

Photographs

Cat. 198
Unknown photographer
*Photographs of the original models
of the* Normalbühne Merz *in four different
arrangements*, circa 1924
4 black and white photographs
Each 5.5 x 8 cm
Kurt Schwitters Archiv im Sprengel Museum
Hannover

Cat. 199
Ernst Schwitters, photographer
*Ohne Titel (Detail aus der 'Grossen Gruppe',
Ecke oberhalb der 'Goldgrotte',
Teil des* Merzbaus *von Kurt Schwitters, 1932)
Untitled (Detail of 'Grand Group',
Corner above 'Golden Grotto', Part of Kurt
Schwitters's* Merzbau, *1932)*
1936
Silver gelatine print
23.8 x 16.2 cm
Kurt und Ernst Schwitters Stiftung, Hanover
(Orchard/Schulz 1199, illus. 17)

Cat. 200
Ernst Schwitters, photographer
*Grotte zur Erinnerung an Molde
(Teil des* Merzbaus *von Kurt Schwitters, 1935)
Grotto in Memory of Molde
(Part of Kurt Schwitters's* Merzbau, *1935)*
1936
Silver gelatine print
23.8 x 16.2 cm
Kurt und Ernst Schwitters Stiftung, Hanover
(Orchard/Schulz 1199, illus. 30)

Cat. 201
Ernst Schwitters, photographer
Schlanke Plastik (Teil des Merzbaus
*von Kurt Schwitters, 1935)
Slender Sculpture (Part of Kurt Schwitters's*
Merzbau, *1935)*
1936
Silver gelatine print
23.2 x 15.2 cm
Kurt und Ernst Schwitters Stiftung, Hanover
(Orchard/Schulz 1199, illus. 31)

Cat. 202
Ernst Schwitters, photographer
Barbarossagrotte (Teil der KdeE *von
Kurt Schwitters, 1935)
Barbarossa Grotto (Part of by Kurt
Schwitters's* KdeE [Cathedral of Erotic
Misery], *1935)*
1936
Silver gelatine print
23.8 x 15.9 cm
Kurt und Ernst Schwitters Stiftung, Hanover
(Orchard/Schulz 1199, illus. 8)

Cat. 203
Ernst Schwitters, photographer
Grotte mit Kuhhorn, (Teil des Merzbaus
*von Kurt Schwitters, 1925)
Grotto with Cow Horn,
Part of Kurt Schwitters's* Merzbau, *1925)*
1936
Silver gelatine print
23.4 x 15.1 cm
Kurt und Ernst Schwitters Stiftung, Hanover
(Orchard/Schulz 1199, illus. 9)

Cat. 204
Ernst Schwitters, photographer
Grotte mit Puppenkopf (Teil des Merzbaus
*von Kurt Schwitters, um 1932)
Grotto with Doll's Head, Part of
Kurt Schwitters's* Merzbau, *circa 1932)*
1936
Silver gelatine print
23.1 x 14.7 cm
Kurt und Ernst Schwitters Stiftung, Hanover
(Orchard/Schulz 1199, illus. 28)

Cat. 205
Redemann, photographer
Grosse Gruppe (Teilansicht des Merzbaus
*von Kurt Schwitters, 1933)
Grand Group (Detail of Kurt Schwitters's*
Merzbau, *1933)*
1933
Silver gelatine print
23.2 x 17.2 cm
Archiv Georges Vantongerloo,
Angela Thomas Schmid
(Orchard/Schulz 1199, illus. 22)
see illus. p. 5

Cat. 206
Redemann, photographer
Blaues Fenster (Teilansicht des Merzbaus
*von Kurt Schwitters, 1933)
Blue Window (Detail of Kurt Schwitters's*
Merzbau, *1933)*
1933
Silver gelatine print
22.9 x 17 cm
Archiv Georges Vantongerloo,
Angela Thomas Schmid
(Orchard/Schulz 1199, illus. 24)
see illus. p. 36

Cat. 207
Anonymus photographer
Goldgrotte und Grotte mit Puppenkopf
(Teil des Merzbaus *von Kurt Schwitters, 1933)*
Golden Grotto and Grotto with Doll's Head
(Part of Kurt Schwitters's Merzbau, *1933)*
1933
Silver gelatine print
22.5 x 15.9 cm
Archiv Georges Vantongerloo,
Angela Thomas Schmid
(Orchard/Schulz 1199, illus. 27)

Works by Jean Tinguely

The catalogue entries with the abbreviation
BB refer to the catalogue numbers
in Christina Bischofberger, *Jean Tinguely:*
Werkkatalog Skulpturen und Reliefs,
1954–1968, Zurich 1982.

Cat. 208
Élément Détaché I
Relief méta-mécanique
1954
Steel tube frame, steel wire,
12 differently shaped cardboard elements,
all painted white, 110 V electric motor
81 x 131 x 35.5 cm
Museum Tinguely, Basel
(BB 20)
Illus. p. 116 bottom

Cat. 209
Trois points blancs
Relief méta-mécanique
1955
Painted wood panel with 8 metal elements
of different shapes and colours. Verso:
wood pulleys, rubber belt, metal fixtures,
electric motor
50 x 62.5 x 17 cm
Museum Tinguely, Basel
(BB 49)

Cat. 210
Méta-matic No. 6
1959
Iron tripod, wood wheels, shaped sheet
metal, rubber belts, metal bars, all painted
black, electric motor
50 x 70 x 30 cm
Museum Tinguely, Basel

Cat. 211
Tricycle
1960
Welded bicycle pedals on stone pedestal
150 x 35 cm
Private collection
(BB 157)
Illus. p. 204

Cat. 212
Mes roues no. 1
1960
10 metal wheels, rubber belts, iron base,
iron bar support, 110 V electric motor
110 x 60 x 45 cm
Collection Sylvio Perlstein, Antwerp
(BB 170)
Illus. p. 205

Cat. 213
Crown-Jacket
1960
Iron base, metal bands and rods,
bicycle seat, bell, rubber tube, strings,
110 V electric motor
101 x 58 cm
Sammlung Theo und Elsa Hotz
(BB 203)
Illus. p. 207

Cat. 214
Ecrevisse
1962
Masonite board, aluminium bars, cardboard,
electric motor
40 x 65 x 18 cm
Museum Tinguely, Basel
(BB 252)
Illus. p. 206

Cat. 215
Radio Tokyo no. 2
1963
Welded scrap metal, radio,
110 V electric motor, all painted black
92 x 26 x 15 cm
Collection A. L'H
(BB 308)
Illus. p. 203

Cat. 216
Letter and sketch of the *Lunatour*
by Jean Tinguely to Le Corbusier, 1965
Blue felt-tip and pencil on paper
46.1 x 55 cm
Fondation Le Corbusier, Paris
Illus. p. 93 top

Cat. 217
Jean Tinguely, Bernhard Luginbühl,
Maurice Ziegler
TILUZI
1967
Iron, welded and screwed
circa 55 x 90 x 58 cm
Bernhard Luginbühl, Mötschwil
(cat. rais. Bernhard Luginbühl BL 1282)
Illus. p. 201 top

Cat. 218
Gigantoleum
1968
Felt-tip on paper
29.5 x 42 cm
Private collection
Illus. p. 93 bottom

Cat. 219
Bernhard Luginbühl/Jean Tinguely
Gigantoleum, Kulturstation I
1968
Iron, welded and screwed
109 x 170 x 130 cm
Bernhard Luginbühl, Mötschwil
Collaboration with Jean Tinguely
for a project in Bern-Weyermannshaus.
(cat. rais. Bernhard Luginbühl BL 1283)
Illus. p. 201 bottom

Cat. 220
Bernhard Luginbühl
Gigantoleum, Kulturstation II
1968
Iron, welded and screwed, electric motor
254 x 345 x 218 cm
Bernhard Luginbühl, Mötschwil
(cat. rais. Bernhard Luginbühl BL 1284)

Cat. 79
MODEMADONNA
FASHION MADONNA
1924
Collage on paper
12.2 x 8.5 cm
Staatliche Museen zu Berlin,
Kupferstichkabinett,
Stiftung Sammlung Dieter Scharf
zur Erinnerung an Otto Gerstenberg

Authors

Christoph Bignens

Born 1943, received his Ph.D. in art history at the Universität Zürich. 1992–1996, co-editor of the journal *archithese*. Publication as a freelance writer in Zurich of articles on the visual culture of the twentieth century, including writings on the architecture of cinemas, the design of Swiss consumer goods and on consumer and advertising graphic art, in particular that of Max Bill and Richard Paul Lohse.

He recently published *American Way of Life: Architektur – Comics – Design – Werbung* [American Way of Life: Architecture – Comics – Design – Advertising], Sulgen 2003.

Peter Bissegger

Born 1932 in Zurich. Attended the Zurich Kunstgewerbeschule (A9 applied arts with Serge Brignoni). Apprenticeship at and first set designs for the Zurich Schauspielhaus. From 1961 to 1966, he was set designer for the Basler Stadttheater. Since 1966, he has been an independent set designer at numerous major European theatres. In addition to his reconstruction of Kurt Schwitters's *Merzbau (Merz Building)*, he has also built other models and reconstructions in the 1980s and 1990s.

Iris Bruderer-Oswald

Raised in the Netherlands and Switzerland. Studied art history, German and Dutch at the Universität Zürich, completing her degree with her thesis *Tachismus in der Schweiz: Ein Kapitel Kunstkritik* (Tachism in Switzerland: A Chapter in Art Criticism] under Stanislaus von Moos. 1997 Ph.D., under Gottfried Boehm at the Universität Basel, with her dissertation *Hugo Weber: Vision in Flux; Ein Pionier des Abstrakten Expressionismus* [Hugo Weber: Vision in Flux; A Pioneer of Abstract Expressionism]. Worked on the Hugo Weber retrospective at the Kunsthaus Aarau in summer 1999. Several extended study periods in the USA, where she worked on exhibitions in Chicago and New York.

Author of various scholarly texts and lectures on twentieth-century art, including for the Schweizerisches Institut für Kunstwissenschaft in Zurich. Several years as lecturer for art history and architectural history at the Pädagogische Hochschule in Saint Gall and the Zürcher Hochschule Winterthur. Since 2001 research project *Das Neue Sehen: Carola Giedion-Welcker und die Kunstkritik der Moderne* [The New Vision: Carola Giedion-Welcker and the Modern Art Critism]. Currently holds a study position for scholarly research at the Deutsches Forum für Kunstgeschichte in Paris.

Ralf Burmeister

Born 1963. Studied German literature, political science and journalism at the Freie Universität Berlin, earning an M.A. From 1990 until 2002, he was scientific assistant at the Berlinische Galerie: Landesmuseum für Moderne Kunst, Photographie und Architektur, Berlin, working on, among other efforts, the research and exhibition projects 'Profession ohne Tradition' (Profession without Tradition; 1992) and 'Raoul Hausmann und seine Freunde' (Raoul Hausmann and His Friends; 1998). He collaborated on the archive edition *Scharfrichter der bürgerlichen Seele: Raoul Hausmann in Berlin, 1900–1933* (Executioner of the Bourgeois Soul: Raoul Hausmann in Berlin, 1900–1933; 1998). Editing and publication of the literary remains of Hannah Höch in the series *Hannah Höch: Eine Lebenscollage* (Hannah Höch: A Life Collage; 1995 and 2002). Academic advisor to the exhibitions 'Grotesk! 130 Jahre Kunst der Frechheit' (Grotesque! 130 Years of the Art of Impudence), Schirn Kunsthalle, Frankfurt am Main, Haus der Kunst, Munich (2003), and 'Hannah Höch', Museo Nacional Centro de Arte Reina Sofia, Madrid (2004). Articles and lectures on early twentieth-century art, in particular on Hannah Höch, Dada, Merz and Fluxus, and on contemporary artists.

Karl Gerstner

Born 2 July 1930 in Basel. Preliminary course at the Allgemeine Gewerbeschule Basel, and in parallel with that an apprenticeship as graphic artist in the Atelier Fritz Bühler, from 1945 to 1948. Later sat in on Hans Finsler's photography courses at the Kunst-gewerbeschule Zürich. Went freelance in 1950, working both in the fine and applied arts. First solo exhibition in Zurich in 1957. From the 1950s onwards has been one of the most rigorous representatives of Concrete Art, a competent journalist on art and design issues and an outstanding figure in graphic design, particularly famous for his activity as a founding member of the legendary adver-tising agency GGK. The bases for Gerstner's Concrete Art and design are science, methodology and innovative approaches. Numerous solo and group exhibitions in Switzerland and abroad, including participa-tion in 'documenta' in Kassel in 1964 and 1968 and at the Biennale di Venezia in 1986. Further reading: *Karl Gerstner: Rückblick auf 5 x 10 Jahre: Graphik Design. Etc.*, ed. and with a foreword by Manfred Kroepplin, Ost-fildern 2001. *Karl Gerstner: Rückblick auf sieben Kapitel konstruktive Bilder Etc.*, ed. by Eugen Gomringer, Ostfildern 2003.

Recent Exhibitions (selection)

Solo Exhibitions
2003–2004 'Karl Gerstner: Künstler, Autor, Grafiker' (Karl Gerstner: Artist, Author, Graphic Artist), 9 November 2003 – 22 Febru-ary 2004, Haus Konstruktiv, Zurich
'Karl Gerstner: Bilder en Relief' (Karl Gerstner: Paintings in Relief), 16 January – 28 Febru-ary 2004, Galerie Jamileh Weber, Zurich
'Karl Gerstner. Color Fractals', 16 January – 15 July 2004, Galerie Denise René, Paris

Group Exhibitions
2004 'Amicalement' vôtre, 6 March – 24 May 2004, Musée des Beaux-Arts, Lille
2001 'Ornament and Abstraction', 10 June – 7 October 7 2001, Fondation Beyeler, Riehen
'Denise René: l'intrépide', 4 April – 4 June 2001, Centre Georges Pompidou, Paris

Eric Hattan

Born 1955 in Wettingen, Switzerland. Based in Paris and Basel.

Recent exhibitions (selection)
(° with catalogue;* with video)

Solo exhibitions
2003 'Kennen sie DIE? E. H. & Werner Rei-terer', Kunsthaus Baselland Muttenz / Basel°*
'Vu', Ecole Régional des Beaux-Arts et La Plate Forme, Dunkirk*
'Liquid Concrete', SI Swiss Institute, New York*

2000/1 'Beton liquide', MAMCO Musée d'art modern et contemporain, Geneva*

2000 'You never know what you need', Skopia Art contemporain, Geneva
'Beton liquide', Aargauer Kunsthaus, Aarau°*
'Courant d'air', Galerie Gilles Peyroulet & Cie, Paris *

1999 'The Corridor', Reykjavik (with Silvia Bächli)

Group exhibitions
2003 'Buenos dias Buenos Aires', Museo de Arte Moderno, Buenos Aires, Comisario: Attitudes, Geneva°
'Paris Nuit Blanche', Ville de Paris, Secteur Bibliotheque National, Paris°*
'Pantalla Suiza', Museo Nacional Reina Sofia, Madrid, Comisario: Attitudes, Geneva*

2002 'Art Unlimited/ Art 33', Messe Basel, Basel°*
'premiers mouvement', le plateau, Paris*
'énergies de résistance', Attitudes, Geneva°*

2001 'Under pressure', Swiss Institute, New York°

2000 'Paris pour escale', ARC, Musée d'Art Moderne de la Ville de Paris, Paris°*
'Motti, Büchel, Hattan', Galerie Nicolas Krupp, Basel
'TRANSFERT. Kunst im Urbanen Raum', Biel-Bienne°
'Berlin. Cruce de caminos', Sala Plaza de Espagna, Madrid°

Thomas Hirschhorn

Born in Bern 1957. 1978–1983 Schule für Gestaltung [Design Academy] Zurich. Lives and works in Paris since 1984.

Recent exhibitions (selection)

Solo exhibitions
2003 Schirn Kunsthalle, Frankfurt am Main

2002 Kunsthaus Zürich (Preis für Junge Schweizer Kunst) [Award for Young Swiss Art]

2001 MACBA, Barcelona
Musée national d'art moderne / Centre Georges Pompidou, Paris (Prix Marcel Duchamp)

Group exhibitions
2003 Tate Modern, London
Fondacion Bancaja, Biennale Valencia
Palais de Tokyo, Paris

2002 Documenta 11, Kassel
Walker Art Center, Minneapolis
2001 Museum of Modern Art, New York
Musée d'Art Contamporain, Marseille

Christian Janecke

Ph.D., born 1964 in Wuppertal, art historian, worked first as assistant lecturer at the Hochschule für Bildende Künste Dresden, then as instructor at numerous universities and art schools. He has been the Wella Foun-dation Lecturer for Fashion and Aesthetics at the Technische Universität Darmstadt since 2002.
Focuses of research: Modern and contempo-rary art, image theory, all interactions be-tween theatre and art, zoos, fashion.
Publications (books): *Zufall und Kunst: Analyse und Bedeutung* [Accident and Art: Analysis and Significance; dissertation, Uni-versität des Saarlandes 1993] Nuremberg 1995; *Johan Lorbeer: Performances und Bild-nerische Arbeiten* [Johan Lorbeer: Perfor-mances and Visual Works], Nuremberg 1999; *Tragbare Stürme: Von spurtenden Haaren und Windstossfrisuren* [Wearable Storms: On Spurting Hair and Windswept Hairstyles], Marburg 2003; ed.: *Performance und Bild / Performance als Bild* [Performance and Image

Kurt Schwitters at a recital
of the *Ursonate (Primal Sonata)*,
late 1920s

Cat. 161
Ohne Titel (Blatt eines Lautgedichts)
Untitled (Sheet from a Sound Poem)
Circa 1922
Mechanical print
33.2 x 8 cm
Collection of Elaine Lustig Cohen

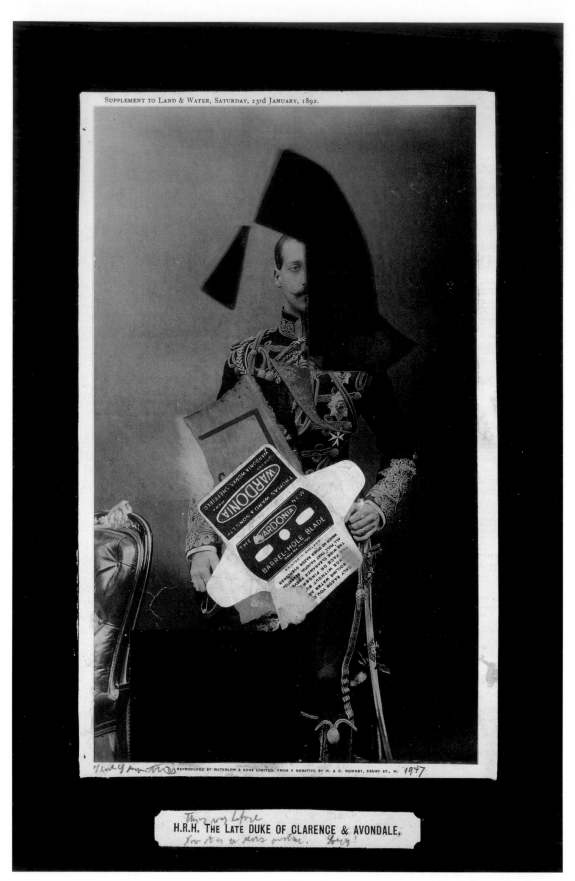

SUPPLEMENT TO LAND & WATER, SATURDAY, 23rd JANUARY, 1892.

REPRODUCED BY WATERLOW & SONS LIMITED. FROM A NEGATIVE BY W. & D. DOWNEY, EBURY ST., W. *1947*

H.R.H. THE LATE DUKE OF CLARENCE & AVONDALE.

Cat. 147
This was before H.R.H.
The Late Duke of Clarence & Avondale.
Now it is a Merz picture. Sorry!
1947
Collage and leather on paper
39.1 x 27.3 cm
Sprengel Museum Hannover,
Sammlung NORD/LB in der Niedersäch-
sischen Sparkassenstiftung

/ Performance as Image, Fundus-Bücher 160]
Dresden and Berlin 2004; ed.: *Haar tragen:
Eine kulturwissenschaftliche Annäherung*
[Wearing Hair: A Cultural Approach],
Cologne, Vienna and Weimar 2004.

Konrad Klapheck

1935 born Konrad Peter Cornelius Klapheck
in Dusseldorf; his father, Richard Klapheck,
was professor of art history at the Art Acad-
emy in Dusseldorf until his dismissal forced
by the Nazis.
1951–1954 Journeys to England, Italy and
France; meets Max Ernst in Paris.
1954 Begins studies at the Art Academy
in Dusseldorf with Prof Bruno Goller.
1955 First painting of typewriter.
1959 First solo exhibition at the Galerie
Schmela, Dusseldorf.
In the sixties Klapheck meets Surrealists
such as André Breton and Richard Oelze.
1966 First retrospective at the Kestner
Gesellschaft, Hanover.
1979 Professorship at the Art Academy,
Dusseldorf.
1985 Major retrospective at the Hamburger
Kunsthalle, Kunsthalle Tubingen and Staats-
galerie Moderner Kunst, Munich.
1997 Ends the series dedicated to the object
and the machine and begins a new series
of interiors and landscapes with nudes.

Recent publication: Arturo Schwarz,
Klapheck, with contributions by André Breton
and Werner Schmalenbach, Milan 2002.

Jakob Kolding

1971 Born in Albertslund, Denmark
1995–2000 The Royal Danish Academy
of Fine Arts, Copenhagen
Lives and works in Berlin

Recent exhibitions (selection)

Solo exhibitions
2003 Cubitt Gallery (with Luke Fowler),
London
Centre d'Edition Contemporaine, Geneva
2002 Galleri Nicolai Wallner, Copenhagen

Martin Janda-Raum Aktueller Kunst, Vienna
2001 Hamburger Kunstverein, Hamburg
Project at Center for Urbanism, Dialogue and
Information, Vollsmose, Denmark

Group exhibitions
2003 'GNS', Palais de Tokyo, Paris
'Utopia Station', Ongoing project – First in-
stalment at the Venice Biennale 2003, Venice

2002 'Concrete Garden', Museum of Modern
Art, Oxford
'Centre of Attraction', Baltic Triennial
of International Art, Vilnius, Lithuania

2001 'Intentional Communities', Rooseum –
Center For Contemporary Art, Malmo,
Sweden
'Zero Gravity', Kunstverein für die Rheinlande
und Westfalen, Dusseldorf

Karin Orchard

Born 1961. She studied art history, history
and literature in Hamburg, Edinburgh and
London. She received her doctorate in 1988
with a dissertation on androgyny in six-
teenth-century art. From 1984 to 1991,
she interned and worked at the Hamburger
Kunsthalle, including work on the exhibitions
'Zauber der Medusa: Europäische Manieris-
men' [Magic of the Medusa: European Man-
nerisms, for the Wiener Festwochen, 1987]
and 'Europa 1789: Aufklärung, Verklärung,
Verfall' [Europe 1789: Enlightenment, Trans-
figuration, Collapse, 1989]. In 1990 to 1991,
she was involved with the Hamburg project
group of the 'Europäisches Museumsnetz-
werk' [European Museum Network] project
of the EU. She has been a curator since 1991
at the Sprengel Museum Hannover, in charge
of such exhibitions as 'Die Erfindung der
Natur: Max Ernst, Paul Klee, Wols und das
surreale Universum' [The Invention of Nature:
Max Ernst, Paul Klee, Wols and the Surreal
Universe; 1994], 'BLAST: Vortizismus – Die
erste Avantgarde in England 1914–1918'
[BLAST: Vorticism – The First Avant-Garde in
England, 1914–1918; 1996] and 'Aller Anfang
ist MERZ. Von Kurt Schwitters bis heute' [In
the Beginning was Merz: From Kurt Schwit-
ters to the Present Day, 2000]. She has been

head of the Kurt Schwitters Archiv of the
Sprengel Museum Hannover since 1994 and
is co-editor of the Kurt Schwitters catalogue
raisonné. She is also author of articles on the
art of the sixteenth and twentieth centuries.

Daniel Spoerri

Born 1930 in Galati, Romania, as Daniel Isaac
Feinstein. After the death of his father in
1942, the family moved to Switzerland. There
he met Jean Tinguely in Basel in 1949. From
1950 to 1954 he studied classical ballet and
pantomime in Zurich and Paris. Between
1954 and 1959, he was a dancer and director
at theatres in Bern and Darmstadt. In 1959,
he moved to Paris, where he organised and
published MAT (Multiplication d'art trans-
formable) and created his first *tableau-pièges*
(trap pictures). His *Topographie anecdotée du
hasard* [An anecdoted topography of chance]
appeared in 1961. From 1966 until 1967, he
lived on the isle of Simi, off Rhodes. In 1968,
he founded the 'Spoerri Restaurant' and two
years later the 'Eat Art Gallery' in Dusseldorf.
In 1977, his *Musée sentimental* was at the
Centre Pompidou in Paris. (Additional
Musées sentimentaux in Cologne in 1979, in
Berlin in 1981, in Salzburg in 1983 and in
Basel in 1989.) In 1978, he and Marie-Louise
Plessen co-authored the book *Heilrituale an
bretonischen Quellen* [Healing Rituals at Bre-
ton Springs]. From 1978 until 1982 he taught
at the Fachhochschule Kunst und Design in
Cologne (multimedia class). In 1983, he was
named full professor at the Akademie der
Künste in Munich. The foundation 'Hic termi-
nus haeret: Il Giardino di Daniel Spoerri' was
established in 1997 in Seggiano, Italy.

Selected Recent Exhibitions

From 2001 to 2004 In addition to solo exhibi-
tions in various galleries, a large travelling ex-
hibition with works from 1980 onwards has
been shown in Halle, Lingen, Regensburg,
Budapest, Brno and Klagenfurt and will visit
Reggio Emilia, Mulhouse and Trieste in 2004.
2002 'Les dîners de Daniel Spoerri', Galerie
Nationale du Jeu de Paume, Paris
2001 'Daniel Spoerri: Metteur en scène
d'objets', Museum Tinguely, Basel

Klaus Staeck

1938 Born in Pulsnitz, near Dresden.
1957–1962 Study of law in Heidelberg, Hamburg and Berlin.
1965 Founds Edition Staeck.
since 1969 Attorney-at-law.
1970 First Zille Prize for socially critical graphic arts in Berlin.
1971 First poster action for the Dürer Year in Nuremberg.
1977 Participation in 'documenta 6', followed by 'documenta 7' in 1982 and 'documenta 8' in 1987.
1978 Criticism Prize of Berlin.
since 1986 Visiting professorship at the Art Academy Dusseldorf.
since 1990 Member of the Academy of Arts Berlin-Brandenburg.
1996 Gustav Heinemann Citizenship Prize
1999 *Kulturgroschen* of the German Cultural Council.
2000 Autobiography *Ohne Auftrag* (Without Instructions) published by Steidl-Verlag, Göttingen.

Juri Steiner

Born 1969, Steiner has a Ph.D. in art history and lives in Zurich and Lausanne. Between 1993 and 1998, he worked as an art critic for the 'Neue Zürcher Zeitung' and as a freelance curator at the Kunsthaus Zürich (exhibitions include 'Dada global', 'Arnold Böcklin – Giorgio de Chirico – Max Ernst' with Guido Magnaguagno and 'Freie Sicht aufs Mittelmeer' [Open View of the Mediterranean] with Bice Curiger). Between 2000 and 2003, he was responsible for the form, content and operation of the 'Arteplage mobile du Jura' on the occasion of the Swiss national exhibition Expo.02. He is presently in charge of the realization of the *Dada-Haus* on the site of Zurich's former *Cabaret Voltaire* and is co-curating the exhibition of the Swiss pavilion for the World Expo 2005 in Aichi (Japan). Together with Heinz Stahlhut, he is planning an exhibition on 'Situationistische Internationale' [Situationist Internationals] at the Museum Tinguely, Basel at the end of 2005.

Jean Tinguely

Born 1925, in Fribourg, Switzerland, and spent his childhood and school years in Basel. Following an apprenticeship as a window decorator, began in 1944 to conceive window decorations using wire for shops in Basel and Zurich. In 1951 married the artist Eva Aeppli and moved with her to Paris in 1952/53, where he found his calling as an artist. Using everyday materials such as steel wire, tin and paint, constructed mobile sculptures, which were initially hand-driven. In 1954 at his first solo exhibition at the Galerie Arnaud in Paris, he showed motor-powered reliefs, which he called *Méta-mécaniques*. In Paris he conceived his first sound reliefs and began in 1959 to work on *Méta-Matics*, drawing machines that automatically produced abstract art. In 1960 he met the artist Niki de Saint Phalle, who became his life companion. (Together they realised *Hon*, 1966, *Le paradis fantastique*, 1967, *Fontaine Stravinsky*, 1983, *Il giardino dei Tarocchi*, from 1980 onwards, and many others.) In October 1960 was a co-founder of the artists' group Nouveaux Réalistes. In 1960 his *Homage to New York*, his first action which used a self-destructing machine sculpture, took place in the Museum of Modern Art in New York. In 1961 and 1962 other happenings followed: *End of the World I* in Lousiana, Denmark, and *End of the World II* in the Nevada desert. In the first half of the 1960s he produced sculptures of scrap iron and *objets trouvés*, like the *Baloubas* group of sculpture, which made hectic, twitching, motor-driven movements. In 1963 Tinguely began to paint all his scrap-metal sculptures a uniform black. In the mid-1960s produced the series of black *Chars*, which moved aimlessly back and forth, and the *Eos and Bascule* sculptures. With artist friends he realized several large projects, such as *Le Cyclop*, 1970–1991, and *Crocrodrome*, 1977. His late work of the 1980s was marked by a juxtaposed contrasts and colourful, monumental works, like the *Méta-Harmonien* and works in which the artist took transience and death as his themes, like *Mengele Totentanz* [Mengele Dance of Death], 1987. In the 1980s numerous retrospectives were presented worldwide. Died in Bern 30 August 1991.

Beat Wyss

1947 Born in Basel. Studies art history, philosophy and German literature in Zurich.
1980–1983 Recipient of a stipend of the Swiss National Science Foundation for study at the Freie Universität Berlin and the Istituto Svizzero di Roma.
1986–1989 Editor at Artemis Verlag (Zurich and Munich) and instructor of architectural and cultural history at the Eidgenössisch-Technische Hochschule (ETH) Zürich.
1989–1990 Assistant professor at the Universität Bonn.
1990 Visiting Scholar at the Getty Center, Santa Monica, California.
1991–1997 Professor of art history at the Ruhr-Universität Bochum.
1996 Visiting professorship at Cornell University, Ithaca, N.Y.
since 1997 Head of the Institute for Art History at the Universität Stuttgart.
1999 Visiting professorship at Aarhus Universitet, Denmark.
2001 Receives the Art Prize of the city of Lucerne.
since 2002 Member of the Heidelberg Academy of Sciences.
since October 2003 Speaker of the *Graduiertenkolleg* (Graduate Symposium) of the Hochschule für Gestaltung Karlsruhe.

Recent publications: *Die Welt als T-Shirt: Zur Ästhetik und Geschichte der Medien* [The World as T-shirt: On the Aesthetics and History of Media], Cologne 1997.
Der Wille zur Kunst: Zur ästhetischen Mentalität der Moderne [The Will to Art: On the Aesthetic Mentality of the Modern], Cologne 1996.
Trauer der Vollendung: Zur Geburt der Kulturkritik [The Mourning of Perfection: On the Birth of Cultural Criticism], Munich 1985; new edition, Cologne 1997; English edition under the title: *Hegel's Art History and the Critique of Modernity*, New York 1999.

Cat. 60
Mz 464 Die Not.
Mz 464 Distress.
1922
Collage on paper
18.4 x 14.2 cm (oval)
Private collection

Further Reading (selection)

Catalogue raisonné and collection catalogues

Catalogue raisonné und Sammlungskataloge Kurt Schwitters. Catalogue raisonné, Vol. I (1905–1922), Vol. II (1923–1936), ed. by Sprengel Museum Hannover on commission of Niedersächsischen Sparkassenstiftung, NORD/LB Norddeutschen Landesbank, Sparkasse Hannover and the Kurt and Ernst Schwitters Foundation, by Karin Orchard and Isabel Schulz, Ostfildern 2002 and 2003

Kurt Schwitters. Werke und Dokumente. Werke und Dokumente im Sprengel Museum Hannover / Kurt Schwitters. Catalogue of the Works and Documents in the Sprengel Museum Hannover, ed. by Karin Orchard und Isabel Schulz, Sprengel Museum Hannover und Verein der Freunde des Sprengel Museum Hannover, Hanover 1998

Kurt und Ernst Schwitters Stiftung. Der Nach-lass von Kurt und Ernst Schwitters, ed. by Isabel Schulz, Kurt und Ernst Schwitters Stiftung, Hanover 2002

Maria Haldenwanger and Marion Beaujean: *Bestandesverzeichnis 1986, Stadtbibliothek Hannover, Schwitters-Archiv*, Hanover 1986; Franz Stark: *Bestandesverzeichnis. Nachtrag, Stadtbibliothek Hannover, Schwitters-Archiv*, Hanover 1987

Writings/Correspondance

Carola Giedion-Welcker, Schriften 1926–1971. Stationen zu einem Zeitbild, ed. by Reinhold Hohl, Cologne 1973

Hannah Höch. Eine Lebenscollage, Vol. I, 2 sections (1889–1920), and Vol. II, 2 sections (1921–1945), ed. by Künstlerarchiv der Berlinischen Galerie, Landesmuseum für Moderne Kunst, Photographie und Architek-tur, Berlin 1989
(Vol. I) / Ostfildern 1995 (Vol. II)
(Letters to Hannah Höch)

Kurt Schwitters. Das literarische Werk. 5 Volumes, Cologne 1973–1981.
Vol. 1: Lyrik , Vol. 2: Prosa 1918–1930, Vol. 3: Prosa 1931–1948, Vol. 4: Schauspiele und Szenen, Vol. 5: Manifeste und kritische Prosa

Kurt Schwitters. Poems, performance, pieces, proses, plays, poetics, ed. by Jerome Rothen-berg and Pierre Joris, Cambridge 2002

Kurt Schwitters. Wir spielen, bis der Tod uns abholt. Briefe aus fünf Jahrzehnten, ed. by Ernst Nündel, Frankfurt am Main and Berlin (1974) 1986

Gerhard Schaub: *Kurt Schwitters und die 'andere' Schweiz. Unveröffentlichte Briefe aus dem Exil*, Berlin 1998

Monographs

Uta Brandes and Michael Erlhoff (eds.): *Kurt Schwitters, KUWITTER. Grotesken, Szenen Banalitäten*, Hamburg (1984) 1997

Elizabeth Burns Garmand: *Kurt Schwitters' Merzbau: The Cathedral of Erotic Misery*, New York 2000

Marc Dachy: *Kurt Schwitters. Typography and Graphic Design*, in preparation

John Elderfield: *Kurt Schwitters*, London / New York 1985

Dietmar Elger: *Der Merzbau*, Cologne 1999

Dorothea Dietrich: *The Collages of Kurt Schwitters. Tradition and Innovation*, Cambridge (Massachusetts), (1993) 1995

Per Kirkeby and Edition Blondal (eds.): *Schwitters, Norwegian Landscapes, The Zoological Gardens Lottery and more Stories*, Hellerup 1995

Kurt Schwitters Almanach, Vols. 1–10, ed. by Michael Erlhoff, Klaus Stadtmüller and Sabine Guckel, Hanover 1982–1991

Kurt Schwitters: «Bürger und Idiot». Beiträge zu Werk und Wirkung eines Gesamtkünstlers, ed. by Gerhard Schaub, Berlin 1993

Beatrix Nobis: Kurt Schwitters und die romantische Ironie. Ein Beitrag zur Deutung des Merz-Kunstbegriffes, Alfter 1993

Ernst Nündel: Kurt Schwitters in Selbstzeugnissen und Bilddokumenten, Reinbek 1981

Stefan Themerson: Kurt Schwitters in England, London 1958

Werner Schmalenbach: Kurt Schwitters, Cologne 1967 / New York 1967 / London 1970 / Munich 1984

Schwitters in Norwegen. Arbeiten, Dokumente, Ansichten, ed. by Klaus Stadtmüller, Hanover 1997

Käte T. Steinitz: Kurt Schwitters. Erinnerungen aus den Jahren 1918–1930, Zurich 1963 (1987)

Gwendolen Webster: Kurt Merz Schwitters. A Biographical Study, Cardiff 1997

Exhibition catalogues

Kurt Schwitters, exh. cat., Städtische Kunsthalle, Dusseldorf / Nationalgalerie, Berlin / Staatsgalerie Stuttgart / Kunsthalle Basel, Dusseldorf 1971

Kurt Schwitters. Typographie und Werbegestaltung, ed. by Volker Rattenmeyer and Dietrich Helms, exh. cat., Landesmuseum Wiesbaden 1990 / Sprengel Museum Hannover 1990 / 1991 / Museum für Gestaltung Zürich 1991, Wiesbaden 1990

Kurt Schwitters, ed. by Serge Lemoine, exh. cat., Centre Georges Pompidou, Musée national d'Art moderne, Paris et al., Paris 1994

Aller Anfang ist Merz. Von Kurt Schwitters bis heute, ed. by Susanne Meyer-Büser and Karin Orchard, exh. cat., Sprengel Museum Hannover 2000 / Kunstsammlung Nordrhein-Westfalen, Dusseldorf 2001 / Haus der Kunst, Munich 2001, Ostfildern 2000

Kurt Schwitters. Ich ist Stil / I is Style, ed. by Rudi Fuchs, Siegfried Gohr and Gunda Luyken, exh. cat., Museum der bildenden Künste Leipzig / Stedelijk Museum Amsterdam, Rotterdam 2000

Kurt Schwitters, ed. by Ingried Brugger, Siegfried Gohr and Gunda Luyken, exh. cat., Kunstforum Wien, Salzburg 2002

Secondary literature

Der Hang zum Gesamtkunstwerk. Europäische Utopien seit 1800, ed. by Harald Szeemann, exh. cat., Kunsthaus Zürich et al., Aarau 1983

Hanno Möbius: Montage und Collage. Literatur, bildende Künste, Film, Fotografie, Musik, Theater bis 1933, Munich 2000

The Art of Assemblage, exh. cat., ed. by William C. Seitz, The Museum of Modern Art, New York 1961

Harald Szeemann: «Unsterblichkeit ist nicht jedermanns Sache»: Zum Gesamtkunstwerk von Kurt Schwitters (1887–1948), in: idem, Zeitlos auf Zeit. Das Museum der Obsessionen (Series: Statement-Reihe, Vol. S 9), Regensburg 1994, pp. 240–265.

Diane Waldmann: Collage und Objektkunst vom Kubismus bis heute, Cologne 1993

Herta Wescher: Die Kunst der Collage, Cologne 1968

Photos

Archiv Baumeister, Stuttgart: p. 129

Archiv Museum Tinguely: p. 108 bottom,
p. 203

Christian Baur, Basel: p. 19, p. 33, p. 51,
p. 55, p. 93 bottom, p. 116 bottom,
p. 124 top left, p. 188 left, p. 206, p. 207

Berlinische Galerie, Landesmuseum
für Moderne Kunst, Photographie und
Architektur, Berlin: p. 143 top, p. 145

Berlinische Galerie, Landesmuseum
für Moderne Kunst, Photographie und
Architektur, Berlin, Hannah-Höch-Archiv:
p. 144 bottom

Leonardo Bezzola; Archiv Museum Tinguely,
Basel: p. 71, p. 114

Cabinet des estampes, Geneva; photo: Denis
Ponté, Geneva: p. 127, p. 185 right

Courtesy of J & P Fine Art, Zurich: p. 98,
p. 100 right, p. 242

Hugo Erfurth; repro: Rheinisches Bildarchiv,
Köln: p. 2

Fondation Le Corbusier, Paris: p. 93 top

Noel A. Forster; repro: Kurt Schwitters
Archiv im Sprengel Museum Hannover:
p. 40

Fotocentrum Zimmermann GmbH, Hanover,
Kurt Schwitters Archiv im Sprengel
Museum Hannover: p. 69

Galerie Brusberg, Berlin: p. 48

Galerie Gmurzynska, Cologne: p. 50, p. 52
left, p. 134, p. 153 left and right, p. 225,
back cover

Galerie Kornfeld, Bern: p. 137, p. 141,
p. 154 bottom left, p. 180, p. 209, p. 231

Galerie Levy, Hamburg;
photo: Dirk Masbaum, Hamburg: p. 90

Sigfried Giedion: p. 14, p. 24

Indiana University Art Museum,
Bloomington; photo: Michael Cavanagh/
Kevin Montague: p. 179

Internationale Bildagentur Sennecke,
Bildarchiv Preussischer Kulturbesitz,
Berlin: p. 142 bottom

Carroll Janis Inc., New York: p. 138, p. 173
(photo: Allan Finkelman, New York)

Gisle Johnsen, Molde, courtesy of Dietmar
Elger, Hanover; repro: Kurt Schwitters
Archiv im Sprengel Museum Hannover:
p. 38

Kunstmuseum Bern; photo: Peter Lauri, Bern:
p. 109

Kunstmuseum Winterthur; photo: Schwei-
zerisches Institut für Kunstwissenschaft,
Zurich: p. 56

Kunsthaus Zug: p. 169, p. 133

Kunsthaus Zürich: p. 26 bottom, p. 245

El Lissitzky, Kurt Schwitters Archiv
im Sprengel Museum Hannover; repro:
Michael Herling/Uwe Vogt: p. 224

Schecter Lee: p. 187 left

Robert Lorenzson, New York: p. 8, p. 139 top,
p. 181 top left, p. 194 bottom left,
p. 196, p. 198, p. 229

Brutus Luginbühl: p. 201 top and bottom

Marlborough International Fine Art, London;
repro: Prudence Cuming Associates
Limited, London: p. 94, p. 97 right,
p. 104 top right, p. 139 bottom left,
p. 181 bottom left

Medienzentrum Wuppertal; photo: Assunta
Windgasse: p. 97 left

Lucia Moholy, Kurt Schwitters Archiv
im Sprengel Museum Hannover; repro:
Michael Herling/Uwe Vogt: p. 223 left

Johannes Molzahn Centrum für
Documentation und Publication, Kassel;
p. 121 (Foto Klintzsch, Kassel), p. 195

Musée d'Art Moderne et Contemporain,
Strasbourg: p. 219

Museumsinsel Hombroich, Neuss; photo:
Nic Tenwiggenhorn: p. 108

Muzeum Lodz; photo: Piotr Tomcyk:
p. 194 top left

Nachlass Theo van Doesburg, Rijksbureau
voor Kunsthistorische Documentatie,
Den Haag: p. 144 top

Courtesy of Helly Nahmad Gallery, London:
Cover, p. 157 top

Photo H. Preisig, Sion: p. 95 top right

Photographie Engel & Seeber: p. 167 bottom
left, p. 186 left

Redemann: p. 2, p. 36

Sammlung Deutsche Bank, Frankfurt
am Main: p. 99

Margo Pollins Schab Inc., New York: p. 181
bottom right

Peter Schälchli, Zurich: p. 52 bottom right,
p. 96, p. 103 bottom left, p. 156, p. 190
top left, p. 191

Emil Schulthess, Zurich: foldout

Schweizerisches Institut für Kunstwissen-
 schaft Zürich; photo: J. P. Kuhn: p. 113
Ernst Schwitters, Kurt Schwitters Archiv
 im Sprengel Museum Hannover: p. 168,
 p. 214, p. 226 left and right, p. 255 right
Ernst Schwitters; repro: Kunstmuseum
 Hannover mit Sammlung Sprengel: p. 32
Ernst Schwitters, Kurt Schwitters Archiv
 im Sprengel Museum Hannover; repro:
 Michael Herling: p. 43
Kurt Schwitters Archiv im Sprengel Museum
 Hannover: p. 39, p. 42 top, p. 45, p. 53,
 p. 113 top, p. 118, p. 125, p. 128 left and
 right, p. 142 top, p. 147, p. 182 left,
 p. 188 bottom right, p. 247
Kurt Schwitters Archiv im Sprengel Museum
 Hannover; photo: Kunstmuseum Hannover
 mit Sammlung Sprengel: p. 20,
 p. 126 right, p. 184, p. 218, p. 256
Kurt Schwitters Archiv im Sprengel Museum
 Hannover; photo/repro: Michael Herling:
 p. 35, p. 37 top, p. 42 bottom, p. 47,
 p. 65, p. 73, p. 104 top left, p. 107,
 p. 112 top, p. 117 bottom, p. 122, p. 123,
 p. 135 top, p. 176, p. 182 right, p. 184,
 p. 189, p. 193 top right
Kurt Schwitters Archiv im Sprengel Museum
 Hannover; photo/repro: Michael Herling/
 Uwe Vogt: p. 11, p. 12, p. 13, p. 37 bottom,
 p. 110, p. 124 right, p. 165, p. 181 top
 right, p. 192, p. 210, p. 223 right, p. 228
Kurt Schwitters Archiv im Sprengel Museum
 Hannover; photo/repro: Michael Herling/
 Aline Gwose: p. 46, p. 54, p. 73,
 p. 100 left, p. 102, p. 126 left, p. 132,
 p. 135 bottom, p. 139 bottom right,
 p. 158 right, p. 167 top left, p. 171 bottom,
 p. 190 bottom right, p. 212
Schwitters-Archiv der Stadtbibliothek
 Hannover: p. 120 left and right
Staatliche Museen zu Berlin, Kupferstich-
 kabinett; photo: Jörg P. Anders, Berlin:
 p. 171 top, p. 193 left, p. 252
Staatliche Museen zu Berlin, Nationalgalerie;
 photo: Jörg P. Anders, Berlin: p. 115
Käte Steinitz; repro: Kurt Schwitters Archiv
 im Sprengel Museum Hannover: p. 44
The Menil Collection, Houston, photo:
 Janet Woodarad: p. 157

© 2004, Digital image, The Museum
 of Modern Art, New York/Photo Scala,
 Florence: p. 112 bottom, p. 117 top,
 p. 172, p. 199
Ubu Gallery, New York: p. 49, p. 101,
 p. 164 top right, p. 185 top left
Brigitte Wegner, Fotodesign, Bielefeld:
 p. 105, p. 193 bottom right
Wilhelm-Hack-Museum, Ludwigshafen:
 p. 161
Dorothy Zeidman: p. 186 right

This catalogue is published on the occasion of the exhibition
Kurt Schwitters. MERZ – a Total Vision of the World

KURT SCHWITTERS
MERZ – a Total Vision of the World

Museum Tinguely, Basel
1 May – 22 August 2004

© 2004 Benteli Publishers, Bern,
and Museum Tingely, Basel
© 2004 by ProLitteris, 8033 Zurich/
VG Bild-Kunst, Bonn, for the works by
Hannah Höch, Kurt Schwitters, El Lissitzky,
Lucia Moholy, Daniel Spoerri,
Niklaus Stoecklin, Jean Tinguely

© 2004 by Eva Aeppli, Jakob Kolding,
Bernhard Luginbühl for their works

© 2004 by ProLitteris, 8033 Zurich/
VG Bild-Kunst, Bonn, for the texts by
Konrad Klapheck, Kurt Schwitters,
Daniel Spoerri, Klaus Staeck

© 2004 by Karl Gerstner, Eric Hattan,
Thomas Hirschhorn, Jakob Kolding
for their texts

© 2004 by Peter Bissegger for the recon-
struction of Kurt Schwitters's *Merzbau*
© 2004 by Estate of Emil Schulthess, Photo-
archiv, Zurich, for the photograph of
the reconstruction of Schwitters's *Merzbau*
© 2004 by ProLitteris, 8033 Zurich/
VG Bild-Kunst, Bonn, for the photographs
by Hugo Erfurth and Ernst Schwitters

© 2004 by the authors and the translators
for their texts

We have made every effort to identify
copyright holders. However, if we have failed
to inform someone, we ask to contact
the publisher

ISBN 3-7165-1350-4

Benteli Publishers Ltd.
Seftigenstrasse 310, CH 3084 Wabern/Bern
tel. (+41)31 960 84 84; fax (+41)31 961 74 14
info@benteliverlag.ch; www.benteliverlag.ch

Exhibition

Director
Guido Magnaguagno

Curators
Guido Magnaguagno
Annja Müller-Alsbach

Organization and Coordination
Annja Müller-Alsbach

Exhibition Architecture
The basic elements of the variable exhibition
architecture used were designed by
Harald Szeemann for the Museum Tinguely
in 1998/1999.

Office
Sylvia Grillon
Katrin Zurbruegg

Registrar
Annja Müller-Alsbach

Archive/Library
Claire Wüest

Conservation
Reinhard Bek
Josef Imhof
Olivier Masson
Christian Lindhorst

Technician
Urs Biedert

Transport
ZF Kraft ELS AG, Josy Kraft, Basel

The Museum Tinguely is supported by
F. Hoffmann-La Roche Ltd., Basel

Catalogue

Editor
Museum Tinguely, Basel

Editing
Annja Müller-Alsbach
Heinz Stahlhut

Copy-editing
Ingrid Nina Bell

Translations
Caroline Saltzwedel, Hamburg: Bissegger,
Bruderer, Burmeister, Gerstner, Janecke,
Magnaguagno, Spoerri, Staeck, Tinguely,
Wyss, transcribed texts by Schwitters;
Steven Lindberg, Berlin: Orchard, List of the
exhibited works, Biographies of the authors;
Anne Heritage, Munich: Bignens, Hattan,
Steiner; Jeanne Haunschild: Klapheck;
Charles Penwarden, Paris: Hirschhorn

Managing Editor
Christine Flechtner, Benteli Publishers

Graphic Design
desktalk, Basel

Layout
Arturo Andreani, Benteli Publishers

Photolithography
Prolith AG, Köniz

Printing
Benteli Hallwag Druck AG, Bern

Binding
Schumacher AG, Schmitten

Cover illustration
front: *Die heilige Sattlermappe (The Holy
Saddlers' Portfolio)* 1922, see cat. 62, p. 237
back: *Untitled (Collaged Portrait Postcard
'Kurt Schwitters' to the Dexel Family)*
4 November 1921, see cat. 157, p. 246

Frontispiece
Hugo Erfurth (photographer)
Collaged wall of the *Merzbau* and movable
column, with Kurt Schwitters in front of it,
1932/1936
Agfa-Foto-Historama, Cologne